RITA LEJEUNE AND JACQUES STIENNON

THE LEGEND OF
ROLAND
IN THE MIDDLE AGES

II

PHAIDON

Translated by Dr Christine Trollope

Phaidon Press Limited, 5 Cromwell Place, London SW7

Published in the United States by Phaidon Publishers, Inc.
and distributed by Praeger Publishers, Inc.
111 Fourth Avenue, New York. N.Y. 10003

First published 1971

Originally published as
La Légende de Roland dans l'art du Moyen Age
© 1966 by Editions Arcade, Brussels
Translation © 1971 by Phaidon Press Limited
All rights reserved

ISBN 0 7148 1414 8 — used for Vol 1.
Library of Congress Catalog Card Number : 73-111061

Printed in Belgium by Leemans and Loiseau, Brussels

THE LEGEND OF ROLAND
IN THE MIDDLE AGES

CONTENTS

BLACK AND WHITE ILLUSTRATIONS

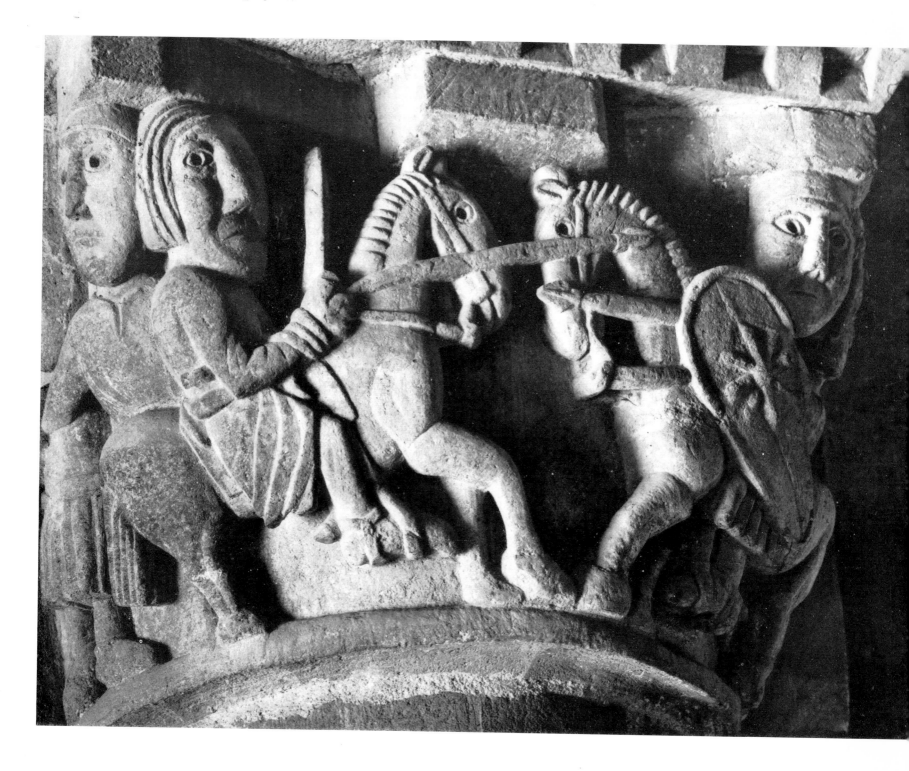

1. Confronted knights.

Conques, Rouergue.　　Church of Sainte-Foy.　　Gallery capital.
Between 1087 and 1119.

The scenes carved on the capitals in Romanesque churches generally have a didactic purpose. This capital at Conques, carved at the time of the First Crusade, exhorts Christian knights to cease their fratricidal strife and transfer their enthusiasm for war to the struggle against the infidel.

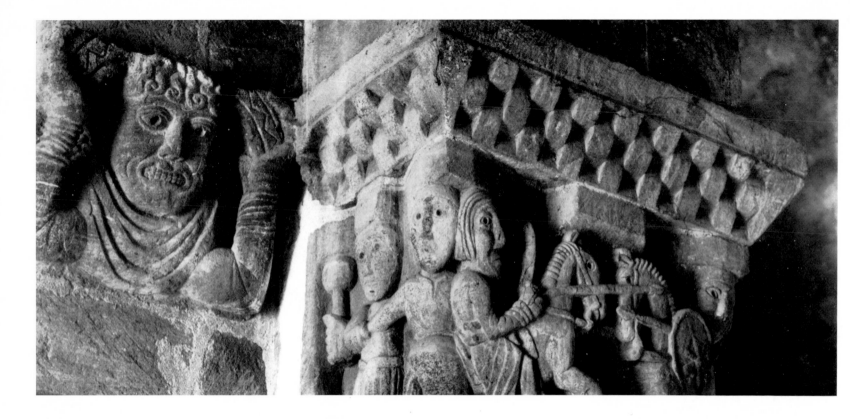

2

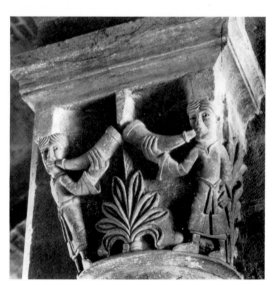

3 4 5

2. Bust of telamon and confronted knights.
Conques, Rouergue. High relief and capital.

3. Confronted knights separated by a figure.
Fruniz (Biscay). Church of San Salvador. Capital at main
doorway. 12th century.

4. Crowned king surrounded by dignitaries and prelates.
Ibid. Capital at main doorway. 12th century.

5. Men blowing horns.
Conques, Rouergue. Church of Sainte-Foy. Gallery capital.
Between 1087 and 1119.

*Some of the capitals in a church in Biscay show the
influence of the same idea. The grinning face on a
support at Conques is intended to bring the Saracen
peril to mind.*

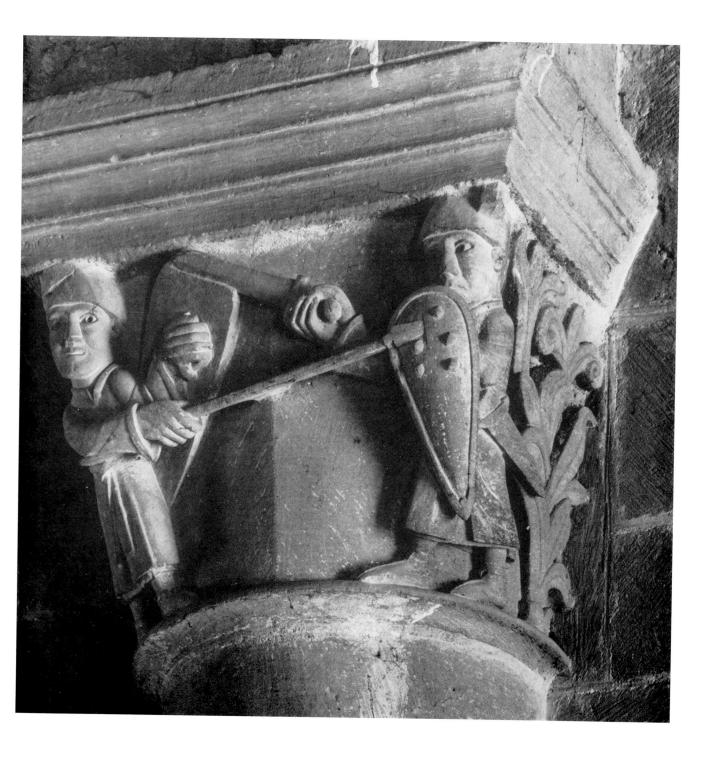

6. Two warriors fighting on foot.
Conques, Rouergue. Church of Sainte-Foy.
Gallery capital. Between 1087 and 1119.

The fierce fighting of the Spanish Crusade has its echoes in the church of Sainte-Foy at Conques, a well-known stopping point on the route to Compostela.

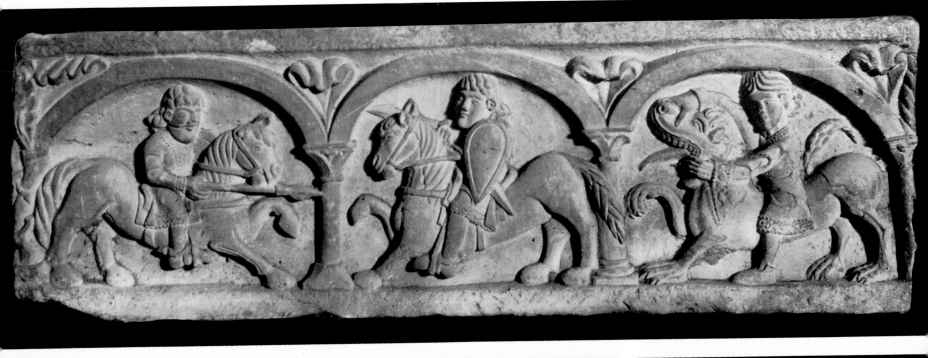

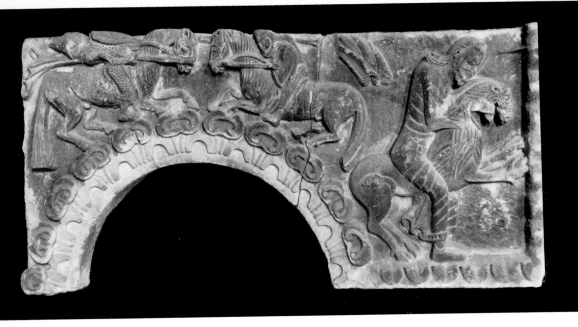

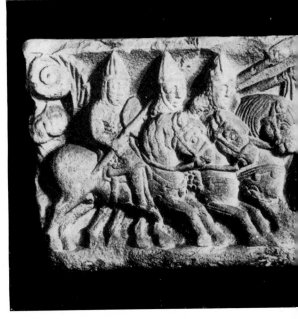

9 7

10 8 11

7. Confronted knights and Samson wrestling with the lion.

Front of Doña Sancha's sarcophagus. Jaca, Benedictine Convent. End of 11th century.

8. Confronted knights and Samson wrestling with the lion.

"La Belle Pierre". Cluny, Musée Ochier. About 1160.

9. Confronted knights.

Miniature. *Psalter of San Millán de la Cogolla*. Madrid, Biblioteca de la Academia de la Historia. 11th century.

10. Battle between Christians and infidels.

Pavia, Museo Civico (from the Church of San Giovanni in Borgo). Bas-relief. Second quarter of 12th century.

11. A Christian knight fighting with an Arab.

Detail of Doña Sancha's sarcophagus.

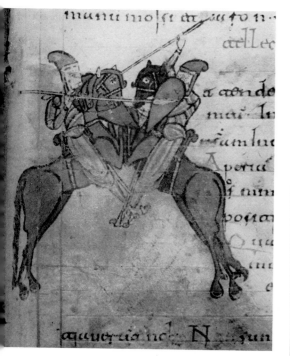

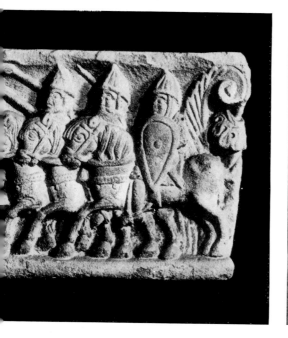

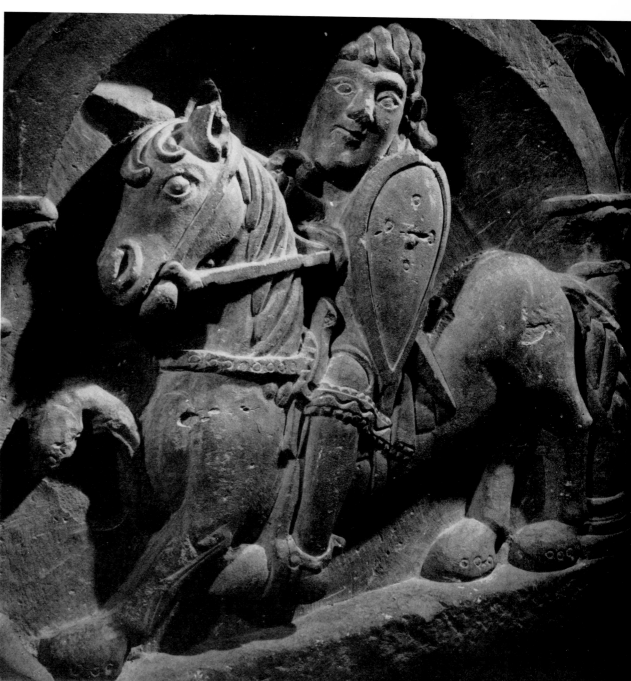

*Variations on the theme of confronted knights in
Lombardy, Spain and Burgundy.*

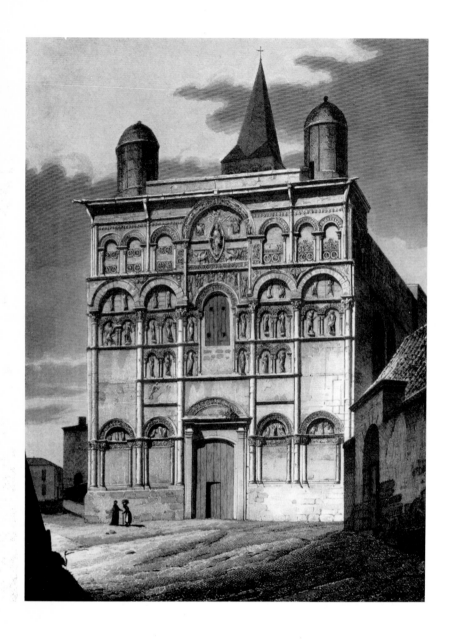

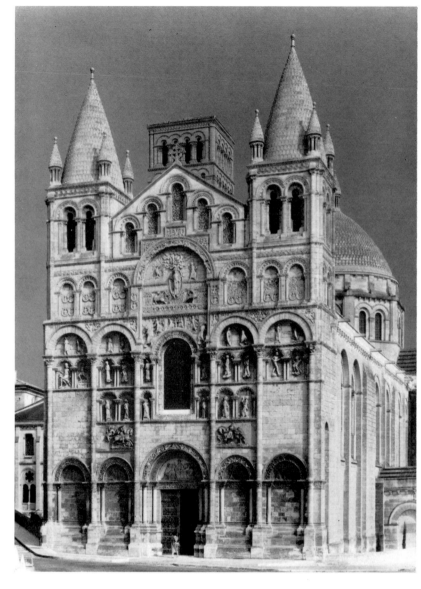

12. Original façade of St. Peter's Cathedral,
Angoulême.

Engraving. Angoulême, Musée de la Ville.

13. Present façade of St. Peter's Cathedral,
Angoulême.

*This great white cliff of sculptures gleams under the
clear Charente sky.*

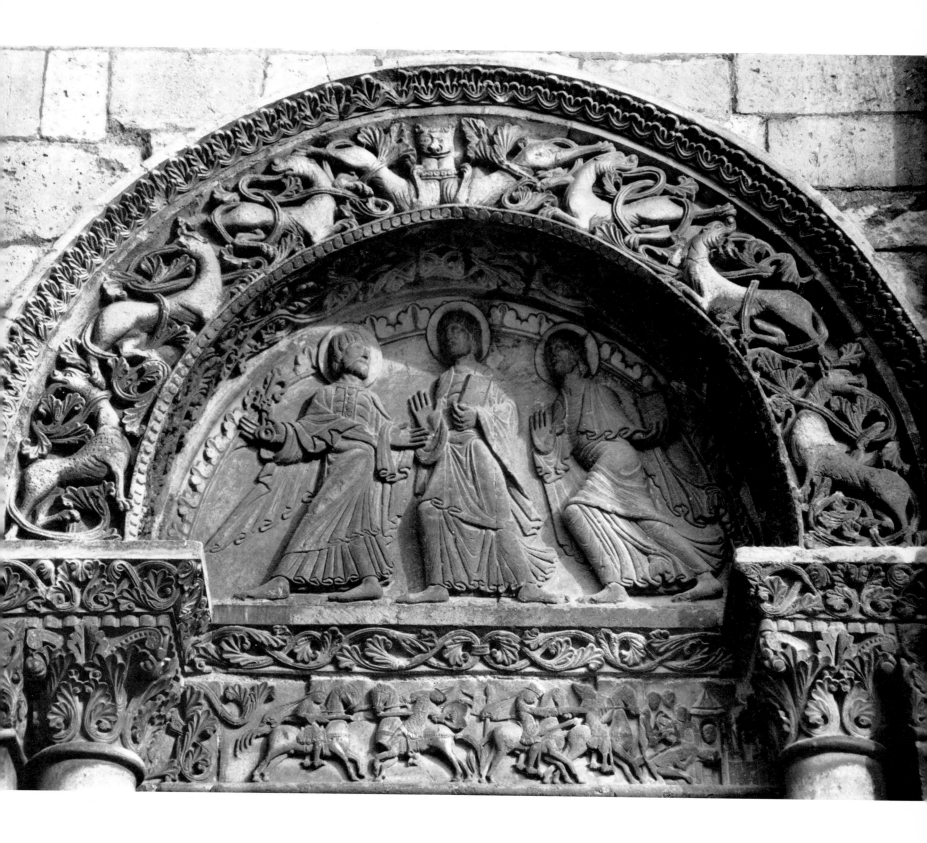

14. Three apostles. The preaching of the Gospel.
Angoulême. St. Peter's Cathedral. Tympanum of the first
blind doorway on the right of the main door. About 1120.

*This lintel in Angoulême cathedral marks the first,
spectacular appearance of the* Chanson de Roland *in
the history of art. The successes of Charlemagne's
warriors were also the triumphs of the Christian faith.*

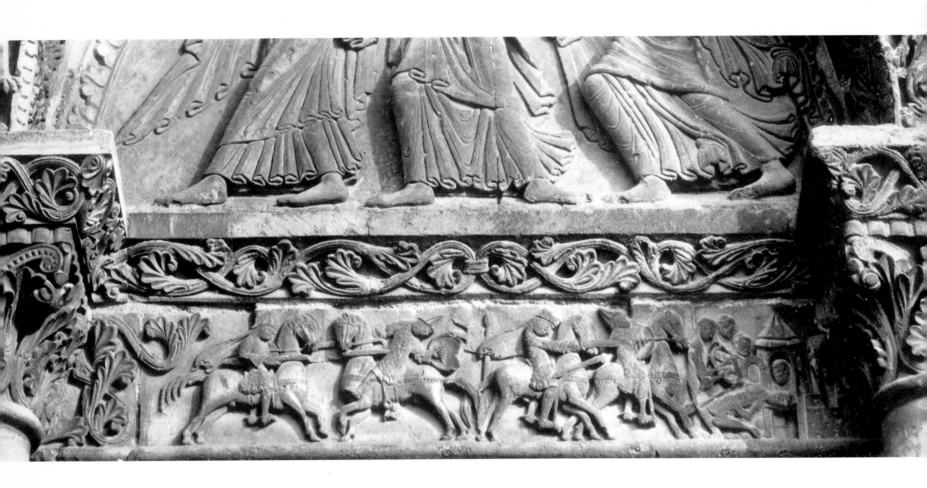

15. Lintel of the tympanum, Angoulême Cathedral.

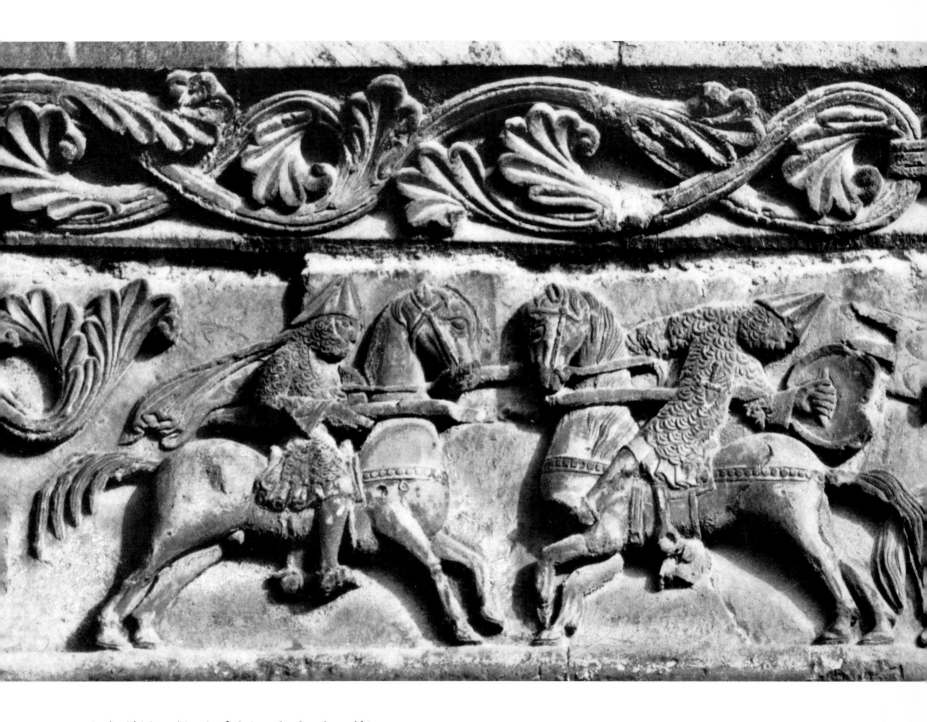

16. Archbishop Turpin fighting the heathen Abisme.
Angoulême. Detail of the lintel.

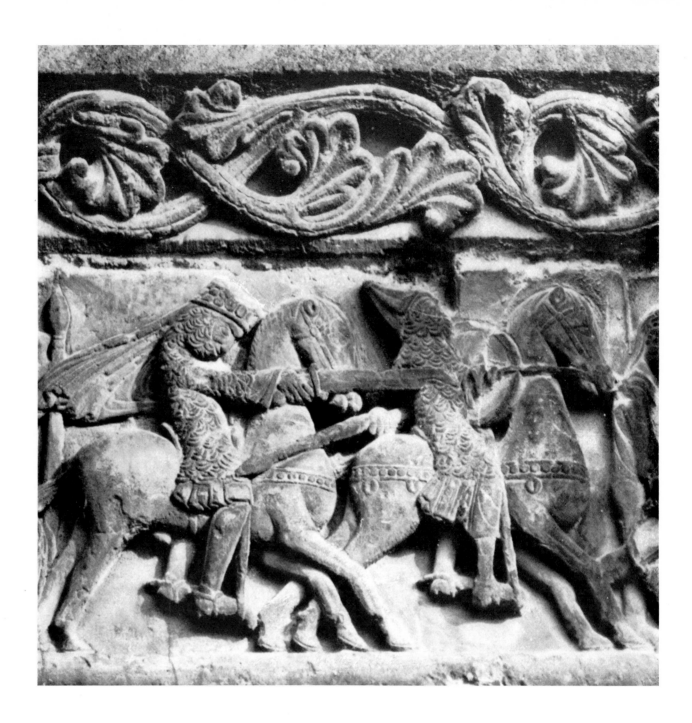

17. Roland cutting off the arm of the heathen king Marsile.
Angoulême. Detail of the lintel.

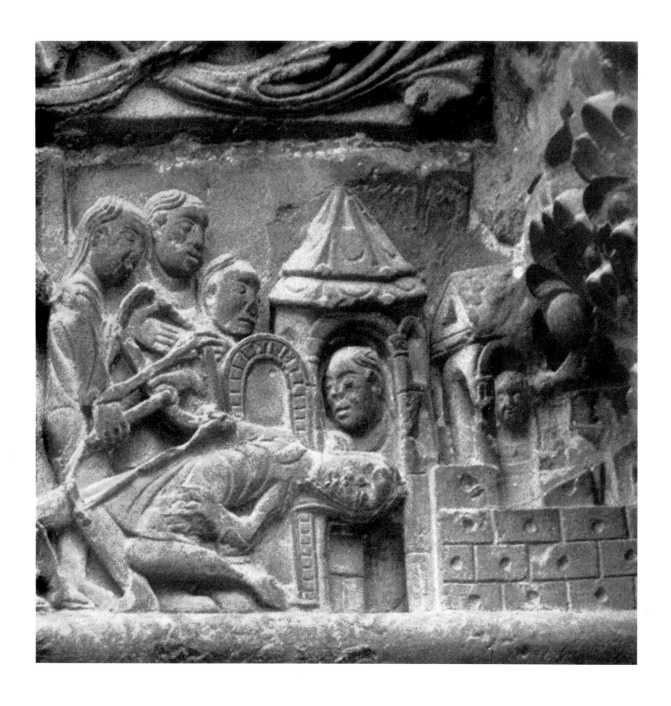

18. Marsile fainting outside his capital Saragossa.
Angoulême. Detail of the lintel.

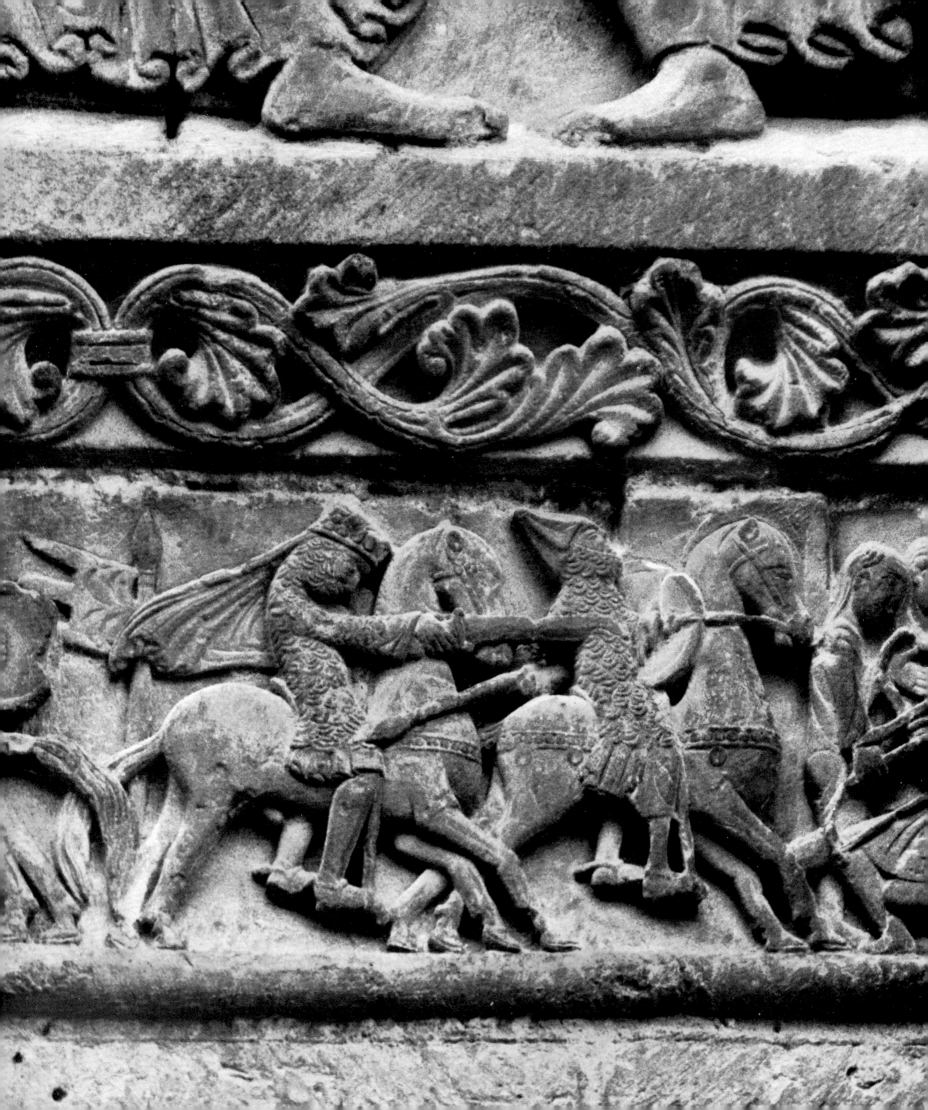

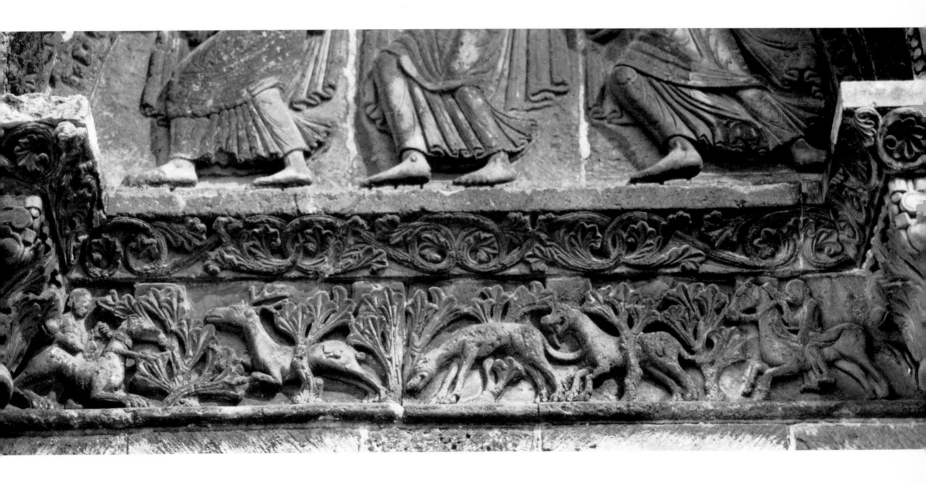

19. Stag-hunt.

Angoulême. Lintel of the second blind doorway on the right
of the main door. About 1120.

*This lintel, neighbour of the preceding one, illustrates
the frequent use in medieval bestiaries of animal char-
acteristics to illustrate human ones. The* Chanson de
Roland *says : 'As the stag flees before the hounds, so do
the heathen flee before Roland'.*

20. Frescoes of the Charlemagne cycle.
Rome. Church of Santa Maria in Cosmedin. Central nave,
left-hand wall. Between 1119 and 1124.

At the beginning of the 12th century these pitiful remnants were brilliantly coloured mural paintings of the life of Charlemagne, in which the first hints of the Roland legend were already to be seen.

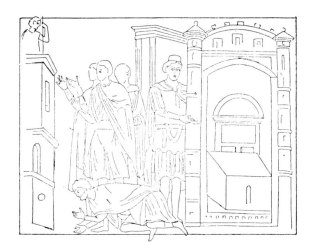

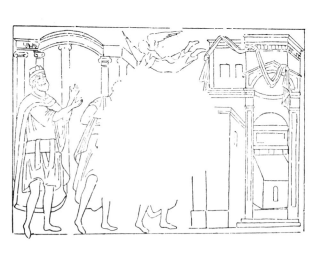

22 21

24 23

26 25

21. Charlemagne receiving Haroun-al-Raschid's gifts.
Ibid. Scene 9 of the cycle.

22. Charlemagne receiving Haroun-al-Raschid's gifts.
Reconstruction by G.B. Giovenale.

23. Charlemagne arriving in Jerusalem.
Charlemagne before the Holy Sepulchre.
Fresco. *Ibid.*

24. Charlemagne arriving in Jerusalem.
Charlemagne before the Holy Sepulchre.
Reconstruction by G.B. Giovenale.

25. An angel appears to Charlemagne to give him the
task of liberating the tomb of St. James.
Fresco. *Ibid.*

26. An angel appears to Charlemagne to give him the
task of liberating the tomb of St. James.
Reconstruction by G.B. Giovenale.

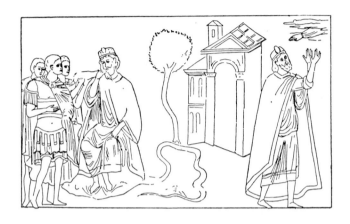

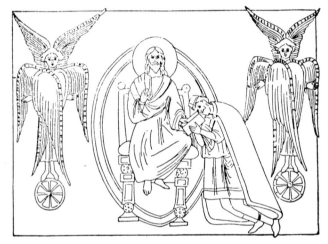

27

28 29 30

27. Charlemagne weeps. Miracle in his favour.
Reconstruction by G.B. Giovenale.

28. Christ judging and absolving Charlemagne.
Reconstruction by G.B. Giovenale.

29. Portrait of the apostle St. James (?)
Fresco. Rome, Santa Maria in Cosmedin.

30. Archbishop Turpin.
Historiated initial T. *Codex Calixtinus*, Santiago de Compostela.
Archivo Catedral, fº 63 rº. Second half of 12th century.

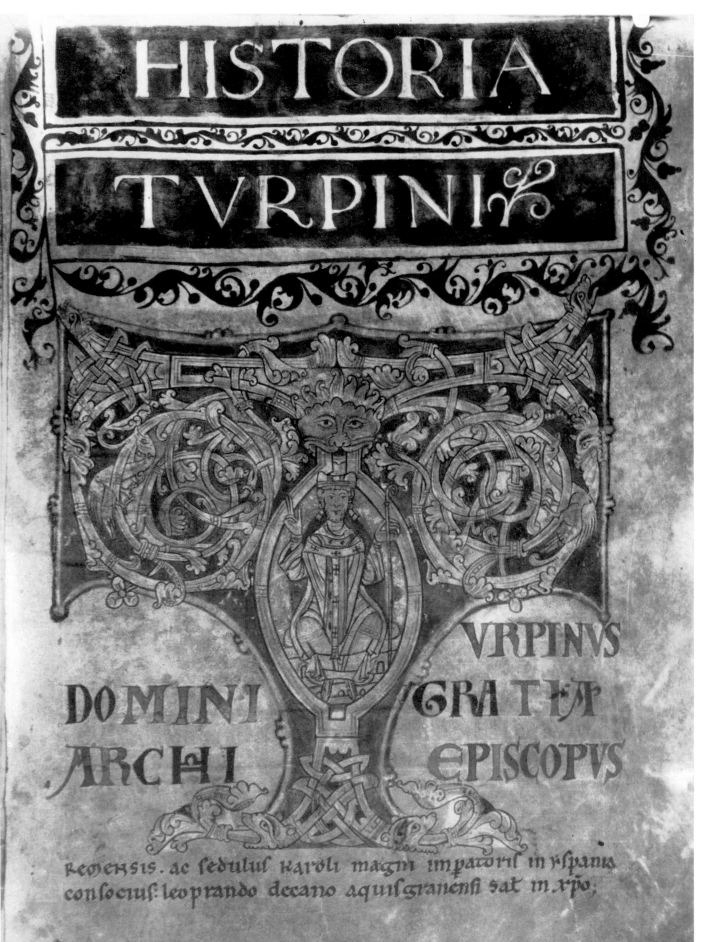

HISTORIA TVRPINI

VRPINVS

DOMINI

ARCHI

GRATIA

EPISCOPVS

Regensis. ac sedulus karoli magni impatoris in yspania
consocius: leoprando decano aquisgranensi sat in xpo.

Turpin sits amid the tendrils
of an illuminated letter; one
of Charlemagne's peers, he
was popularily supposed to
be the author of a celebrated
account of Roland's exploits
at Roncevaux.

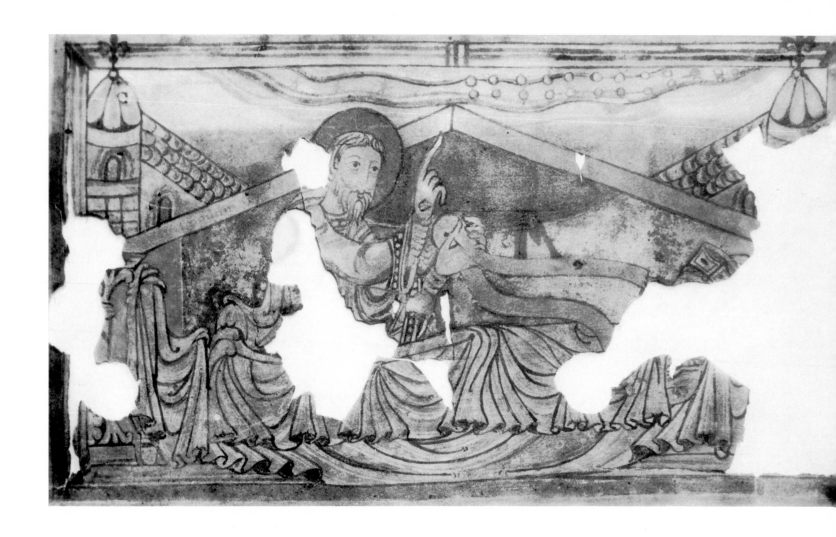

31. St. James appearing to Charlemagne.
Miniature. *Codex Calixtinus,* Santiago de Compostela, Archivo Catedral, fo. 162 ro.

Charlemagne's vision of St. James was the prelude to the Spanish campaign in which Roland won fame.
This scene from the manuscript at Santiago de Compostela reappears in a large number of manuscripts about Charlemagne's life.

32. St. James appearing to Charlemagne.
Miniature. *Codex Calixtinus*. Rome, Biblioteca Vaticana,
Arch. S. Pietro, ms. C 128, fo. 133 vo. 14th century.

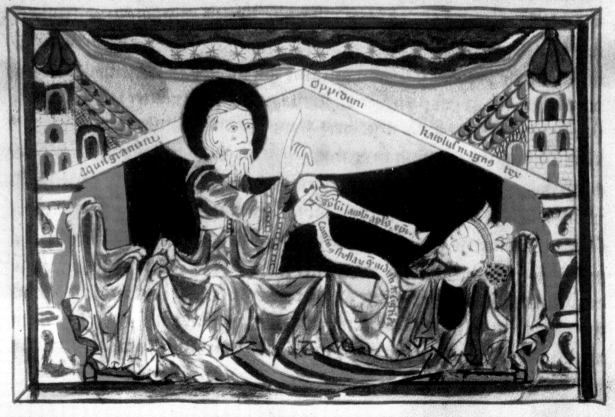

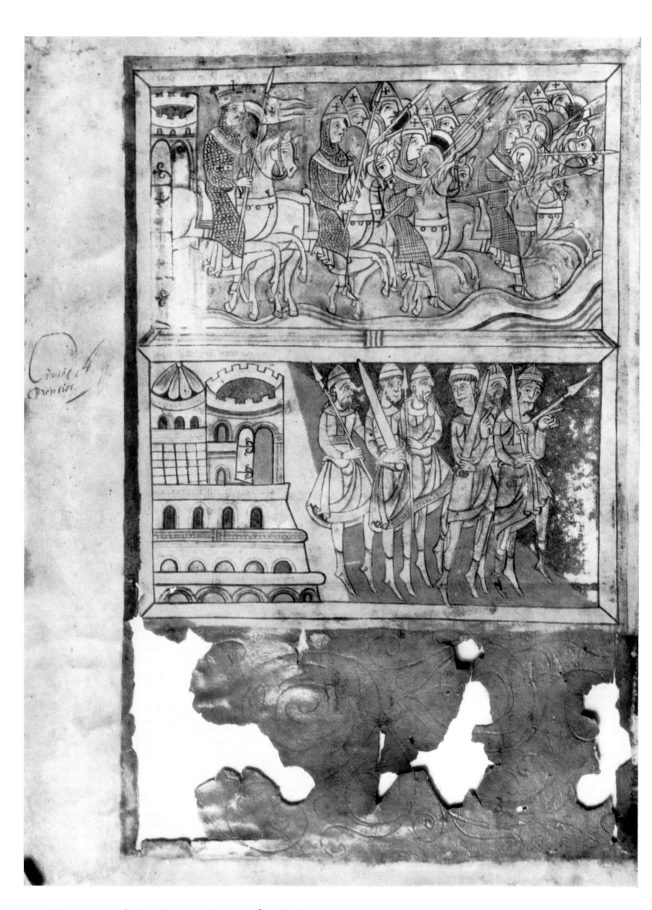

33. Departure of Charlemagne's army for Spain.
Charlemagne and the Spanish war veterans at
Aix-la-Chapelle.

Miniature. *Codex Calixtinus,* Santiago de Compostela, Ar-
chivo Catedral, fo. 162 vo.

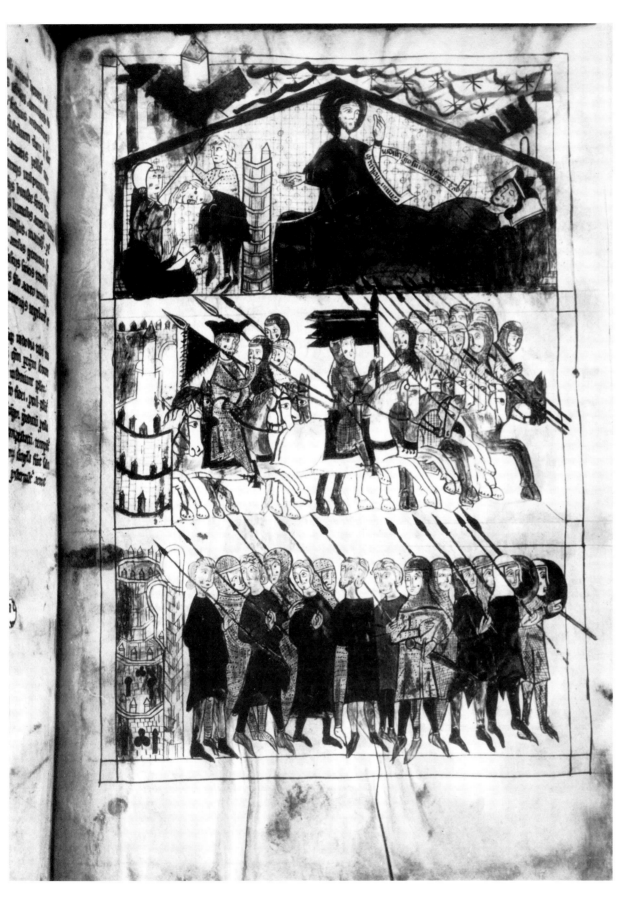

The legendary Spanish expedition set out from Aix-la-Chapelle and returned there when all was over. Roland is shown proudly bearing the Emperor's standard.

34. St. James appears to Charlemagne. Charlemagne's army leaving for Spain. Charlemagne and the Spanish War veterans at Aix-la-Chapelle.

Miniature. *Codex Calixtinus.* Salamanca, Biblioteca Universitaria, ms. 2631, fo. 90 ro. 13th century.

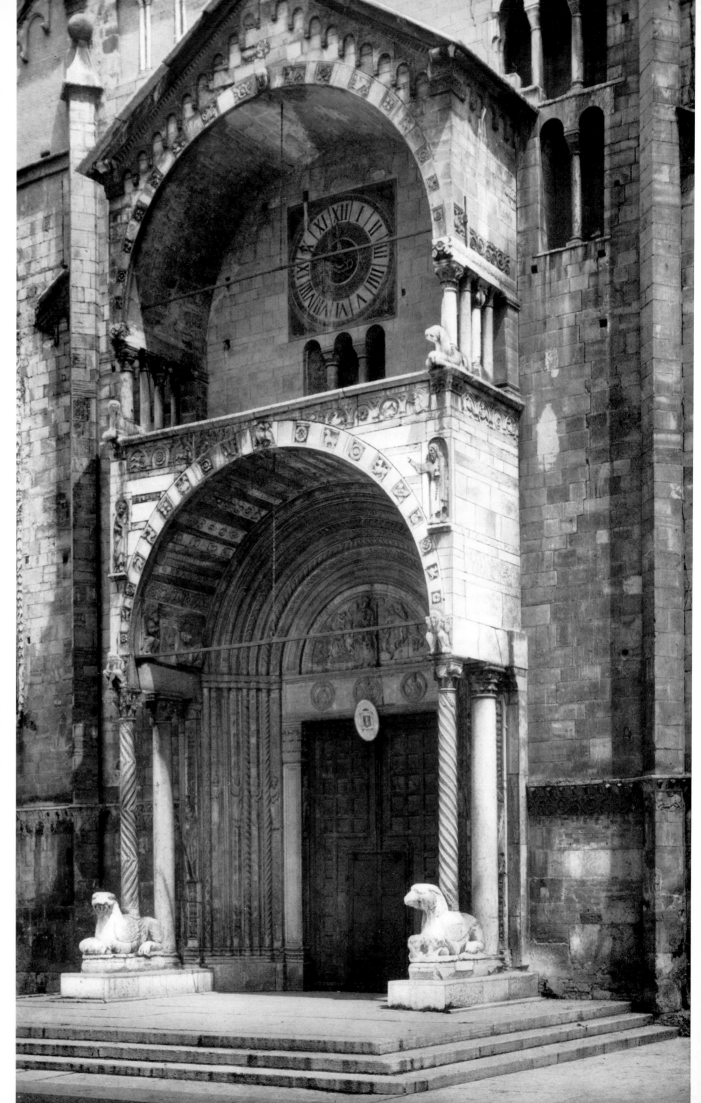

The cathedral of Verona, with its white marbles and sculpture, is a landmark in the red and green of the medieval city.

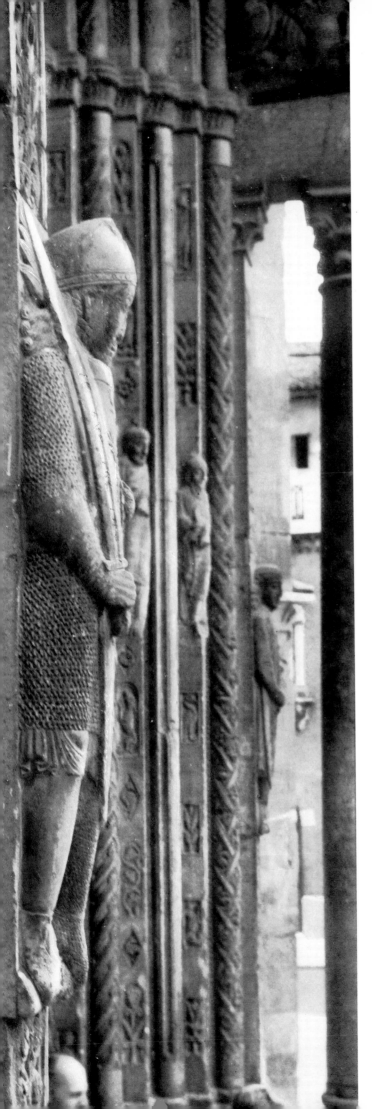

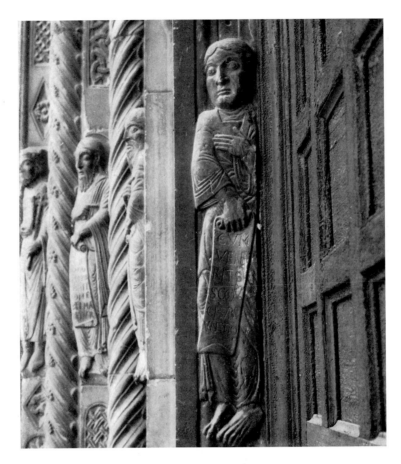

35. Façade of the Cathedral of Verona (1139).

36. Statues of Roland and Oliver.
Verona. Cathedral. Side view of the main entrance. 1139.

37. Prophets, side view with prophet on the door jamb.
Detail of main doorway, left-hand side.

The two Christian heroes keep watch at the door among the prophets.

38. Statue of Roland, frontal view.
Detail of doorway, left-hand side.

This Roland is harsh and severe in outline,
and foreshadows the gigantic German statues.

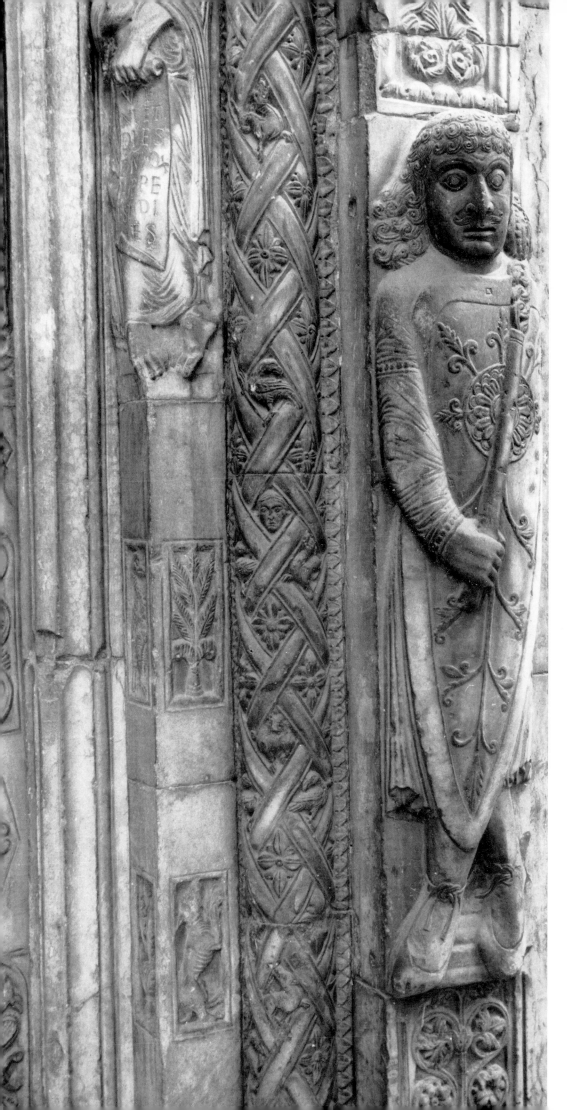

39. Statue of Oliver, frontal view.
Detail of doorway, right-hand side.

Oliver's attitude and dress conform to the legend of the handsome, courtly and gallant knight. The flail he carries is also in keeping with his legendary personality.

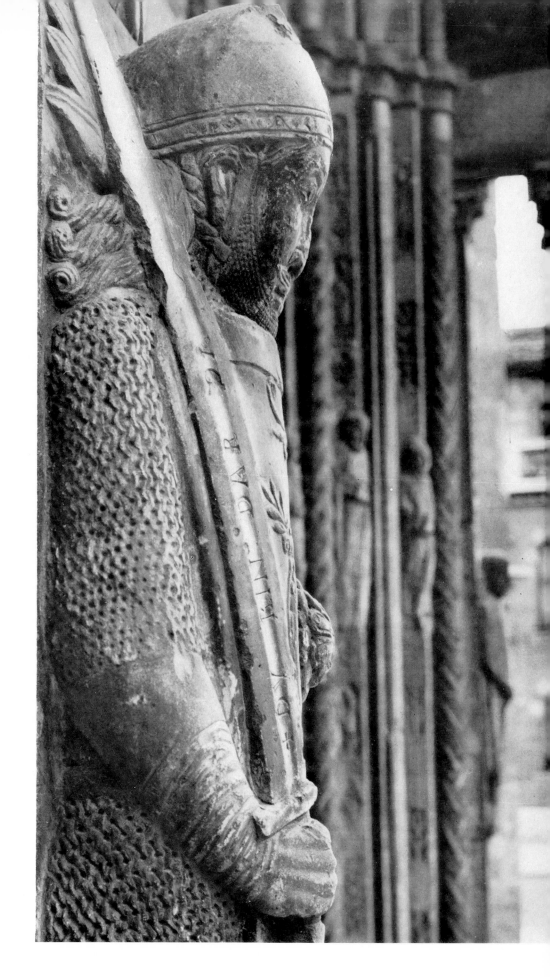

40. The inscription 'Durindarda' on Roland's sword.
Detail of the statue.

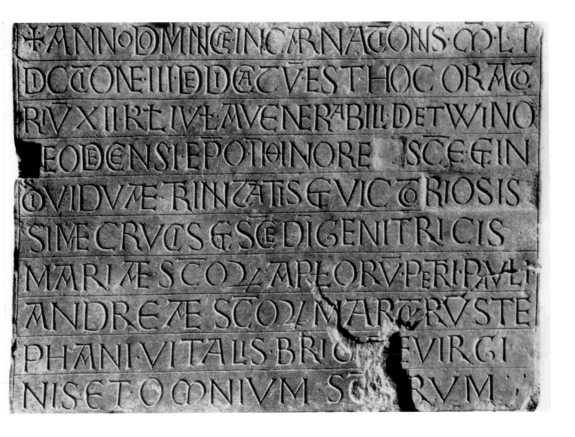

41. Dedicatory inscription in Waha church. Belgium, province of Luxembourg. 1050.

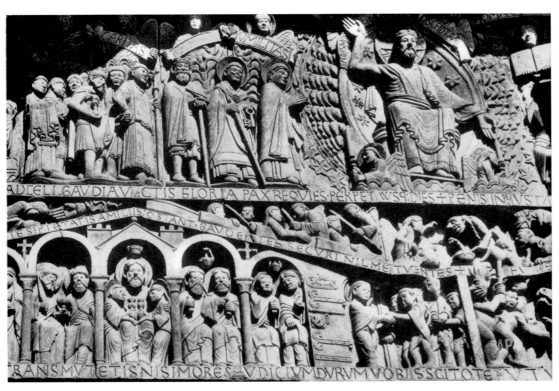

42. Last Judgement.
Conques, Rouergue. Church of Sainte-Foy.
Detail of tympanum. Beginning of 12th century.

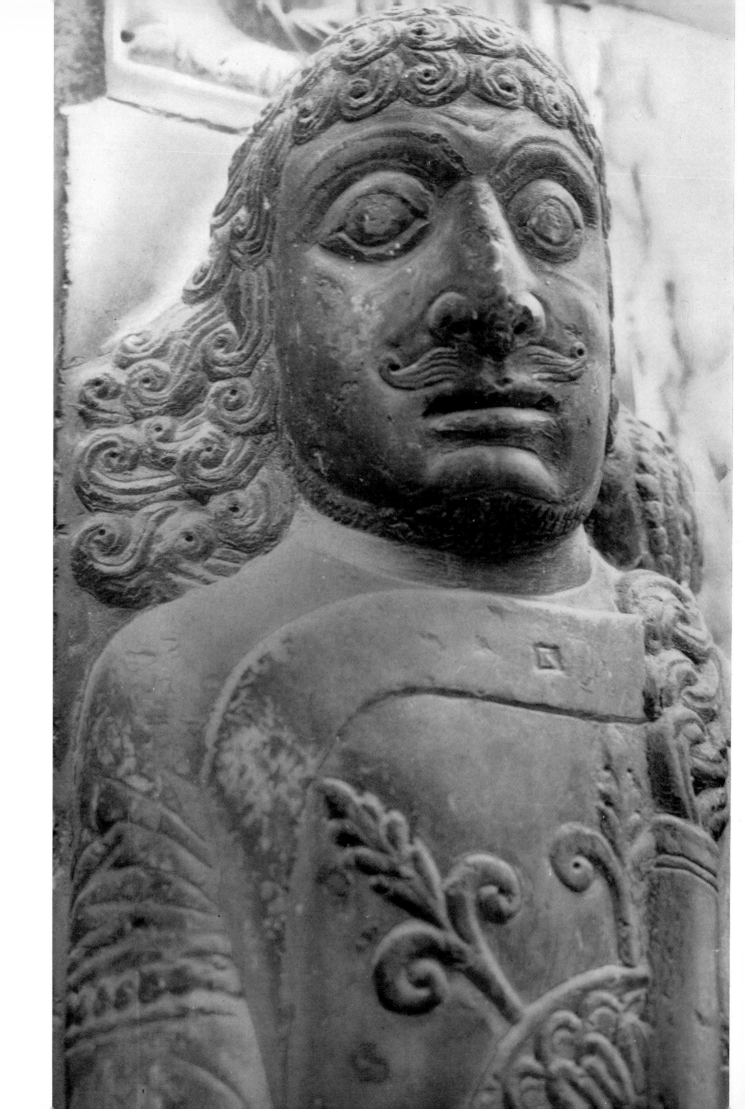

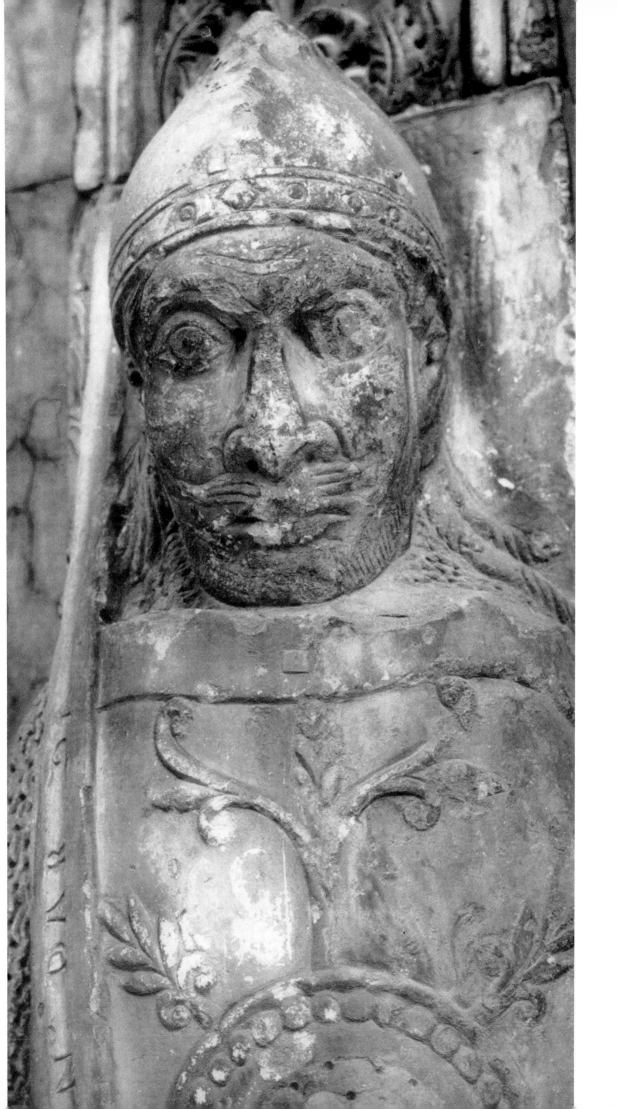

43. Head of Oliver.
Detail. Verona, Cathedral.

44. Head of Roland.
Detail. Verona, Cathedral.

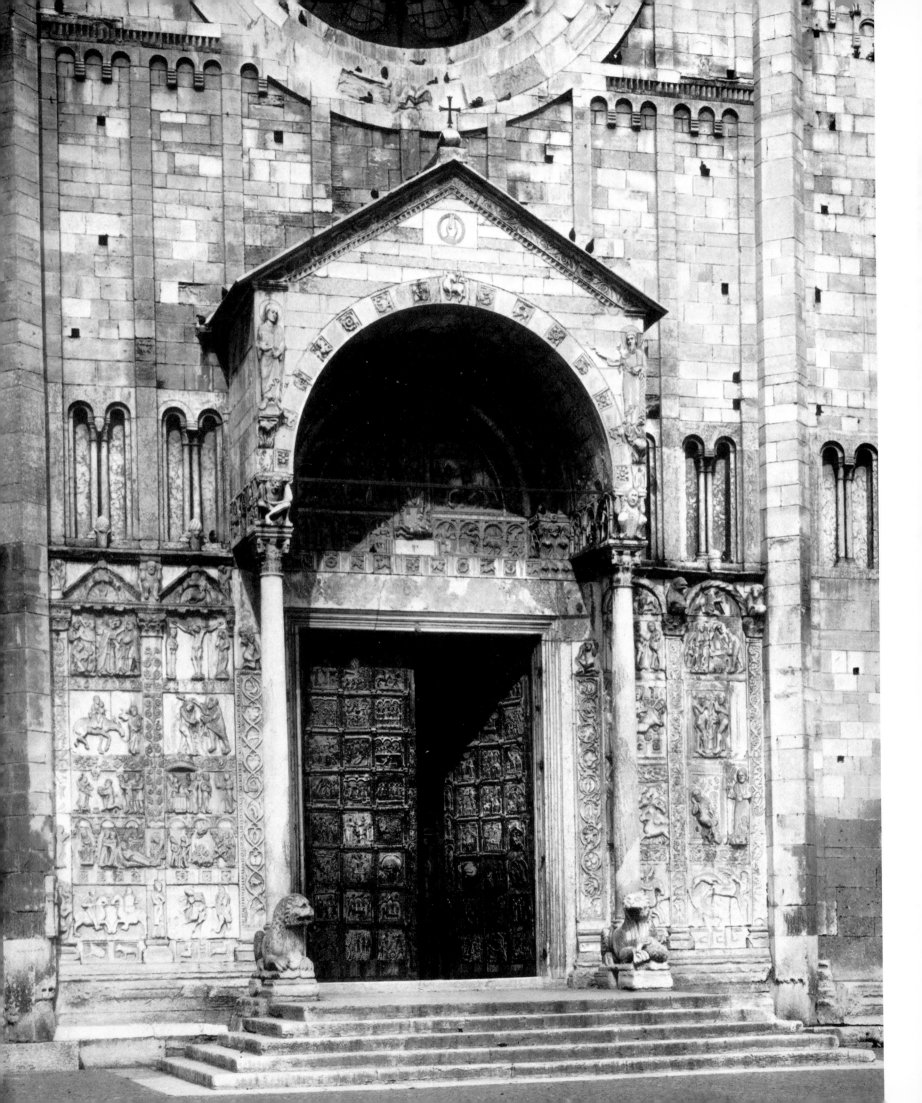

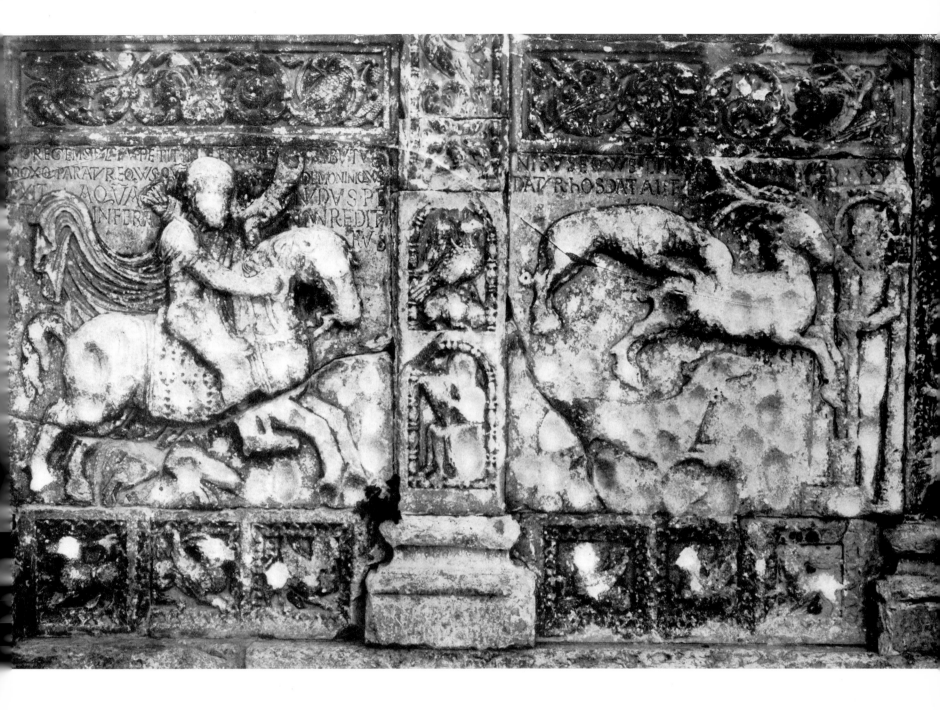

45. Façade of the church of Santo Zeno, Verona.
Main doorway. About 1138.

46. Theodoric the Visigoth hunting.
Verona. Church of Santo Zeno. Bas-relief on the façade,
to the right of the doorway.

*The intermingling of sacred and secular pictures carved
in marble or cast in bronze make the church of Santo
Zeno in Verona a veritable 'poor man's Bible'.*

*The Visigothic king Theodoric here becomes the type
of the evil huntsman.*

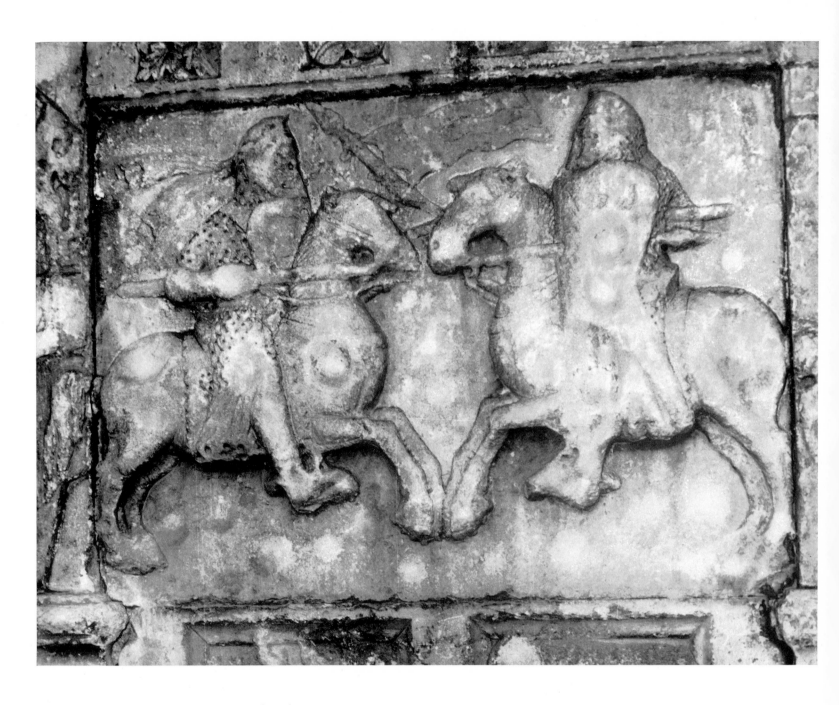

47. Mounted combat between Roland and the heathen
 Ferragut.
Verona.　Church of Santo Zeno.　Bas-relief on the façade,
to the left of the doorway.

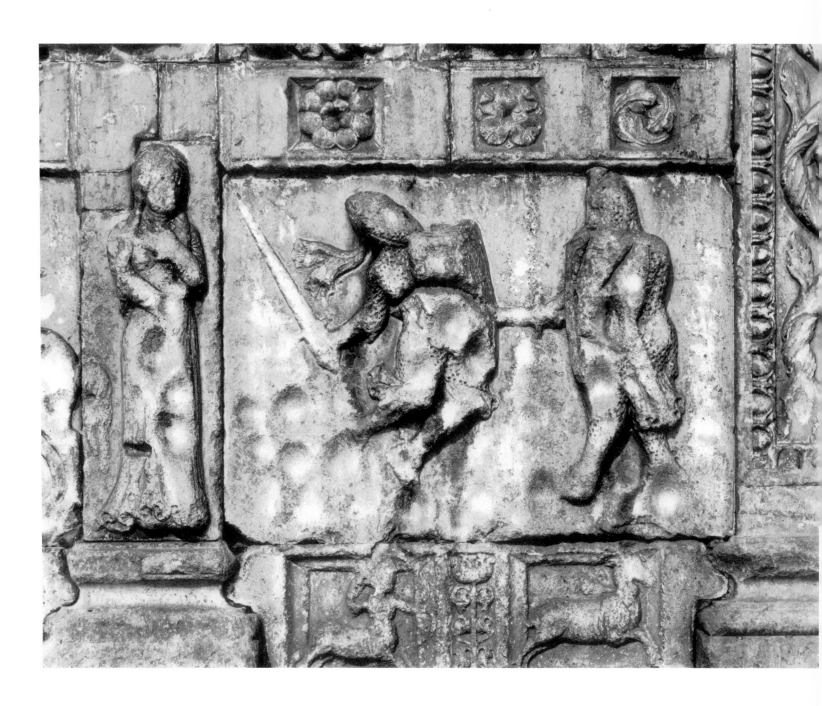

48. Roland and Ferragut fighting on foot. Roland kills
 Ferragut.
Ibid.

In the church of Santo Zeno in Verona we find for the
first time one of the most frequent themes in the
illustration of the Roland legend – the fight between
Roland and Ferragut, the Christian and the heathen
champions. Tradition divides the combat into two
phases – first mounted, then on foot.

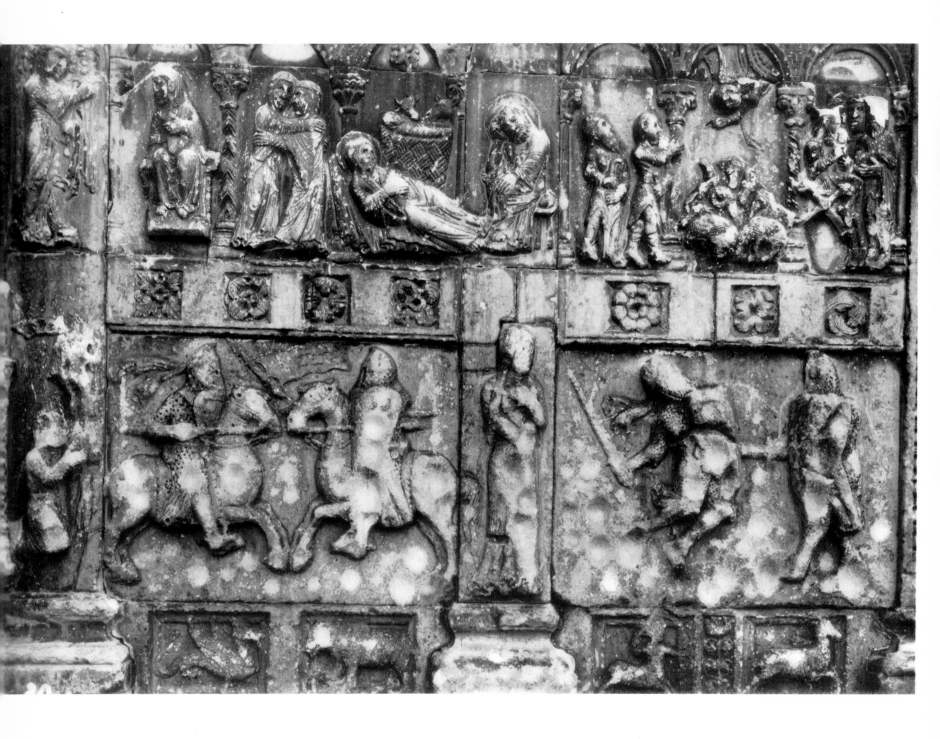

49. General view of the fight between Roland and Ferragut.
Verona. Church of Santo Zeno.

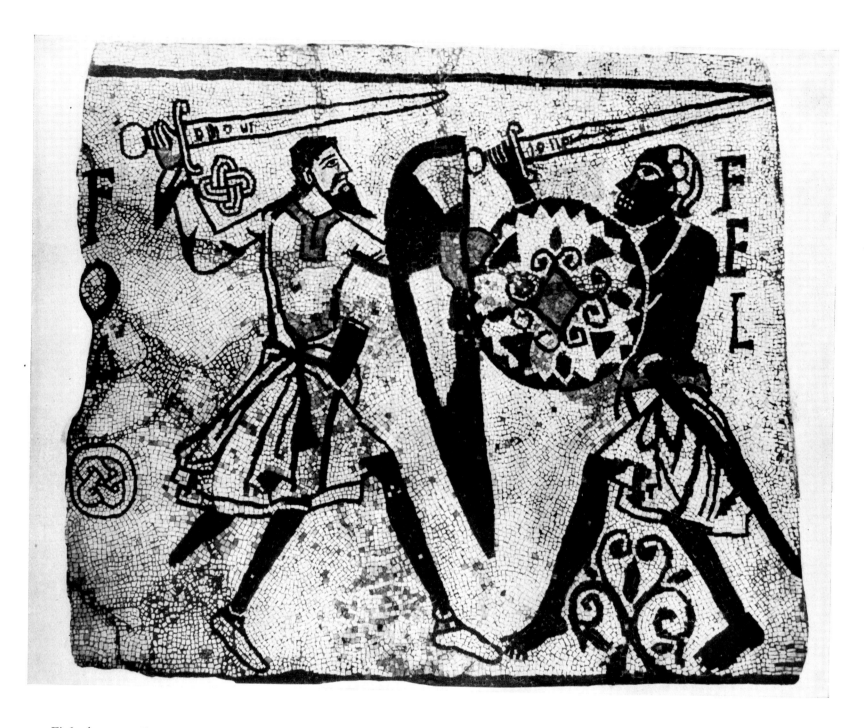

50. Fight between 'le Fol' and 'le Fel'.
Mosaic at Vercelli, Museo Leone. About 1148.

Sometimes pseudo-Rolands appear side by side with the genuine images of Roland. The Fol *seen in a mosaic at Vercelli in Piedmont is not Roland, as has sometimes been claimed, but a character in local history.*

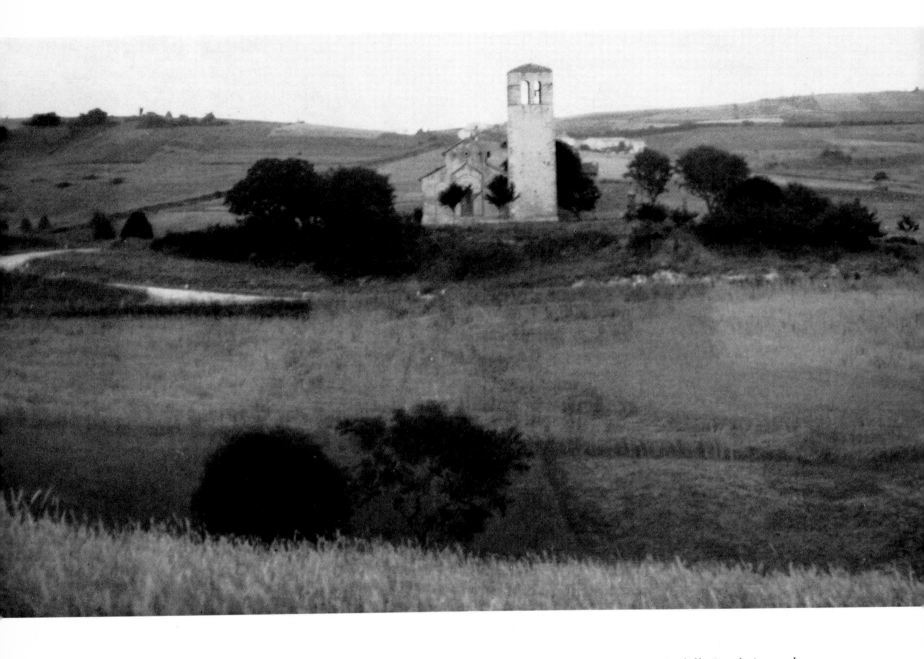

51. Santa Maria della Strada at Matrice.
Molise, Italy.

The little church of Santa Maria della Strada in southern Italy was a welcome resting-place for pilgrims on their way from Monte Gargano to Brindisi.

52. Façade of the church of Santa Maria della Strada.
About 1148.

All the carvings on the façade of this church illustrate the dangers of travel by land and sea, and even the presumptuous notion of journeying by air.
On the left-hand tympanum a woman is abducted by three bandits, whom a knight is putting to flight.

53. An episode from the *chanson de geste* of *Floovant*.
Ibid., tympanum on the left of the main doorway. About 1148.

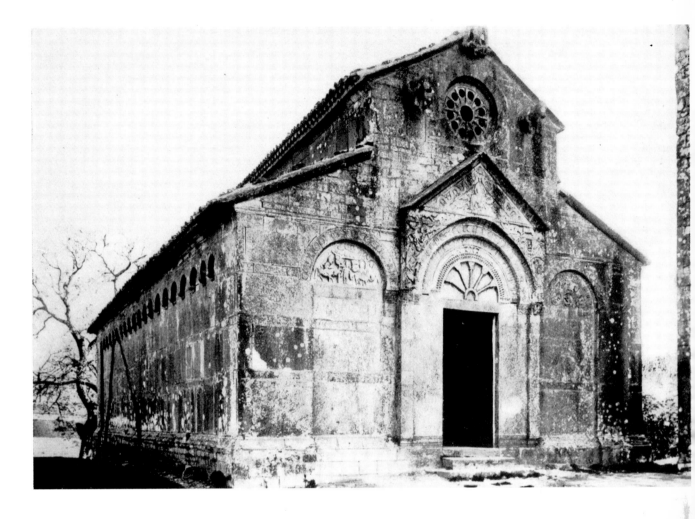

51 52
53

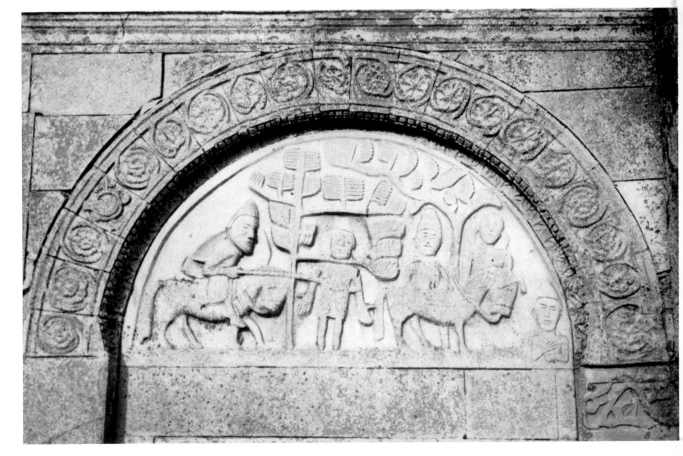

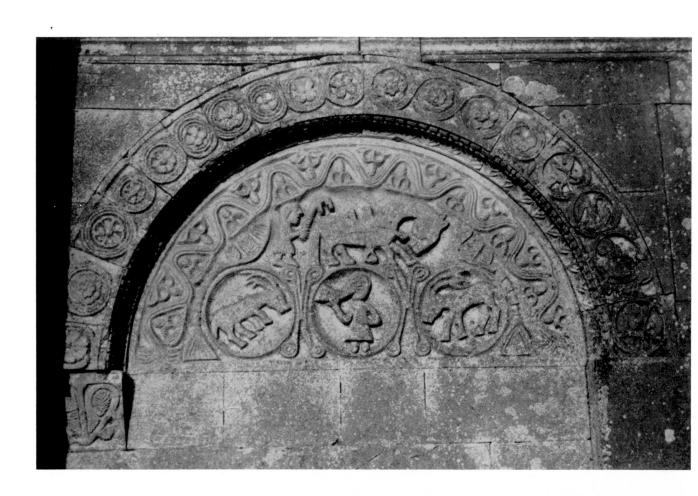

54 57
 56
55

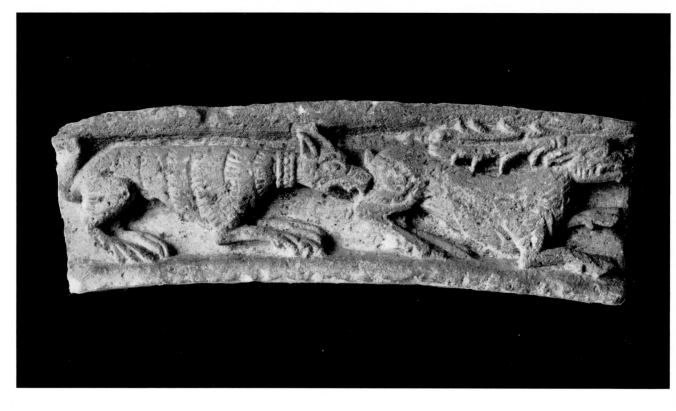

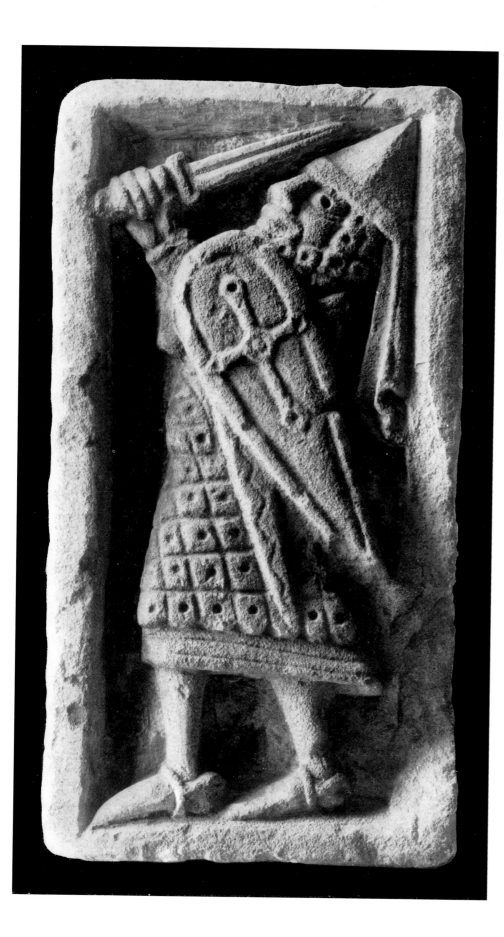

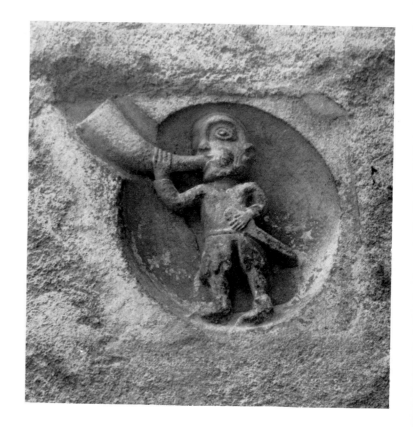

54. Episodes of the *Chanson de Roland*. Roland trying to break his sword, his horse lying beside him; Roland blowing his horn.

Matrice, Santa Maria della Strada. Tympanum on the right of the doorway. About 1148.

55. Dog chasing a stag.

Limoges, Musée des Beaux-Arts. From the façade of the church of Notre-Dame-de-la-Règle at Limoges. First third of the 12th century.

On the right-hand tympanum is an allusion to the ambush at Roncevaux in the Pyrenean forests. The stags recall these forests and at the same time symbolize the heathen routed by Roland.

56. Roland brandishing his sword.
Ibid.

57. Roland blowing his horn.

Cluny. Carved stone incorporated in the wall of a house. 12th century.

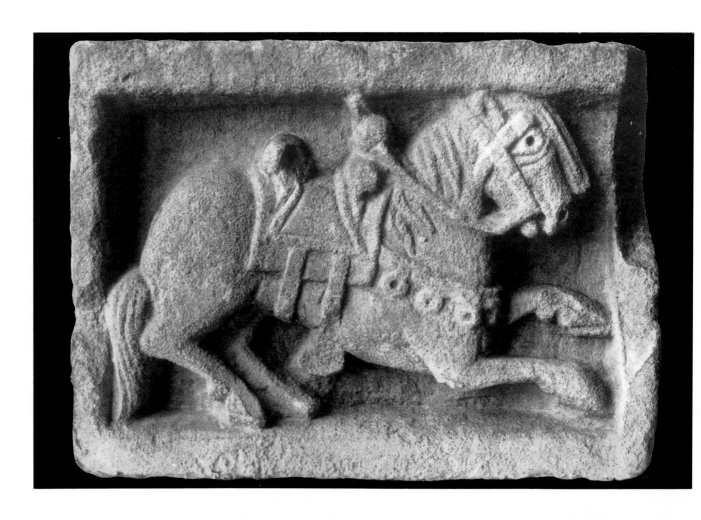

58. Roland's horse sinking to the ground.
Limoges. Musée des Beaux-Arts. From the façade of the
church of Notre-Dame-de-la-Règle at Limoges. First third of
the 12th century.

59. Roland's horse sinking to the ground.
Detail. Matrice, Santa Maria de la Strada.

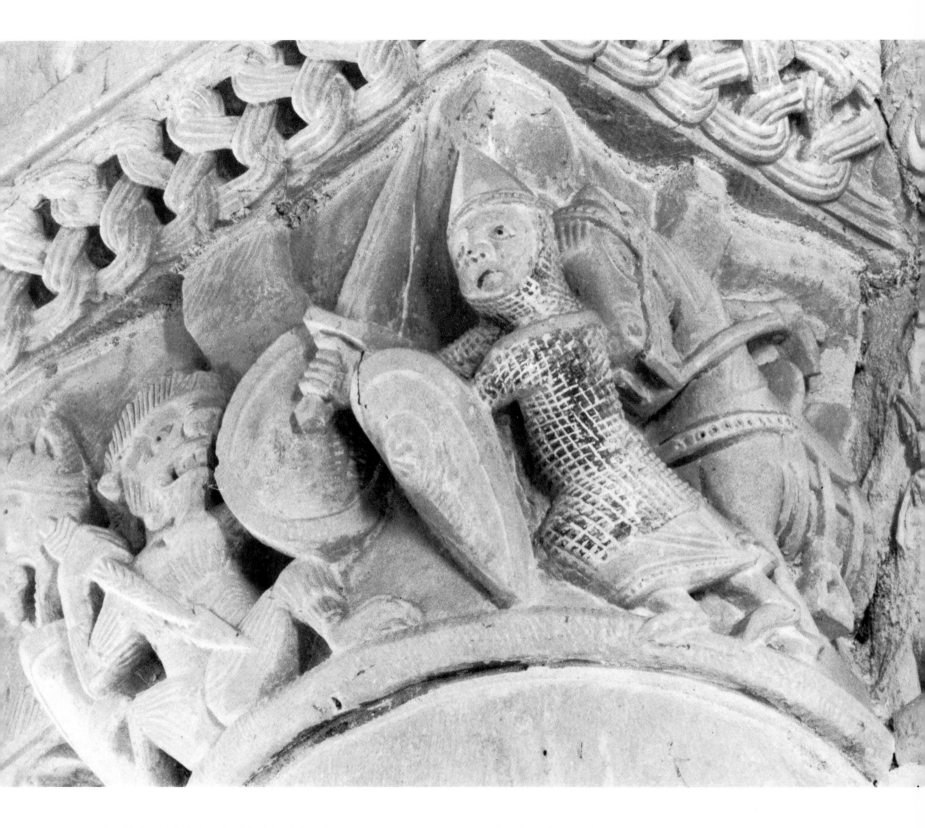

60. Roland fighting beside his dying horse.
Cunault (Maine-et-Loire). Church of Notre-Dame. Capital
in the Choir. 12th century.

Roland performs the same actions at Matrice, Limoges.
Cluny and Cunault. The dying hero, with his horse
sinking beside him, strikes his final blow, tries to break
his sword, and blows his horn for assistance.

61. Façade of the palace of the Dukes of Granada at Estella (Navarre).
Between 1150 and 1165.

62. Mounted combat between Roland and Ferragut.
Estella. Palace of the Dukes of Granada. Capital on the façade (left-hand side), frontal view.

63. Mounted combat between Roland and Ferragut. Roland and Ferragut fighting on foot.
Ibid. Left-hand side of the capital.

64. Roland and Ferragut fighting on foot.
Ibid. Right-hand side of the capital.

Roland must have loomed large in the imagination of those who took the Spanish pilgrim route to Santiago de Compostela. His fight with the Saracen giant Ferragut has been pictured in Navarre and elsewhere.

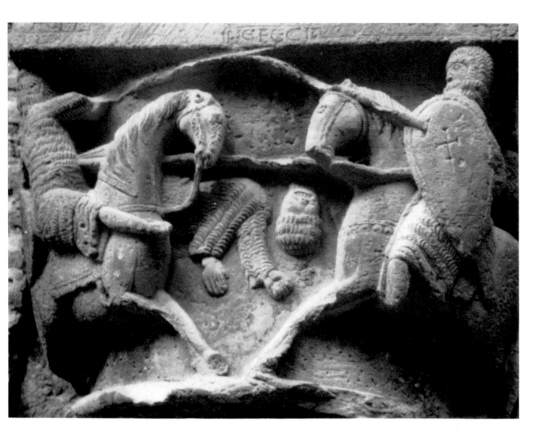

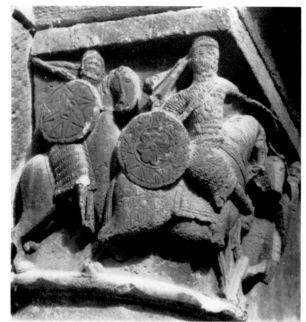

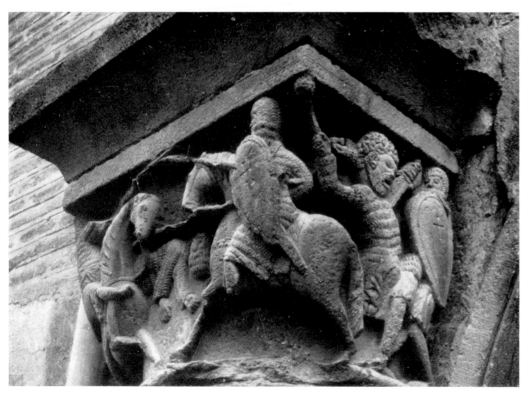

61 62 63
64

65. Mounted combat between Roland and
 Ferragut.
Brioude (Haute-Loire). Church of St. Julian.
Capital in the nave. About 1140.

66. Roland and Ferragut fighting on foot.
 Tarragona. Capital in the Cloister.

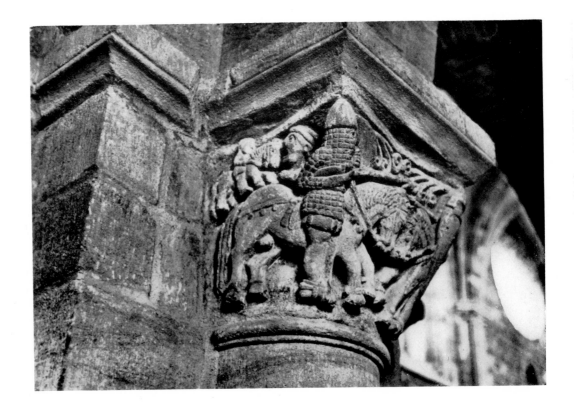

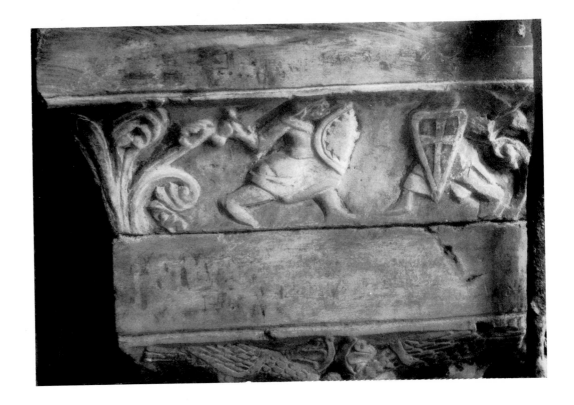

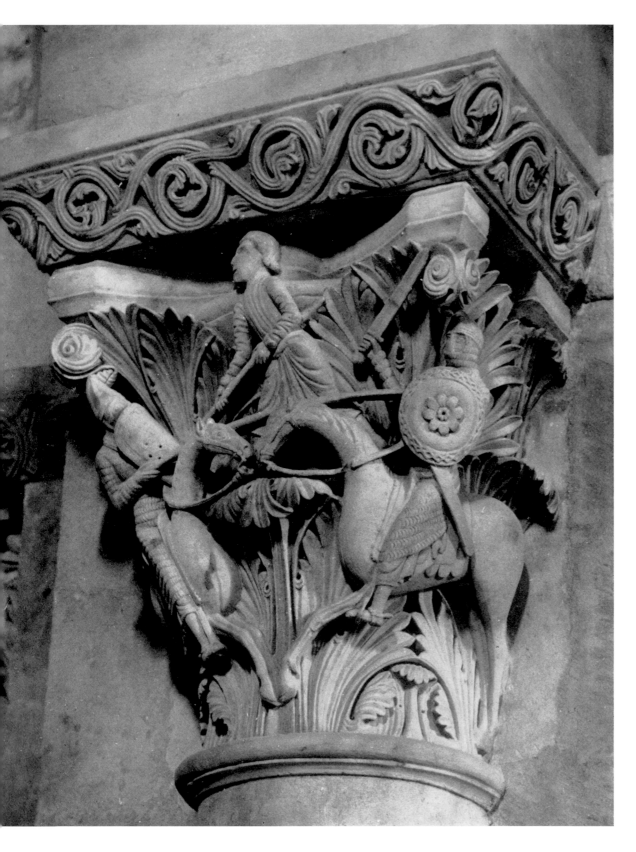

67. Mounted combat between
Roland and Ferragut.
Salamanca. Catedral Vieja. Gallery
capital. After 1160-1165.

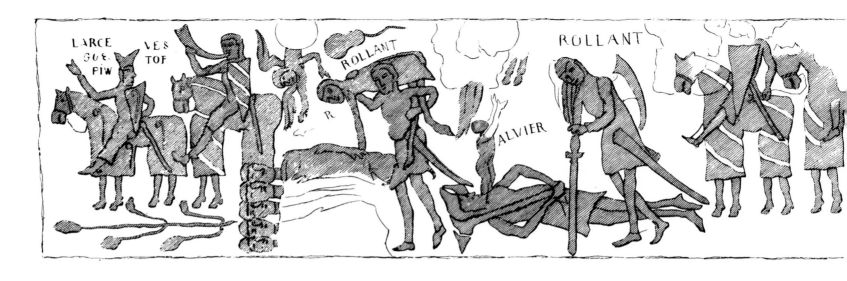

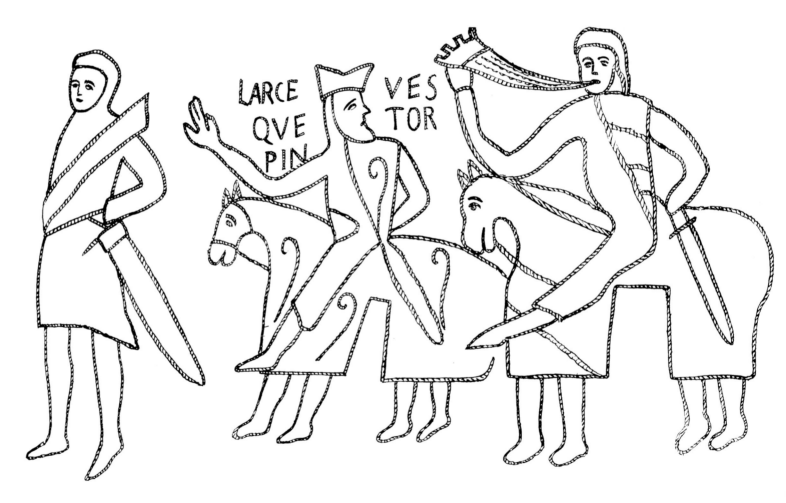

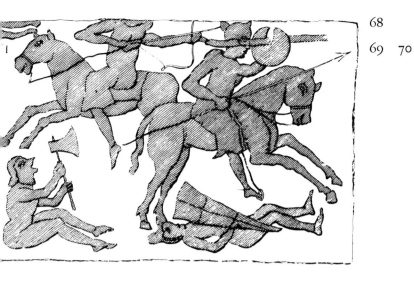

68

69 70

68. Border of the mosaic in Brindisi Cathedral. 1178. Copy by Schultz.

69. Quarrel between Roland and Oliver at Roncevaux. Detail of the Brindisi mosaic. Copy by Millin.

70. Quarrel between Roland and Oliver. Roland bringing back the bodies of his dead comrades. Details of the Brindisi mosaic. After the copy by Schultz.

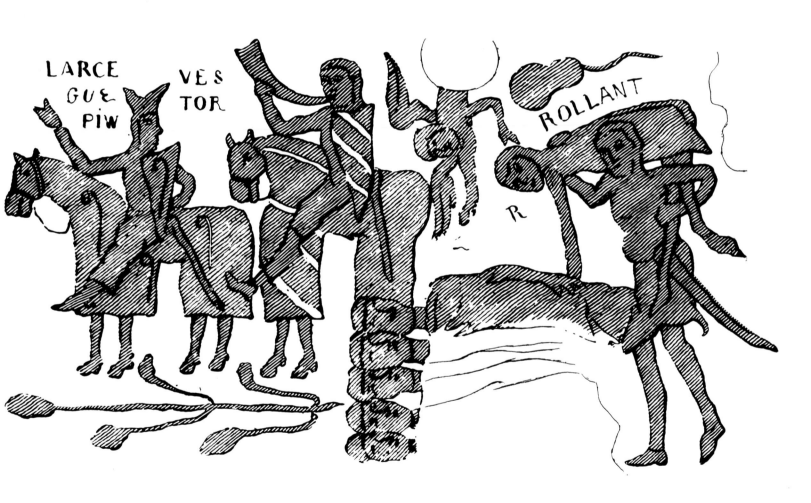

LARCE GUE PIW VES TOR ROLLANT R

As on the borders of the famous Bayeux tapestry, great feats of arms figured in the border of the mosaic decoration in Brindisi cathedral.

ROLLANT

ALVIER

71 73
72 74

IVI
R

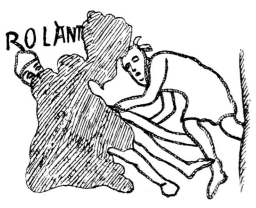

71. Roland carrying the dying Oliver.
Details of the Brindisi mosaic. After Schultz.

72. Roland mourning by Oliver's body.
Detail of the Brindisi mosaic. After Schultz.

73. The dying Roland striking down an infidel who is
 trying to steal his sword.
Detail of the Brindisi mosaic. After Millin.

74. Detail of the Battle of Roncevaux.
Detail of the Brindisi mosaic. After Schultz.

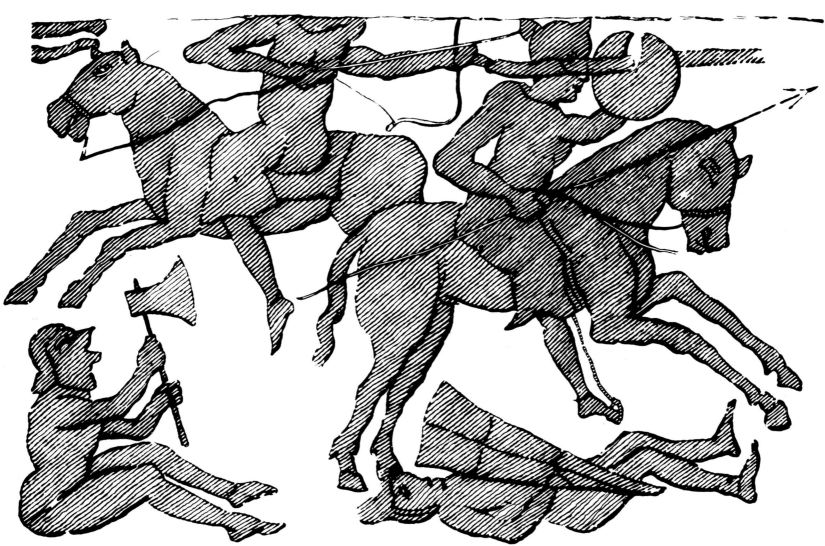

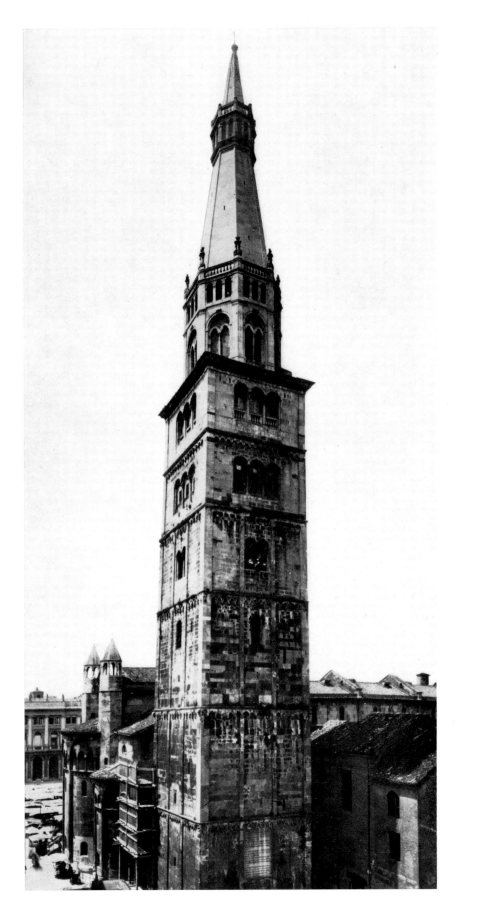

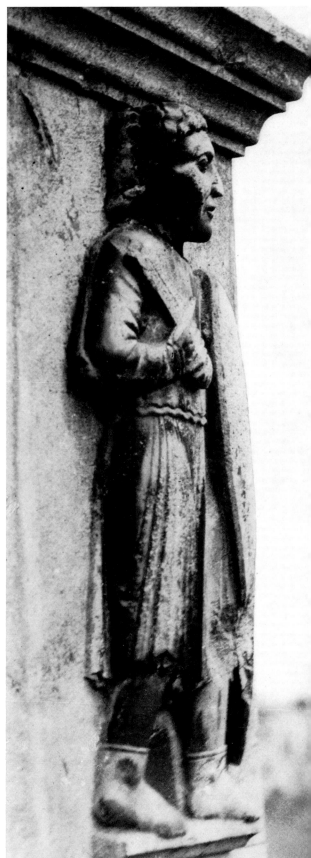

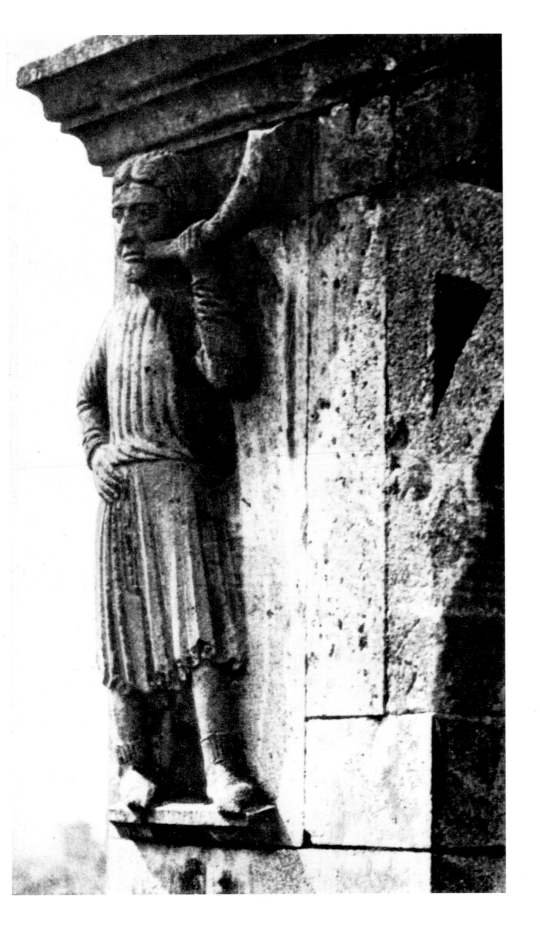

75. The tower of Modena Cathedral known as La
 Ghirlandina.
About 1169-1179.

76. Roland as sword-bearer.
La Ghirlandina, Modena. Bas-relief. About 1168-1179.

77. Roland blowing his horn.
Ibid. Bas-relief.

*At the corner of one storey of the Cathedral bell-tower,
two statues of Roland look out over the city of Modena.*

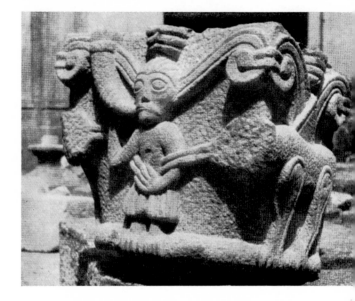

There may be grounds for identifying Roland as the subject of these Romanesque sculptures in Portugal, not far from Santiago de Compostela.

78 80 81

79 82 83

78. Man blowing horn.
Minho (Portugal), unidentified church. 12th century.

79. Man blowing horn.
Braga cathedral. Transept capital. 12th century.

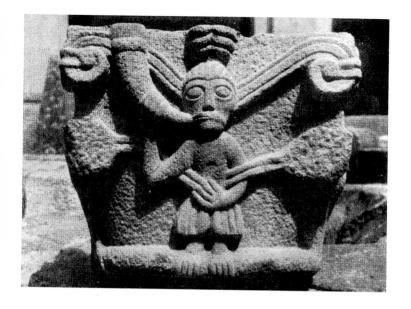

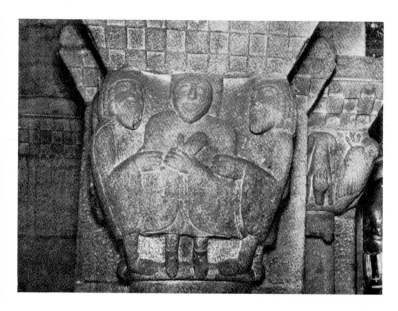 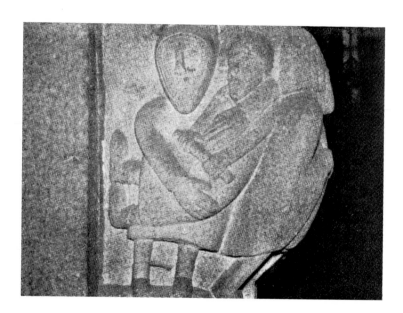

80. Man blowing horn.
Braga cathedral. Transept capital. 12th century.

81. Rebeck-player.
Rio Mau (Portugal). Capital in the church. Second half of 12th century.

82. Burial of Roland (?)
Ibid.

83. Roland carrying one of his dead comrades (?)
Ibid.

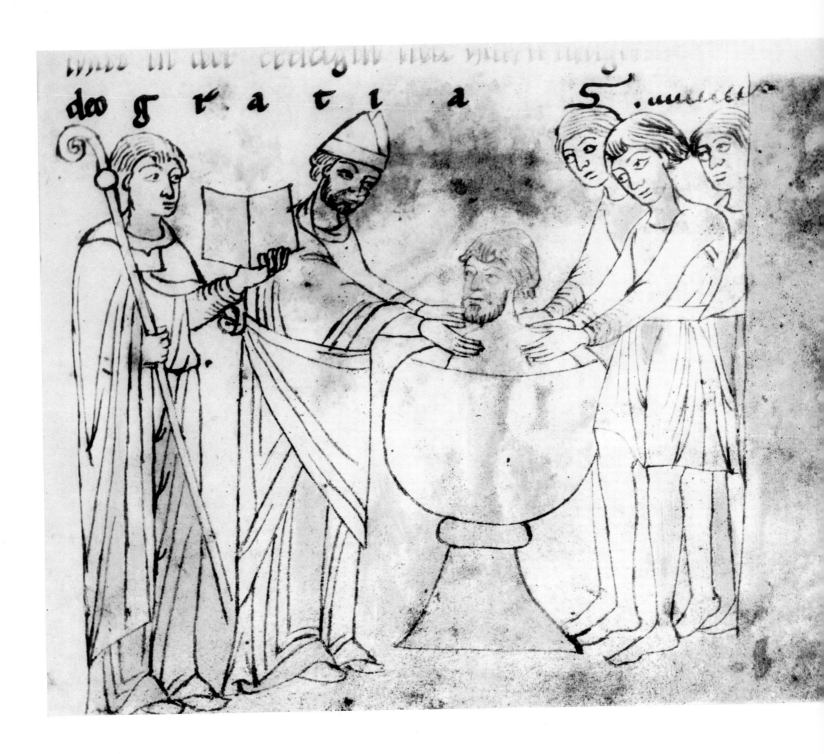

The Heidelberg manuscript of Ruolantes Liet, *a German translation of the* Chanson de Roland, *has thirty-nine drawings to illustrate the main events of the story.*

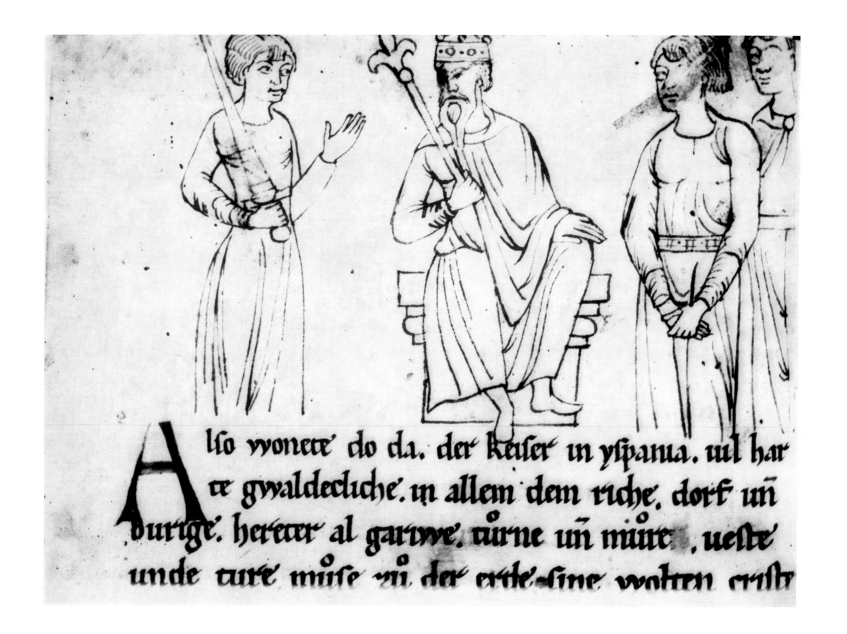

Also wonete do da. der keiser in yspania. vil har
te gwaldecliche. in allem dem riche. dorf un
burige. heretar al gariwe. türne un müte. ueste
unde türe müse vii. der erde sine wolten cristi

84. **Archbishop Turpin baptizing the Spanish infidels.**
Pen-drawing. *Ruolantes Liet* of Conrad the Priest. Heidel-
berg, Universitätsbibliothek, Pal. Germ. 112, fo. 5 ro. About
1180-1190.

85. **Charlemagne seated between Roland and Oliver
the wise.**
Pen-drawing. *Ibid.* fo. 5 vo.

86. Marsile, the heathen king of Saragossa, in council.
Pen-drawing. *Ruolantes Liet* of Conrad the Priest. Heidelberg. Universitätsbibliothek, Pal. Germ. 112, fo. 6 ro.

87. Marsile's emissaries offer Charlemagne a false peace.
Pen-drawing. *Ibid*, fo. 8 vo.

88. The legendary capture of Corderes (Cordova) by Roland and Oliver.
Pen-drawing. *Ibid*, fo. 11 vo.

89. The siege of Cordova by Charlemagne's army.
Wall painting. Le Puy Cathedral, former chapterhouse. About 1150.

90. The council of the Franks presided over by Turpin.
Pen-drawing. *Ruolantes Liet* of Conrad the Priest. Heidelberg, Universitätsbibliothek, Pal. Germ. 112, fo. 15 vo.

91. The general council of the Franks. Discussion between Turpin and Ganelon.
Pen-drawing. *Ruolantes Liet* of Conrad the Priest. Second half of 12th century. Strasburg, Bibliothèque Nationale et Universitaire (ms. burnt in 1870).

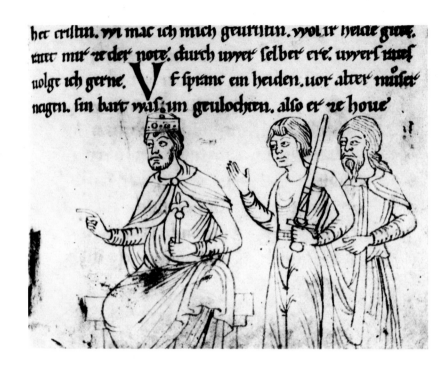

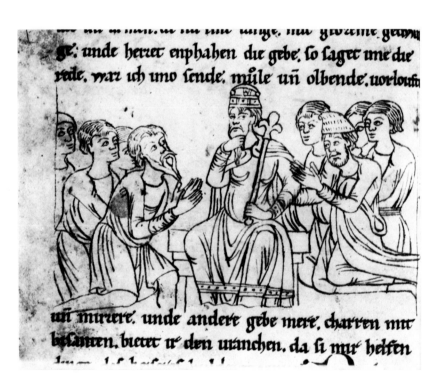

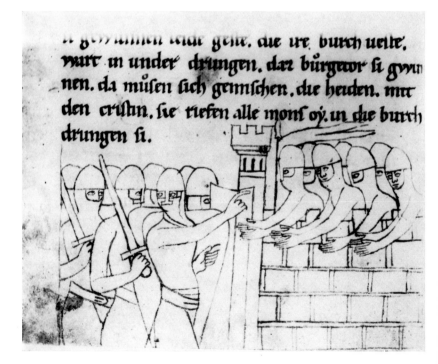

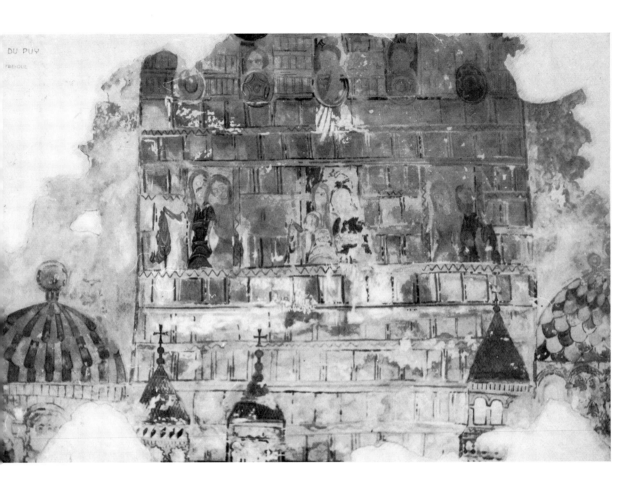

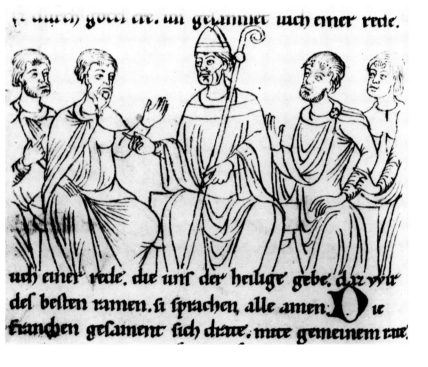

durch got ete. un geſamnet ſich einer rede.

uch einer rede. die uns der heilige gebe. daz wir
deſ beſten ramen. ſi ſprachen alle amen. Die
franchen geſament ſich driete. mite gemeinem rate

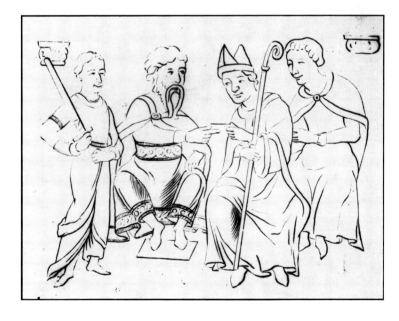

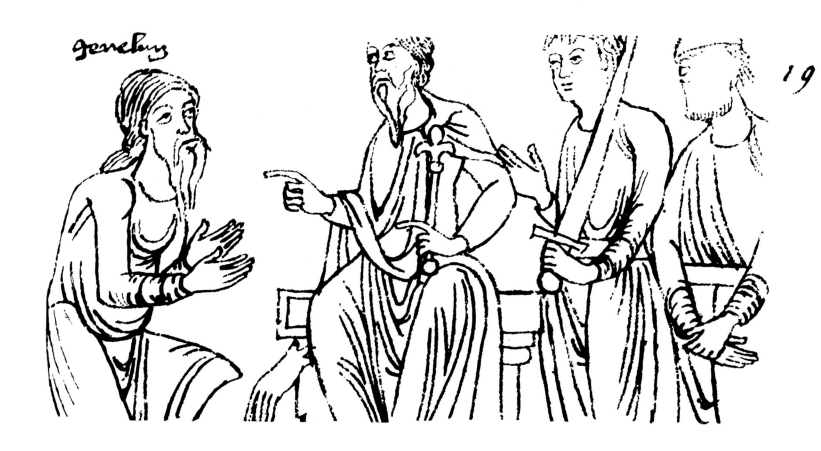

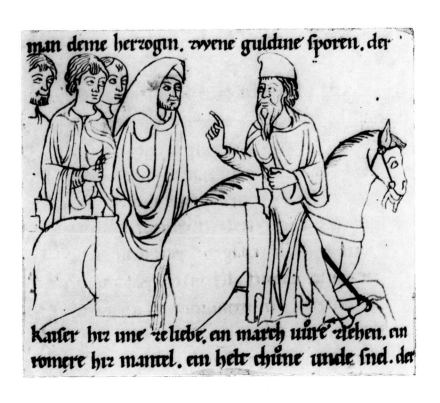

man deine herzogin. zwene guldine sporen. der

kaiser hir une ze liebe. ein march uiure ziehen. ein
romere hir mantel. ein helt chune unde snel. der

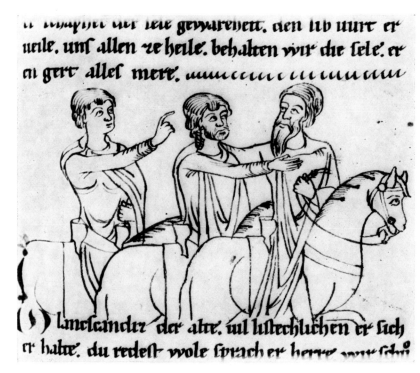

ir wapphet der sele gewareiten. den lib wirt er
ueile. uns allen ze heile. behalten wir die sele. er
en gert alles mere. mmmmmmmmmmmmmmmmm

(S) lanzelndz der alte. uil listechlichen er sich
er halte. du redest wole sprach er herre wir schu

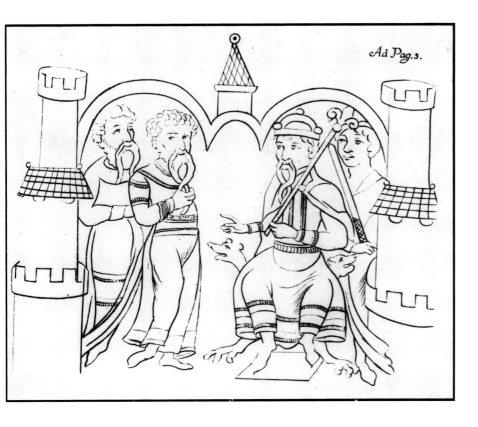

92. Charlemagne appointing his brother-in-law, Gane-lon, Roland's stepfather, ambassador to Marsile.
Pen-drawing, *Ruolantes Liet* of Conrad the Priest. Heidelberg, Universitätsbibliothek, Pal. Germ. 112, fo. 19 ro.

93. Charlemagne appointing Ganelon ambassador to Marsile.
Pen-drawing. *Ruolantes Liet* of Conrad the Priest. Second half of 12th century. Strasburg, Bibliothèque Nationale et Universitaire (ms. burnt in 1870).

94. Ganelon uttering threats as he leaves Charlemagne's court with an emissary from Marsile.
Pen-drawing, *Ruolantes Liet* of Conrad the Priest. Heidelberg, Universitätsbibliothek, Pal. Germ. 112, fo. 21 vo.

95. Ganelon plotting with the heathen Blancandrin.
Pen drawing. *Ibid.*, fo. 24 ro.

96. Ganelon holding council with the infidels.
Pen-drawing. *Ibid.*, fo. 26 ro.

97. Marsile and Ganelon.
Pen-drawing. *Ibid.*, fo. 29 vo.

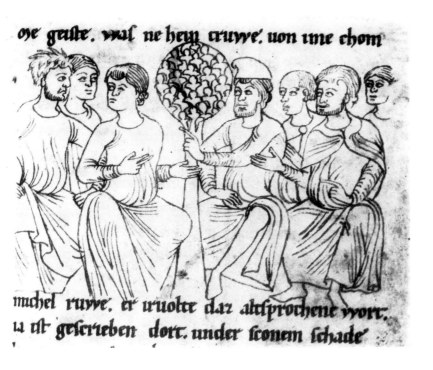

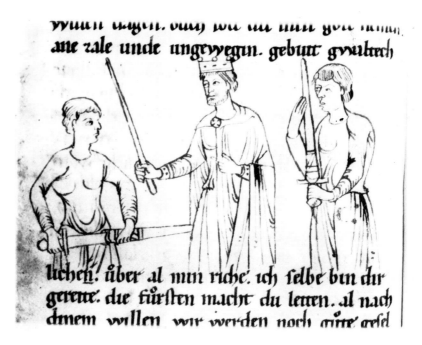

Ganelon's appointment to a dangerous mission was suggested by his stepson Roland. Furious at this ill-timed interference, Ganelon swore vengeance and the ground was prepared for the treachery which led to the battle of Roncevaux and Roland's death.

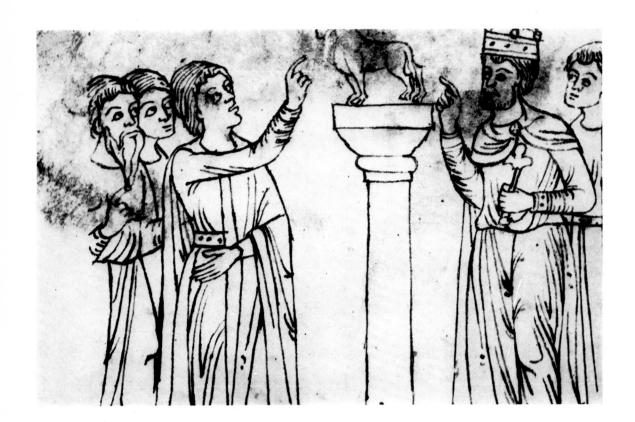

98. Ganelon swearing on an idol to hand over Roland.
Pen-drawing, *Ruolantes Liet* of Conrad the Priest. Heidelberg, Universitätsbibliothek. Pal. Germ. 112, fo. 32 vo.

99. Charlemagne's dreams before returning to France.
Pen-drawing. *Ibid.*, fo. 41 vo.

100. Marsile handing over the standard to Cernubile.
Pen-drawing. *Ibid.*, fo. 52 vo.

101. Marsile and another heathen king.
Pen-drawing. *Ibid.*, fo. 49 vo.

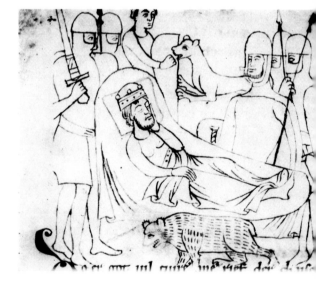

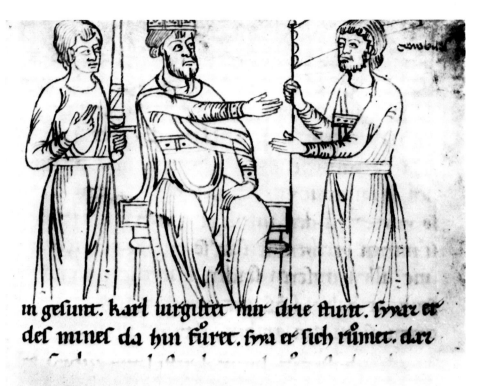

in gefunt. karl urgiltet mir dire ftunt. fwaz er
def mines da hin füret. fwa er fich rümet. daz

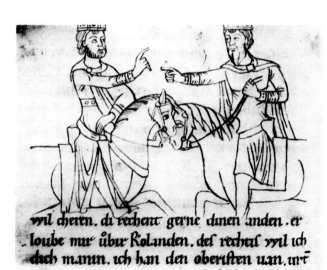

wil cheren. di rechent gerne dinen anden. er
loube mir übir Rolanden. def rechtif wil ich
dich manin. ich han den oberiften uan. unt

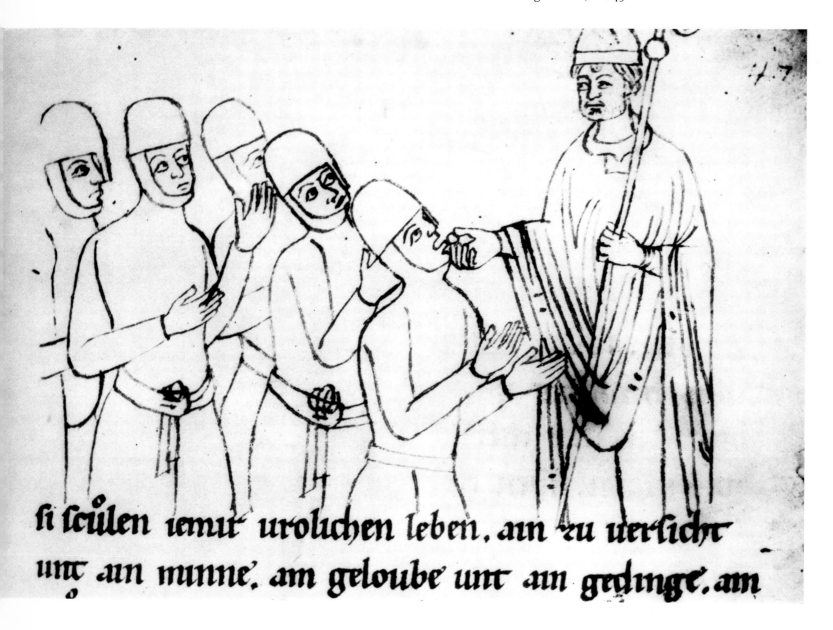

si sculen iemit vrolichen leben. ain zu versicht
unt ain minne. am geloube unt ain gedinge. ain

barmen. daz ich dich hi mir lazen. 11 ne mag
ich nicht dar zu geben mare. daz ich da fürr
name. hete daz ich dich tagelichen sehe.

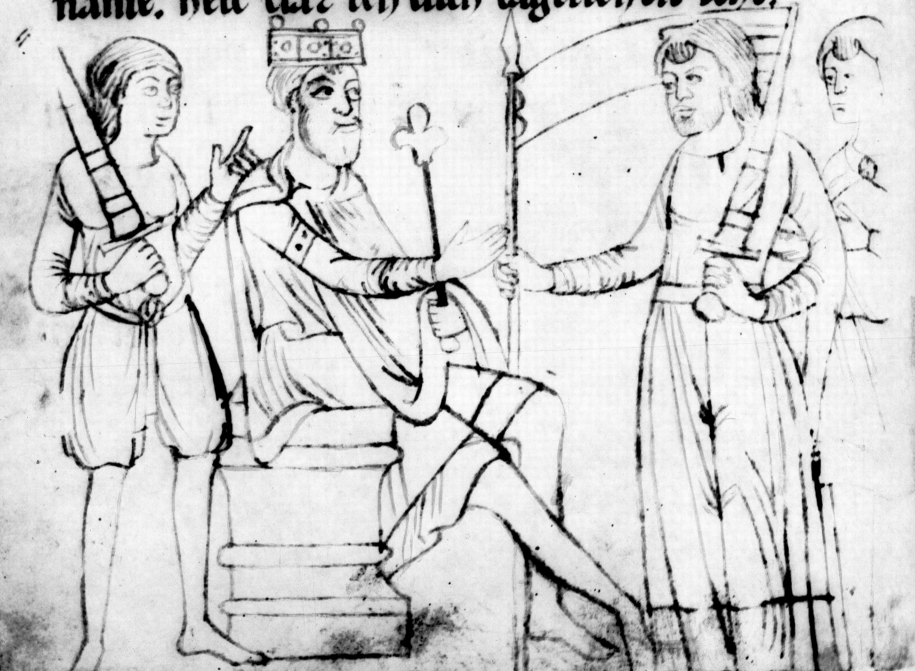

sine augen erscainen.

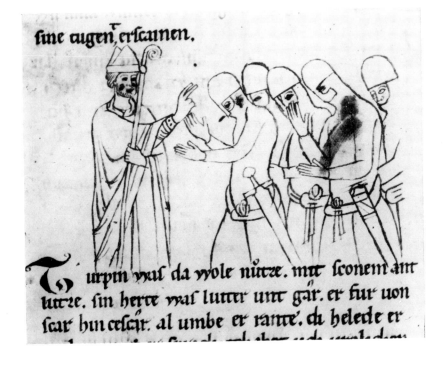

Turpin was da wole nütze. mit sconem ant
lütze. sin herze was lutter unt gar. er fur von
scar hin cescir. al umbe er rante. di helede er

are getan. din hus wil ich prechen. macht dur

nu rechen. di dine plasure. hutte ware du
uil mare. nu bistu worden stille. dine gol
de garwen dille. muzen alle zu der erde

men. uz den gotel kinden. gruelen ahtzee unt
sibene. di urouwent sich iemir da zehimele.

gegen der herte. da frumt er mit dem hyer
te. manigen hauden toten. manigen helm

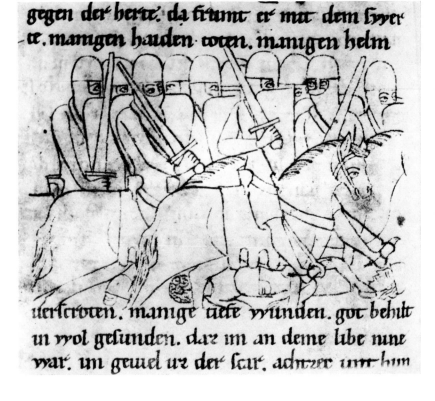

uerscroten. manige tiefe wunden. got behilt
un wol gesunden. daz im an deme libe niene
war. un gewel uz der scar. ahtzee unt hun

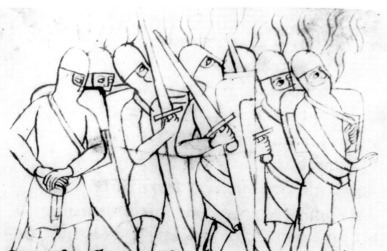

twayn. ſi reſlugen rof unde man. mit ır ſcharp
hen ſpiezen. di gote muſen in dem bluote hin fliez
zen. der ſtrc was unter guten knechten. ſi cun
den wol uechten. mit ſpiezen unt mit oeren

iſt uon im amen chom. ia du herzoge grandon.

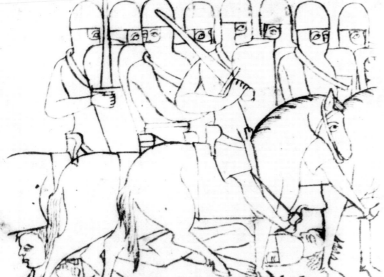

ich wil dich an mmes ſmes ſtete haben. nim
du hett mnen namen. dzr her la dir beuolhen
ſin ich wil ſelbe den lip nim. wagen unt m͘

104. Turpin blessing the Franks at Roncevaux.
Pen-drawing. *Ruolantes Liet* of Conrad the Priest. Heidelberg, Universitätsbibliothek, Pal. Germ. 112, fo. 53 vo.

105. Roland attacking a heathen temple.
Pen-drawing. *Ibid.*, fo. 57 vo.

106. Miraculous dew falling on the Franks.
Pen-drawing. *Ibid.*, fo. 61 vo.

107. Christians and heathen fighting.
Pen-drawing. *Ibid.*, fo. 63 ro.

108. Knights leaving for battle.
Pen-drawing. *Ibid.*, fo. 66 vo.

109. Knights leaving for battle.
Pen-drawing. *Ibid.*, fo. 71 vo.

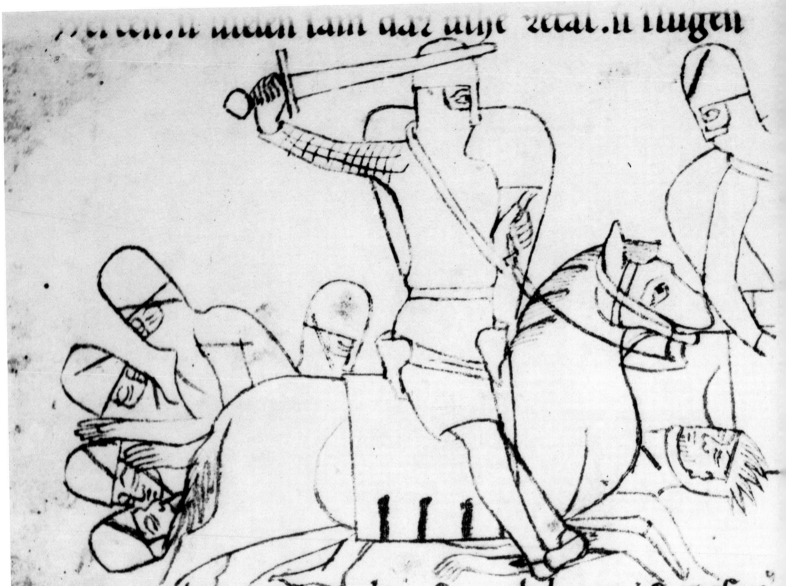

si uon dem wal. rechte fam di hunte. si riefen
alle mit munde. hilf uns chunc marsilie. herr
durch dine chundiche ere. di cristen sint starc

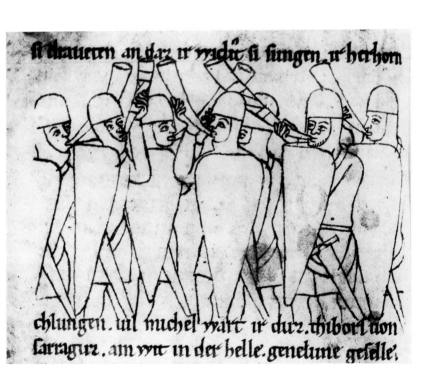

110. Roland pursuing the heathen king Marsile. Pen-drawing. *Ruolantes Liet* of Conrad the Priest. Heidelberg, Universitätsbibliothek, Pal. Germ. 112, fo. 74 vo.

111. Oliver striking the heathen Justin. Pen-drawing. *Ibid.*, fo. 76 vo.

112. Heathen warriors sounding their horns. Pen-drawing. *Ibid.*, fo. 80 vo.

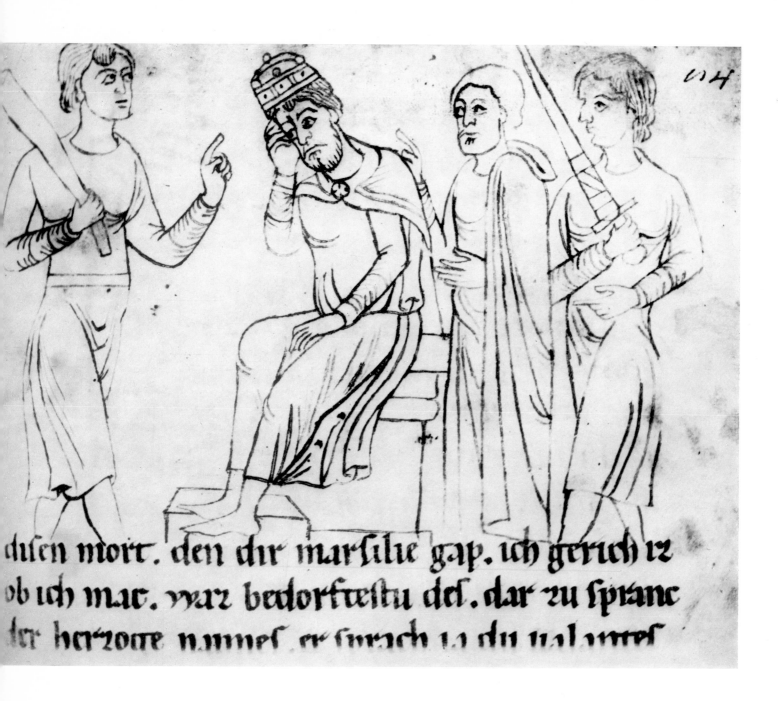

scuiden.

dusen mort. den dir marsilie gap. ich gerich iz

ob ich mac. vwaz bedorftestu des. dar zu sprac

der herzoge naimes. er sprach iz du val mref

113 114

113. Charlemagne's sorrow on hearing Roland's horn.
Pen-drawing. *Ruolantes Liet* of Conrad the Priest. Heidel-
berg, Universitätsbibliothek, Pal. Germ. 112, fo. 84 ro.

114. Roland leads away the dying Oliver.
Pen-drawing. *Ibid.*, fo. 89 ro.

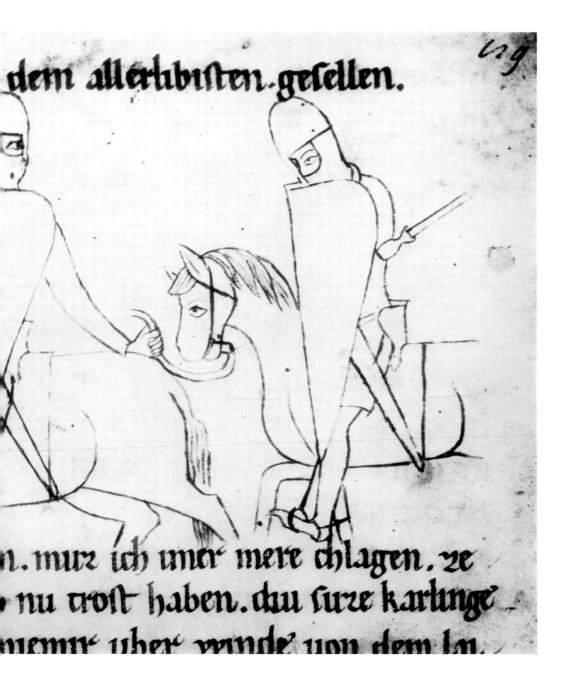

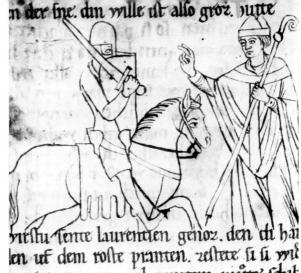

dem allerlibisten gesellen.

bistu sente laurencien genôz. den di har
len uf dem roste pranten. zestêre si si wil

al ame. ich pin verfluchet. ich wune nun gut

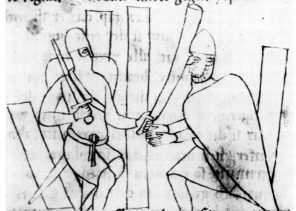

mne rücher. sürze karlinge. zu wem sol ich nu
dingen. nu mustu uner wainen. daz trôste
wol di hauden. sprach der biscof turpin.

n. murz ich uner mere chlagen. ze

nu trost haben. duu surze karlinge

memr uber winde uon dem In

uner herre enphure in wol da. er sprach. piate
et regna. Rôlant cherte gegen yspanie.

werre uon den erslagene. er gesez zu amme
boume. da becter uil chume. in uner siner hant.
rslagene. diu horn obiuant in der indern. turu

115. Turpin blessing Roland.
Pen-drawing. *Ibid.*, fo. 85 vo.

116. The heathen attack Turpin.
Pen-drawing. *Ibid.*, fo. 91 vo.

117. The dying Roland kills his horn
 a heathen who is trying to steal his sword.
Pen-drawing. *Ibid.*, fo. 93 vo.

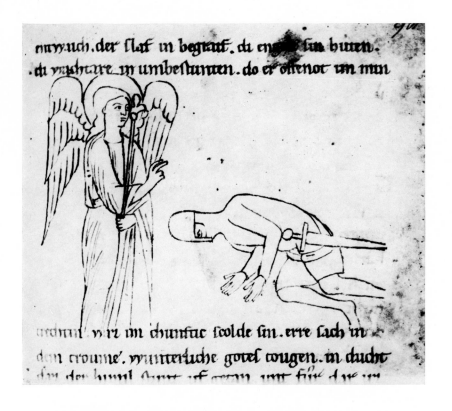

nyyauch. der flaf in begraif. di en... fin binen.
.di vaiheare in umbeftunen. do er offenot vm min

... wiz in chunfac foolde fin. erre fach in ...
den crounne. wunterliche gotef tougen. in duche ...

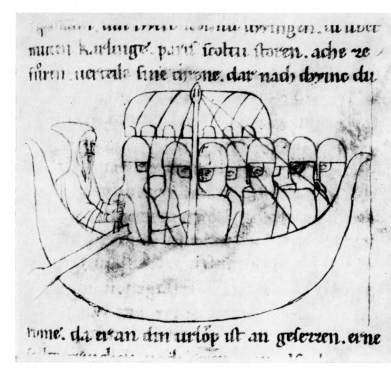

... min Karluge pant feolnn floren. ache ze
furn. uertale fine crone. dar nach dyrine du

rome. da er an din urlop uf an geferzen. eine

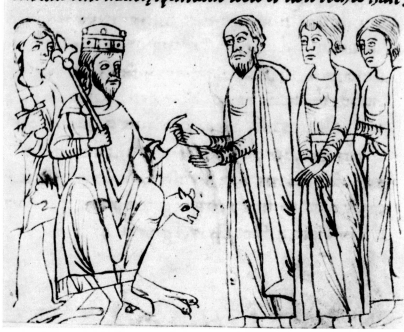

wirth grene in fprungen. fam er ware iunger. do red
en alle fine man. yfpamam feolt er non rechte han.

118 119 120 121

122 123 124

118. An Angel appearing to Charlemagne.
Pen-drawing. *Ruolantes Liet* of Conrad the Priest. Heidel-
berg, Universitätsbibliothek, Pal. Germ. 112, fo. 98 ro.

119. Emir Baligant's fleet.
Pen-drawing. *Ibid.*, fo. 100 ro.

120. Baligant conferring with the Saracen kings.
Pen-drawing. *Ibid.*, fo. 102 ro.

121. Charlemagne praying before his fight with Baligant.
Pen-drawing. *Ibid.*, fo. 108 v.

122. Baligant entrusting his son Malprime with the
 command of the infidel army.
Pen-drawing. *Ibid.*, fo. 109 vo.

123. Baligant slain by Charlemagne.
Pen-drawing. *Ibid.*, fo. 114 vo.

124. Ganelon appearing before Charlemagne.
Pen-drawing. *Ibid.*, fo. 119 ro.

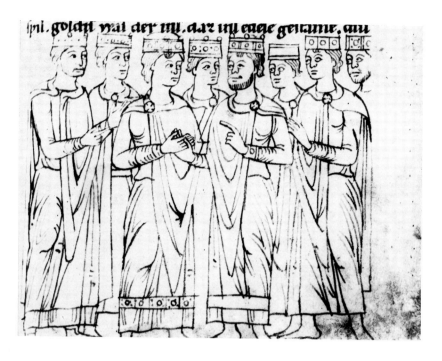
spni. golazit ynal der mi. dar mi ewige gerame. aui

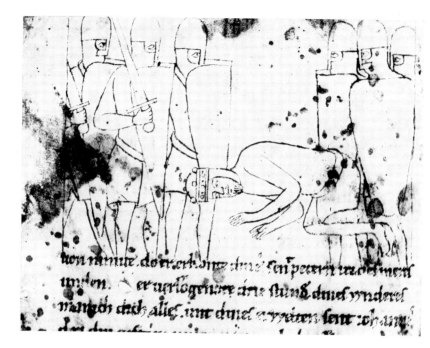
von ramue. do werk one eine sen petem wd ol meii
mplou. er verlogene eine stund eines ynderes
manton noch alier. mit eines zerreten sent. von am

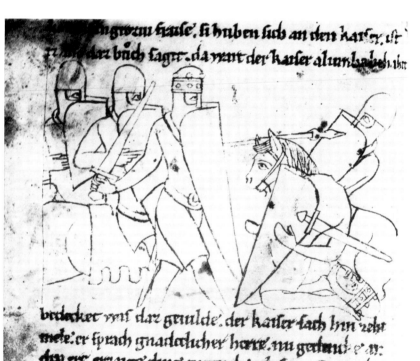
ngm ne hause. si huben sich an den karser. ist
ru da dar buch sager. da rent der karser al ion haibel. ibn
bedecket vns dar gewilde. der kaiser sach hin zeh
mele. er sprach gnadeelicher herre. nu gelaub e ar
din ere. erzuge eine tugende. erlose vns von de

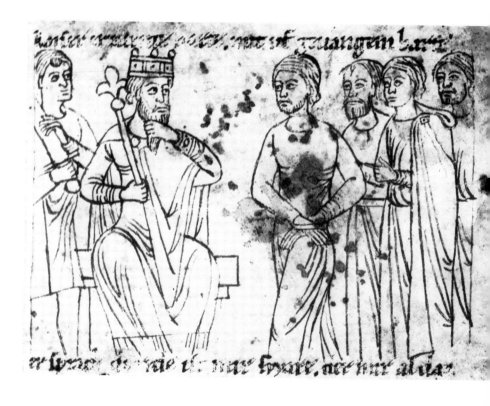
kaiser erzurge gescurmt nuc uf gwangem ba
er spuac da rae is may kymre. act mit alua

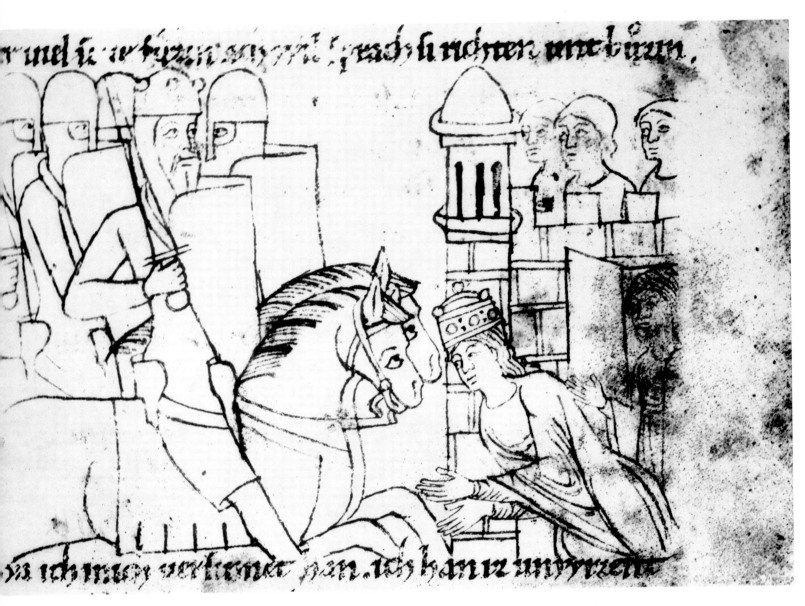

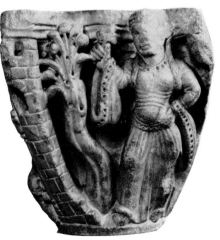

125

126A 126B

125. Charlemagne, victorious, accepting the surrender
 of Queen Bramimonde and the town of Saragossa.
Pen-drawing. *Ruolantes Liet* of Conrad the Prieſt. Heidel-
berg, Univerſitätsbibliothek, Pal. Germ. 112, fo. 117 ro.

126 A and B. A Chriſtian king welcomed by a lady who
 is handing him the key of a town.
Capital from a church in the Holy Land. Paris, Muſée du
Louvre. 12th century.

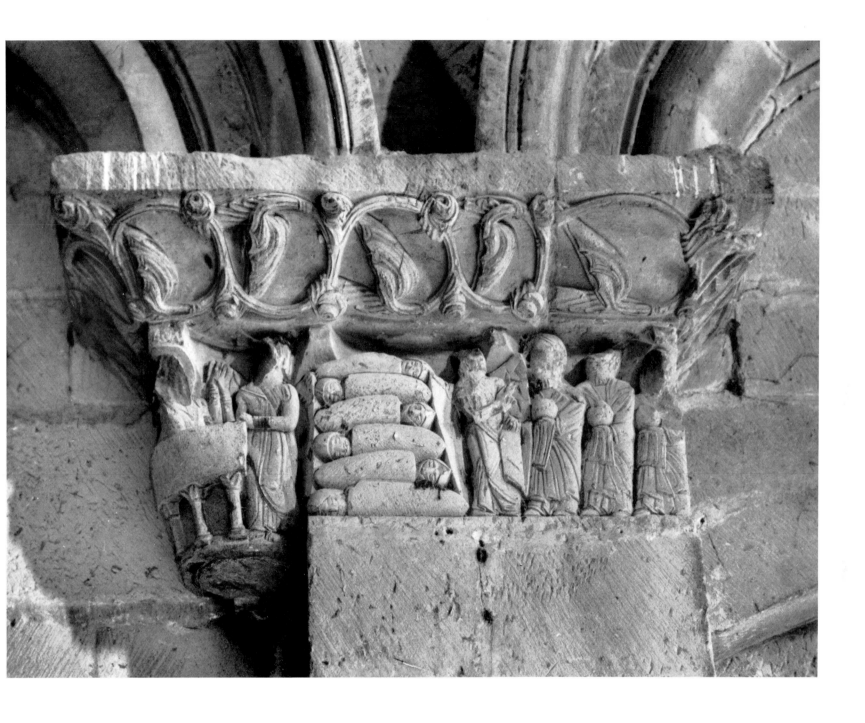

127. St. Giles, celebrating Mass, is given evidence of
 Charlemagne's sin. St. Giles at the embalming
 of the heroes' bodies at Roncevaux.
Capital. Luna (Province of Saragossa), church of San Gil.
About 1150.

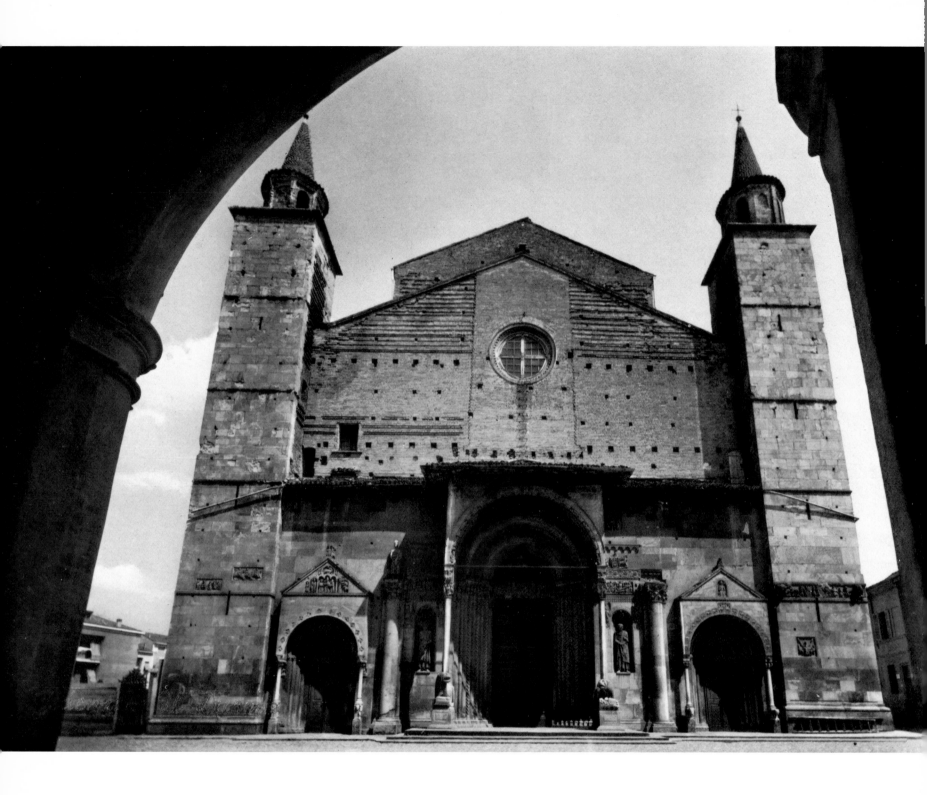

128. Façade of the cathedral of Borgo San Donnino
Fidenza, Italy. About 1200.

*Legend has it that Charlemagne founded the cathedral
at Fidenza (Borgo San Donnino) north of Bologna.
In the* Chanson d'Aspremont, *St. Dominic, patron saint
of the cathedral, protects Roland in battle.*

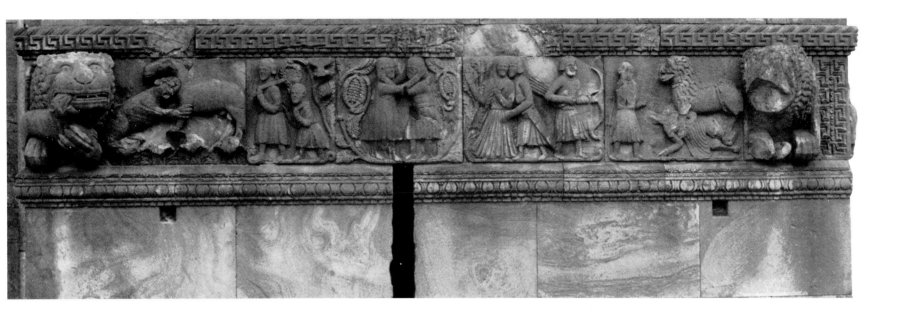

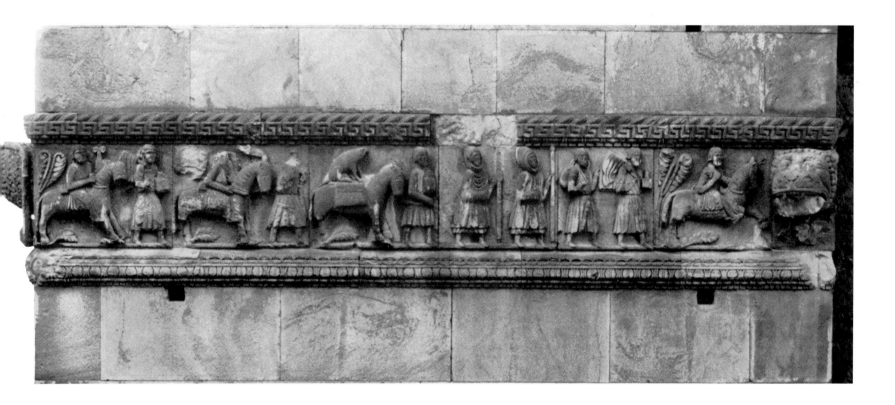

These two friezes, the first of which reads from right to left, illustrate two Franco-Venetian epics which recount the adventures of the supposed parents of the child Roland (Orlandino) and of young Roland himself. These poems were intended to contradict the old legend that Roland was born of an incestuous union between Charlemagne and his sister.

129. Frieze on a corner tower.

Borgo San Donnino (Fidenza). Cathedral façade, right-hand side. About 1200.

130. Second frieze on the corner tower.

Borgo San Donnino (Fidenza). About 1200.

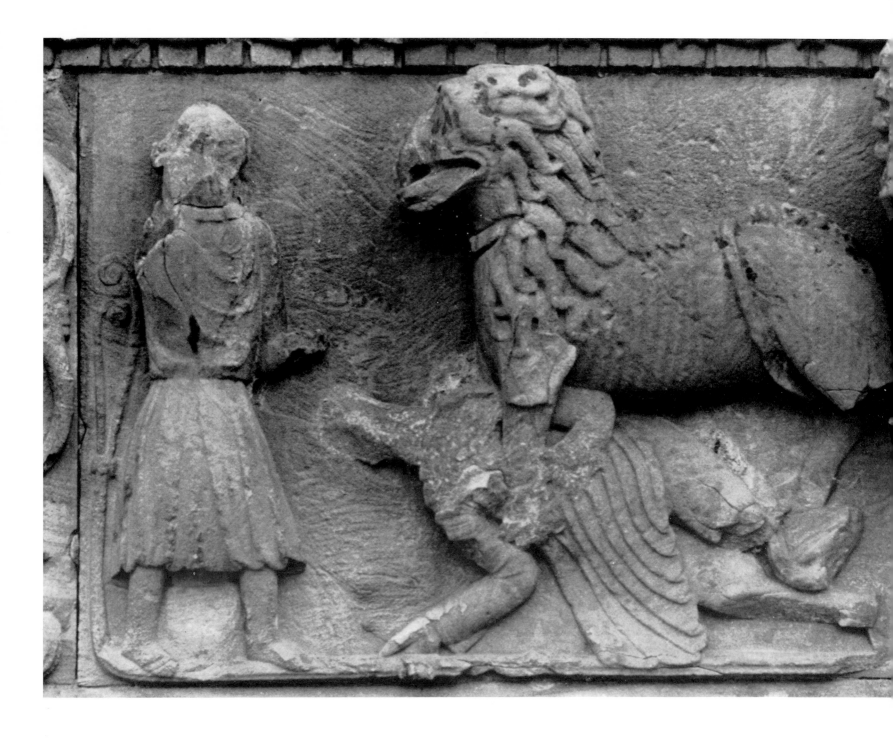

131. Pepin the Short facing a lion.
Borgo San Donnino (Fidenza). Cathedral, frieze on corner tower, detail.

There are chansons de geste *which tell the story of the Frankish king Pepin's fight with a lion.*

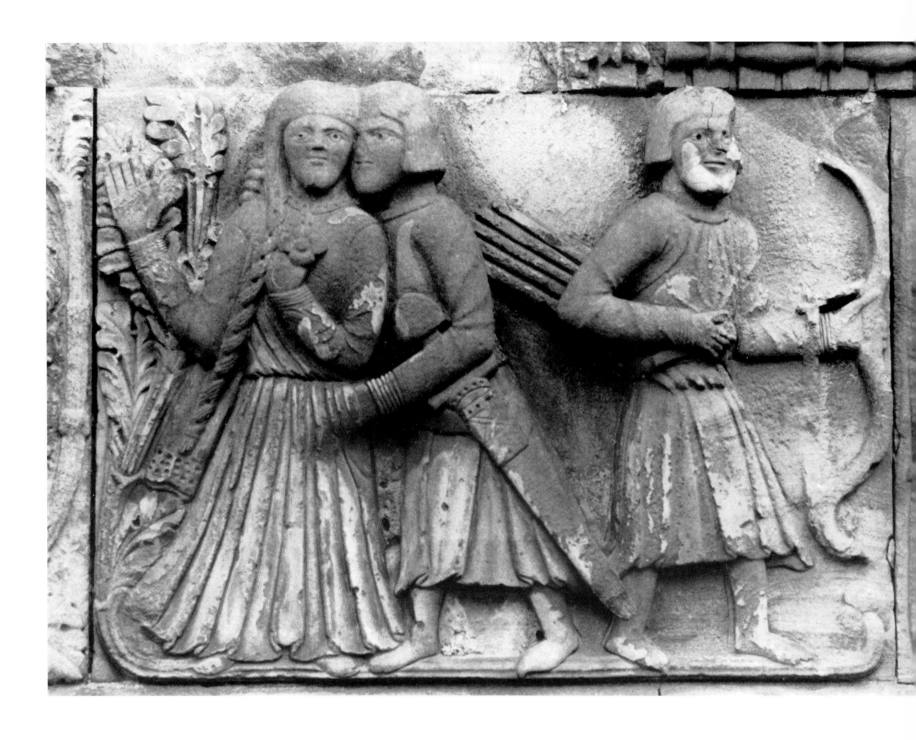

132. Bertha, Pepin's daughter, and the knight Milo making illicit love while Charlemagne is out hunting.

Ibid.

The theme may appear indecent, but its moral lesson is enough to give it a place on the walls of a church bell-tower.

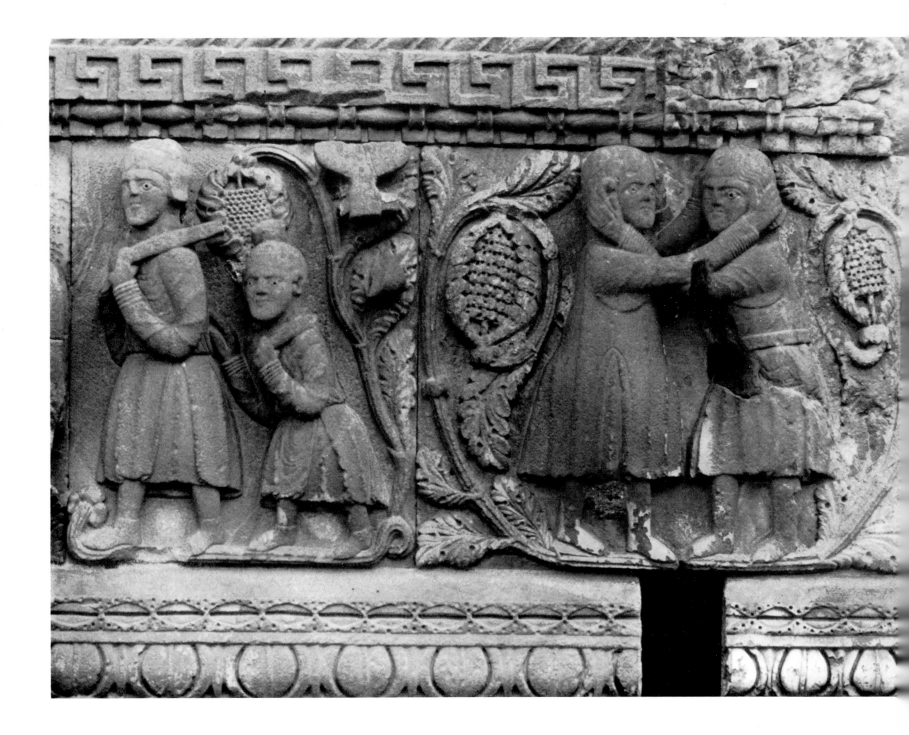

133 A. Roland as a child, following his father, now a
 woodcutter, through the forest.
 B. Bertha and Milo in a forest shortly before
 Roland's birth.

Borgo San Donnino (Fidenza). Cathedral, frieze on corner
tower, details.

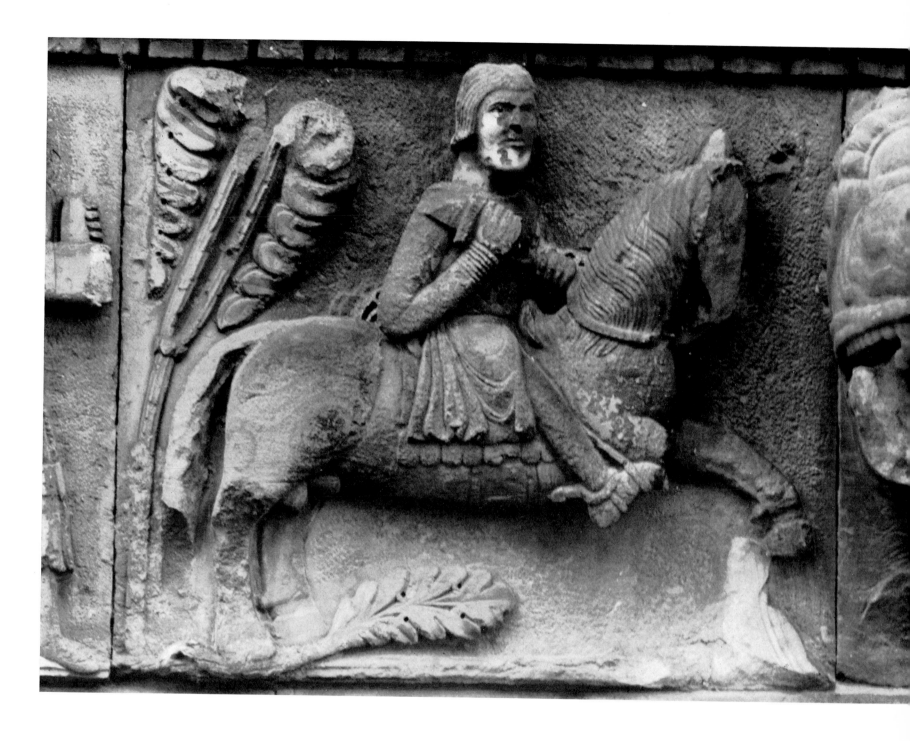

134. The young Roland on horseback, heading the Emperor's procession returning to France.
Borgo San Donnino (Fidenza). Detail of the second frieze.

As Les Enfances Roland *says : 'Along the paved road, in front of Charlemagne, goes Roland on his richly caparisoned horse'.*

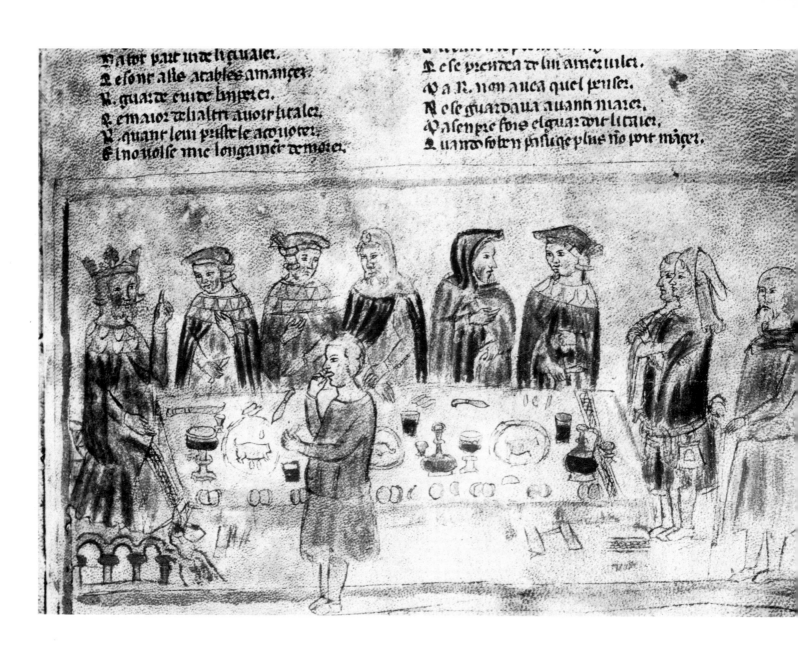

135 137

136

An Italian manuscript and an early printed book show
the scene where little Roland goes to Charlemagne's
own table to seek food for his parents.

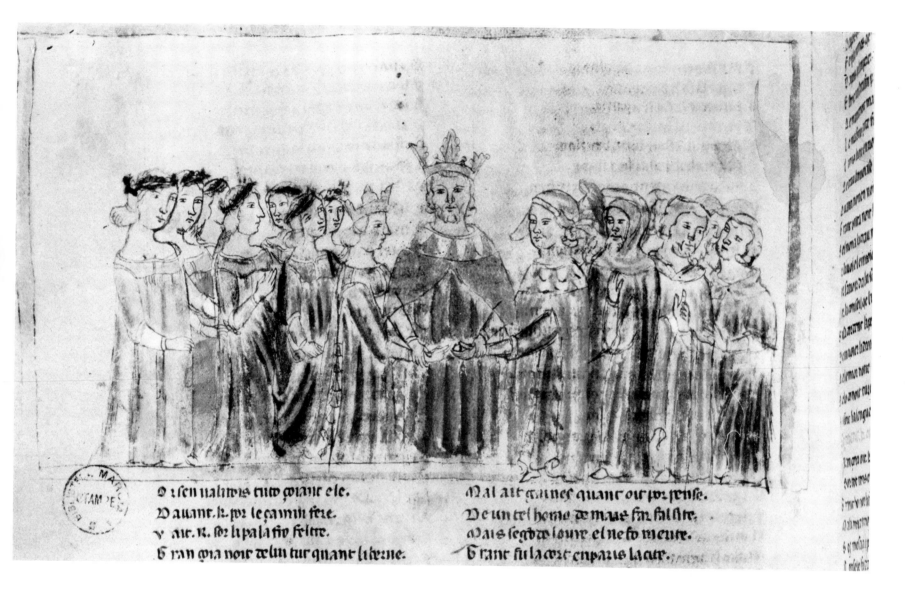

O ï sen natïres tuto qpant ele.
D auant. k. pʒ le camin fere.
v aır. k. ſoʒ lı palaſıo feltre.
G ran qpıa noır œlun tur qnant ſiberne.

Mal aıt gaınef quant oır pʒ pense.
De un tel home œ maʒe ſıʒ. ſıl ſıte.
Daıs ſegʒ œ lourr el ne ſo meure.
G rant ſıı la cʒʒt en paus la cʒte.

135. Young Roland invited to Charlemagne's table.
Wash drawing. *Les Enfances Roland.* Venice, Biblioteca
Marciana, cod. fr. XIII, about 1200.

136. Roland's childhood at Sutri (Italy).
Seville, Library. Woodcut from a post-incunable, *Nascimento
de Orlando.* Early 16th century.

137. Roland at the marriage of Bertha and Milo, before
Charlemagne.
Wash drawing. *Les Enfances Roland.* Venice, Biblioteca
Marciana, cod. fr. XIII, about 1200.

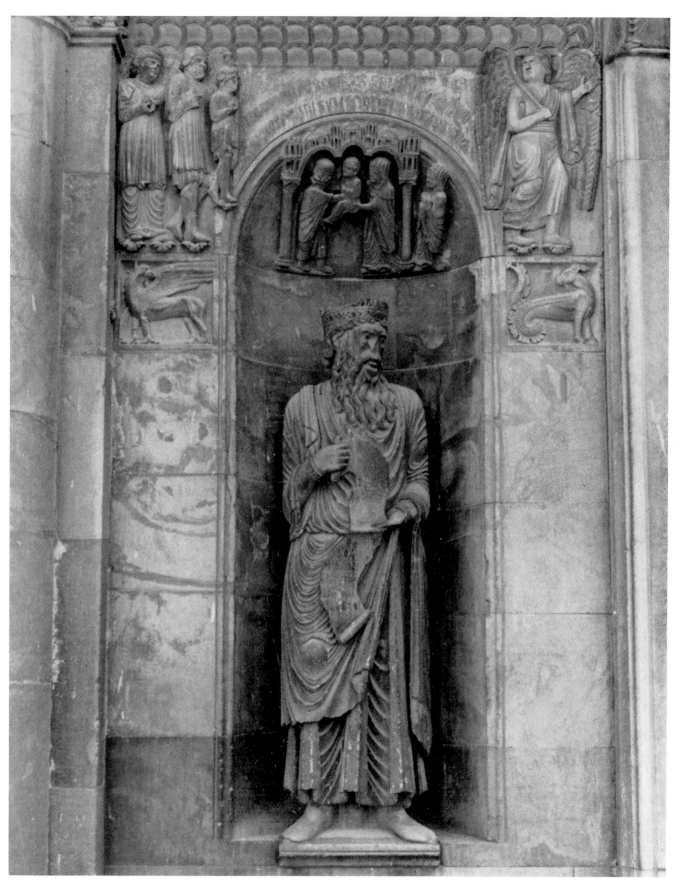

138. The prophet David and the rich man's family.
Fidenza, Cathedral. Detail of the façade, left of the doorway.
Statue and bas-relief. About 1200.

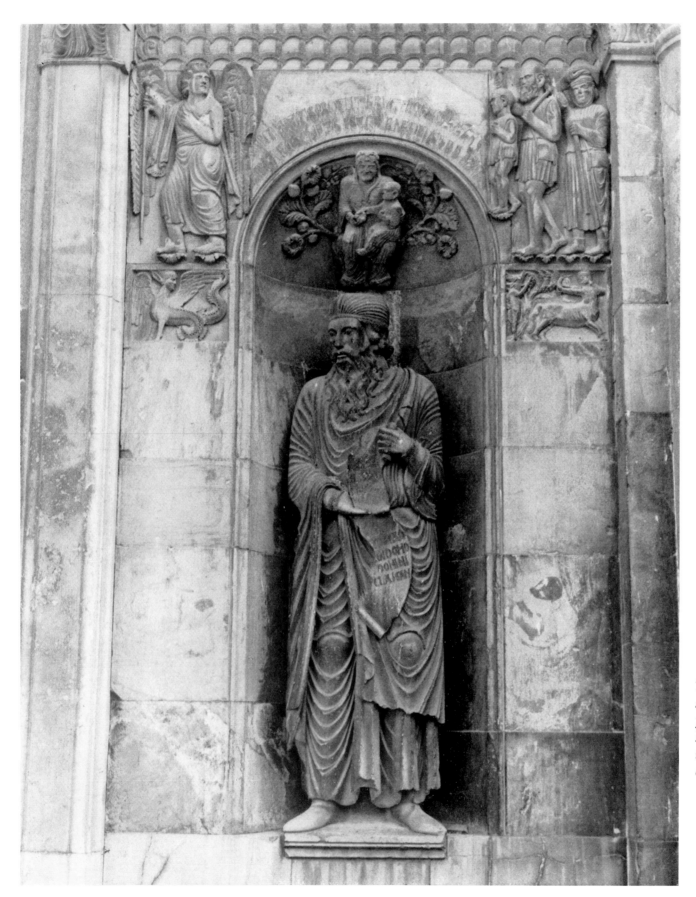

This theme of the two families can be applied to the family of Milo, Bertha and Roland. The resources of medieval symbolism are endless.

139. The prophet Ezekiel and the poor man's family.
Fidenza, Cathedral. Detail of the façade, right of the doorway.
Statue and bas-relief. About 1200.

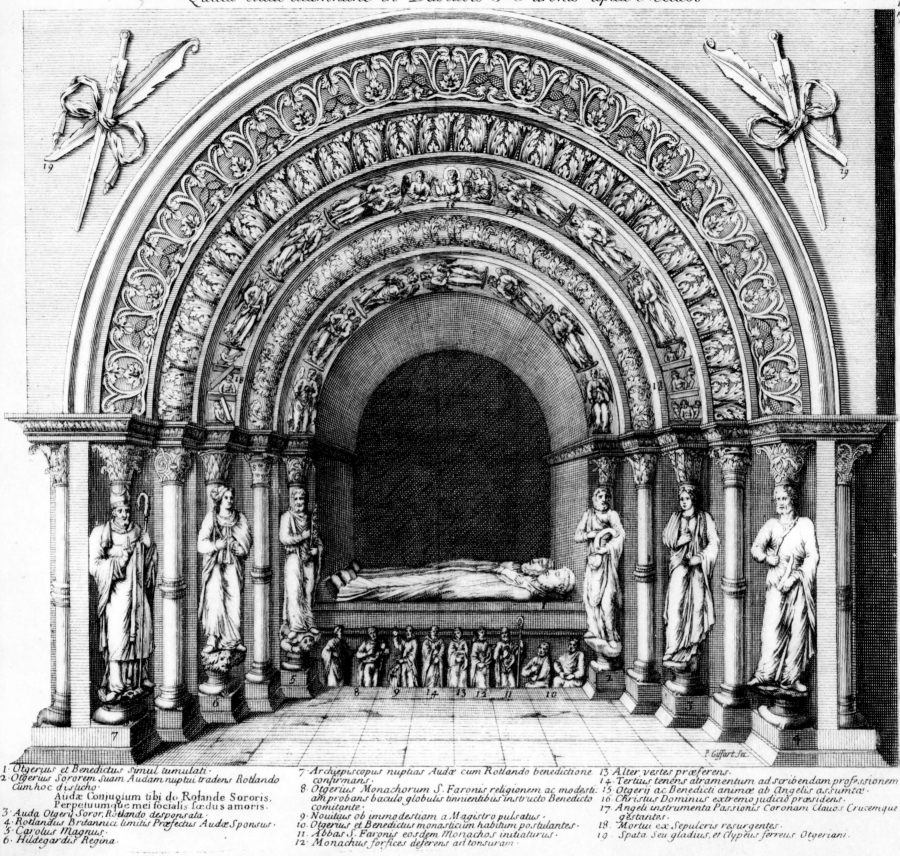

140. Recessed tomb (now destroyed) of Ogier the Dane
in the Church of St. Faro at Meaux (about 1200).

17th century engraving. Mabillon, *Annales ordinis sancti
Benedicti*, Vol. II, 1704.

The original no longer exists, but a 17th century engrav-
ing can give us some idea of a monument which showed
Charlemagne together with some of the most famous
epic heroes.

141. Oliver bestowing his sister Aude upon Roland.
Meaux, Church of St. Faro. Detail of the recess. About
1200.

142. Head of Ogier the Dane.
Meaux, Musée Municipal. Fragment of Ogier's tomb. About
1140-1160.

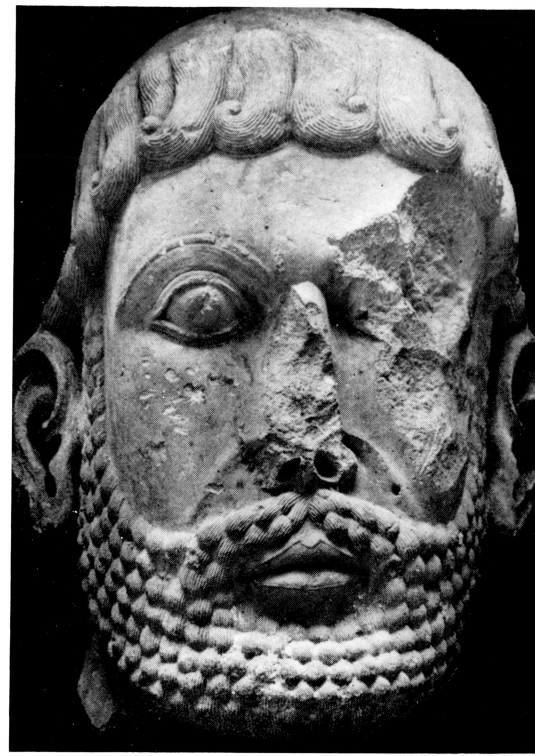

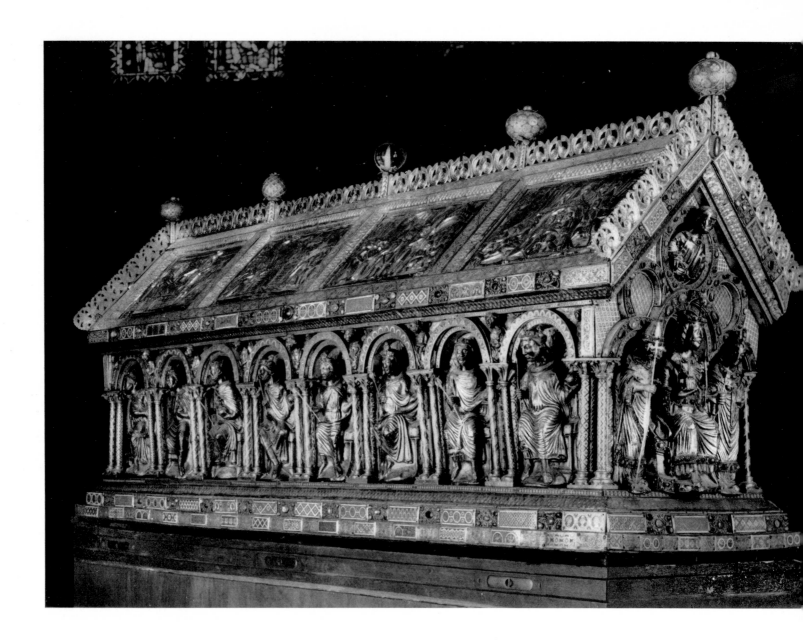

143. Reliquary of Saint Charlemagne.
Metalwork. Aix-la-Chapelle, Cathedral. 1200-1215.

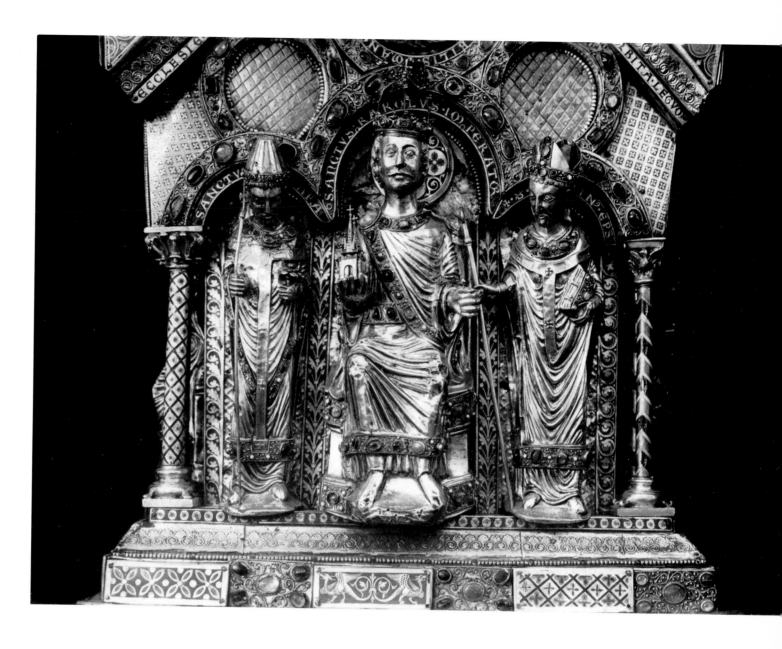

144. Charlemagne between Pope Leo III and Archbishop Turpin.
Aix-la-Chapelle, Cathedral. Detail of the reliquary of St. Charlemagne.

The patron of this masterpiece of Mosan metalwork has given an especially eminent position to Charlemagne, the new saint before whom the Pope himself bows his head.

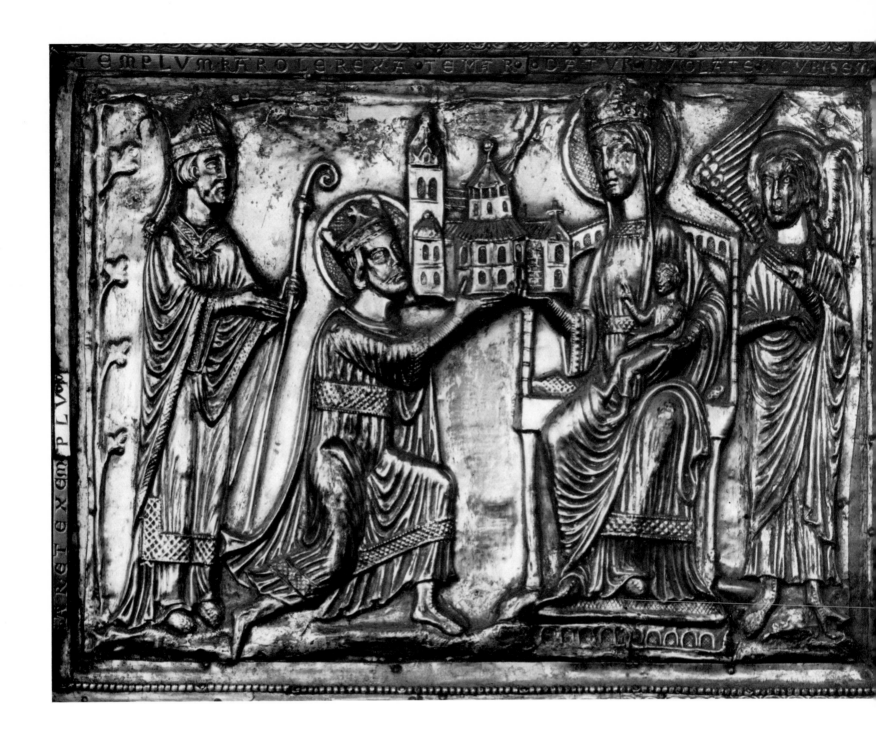

145. Charlemagne offering the chapel of Aix to the
 Virgin. Behind him is Archbishop Turpin.

Aix-la-Chapelle, Cathedral. Relief on the reliquary of St.
Charlemagne.

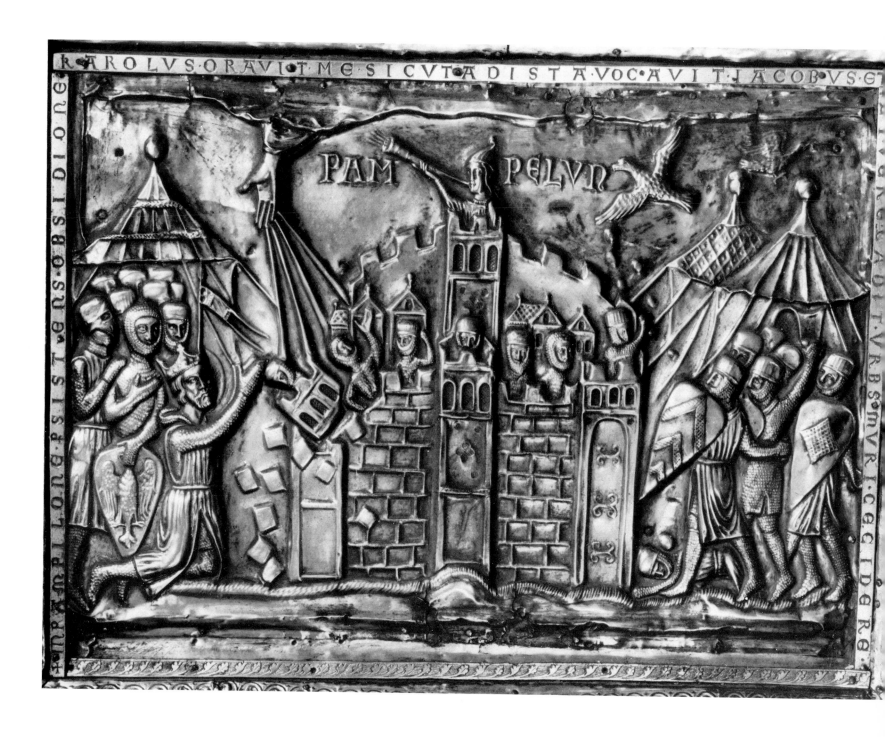

146. The Siege of Pamplona by the Franks, and the
miraculous collapse of the city walls.
Ibid. Relief.

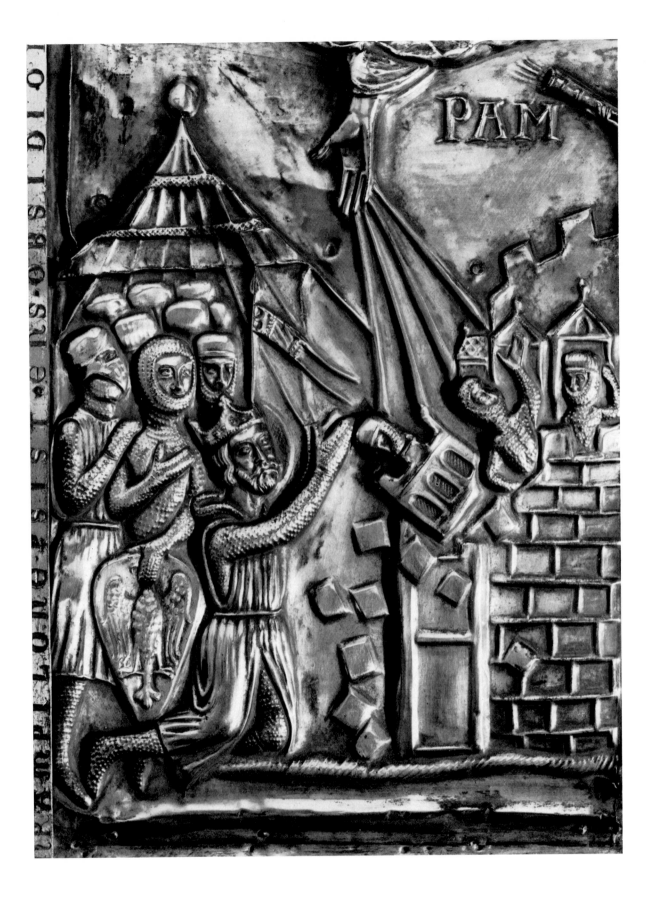

147. Charlemagne praying before Pamplona. Roland witnessing the miracle.
Aix-la-Chapelle, Cathedral. Reliquary of St. Charlemagne. (Detail of fig. 146.)

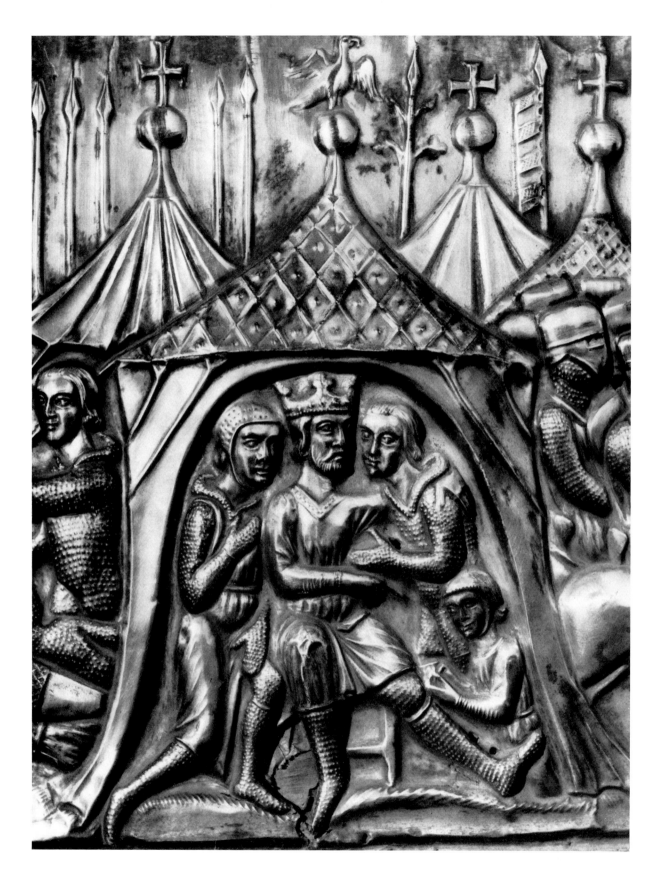

148. Milo telling Charlemagne and Roland of the mir-
acle of the flowering lances.
Reliquary of St. Charlemagne. Detail of a relief.

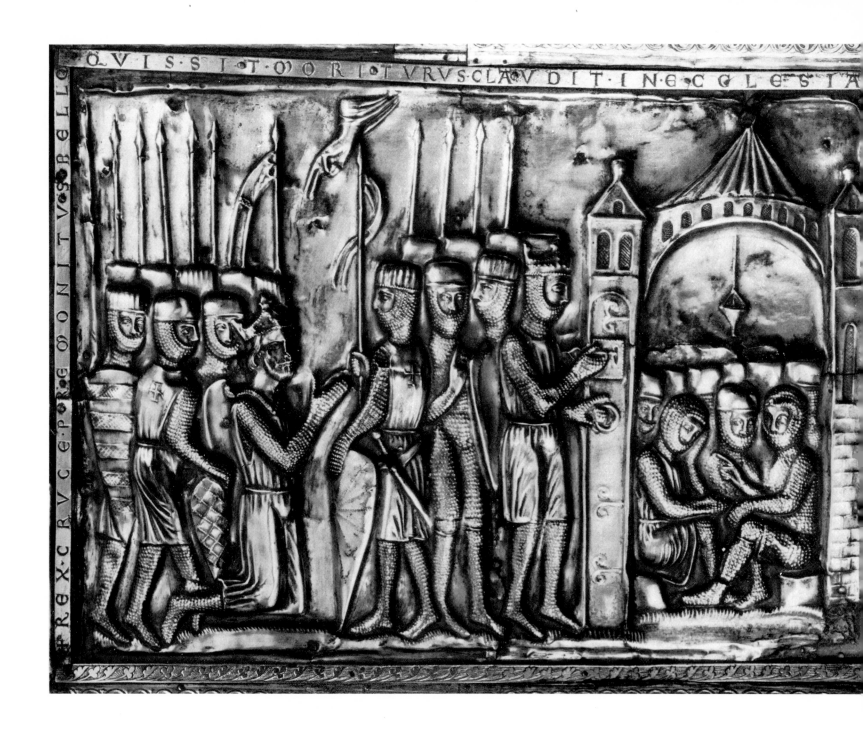

149. Charlemagne and the miracle of the red crosses.
Aix-la-Chapelle, Cathedral. Reliquary of St. Charlemagne.
Detail of a relief.

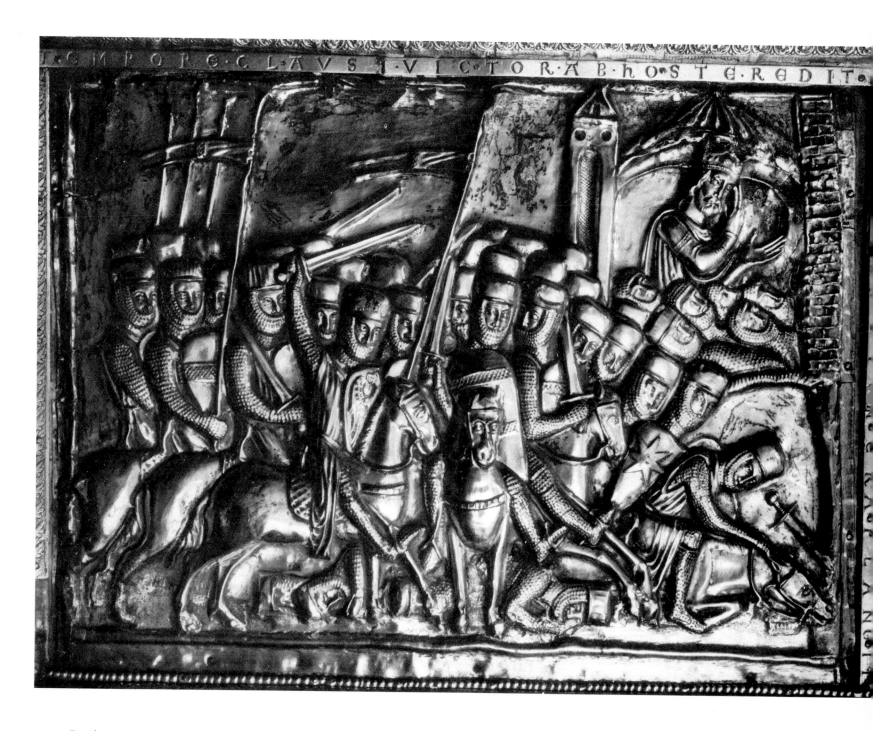

150. Battle against the infidel.
Relief from the reliquary of St. Charlemagne.

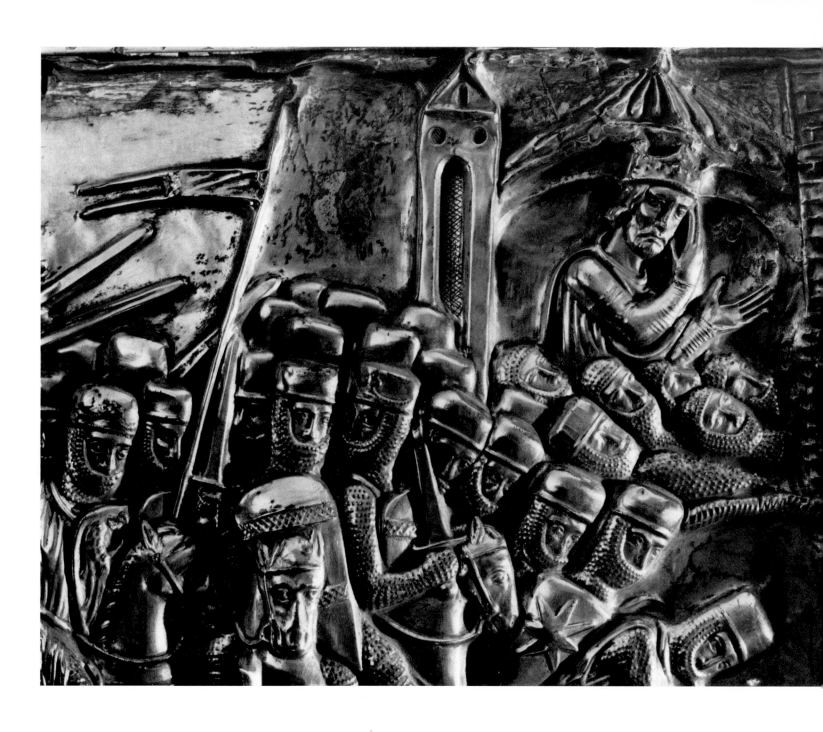

151. Battle against the infidel.

Aix-la-Chapelle, Cathedral. Reliquary of St. Charlemagne.
(Detail of fig. 150.)

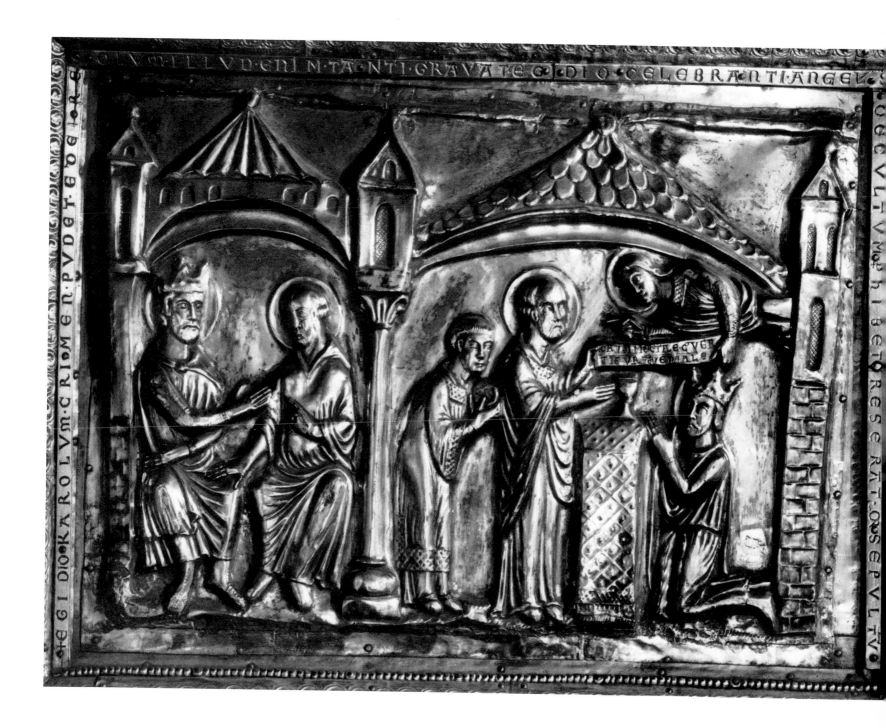

152 A. Charlemagne, confessing to St. Giles, does not
dare to avow his mortal sin.
 B. St. Giles learns of Charlemagne's sin.
Reliquary of St. Charlemagne, relief.

THE GOTHIC PERIOD

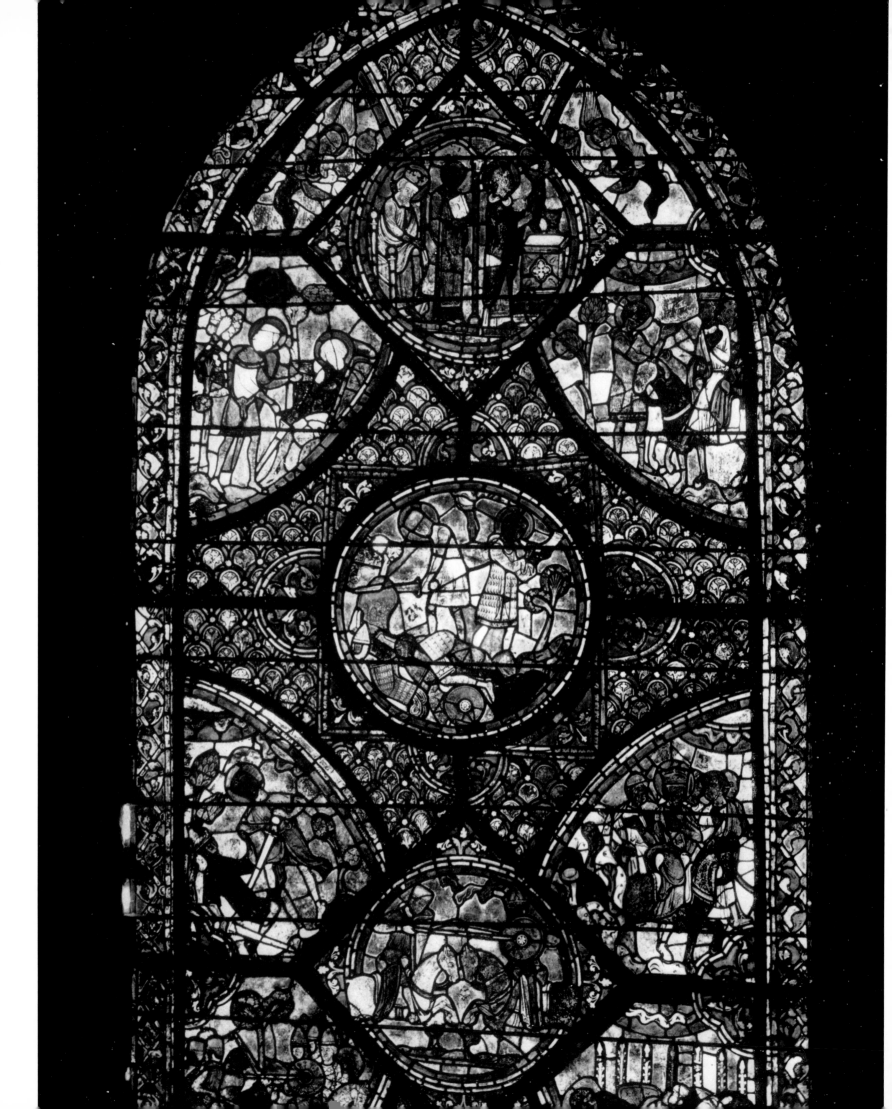



153. Episodes from the legend of St. Charlemagne and
St. Roland.

Chartres, Cathedral of Notre-Dame. Window in the ambul-
atory (upper part). Early 13th century.

154 A. St. Roland bearing on his shield the fleur-de-lis
of the French royal house.

Chartres, Cathedral of Notre-Dame. South portal. About 1230.

154 B. Ganelon swearing on an idol to deliver Roland
into the hands of King Marsile.

Pedestal of the statue.

155. Right to left : St. Lawrence, St. Clement, St. Ste-
phen and St. Roland.

Statues. Chartres, Cathedral, south portal. About 1215-1220
and about 1230.

156. Left to right : St. Vincent, St. Denis, St. Piat and
St. George.

Statues. Chartres, Cathedral, south doorway. About 1215-
1220 and about 1230.

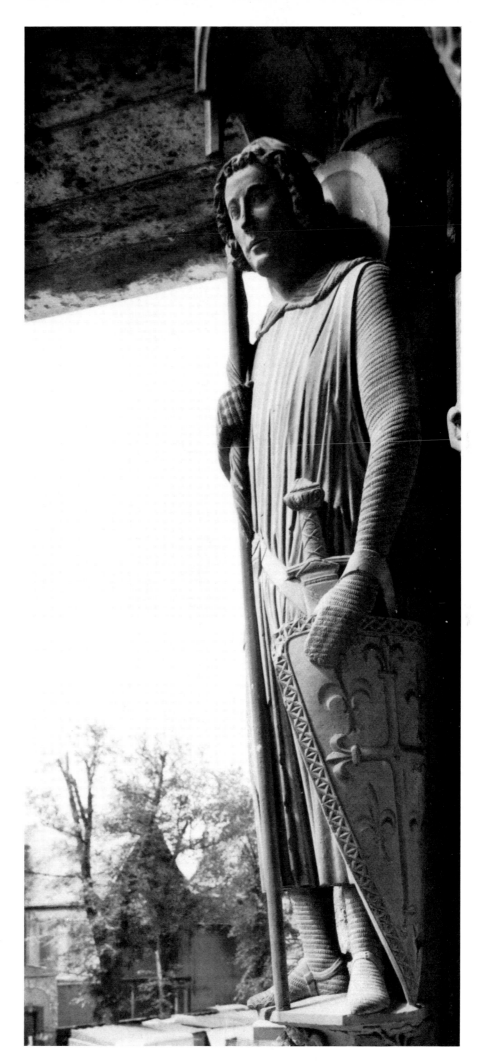

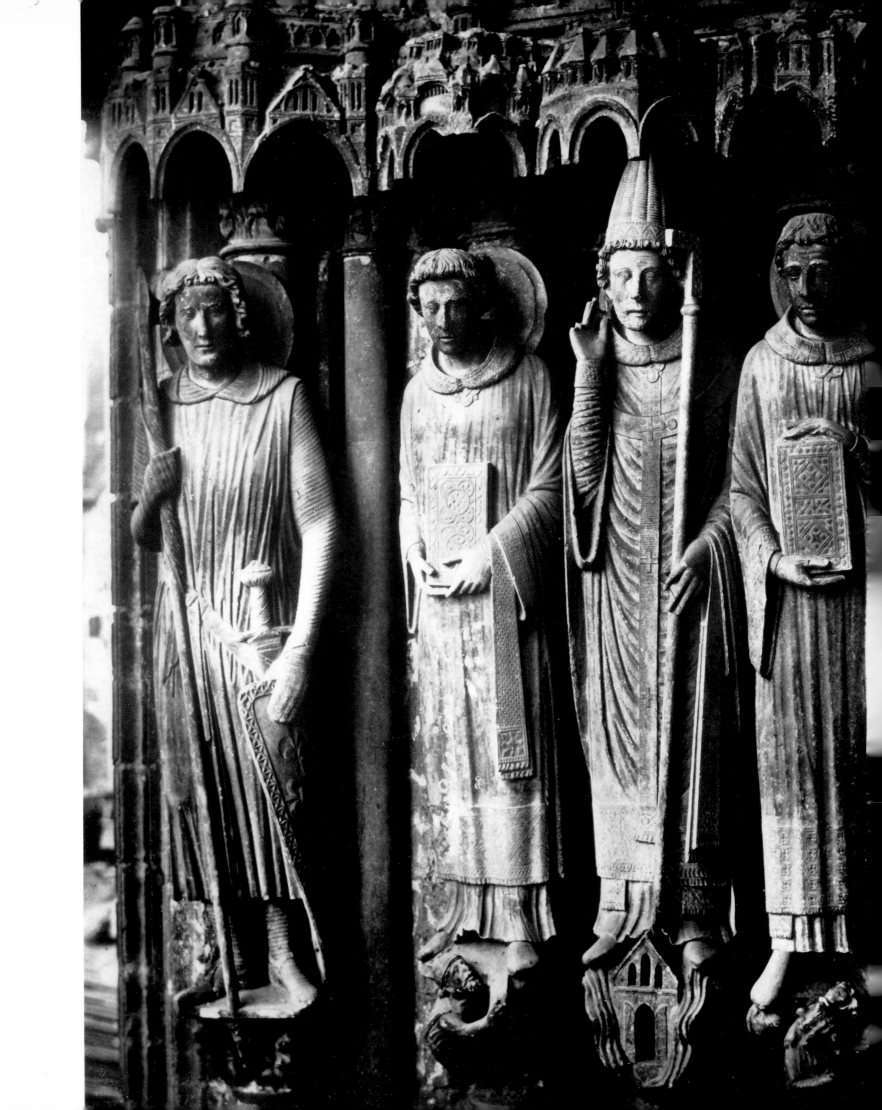

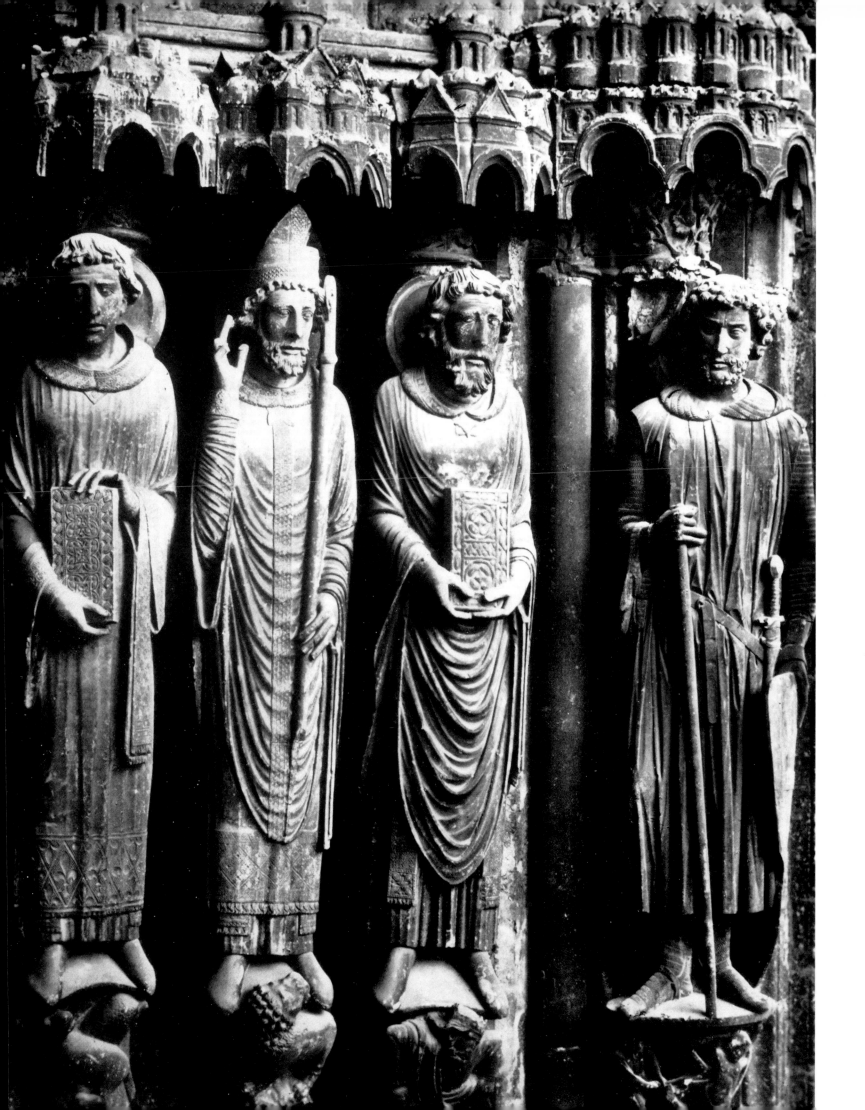

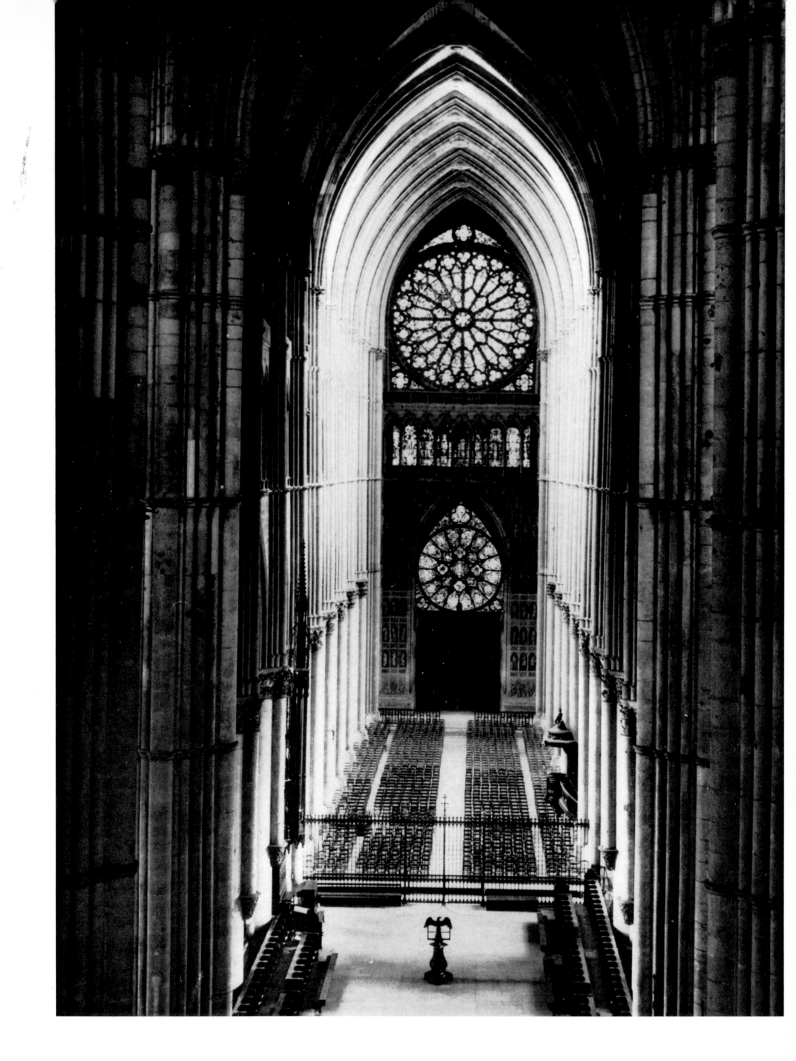

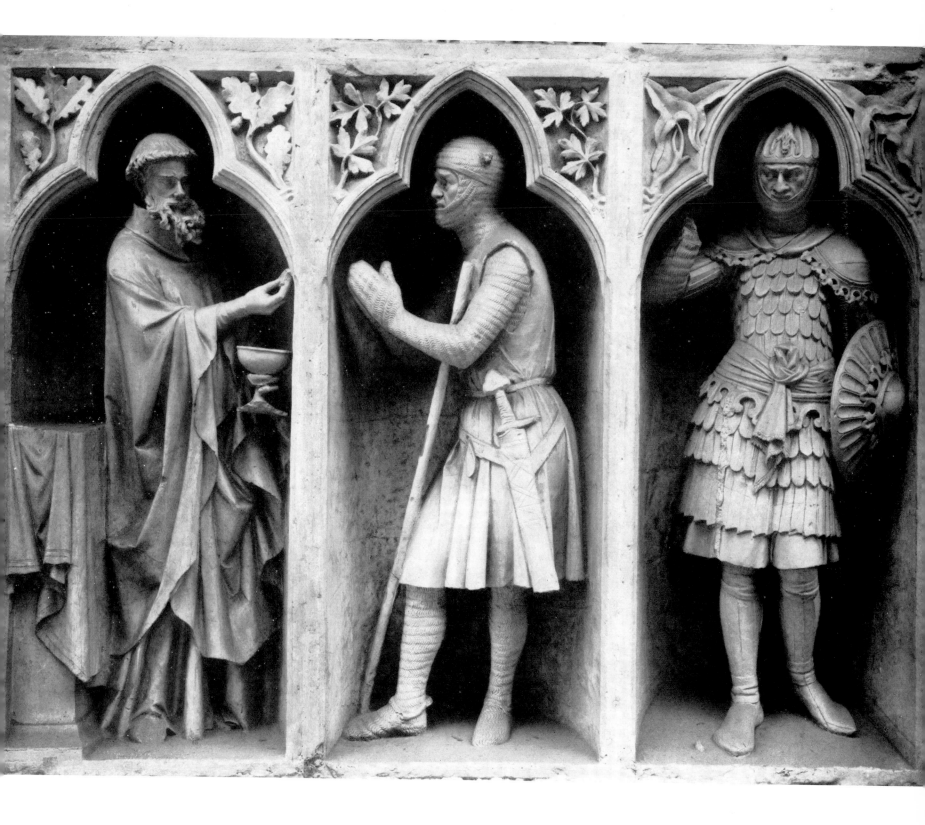

157. Interior of Rheims Cathedral, west end.
Second half of 13th century.

158. Turpin giving communion to Roland. On the right
is King Marsile.

Statues. Rheims, Cathedral of Notre-Dame, interior of west
doorway. Second half of 13th century.

*Rheims was Turpin's own cathedral, and it is hardly
surprising to see the archbishop here, giving communion
to Roland before the battle of Roncevaux. The heathen
Marsile looks on, half-hidden in the shadows.*

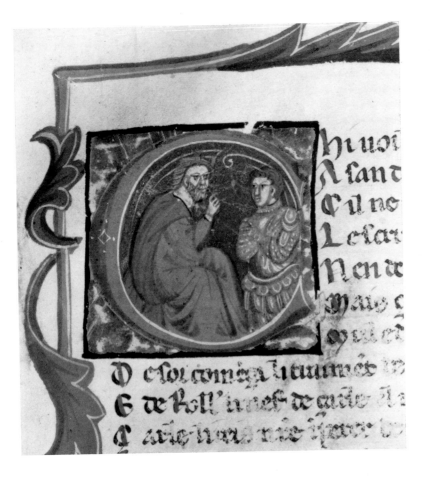

hi uoī
A fan ꝺ
ẽ il noꝛ
L ẽ fac
Ñ en ꝺ
hais ꝙ
ꝙ uᵭ eꝺ

Ꝺ esoꝈ conꝛẽ ꝯ li ꞇuuꝛꝰ ꞇ
ꝉ ꝺe Ꝓoꝉꞁ ꞁꞇ neꝹ ꝺe auꞇꝺ ꞁ
Ꝯ aꝛꞁ li ꝯꝛꞁ rñe ꞁ̃or ꞇ

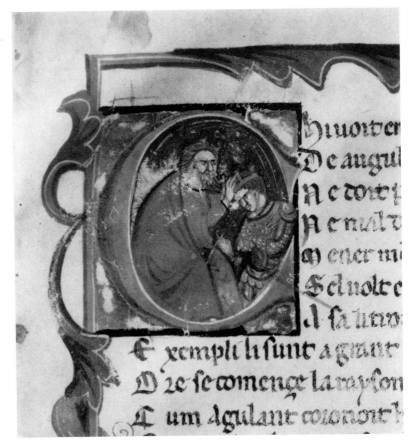

hi uoȳꞇeꝛ
ꝺe auguꝉ
Ñ e ꝺoꝛꞇ Ꝓ
Ñ e nꝑꝺ ꝺ
ꝙ ener mẽ
Ꞁ el uoꝉꞇ ꝯ
ꝉ fa luꞇ̃ꝺ

Ꝓ xempꝉī li ꞁunꞇ a gꝛanꞇ
Ꝺ ꝛe ꞁe ꝯmenꝯ̃ la rꜹꞁoꝛ
Ꞇ um agulaꞇ cõꝛoꝛꞇ ꝉ

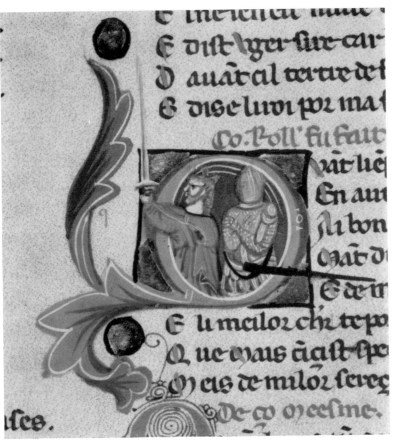

Ꝑ ꞇhe leꞇ ꞇeꝰ huꞇẽ
Ꝑ ꝺiꞁꞇ Aꝯꝺꝛ ꞁṝe caꝛ
Ꝺ auꝛaꞇ al ꞇeꝛce ꝺeꝉ
Ꝑ ꝺiꞁe luꝛꝰ Ꝓꝛ ma ꝺ

 Co. Ꝓoꝉꞁ ꞇ̃ fauꞇ
 ꝯaꞇ li̓e
Ꝑn auꝛ
ꝉi bon
ꝙaꞇ ꝺu

Ꝑ ꝺe u̓

Ꝑ li meꝉoꝛ chꞇ ꞇe Ꝓ
Ꝙ ue uꝛaꝰ ꜹ aꝉꞇ ꞁꝰe
ꝏ eꝉꞁ ꝺe miꝉoꝛ ꞁeꝛeꝯ
 Ꝺe ꝯ ꝏ eeꞁ me⸝
ꞁaꝉeꝰ·

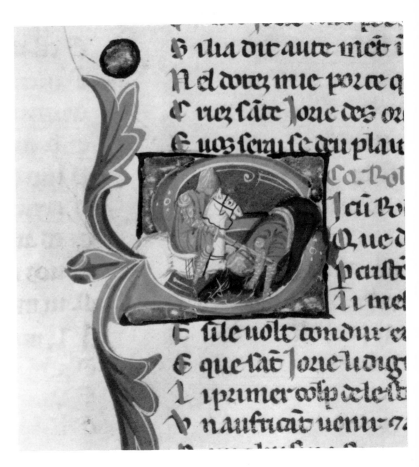

Ꝓ illa ꝺiꞇ auꞇꝰ mẽ ꞇ
Ñ el ꝺoꝛꝝ mꝰe Ꝓꝛ ꝯ ꝙ
Ꝑ ꝛꝯꝝ ꞁ̃aꞇꝰ ꝉoꞁe ꝺeꞁ ou
Ꝑ uꝛꝝ ꞁeꝛuꝰ ꞁe ꝙ̃ planꝝ

 Co· Ꝓoꝉ
Ꞁ ꞇ̃ Ꝓoꝉ
Ꝙ ue ꝺ
Ꝓ aꝛꞇꝺ
ꝉi meꝺ

Ꝑ ꞁile uoꝉꞇ conꝺuꝝ e
Ꝑ ꝙue ꞇãꞇ ꝉoꝛe li ꝺigꞇ
Ꝉ iꝓꝛmeꝛ coꝉꝓ ꝺeꝉeꝛꝺ
ꝟ nauꝺꝛaꞇꝰ uenuꞇ ꝙ꙼

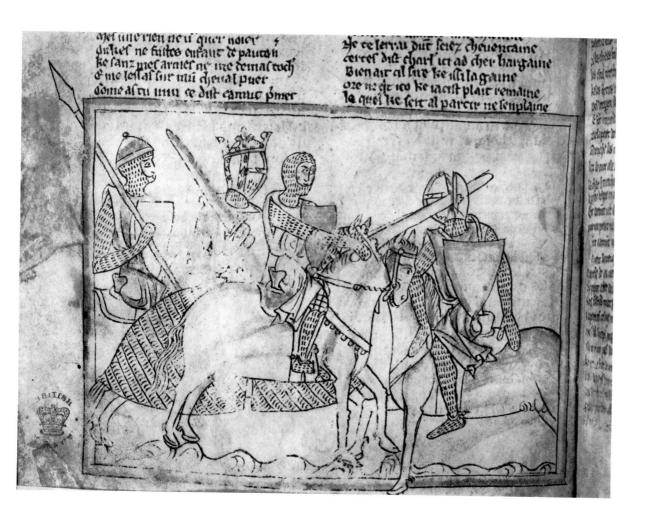

159. Ganelon at the feet of Marsile.

Historiated initial C. *Chanson de Roland,* Venice, Biblioteca Marciana, cod. fr. IV, fo. 69 ro. Late 13th - early 14th century.

160. The heathen king Agolant crowning his son Eaumont.

Historiated initial C. *Chanson d'Aspremont.* Venice, Biblioteca Marciana, cod. fr. IV, fo. 1 ro. Late 13th century.

161. Charlemagne knighting Roland.

Historiated initial. *Ibid.,* fo. 49 ro.

162. Young Roland, protected by St. George, killing a heathen king.

Historiated initial. *Ibid.,* fo. 54 vo.

163. Young Roland saving Charlemagne's life by killing the heathen Eaumont.

Wash drawing. *Chanson d'Aspremont.* London, British Museum, Lansdowne 782, fo. 12 vo. First half of 13th century.

164. Young Roland with his comrades coming to meet Charlemagne.

Wash drawing. *Ibid.,* fo. 21 vo.

This story, rich in movement as it is, is given an added lightness and variety by the technique of colourwash over pen-drawing.

159 160 163

161 162 164

si uot auet armes ne garniut
ke lemperere ne li doinst termi
ge il de ñ ne ueot toure ensemt
ne serrst mte ouels lui lungerñ
e le danaif pla face le prit
e si li baise suef e ducemt.

bel mad ore uil ki dure me uend cher
ico at ore seru de la coupe al maruñ
estoie de lengres sout denanr ñ taill
si mat eu ne ferel cheualer
autre sorianz s'esteor p̄ chacer

Entre le duc ꝃ. e le danais oẽ.
Denant le roi se uist agenuiler
numes pla dux neimes de baui
sire dist il ñ sumes mellager
Sinul uenum un mellage nucier
ure neuou ueot estre cheualer

ꝛ. dist charles ceo ne puis ico pas ueer
encore me mẽbre crestieu del oliuer
ꝛit ico il ni ure cheual laissier
od un truncun de hanste de pomer
vers mai uenistes si tost come leuer
si come elmund qind a braz dreslcar

cel gñꝰ eleuas departir edñ
cel dras de sere des pailles de ourtmer
e hesh en ad plus kil ne peot port̃

ñ auera uere ki cheualer serra.
vñt il aurut ke il uere lur durra
vist lun al autre deus quel seiñ a

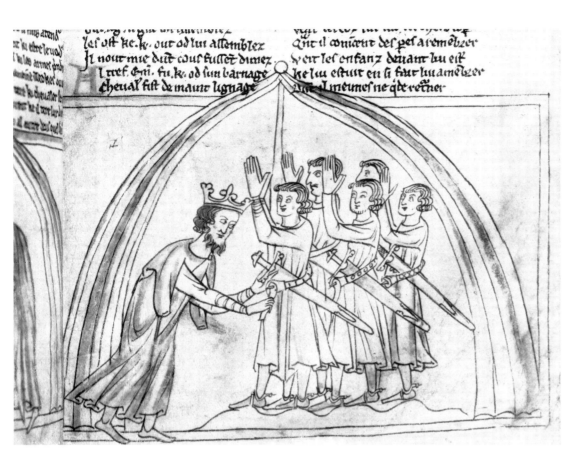

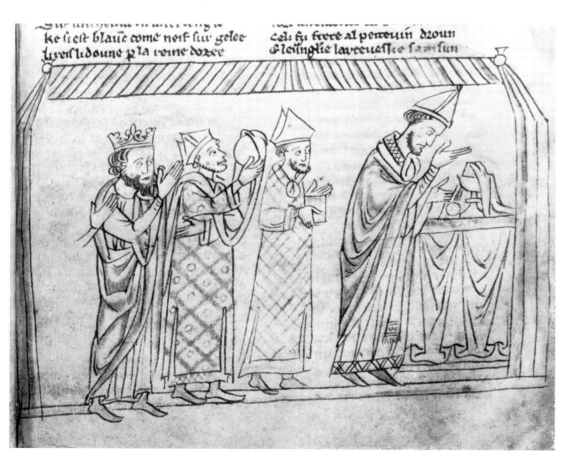

165A 166
165B 167

165A. Naimes and Ogier telling Charlemagne that Roland wishes to be knighted.

B. Charlemagne embracing Roland before knighting him.

Wash drawings *Chanson d'Aspremont,* London, British Museum, Lansdowne 782 fo. 22 ro. and vo.

166. Charlemagne knighting several sons of dukes and peers.

Wash drawing. *Ibid.,* fo. 23 vo.

167. The Pope celebrating Mass in honour of the new knights.

Wash drawing. *Ibid.,* fo. 25 ro.

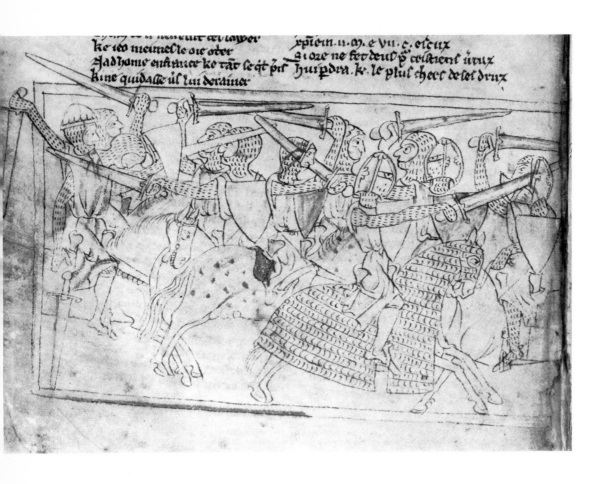

ke two meimesse die over
ad home enfesmer ke rad se qt pit
kine quidasse il sui deramer

xplom. ii. m̃. e vii. c. oī deux
si oze ne fer deus q̃ crostrent itrux
hurpdia ke le plus cheer de sel druz

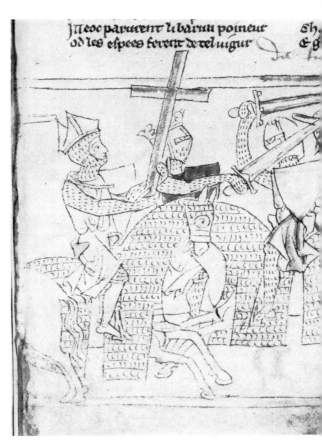

168 A 168 B

169 A 169 B

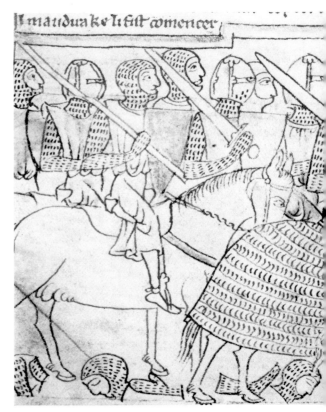

168 A and B. Battle between the armies of Charlema-
gne and Agolant.

Wash drawing. *Chanson d'Aspremont,* London, British Mus-
eum, Lansdowne 782, fo. 26 vo. - 27 ro.

169 A and B. Another phase of the same battle.

Wash drawing. *Ibid.,* fo. 31 vo. - 32 ro.

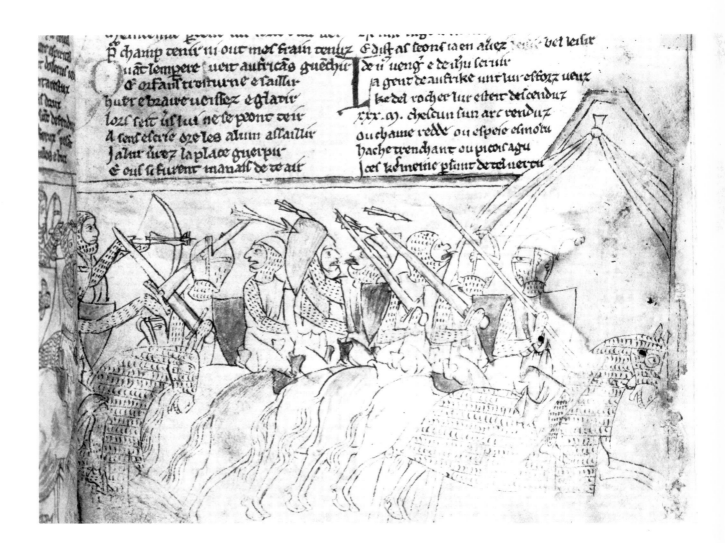

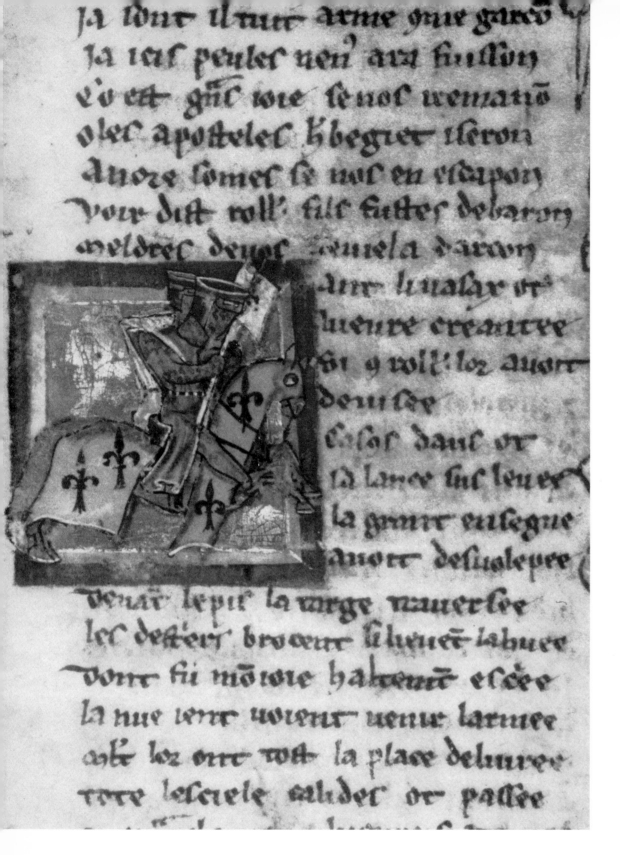

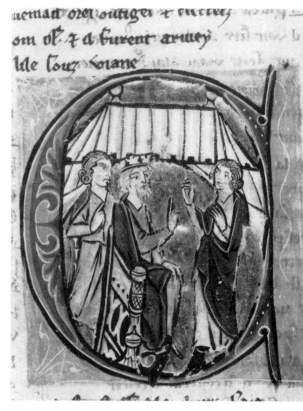

170. Roland leaving for battle with his minstrel
 Graelant.

Historiated initial. *Chanson d'Aspremont.* Nottingham,
Muniment Rooms of the University, ms. Mi. LM. 6, fo. 294 ro.
Third quarter of the 13th century.

171. Oliver coming to meet Charlemagne and Roland
 who are besieging Vienne in Dauphiné.

Historiated initial. *Girart de Vienne.* Paris, Bibliothèque
Nationale, ms. fr. 1448, fo. 23 vo. Second half of 13th
century.

*In the war which raged between Charlemagne and the
Duke Girart de Vienne, the two future friends, Roland
the Emperor's nephew and Oliver the nephew of Girart,
were on opposing sides. This forms the plot of the
chansons de geste of Girart de Vienne.*

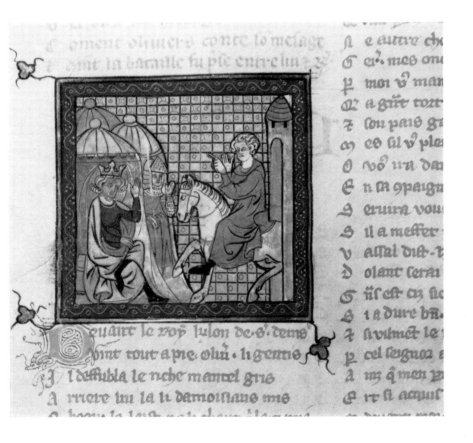

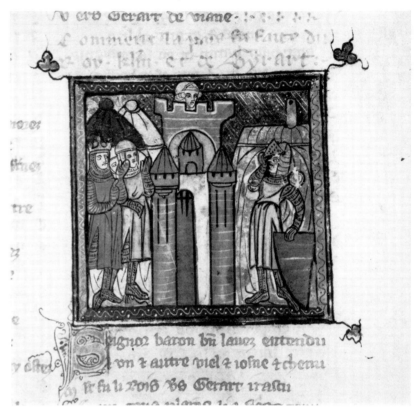

172. Oliver coming to meet Charlemagne and Roland
who are besieging Vienne in Dauphiné.

Miniature. *Girart de Vienne.* London, British Museum,
ms. Royal 20 D XI, fo. 53 vo. First half of 14th century.

173. Girart de Vienne making peace with Charlemagne
in the presence of Roland and Aude.

Miniature. *Girart de Vienne.* London, British Museum
ms. Royal 20 D XI, fo. 60 ro. First half of 14th century.

The giant Fierabras has taken possession of Rome. Charlemagne comes with Roland and Oliver to free the Eternal City from Saracen occupation. Scenes as lively as these furnish a pretext for illustrations which are already popular in character.

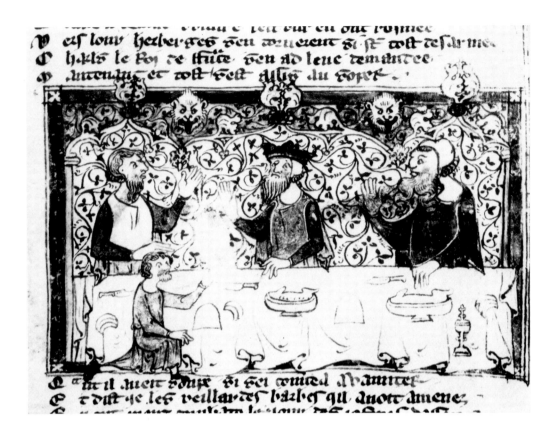

174 175

176 177

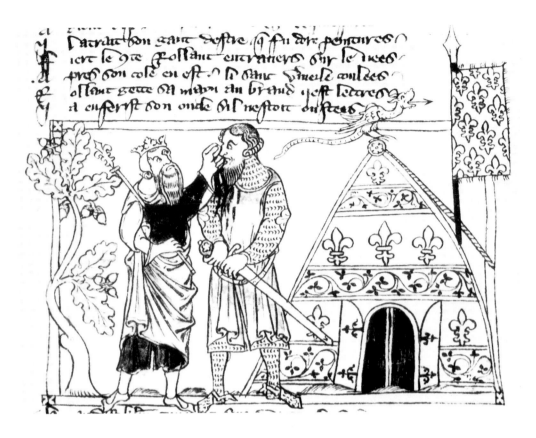

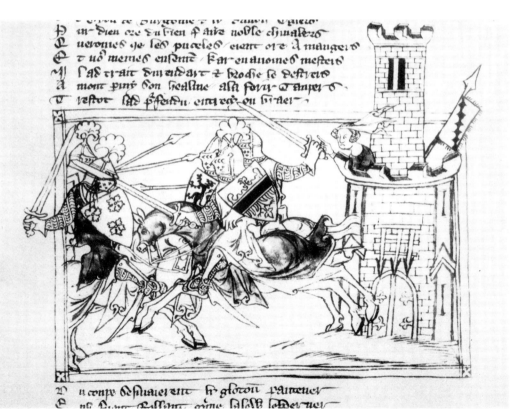

174. Roland and Oliver at a banquet given by Charle-
 magne.

Wash drawing. *Fierabras.* Hanover, Staatsbibliothek, ms.
IV 578, fo. 24 vo. Early 14th century.

175. Charlemagne striking Roland in the face.

Wash drawing. *Ibid.,* fo. 27 ro.

176. Roland brandishing his sword and putting to flight
 the heathen king Balan.

Wash drawing. *Ibid.,* fo. 59 ro.

177. Roland fighting the Saracens with Olivier.

Wash drawing. *Ibid.,* fo. 61 vo.

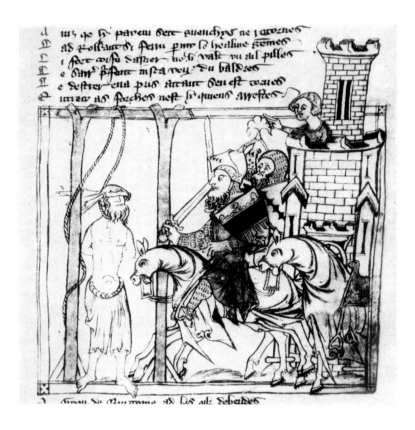
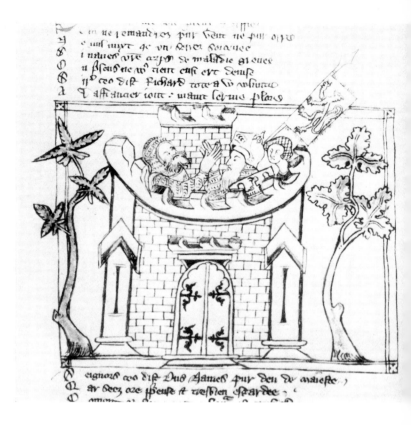

178. Roland liberating Gui de Bourgogne.

Wash drawing. *Fierabras.* Hanover, Staatsbibliothek, ms.
IV 578, fo. 65 ro.

179. Roland and Richard besieged in a tower.

Wash drawing. *Ibid.,* fo. 70 vo.

180. Roland, still besieged, watching Richard depart.

Wash drawing. *Ibid.,* fo. 71 vo.

181. Roland and Oliver destroying the heathen idols.

Wash drawing. *Ibid.,* fo. 89 ro.

182. Roland watching Turpin hand over the relics to
 Charlemagne.

Wash drawing. *Ibid.,* fo. 98 vo.

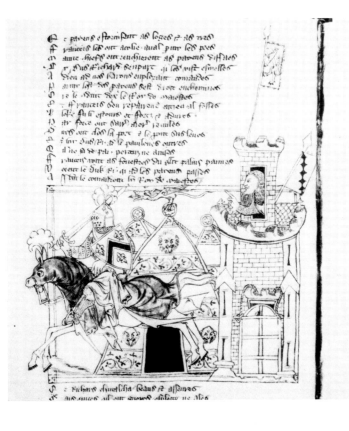

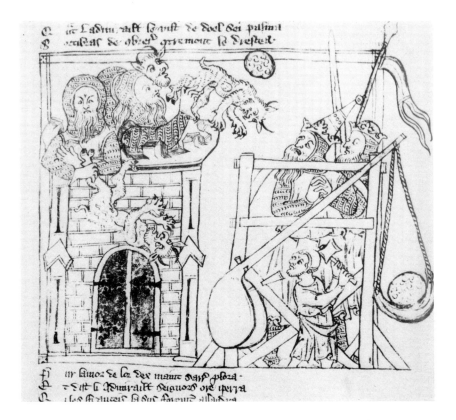

178 179 180 181

182

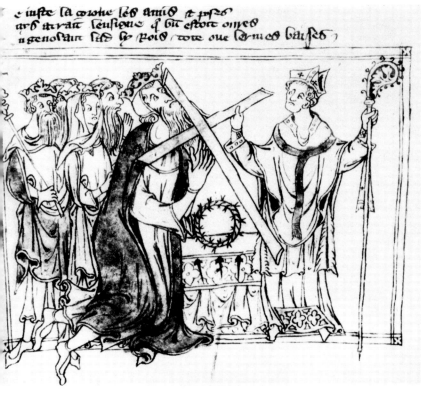

183 184

185 186 187

183. Oliver in mounted combat with Fierabras.

Wash drawing. *Fierabras.* London, British Museum, ms. Fr. Egerton 3028, fo. 87 ro. Mid-14th century.

184. Oliver continuing to fight Fierabras on foot.

Wash drawing. *Ibid.,* fo. 88 ro. Mid-14th century.

185. Oliver wounding Fierabras.

Wash drawing. *Ibid.,* fo. 90 ro.

186. Turpin preparing to baptize the heathen king Laban.

Wash drawing. *Ibid.,* fo. 117 ro.

187. Ganelon addressing Charlemagne.

Wash drawing. *Ibid.,* fo. 110 ro.

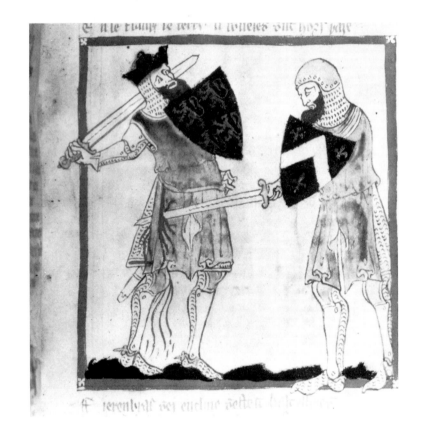

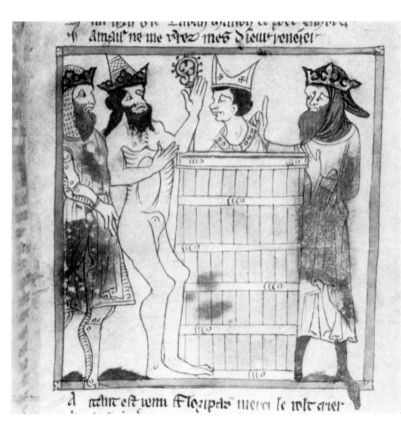

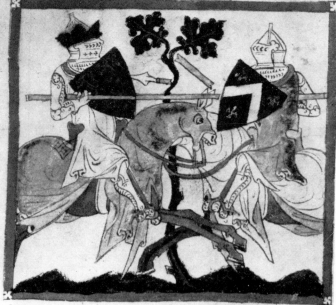

T iels coups s'entredonerent sur les estuz de quaer
Q e lur lances eufirent ou menue pieces trver

B oues furent li hauberc se nels fist famer
L es li barons dei pur loignent si tolient li bisse dastie

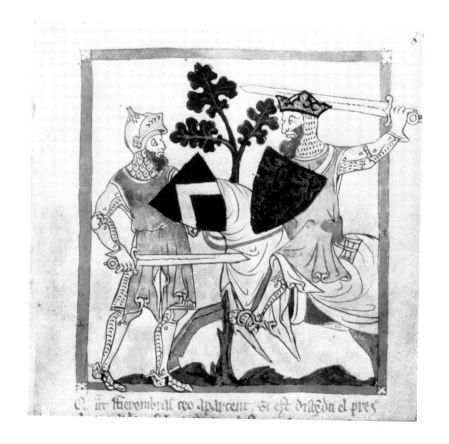

Q ar Macombras reo aparcent si est distedu el pres

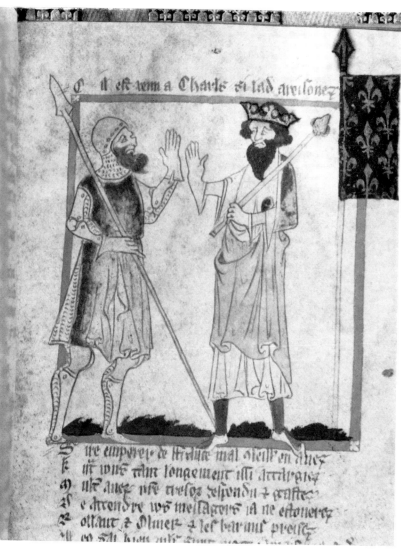

C il est venu a Charle si lad arrisone

S re emperex de fraue mal oiell en auez
L it vous tant lonquement illi arrivarez
A utt auex uns tresos respondu z craste
S e atendre uos messagurs id ne estonerez
R ollaut z Oliuer z les baraus preisez

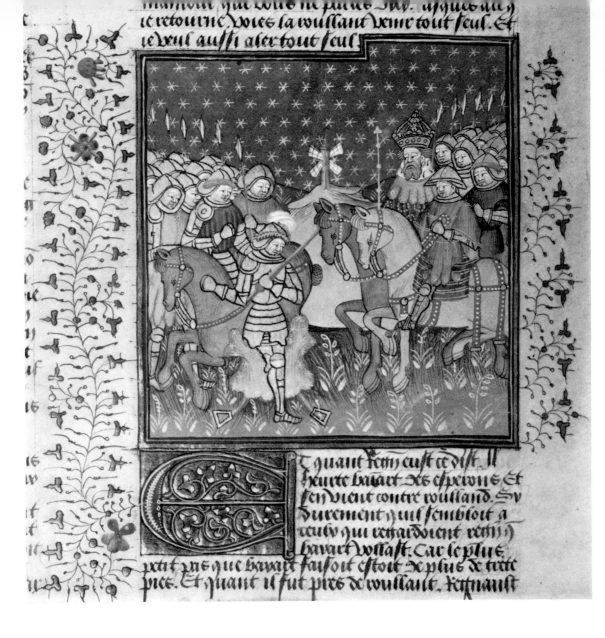

188 190

189

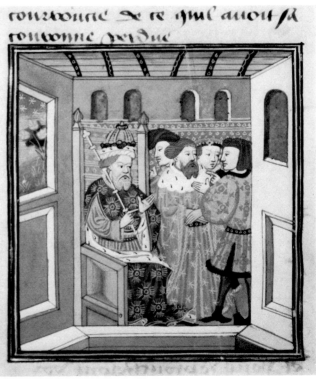

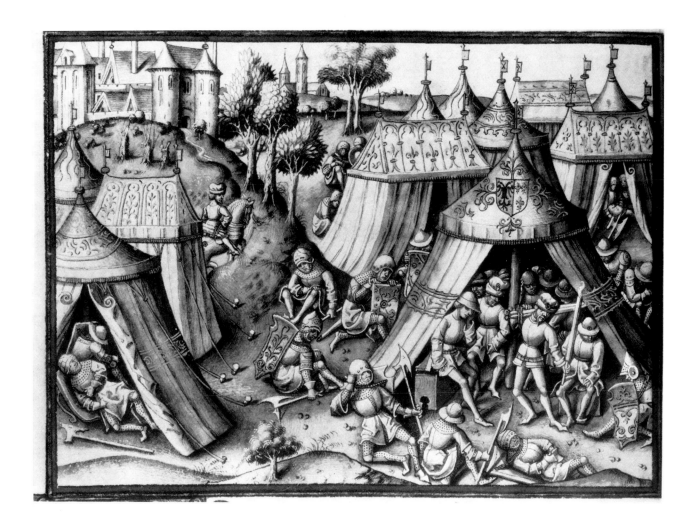

188. Renaut refuses to surrender his ally Maugis the enchanter to Charlemagne's envoy Roland.

Miniature. *Renaut de Montauban*. London, British Museum, Royal 15 E VI, fo. 176 vo. About 1446.

189. Roland and Naimes advising Charlemagne after his crown has been stolen by Maugis.

Miniature, *Renaut de Montauban*. London, British Museum, Royal 16 G II, fo. 40 ro. End of the first half of the 15th century.

190. Maugis stealing the swords of Charlemagne, Roland and the peers.

Grisaille by Tavernier. *Renaut de Montauban* in *Croniques et Conquestes de Charlemaine,* Brussels, Bibliothèque Royale, ms. 9067, fo. 125 vo.

In the famous story of Renaut de Montauban, *or* The Four Sons of Aymon, *Roland acts as mediator between Charlemagne and the rebel knights Renaut and his cousin Maugis.*

charlemaine ses barons et noble
hommes par nigromance et si
emporta leurs espes en motauba.

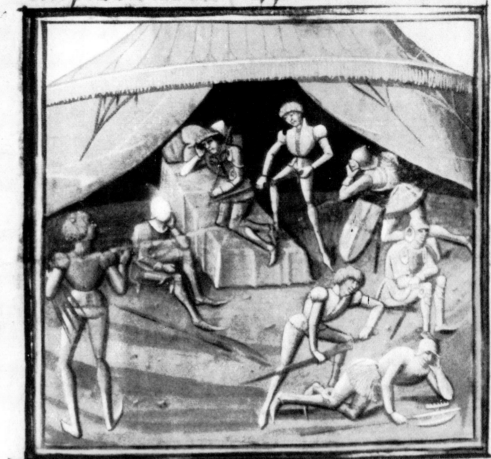

Et dit listoire que quant
sempereur eut fait liez
maniere daigremont a
uns piller z quil eut soupe il

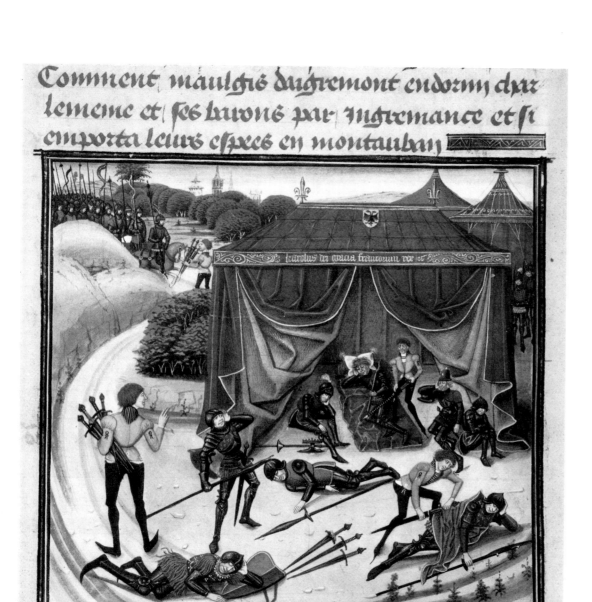

191. Maugis stealing the swords of Charlemagne, Roland and the peers.

Grisaille. *Renaut de Montauban.* Pommersfelden, Biblioteca Palatina, ms. 311, fo. 360 vo. About 1460.

192. Maugis stealing the swords of Charlemagne and Roland.

Miniature by Loyset Liédet. *Renaut de Montauban.* Paris, Bibliothèque de l'Arsenal, Réserve 5072, fo. 271 ro. About 1460.

The horse Bayard, the enchanter Maugis – here Roland is moving in the world of the supernatural. He is sometimes the victim of sorcery as in the amusing incident of the stolen swords.

193

194 195

193. Roland watching as Hernaut surrenders.

Miniature. *Renaut de Montauban.* Paris, Bibliothèque de l'Arsenal, Réserve 5072, fo. 277 vo.

194. A messenger from Renaut arriving at Roland's tent.

Grisaille. *Renaut de Montauban.* Pommersfelden, Biblioteca Palatina, ms. 311, fo. 398 ro. About 1460.

195. Roland watching as Renaut de Montauban surrenders to Charlemagne.

Miniature. *Ibid.,* ms. 312, fo. 3 ro. About 1460.

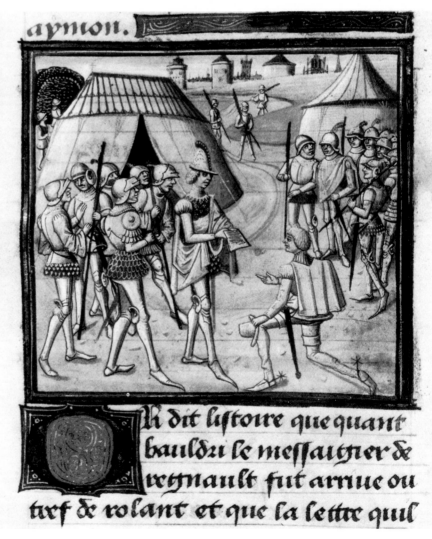

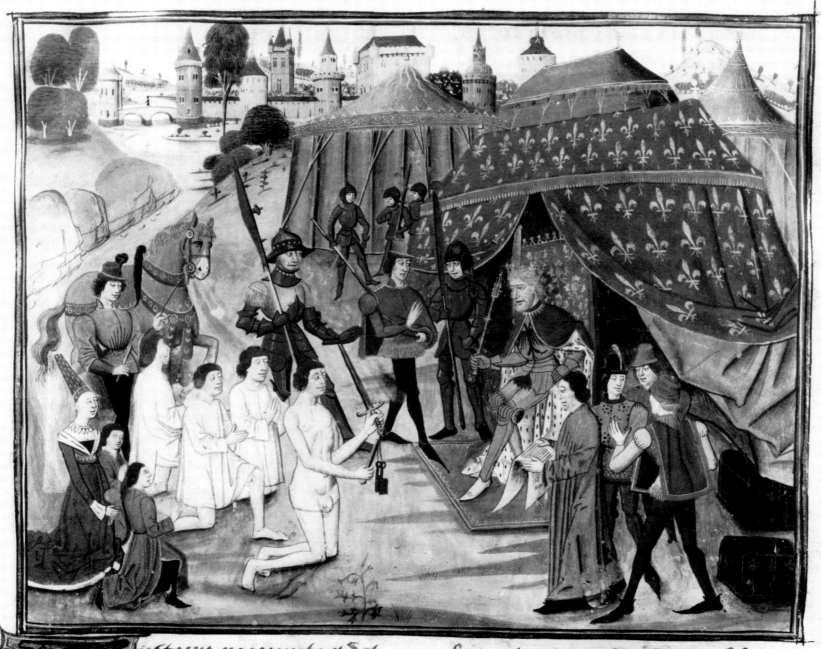

L ystoure racompte et dit
que quant reynault
et ses freres furent mis

bien et pour cellui du noble duc
reynault Pour ce la est ce bouent
beaulx seigneurs fait il si bous

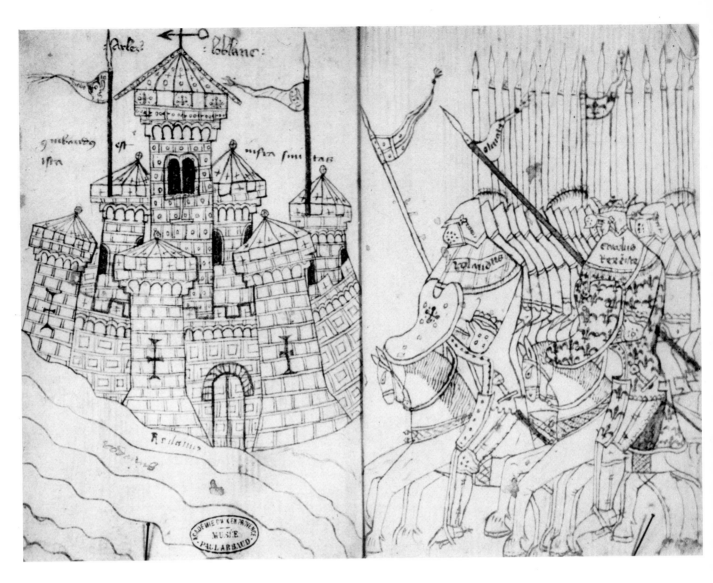

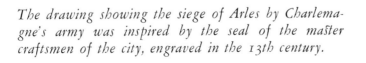

196. Charlemagne and Roland besieging Arles.
Pen-drawing. *Roman d'Arles.* Aix-en-Provence, Bibliothè-
que Arabaud, ms. M.O. 63, fo. 69 vo. - 70 ro. About 1375.

197. Seal of the Master craftsmen of Arles.
13th century.

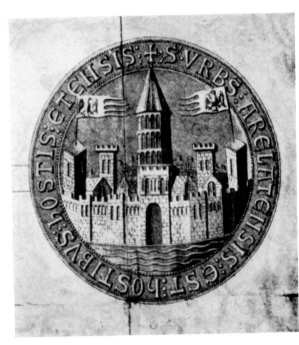

The drawing showing the siege of Arles by Charlema-
gne's army was inspired by the seal of the master
craftsmen of the city, engraved in the 13th century.

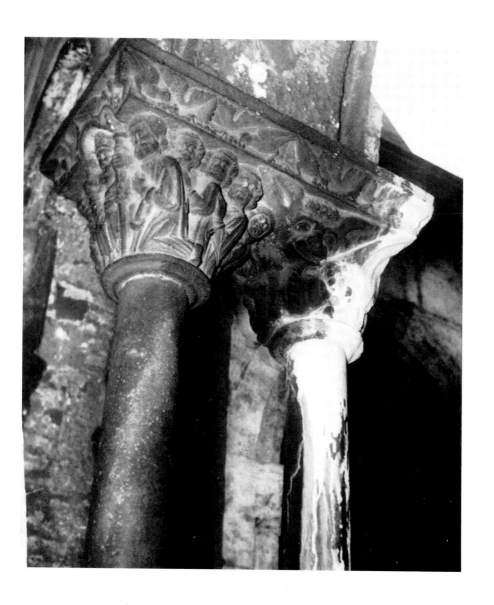

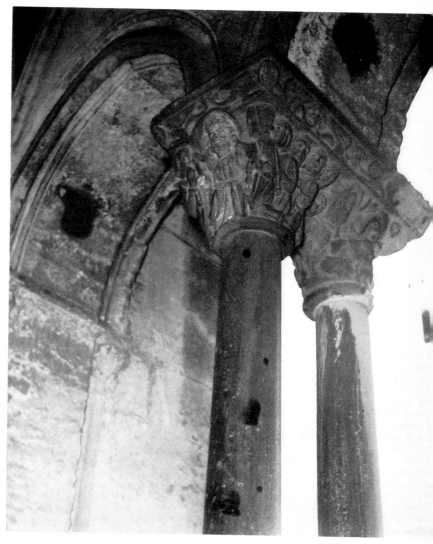

198. Turpin pardoning the barons, who have remained alive by a miracle.

Arles, cloiſter of St. Trophime, capital. About 1300-1350 (?).

199. Charlemagne, assiſted by Roland and Oliver (?), condemning six barons of Arles to be hanged.

Ibid. About 1300-1350 (?).

These capitals from the juſtly famous cloiſter of St. Trophime at Arles illuſtrate a legend which was later to give rise to a 14th century poem Le Roman de Saint Trophime. *In this Archbishop Turpin occupies a place of honour, alongside the patron saint of Arles.*

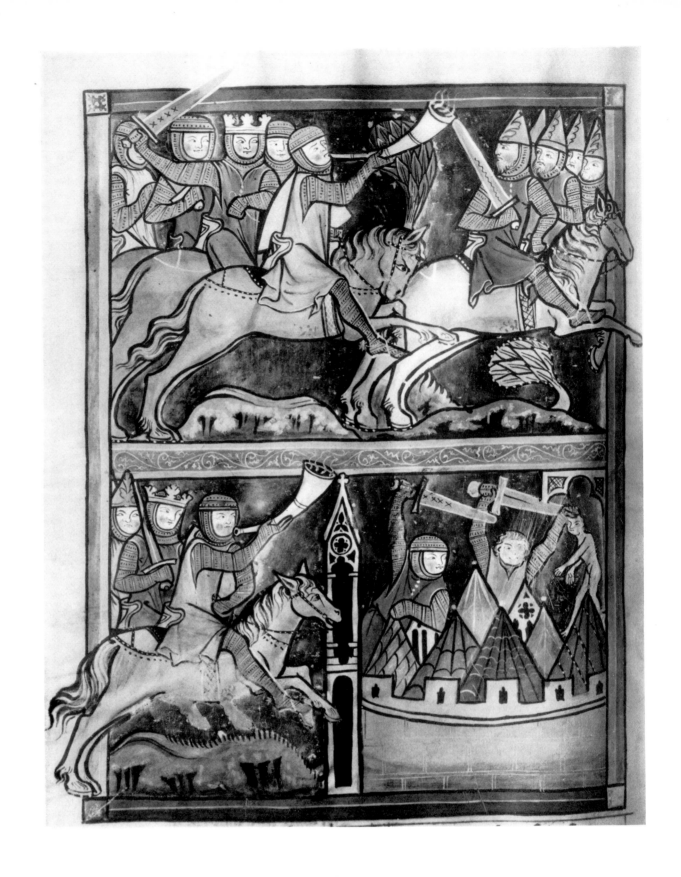

200. Roland, blowing his horn, routs the heathen –
 Roland taking a heathen city.

Miniature divided horizontally. *Karl der Grosse* of Der
Stricker. St. Gall, Stadtbibliothek no. 302, fo. 6 vo. Late
13th century.

The illuśtrations to the St. Gall manuscript of Karl der
Grosse *are among the maśterpieces of German miniature
painting.*

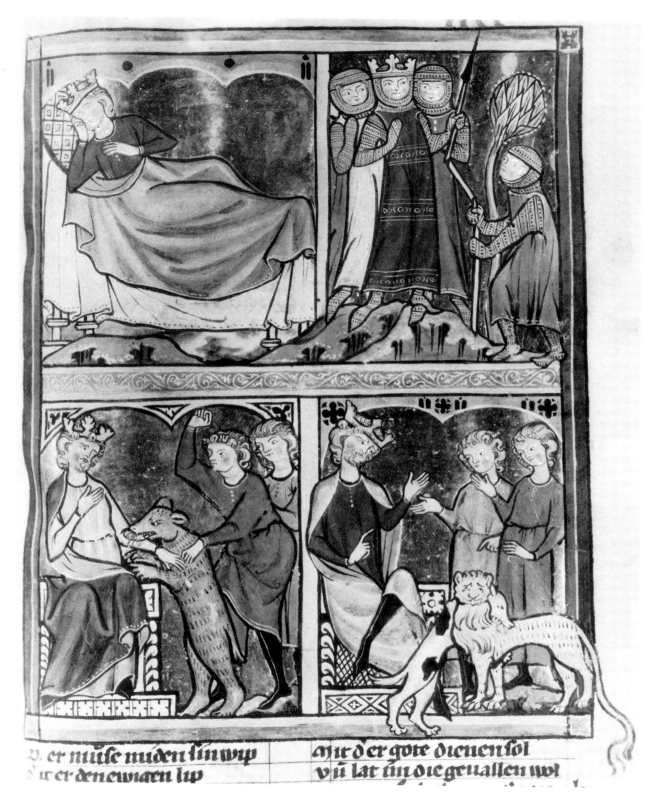

er muse muden sin wip
s wer den ewiaten lip

asit der gote dienen sol
vn lat in die geuallen wol

201. Charlemagne's prophetic dreams before his return
to France.
 A. The lance broken by Ganelon.
 B. The bear's bite.
 C. The fight between dog and leopard.
Miniature divided horizontally. *Ibid.*, fo. 25 ro.

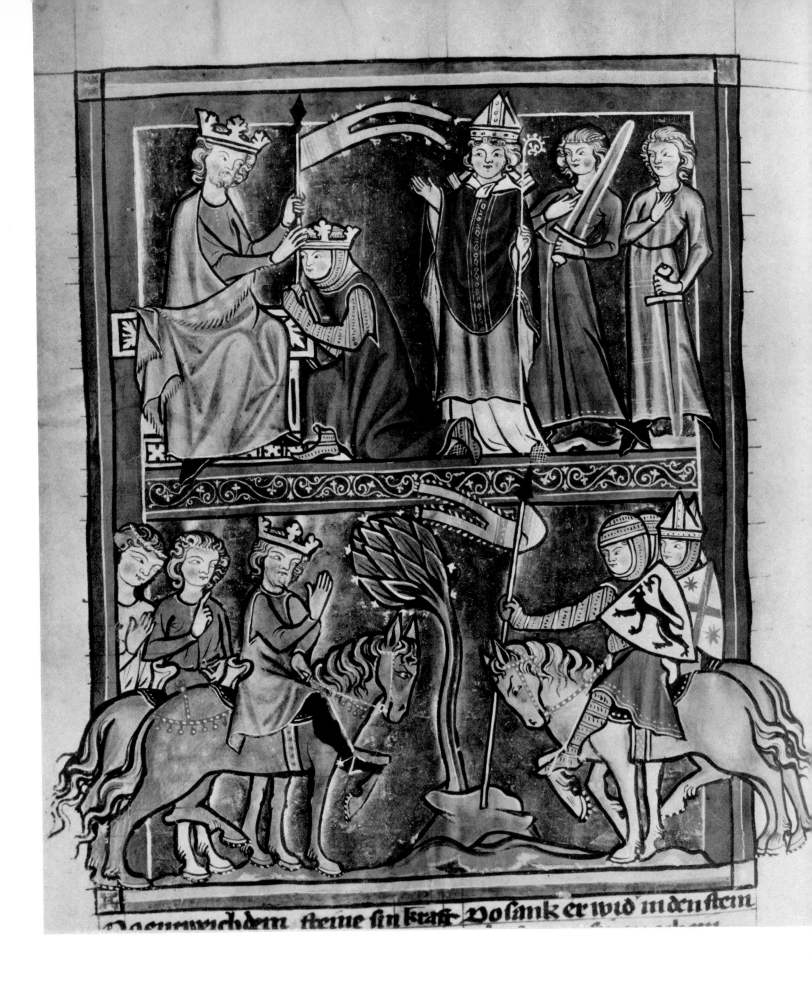

Dagen wich dem keine sin kraft · Do sank er wid in den stein

202. Charlemagne making Roland overlord of the land of Spain, crowning him and giving him the standard — Charlemagne and his army taking leave of the peers.

Miniature divided horizontally. *Karl der Grosse* of Der Stricker. St. Gall, Stadtbibliothek no. 302, fo. 26 vo.

203. At Roncevaux, Roland and Turpin attacking the heathen with lances. Roland killing a heathen king.

Miniature divided horizontally. *Ibid.,* fo. 35 vo.

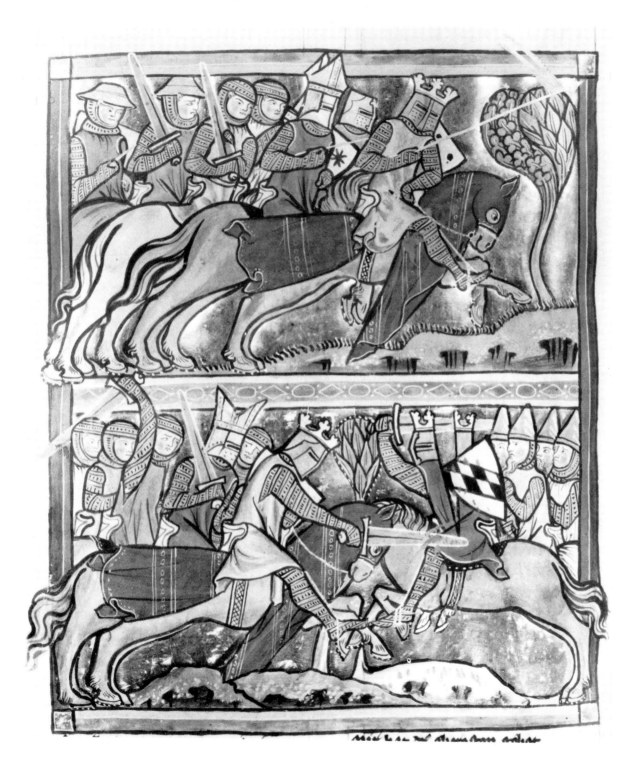

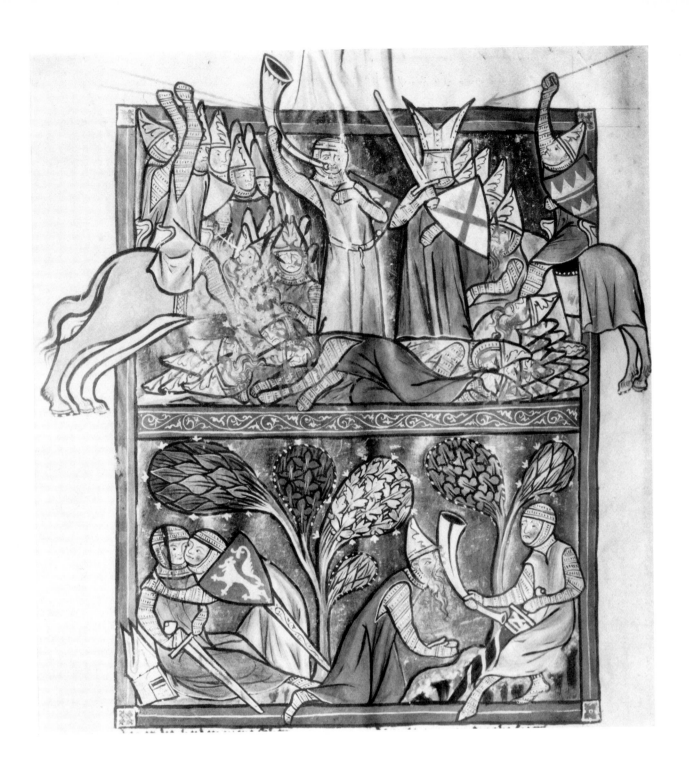

204 Roland and Turpin surrounded by the heathen, Roland blowing his horn – Roland saying farewell to Turpin. Roland striking with his horn the heathen who tries to take Durandal from him.

Miniature divided horizontally. *Karl der Grosse* of Der Stricker. St. Gall, Stadtbibliothek no. 302, fo. 50 vo.

205. Back in Saragossa, Marsile dies with Queen Bramimonde at his side. The Queen ordering the destruction of the heathen idols.

Miniature divided horizontally. *Ibid.*, fo. 55 ro.

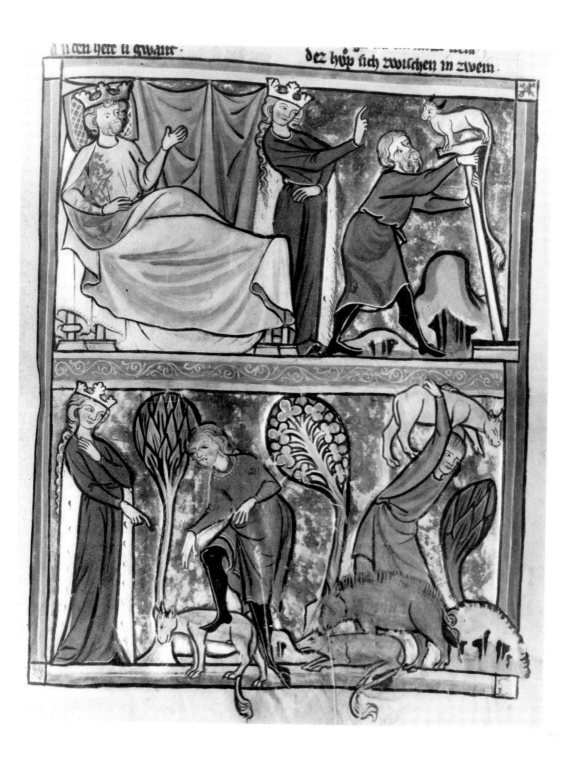

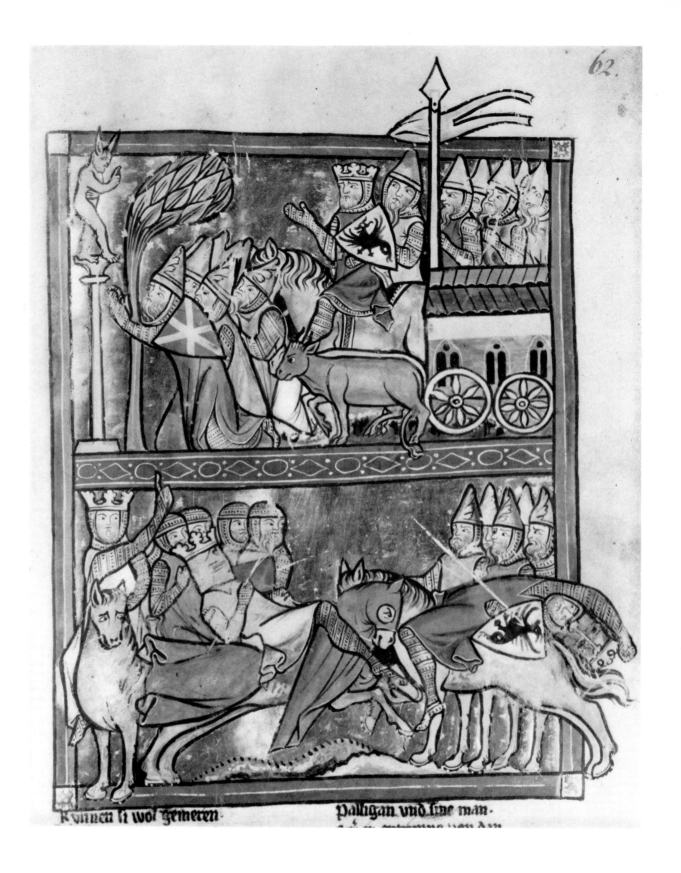

62.

Rūnnen li wol gemeten. Palligan vnd sine man.

206. The chariot of Palligan (Baligant). The heathen praying before the battle. First phase of the fight on horseback between Charlemagne and Palligan.

Miniature divided horizontally. *Karl der Grosse* of Der Stricker. St. Gall, Stadtbibliothek no. 302, fo. 62 ro.

207. With the help of a miracle Charlemagne distinguishes the bodies of the Christians from those of the heathen. Charlemagne and Aude at the heroes' burial in the crypt at Blaye. Beside them is the Emperor's son Louis.

Miniature divided horizontally. *Ibid.*, fo. 71 ro.

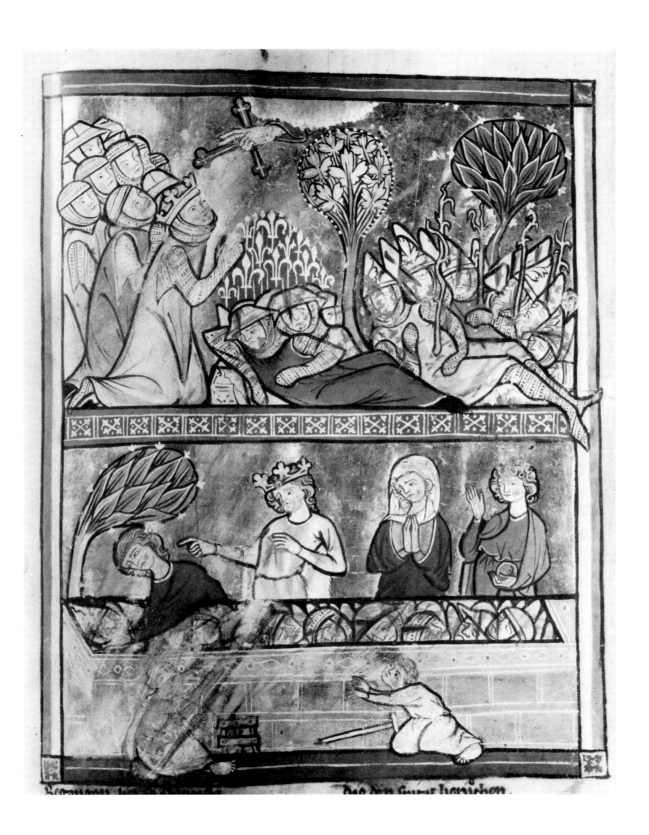

208. Roland riding through the Pyrenees.
Miniature. *Karl der Grosse* of Der Stricker.
Berlin, Deutsche Staatsbibliothek, ms. Germ.
fol. 623, fo. 21 vo. (at present kept at Tübingen, Universitätsbibliothek). Second quarter
of 14th century.

209. The dying Roland striking with his
 horn the heathen who tries to take
 Durandal from him. The hero
 giving his glove to St. Michael.
Miniature. *Ibid.*, fo. 22 vo.

*Roland proudly rides forth to his destiny,
a magnificent figure with his standard
floating against the wind.*

210. Charlemagne handing to Ganelon the message for
Marsile.

Miniature. *Karl der Grosse* of Der Stricker. Wolfenbüttel,
Herzog-August Bibliothek (1. 5. 2 August, 2°), fo. 180 vo.
14th century.

211. Roland breaking the heathen idols. Turpin
baptising the heathen.

Miniature. *Karl der Grosse* of Der Stricker. *Ibid.*, fo.
179 ro.

*From the height of refined elegance the art of the minia-
ture has lapsed into mere clumsy anecdote in this
example, from Wolfenbüttel.*

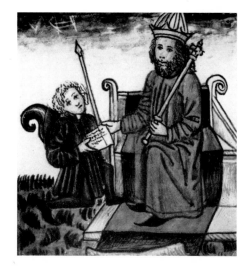

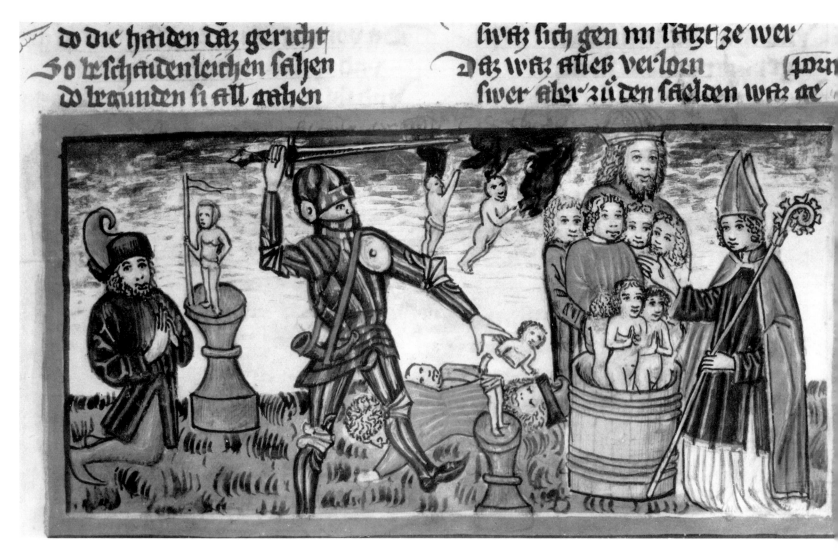

The 'mass-produced' illustrations done in the workshop of the Alsation Dietbold Lauber are characterized by a very sure sense of the rhythm of the story. The artist clearly delights in depicting scenes of battle and single combat.

212. Marsile's ambassadors before Charlemagne.
Ink and wash. *Karl der Grosse* of Der Stricker. Bonn, Universitätsbibliothek S. 500, fo. 17 ro. About 1450.

213. The general council of the Franks. Charlemagne listens to the dispute between Turpin and Ganelon.
Ink and wash. *Ibid.,* fo. 30 ro.

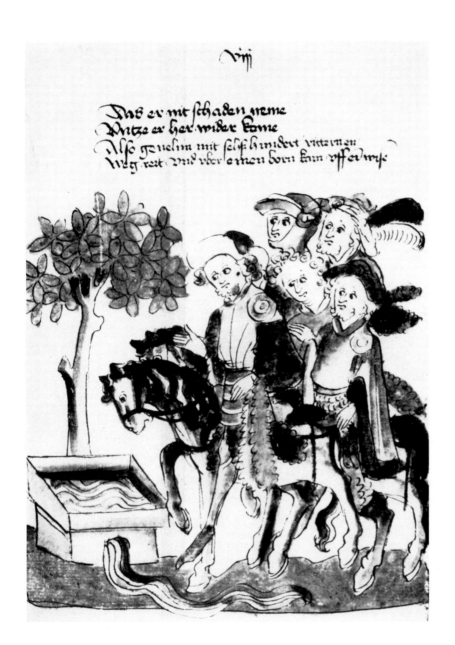

viij

Das er mit schaden neme
Vntze er her wider kome
Also genelun mit selbs hundert rittern
Weg reit vnd vber einen born kam off der wise

ipiij

Also genelun mit eine swert durch eine
guten helm slug vnd er das swert mar-
hien gap vnd das er solt rulanden von den
leben scheiden

214. Ganelon leaving on horseback with the infidel.
Ink and wash. *Karl der Grosse* of Der Stricker. Bonn,
Universitätsbibliothek S. 500, fo. 37 vo.

215. Ganelon swearing to Marsile to hand Roland over
to him.
Ink and wash. *Ibid.*, fo. 41 vo.

xxiii

Das hüp er uff mit einer hant
Vnne die jm hor vntze an die knye
Das gekrützet er ouch ye
Dar kam ouch kümk gomig
Der jegelicher ein krone trüet
Also die künnge vnd die herren zü dem künng
marsilie komint vnd jme ire gobe brochtent
mit fünffhundert mulen reich zü marsilie gar
schon enpfing

vj

Also die fürsten mit einand herrn zü hofe ritt
Vnd Rolant by dem lande bleip

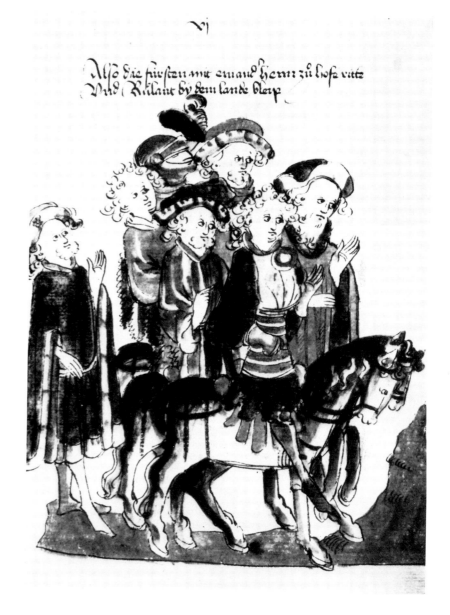

216. The heathen kings and nobles handing to Marsile
the fatal gifts destined for Charlemagne.
Ink and wash. *Ibid.*, fo. 48 vo.

217. The Franks taking leave of Roland at Roncevaux.
Ink and wash. *Ibid.*, fo. 54 ro.

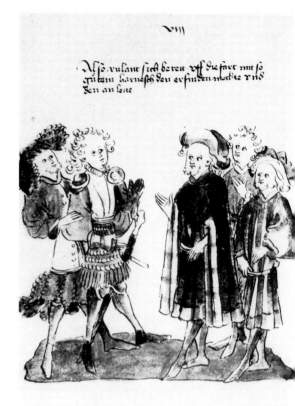

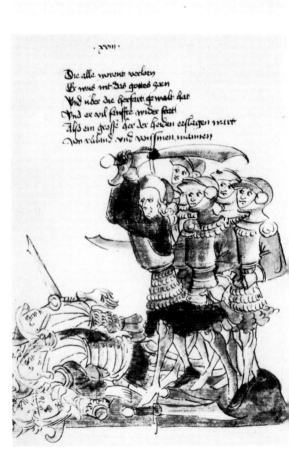

218. Roland arming.

Ink and wash. *Karl der Grosse* of Der Stricker.
Bonn, Universitätsbibliothek S. 500, fo. 64 vo.

219. A daughter of King Marsile.

Ink and wash. *Ibid.,* fo. 75 vo.

220. Roland and his army.

Ink and wash. *Ibid.,* fo. 83 vo.

221. Roland at the head of his troops slaugh-
 tering the heathen.

Ink and wash. *Ibid.,* fo. 88 ro.

222. Roland vanquishing a heathen warrior.

Ink and wash. *Ibid.,* fo. 93 vo.

223. Oliver fighting Falsaron.

Ink and wash. *Ibid.,* fo. 98 ro.

224. Roland fighting Cernubile.

Ink and wash. *Ibid.,* fo. 111 ro.

225. Archbishop Turpin fighting.

Ink and wash. *Ibid.,* fo. 122 ro.

xvii

Also ein künig marsilies dochter began were
es das er vrllant an gesiget

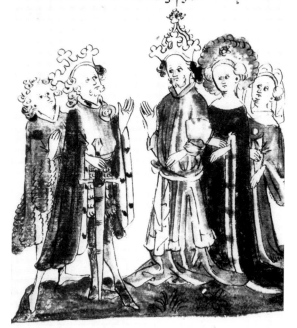

xvi

Also vrllant vnd sin her sich scharten vnd
ir ein her ein sinker schde Wigane de heide
kunen alten alben ab su

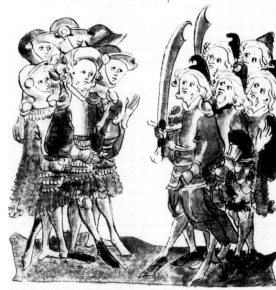

xvii

Also das her de listen vnd de heiden zu samen
keren vnd vrllant einen heiren eghlig vnnit
sin hiwstlist bet vff das gelt zel

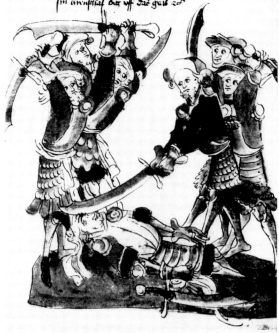

xix

Als der groffe faliain mit einem spieß
bit das stach das er der vff dem blan blub ze

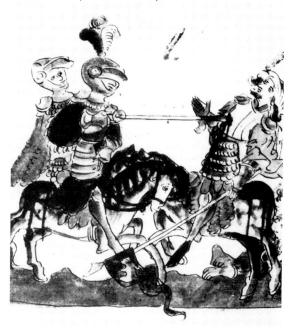

xxiii

Dwie gotte niergent viel duten weser
Als der bischoff ainpim mangen helm zertant
Vnd viel der heiden mide feila vnt siner hant

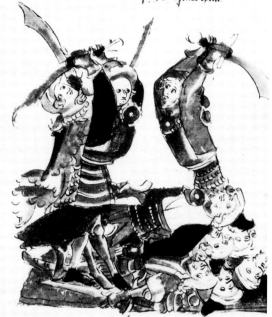

xxvi

Als vrllant vnd gernolt mit ananiter
struttot vor dem her der heiden vnd der cristen

226. Roland, with Oliver, attacking King Marsile and
cutting off his right arm.

Ink and wash. *Karl der Grosse* of Der Stricker. Bonn,
Universitätsbibliothek S. 500, fo. 142 vo.

227. Roland avenging Oliver's death.

Ink and wash. *Ibid.,* fo. 149 ro.

228. Roland and Turpin avenging the death of
Waltharius.

Ink and wash. *Ibid.,* fo. 154 vo.

229. Roland giving Turpin his helmet to protect him.

Ink and wash. *Ibid.,* fo. 161 ro.

230. Charlemagne and his companions finding Roland
and the peers lying dead at Roncevaux.

Ink and wash. *Ibid.,* fo. 168 vo.

231. An angel appearing to Charlemagne.

Ink and wash. *Ibid.,* fo. 174 vo.

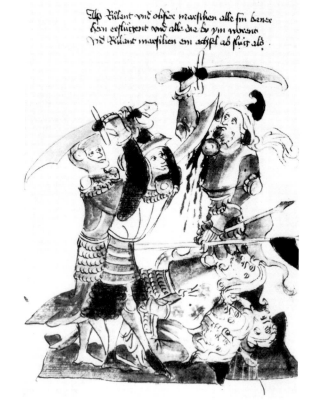

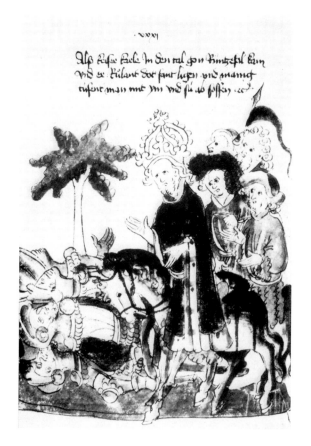

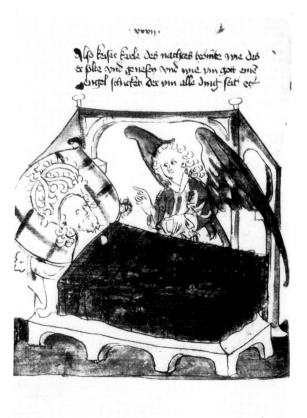

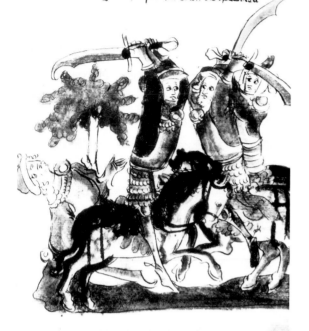

wen das er groslich erschlug
Als külmt siner gesellen vor der see lugen
der was genant Asser vnd er an die heiden rent

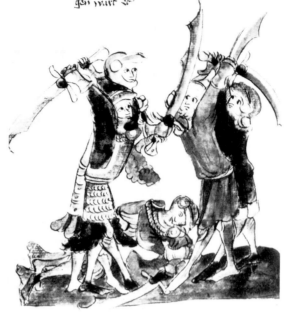

Als külmt vnd tiepin vnd walther allen
an die heiden strittent vnd walther erslagen wart

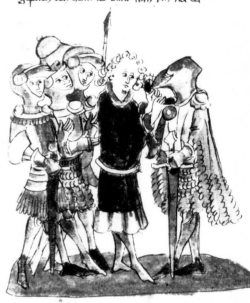

Als külmt vnd der bischoff tiepin die wil
behulten gegen den heiden vnd külmt sine
gesellen den helm ab bant wan wir nit der

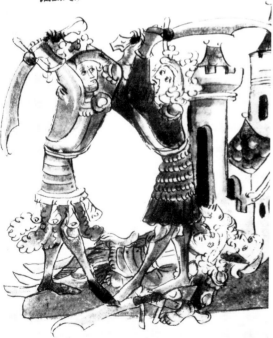

Als keiser karle vnd der küng baliegan eyn
strit vor allem volck hertzlich mitenander
hettent zc

Als keiser karle ob sinen volk stund das vm
erslagen was vnd er sinen nefen külmt
gar sere clagete vnd yn herlich bestatet

232. Single combat between
 Charlemagne and Baligant.
Ink and wash. *Ibid.*, fo. 219 ro.

233. Charlemagne mourning the
 heroes' death on his return to
 Roncevaux.
Ink and wash. *Ibid.*, fo. 231 ro.

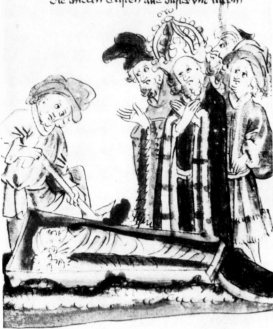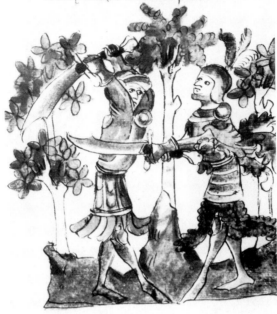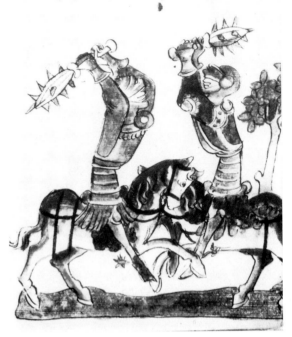

234 235 236

234. Charlemagne at the burial of Roland and Oliver.
Ink and wash. *Karl der Grosse* of Der Stricker. Bonn,
Universitätsbibliothek, S. 500, fo. 236 vo.

235. Margrave Otto fighting with Ganelon.
Ink and wash. *Ibid.,* fo. 252 ro.

236. Single combat between Pinabel and Tierry
 d'Ardenne.
Ink and wash. *Ibid.,* fo. 262 ro.

Tru uolnt famuur œ œ carlos ymaie.
Dist qil leueule sauoiz par gise œ meslue.
Son escaucis enuoie œ mot par estoit saie.
Vn breus lisit esmue elle Romas legnie.
Epist. ij. clzs œ mels œ son bnage.

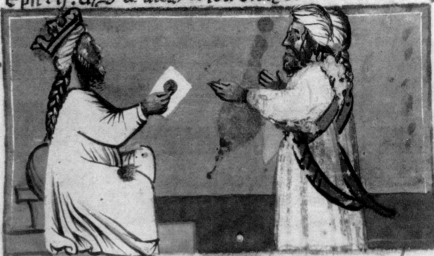

237. Marsile sending an ambassador
to Charlemagne. The ambas-
sador coming before Charle-
magne and Roland.

Miniatures. *L'Entrée d'Espagne.* Ve-
nice, Biblioteca Marciana, cod. fr. xxi,
fo. 8 ro. Mid-14th century.

The pictures in this magnificent
manuscript of the Entrée d'Espagne
follow each other like frames in a
film, recording step by step every
tiny incident in the poem.
Unfortunately
we have been able to
reproduce only a very small
proportion of the total.

Aportez moi cist breus asnchois auane.
E qil uos responra rement ez encoraie:
Celes paztret alaule sa coilet loz uoiage.
E tat oit esploitz pr plans 7 pr loschaie.
Q eil uetet paus los tors 7 liestnie.
Par œ fois la citez uetet couert lebaie.
De tete 7 œ cules œ cuir dimis œpartie.
Cil loz auoit Rollat acopliz son uiaie.
De Rome estoit tornez si amena el bnage.
E œ part lapstoile salue lempraie.
Suat œ unles temate Rollat li gns catanne.
Con tr feit lapstoile il asa get Romaine.

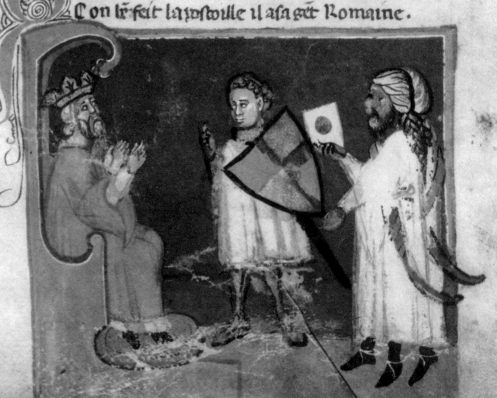

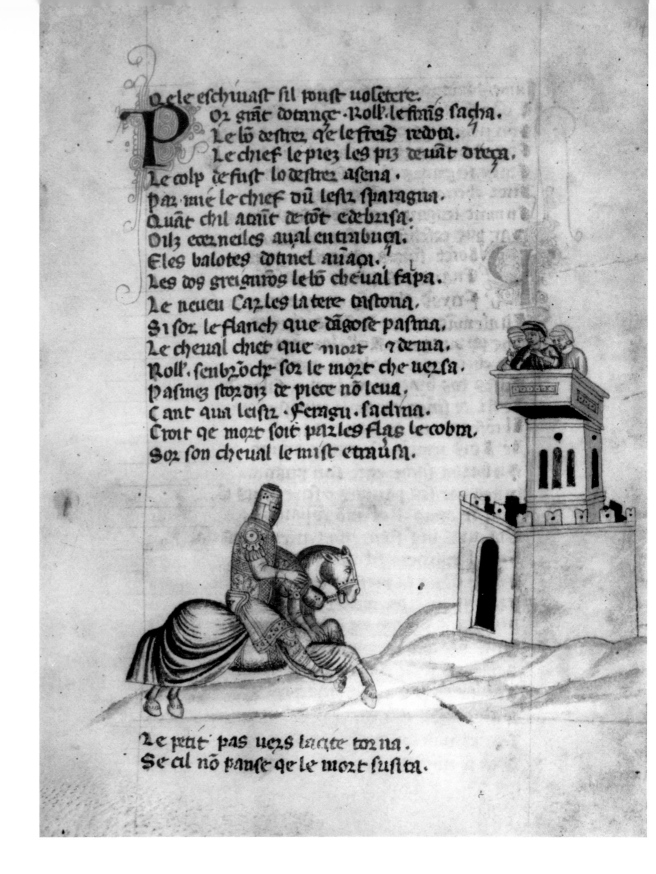

Qe le eschiuast fil poust uoletere.
Or grat dorange·Roll.lesiuis sacha.
Le lo destrez qe lestrais rewtu.
Le chief le prez les prz deuat oreza.
Le colp defust lo destrez asena.
Par mie le chief du lestz sparagua.
Quāt chil acuit de tot cderbzisa.
Oilz cernetles aual entrabuch.
Eles balotes dornel auaor.
Les dos greignors le lo cheual fapa.
Le neueu Carles la tere distona.
Si for le flanch que dagose pasma.
Le cheual chiet que mort 7 dema.
Roll.senbroche for le mort che uersa.
Pasmez stororiz de piece no leua.
Cant aua leistz·Ferragu·sachina.
Croit qe mort soie parles flas le cobm.
Sor son cheual le mist etraūsa.

Le petit pas uers lacite torna.
Se al no pause qe le mort susita.

238. Ferragut carrying away Roland on his horse.
Ink and wash. *L'Entrée d'Espagne*. Venice, Biblioteca Marciana, cod. fr. XXI, fo. 34 ro.

239. Roland sharing a meal in the tent of Solomon de Bretagne.
Ink and wash. *Ibid*., fo. 40 vo.

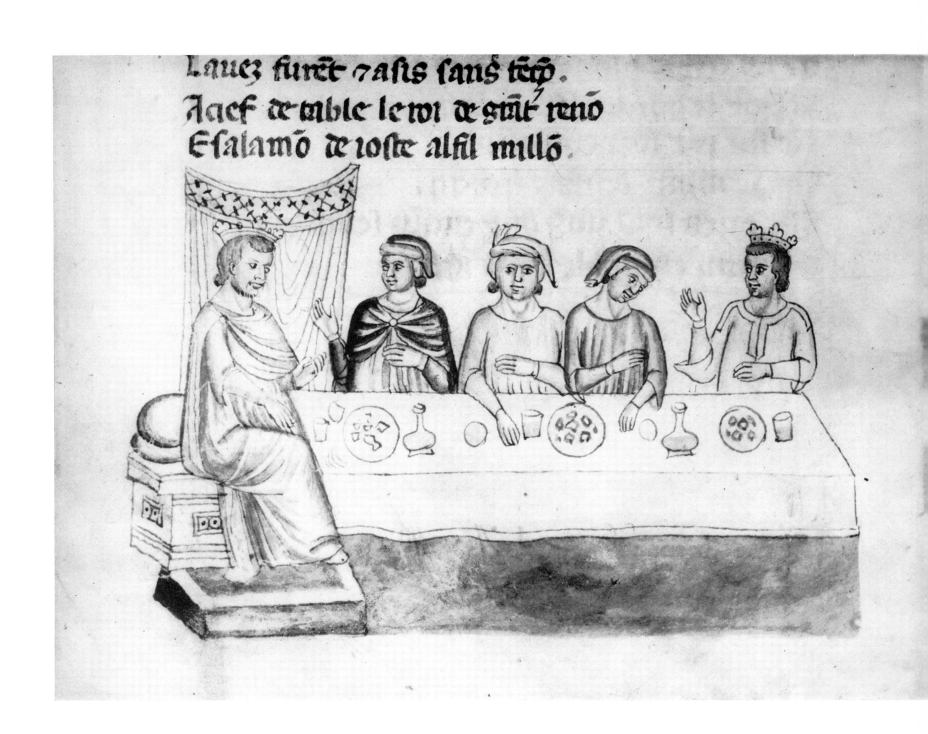

The episode of Roland's struggle with Ferragut in all its stages is portrayed by a miniaturist whose graphic, racy style is quite different from that of the main illustrator who is primarily a colourist.

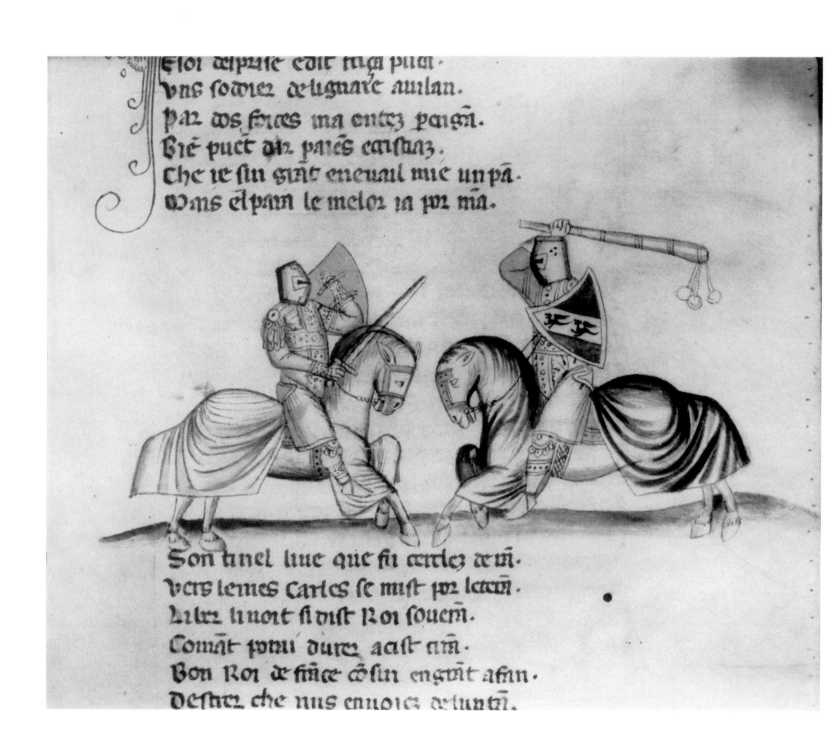

240. Ferragut attacking Roland with his flail.

Ink and wash. *L'Entrée d'Espagne.* Venice, Biblioteca Marciana, cod. fr. XXI, fo. 44 ro.

241. Fight between Roland on foot and Ferragut on
 horseback.

Ink and wash. *Ibid.,* fo. 64 vo.

Le colp auale tlosque le bl̃ nouelle.
Rollãt escale aie see mooelle.
Par al salu quã nis de dins mooelle.
Efer .li côturur zapelle.
Roll̃. Roll̃. le reigne de ãstelle.
vois fait sentaz de maspie lamelle.
Auz qe soies asis for lazcelle.
Ne que poztez corone ne uezcelle.
vos neroit mozt autel ladameiselle.
Jameis teuos naura stut foz mamelle.
Onte euezgoigne oit Roll̃. aic put.

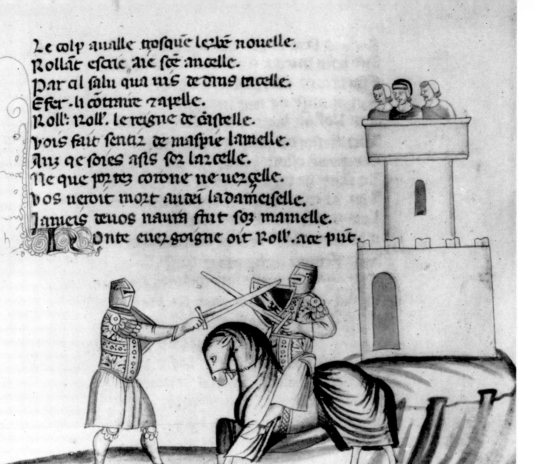

Celui euntr que fa mozt lui despot.
Olebrãt uns se mist affot affot.
Ferit leuit al deunlez telmôt.
Quãt chil côsturt tefen eschu hrôt.
Le blans obers le desmaille côfut.
Trosque lacars lebraz ne fe rezot.
Celle ne trance mais fila stuipa môt.
Quãt pœu fe nest le noble côt.
Ediez diftil quel meznoiles ci fut.

242. Roland attends Mass before the battle is resumed.
Ink and wash. *L'Entrée d'Espagne.* Venice, Biblioteca Marciana, cod. fr. XXI, fo. 58 ro.

243. Roland placing a stone beneath the head of
 Ferragut.
Ink and wash. *Ibid.,* fo. 68 ro.

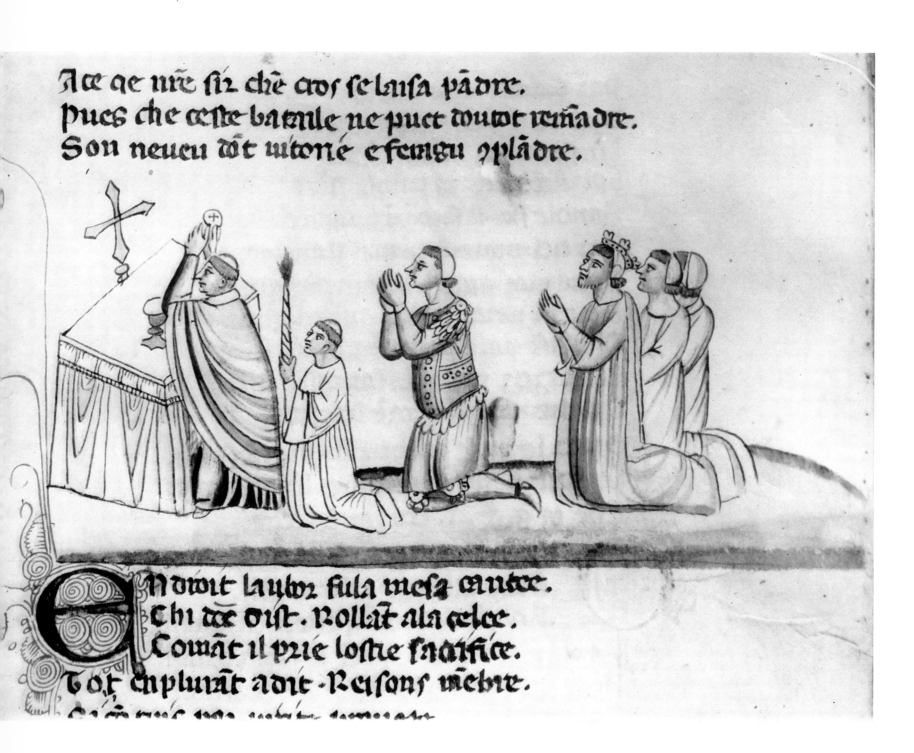

De son bras tient le chief amasis.
Si dist son uoille come fust u sol mis.
R. loi si dist par sant tomais.
Je croi qil dort est fil de satanis.
En cele part sen uent aptit pais.
Prist un prô chil uoit elegaus.
Se dunc nouslist uel tenez mie agais.
Ouas oust le turch enestrepis.
Mais nel ferot par tot lor de baudnis.

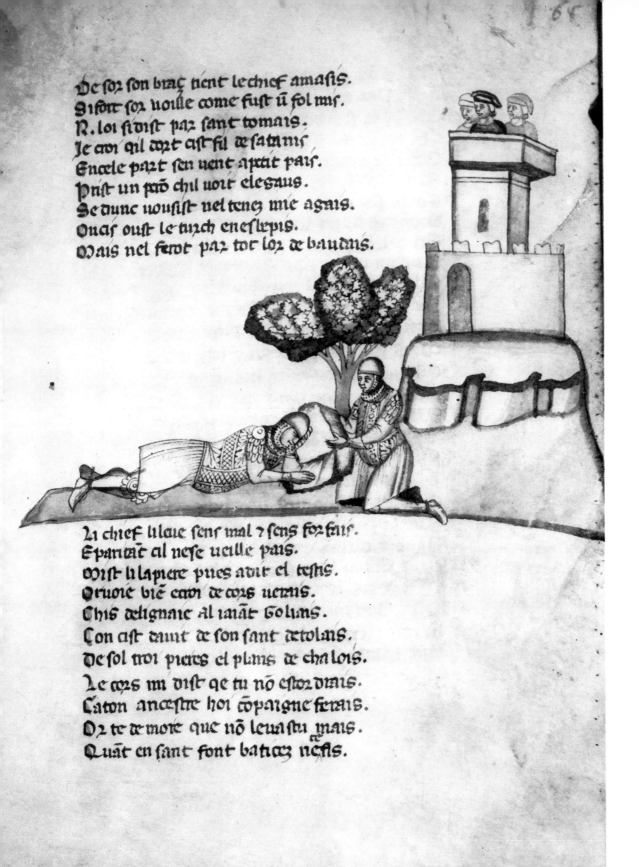

Li chief li laue sens mal z sens forfais.
Epantaic al nese ueille pais.
Mist li la piere pues adit el teshs.
Qruoie bié cror de cors uernis.
Chis delignaic al raiât Golias.
Con ast daint de son sant actolais.
De sol troi pieres el plains de chalois.
Le cors im dist qe tu nô estor dirais.
Caton ancestre hoi copaigne ferais.
Or te demore que nô leuastu mais.
Quât en sant font baticer nefls.

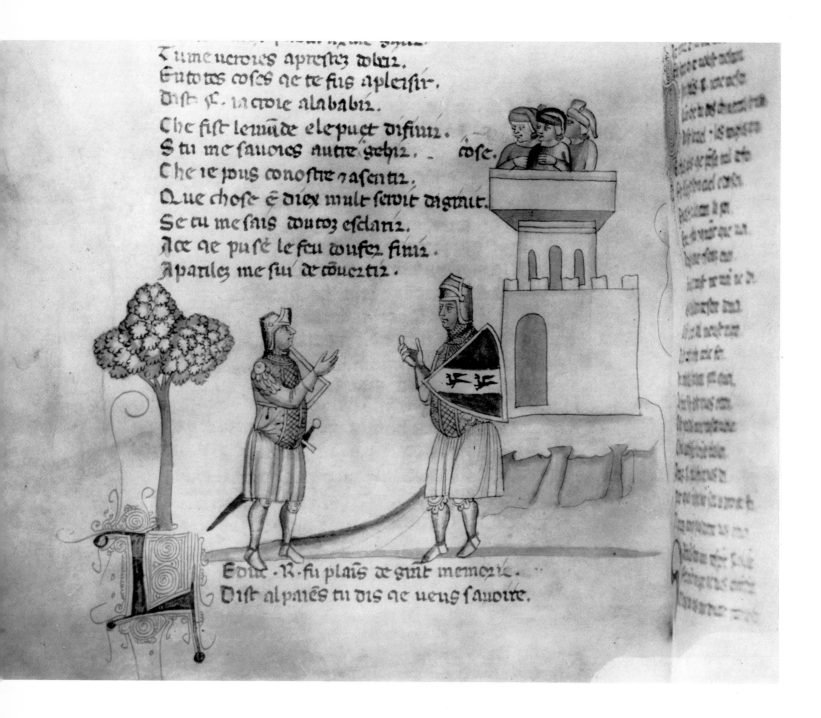

245. Charlemagne, Roland and other peers looking at
 Ferragut's corpse.
Ink and wash. *Ibid.*, fo. 80 ro.

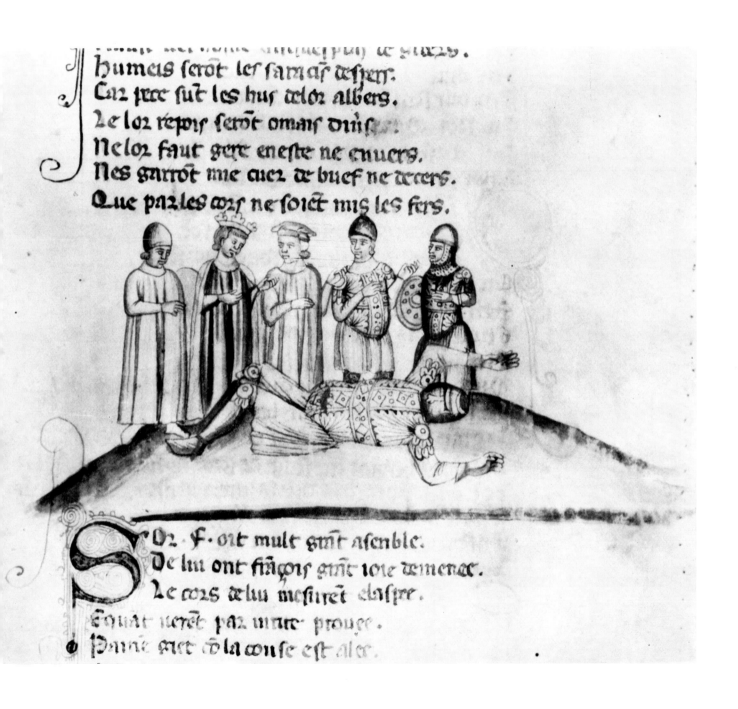

Dela uille sunt et unt gerpi truigant.
Bien seuent le chamin de age en oziant.
Accschus fist doner li duc bon auserant.
Lui eli xii pere un poi fist parlemant.
Les vui enamenes edist a u remanant.
Hon uos seurcs val roy ne da nul sol romano.
Del remanour furent nos baron molt dolant.
Le nies R moтa sor un fauel amblant.
Endestre feit mener uailantis ebruant.
Oliuer et hestos maиterei ereemant.
Gerard de rosigno etrepy luaillant.
La ensagne aufil milon ert un cofano grand.
Aquarter dor batus edun agur seeblant.
Desor ioit une bande roge cu feu ardant.
Quatre crosses ioit esmere tot dargant.
Cil signor les codue qe sor cros fu pendant.
Eli baron san iaches por qi sut trauahant.
e na grant fernt li mes li enperedor.
Les soudoier de rome seguirent lor signor.
E furet bien der mil uasal de gran ualor.
Alensir dela uille ni oit bosine ni tambor.
Deuant cheuaucheret les couers oductor.

246. Roland leaving Nájera
to take up position
before Pamplona.

Miniature. *L'Entrée d'Espagne*,
Venice, Biblioteca Marciana. Cod.
fr. XXI, fo. 88 ro.

247. An engine of war
outside Pamplona.

Miniature. *Ibid.*, fo. 140 vo.

ndementez the dureza lestoz.
et tru le feu au castel tor entoz.
munten at quat ueues lesplendoz.
oz nec uos nez auoie et abauioz.
ut uaugeuis tu a les mon amoz.
on o seil ezt ci ie nel domant miloz.
Stiue mant ch il ne atent ra plu.
A seit liroi auiez les mestreu.
Oe uez belui suit les ardneze ensu.
cest un pou ch n si apelez sn.
ich troi milez che dames sur tor nu.
estoz portent les arth dia o boz tenuu.
egriez furent tost suit amal comu.
et les françois getet si grat les loi.
lx le plus fier en su tott esperdu.
este de bel beu uais quat sesb ascu.
eles bouues aien cotre est uenu.
lbais furer eal sut au tesu.
cauent ebresent mout les unt colattu.
au nos françois nes cotet un festu.
oz de ce uaue che ne fusent feru.
e chen duoie ligranz castel nolsu.
en uent si quanq li gelt onez meut.
lui unt de murteuma no ur brtru.

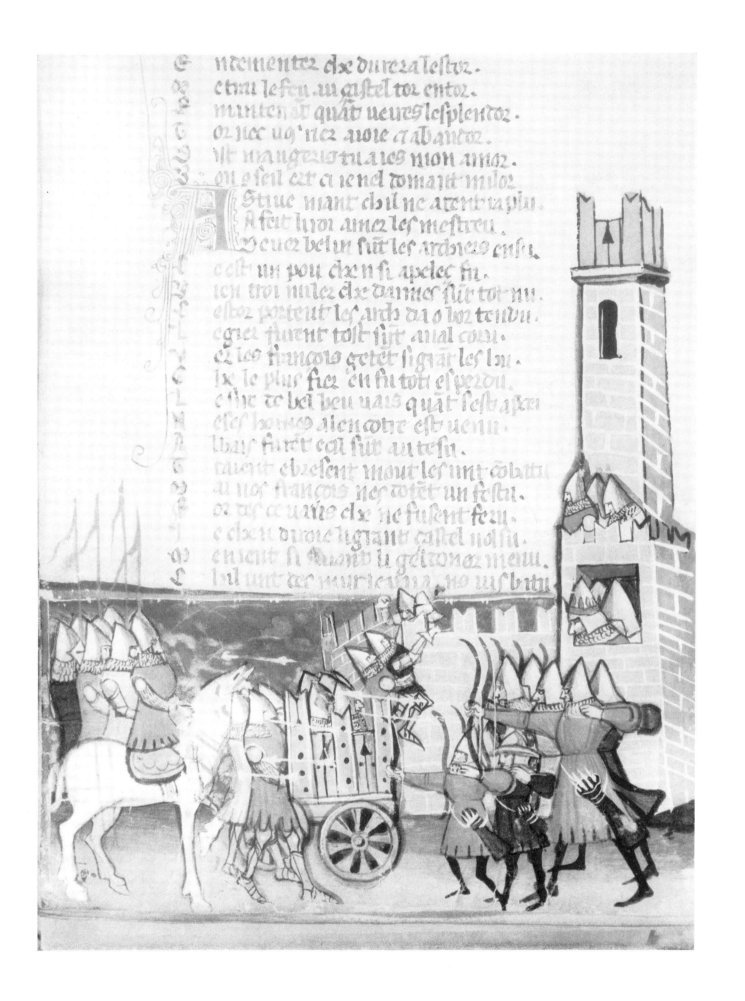

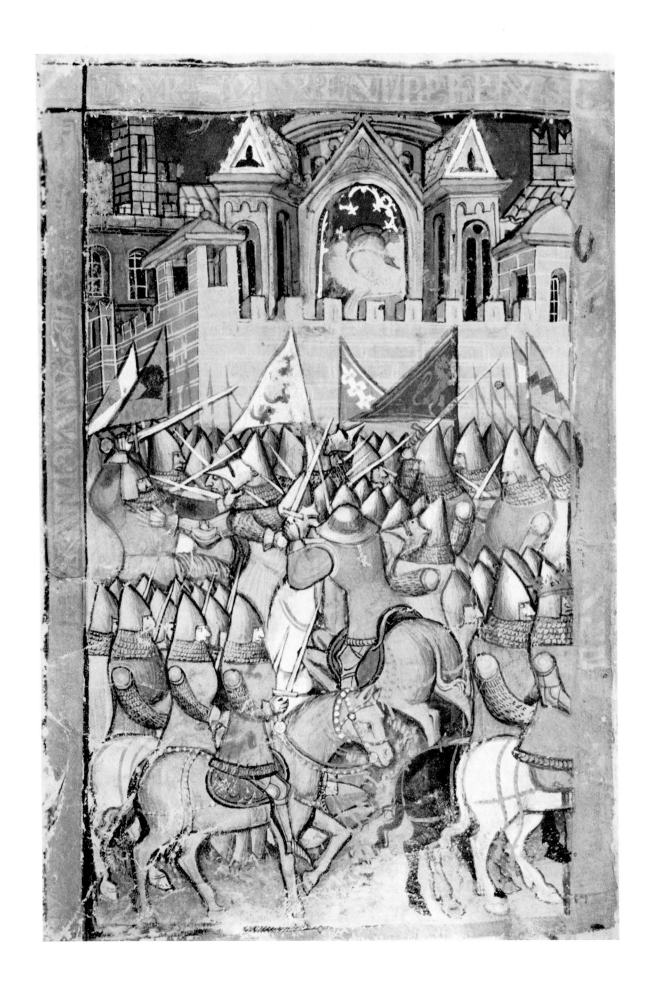

248-249. Siege of Pamplona.
Miniatures. *L'Entrée d'Espagne*.
Venice, Biblioteca Marciana, cod.
fr. XXI, fos. 161 vo.-162 ro.

250. Roland blowing his horn on the morning of battle.
Miniature. *L'Entrée d'Espagne.* Venice, Biblioteca Marciana, cod. fr. XXI, fo. 145 ro.

251. Battle scene during the siege of Noble.
Miniature. *Ibid.,* fo. 176 ro.

Unknown to Charlemagne, Roland slipped away from the siege of Pamplona and captured another city, Noble. This escapade earned him a buffet in the face from Charlemagne.

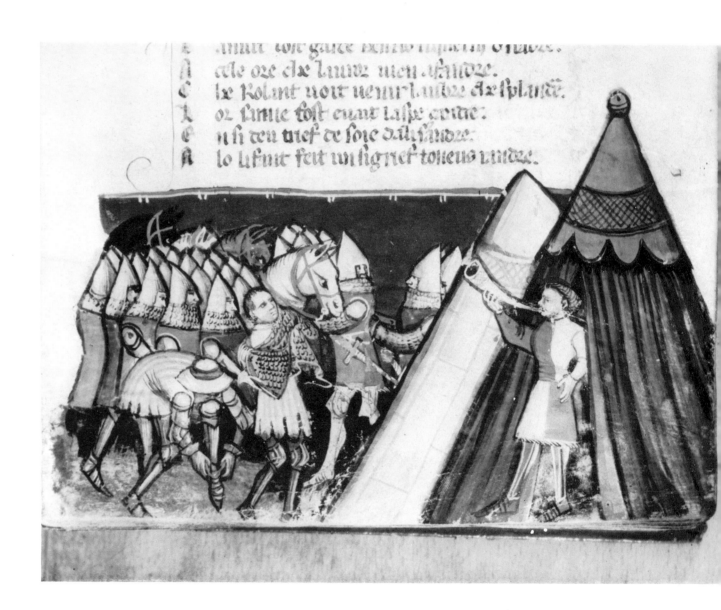

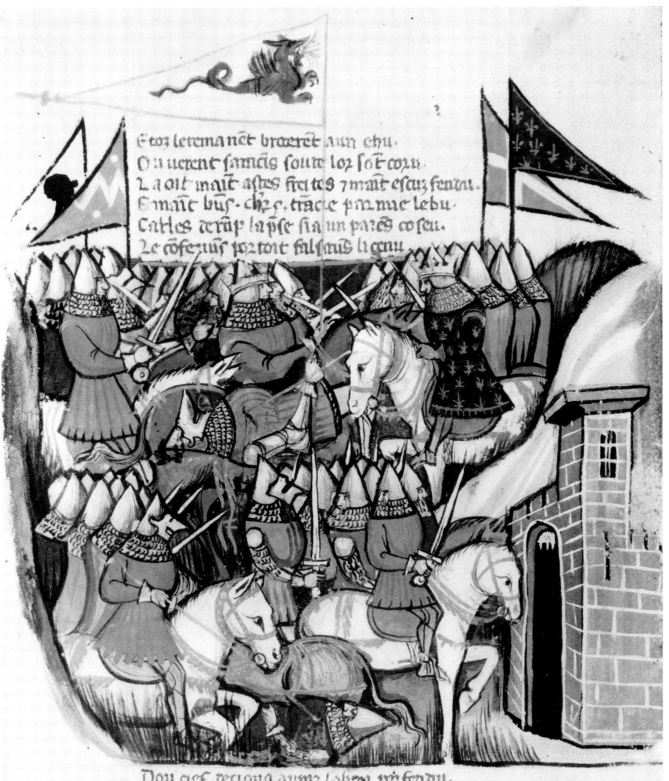

Et tor lerema nent braerent aun chu.
Ou uerent sarucis soute lor sot coru.
La oit mait aftes frei tes 7 mait escuz fentu.
Emait buf. chr. q. tracie par nue lebu
Calles derup la pse sia un pares coseu.
Le coferuns portoit falsarus li cenu.

Doy cief recigna aupir laliroi por fendu.

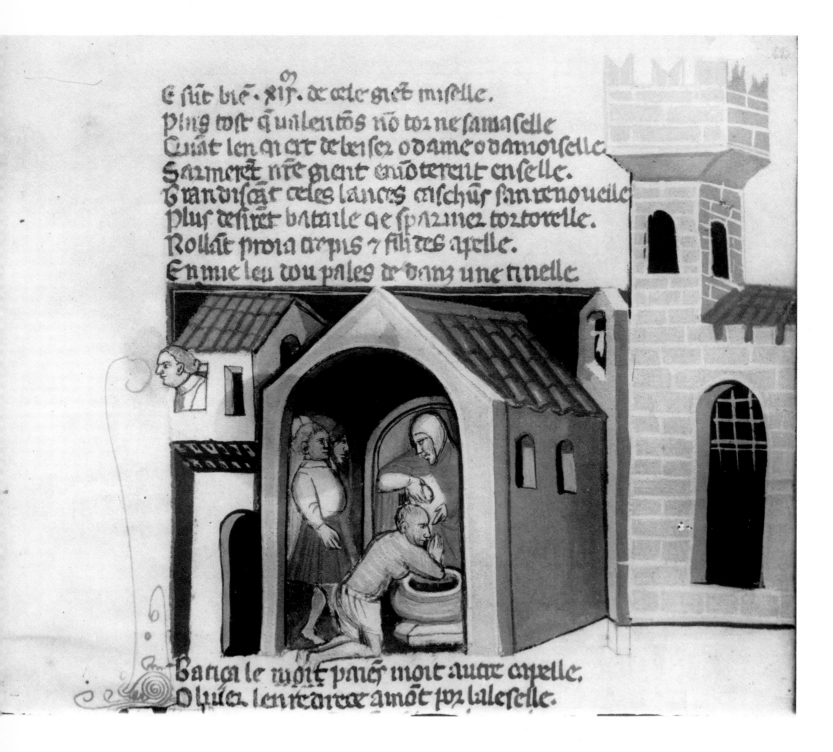

E sut bie · xij · de cele gieê miselle.
Plus tost que nalentos nõ tor ne sama selle
Cuiat len qi ert de briser o dame o damoiselle.
Saumerêt nre gient eñõterent enselle.
Gran discêt celes lances eñschuf san renouelle
Plus desirêt bataile qe sparmez tor torelle.
Rollãt proia crepus 7 siliues crelle.
En mie leu tou pales dr danz une tinelle.

Baticã le rupit pater mort autor crelle.
O luca len redirrar amõt por la le felle.

252. Roland in a tower at Noble.
Miniature. *L'Entrée d'Espagne.* Venice Biblioteca Mar-
ciana, cod. fr. XXI, fo. 204 ro.

253-254. Roland killing two heathen warriors at the
 siege of Noble.
Miniature. *Ibid.,* fo. 209 vo.

Mon seignor ricarts sera qu barbarin.
Sor entrerent nole uiage ne me pris un teulin.
Lors se mist en lestor pres lui agui train.
Ne sen partira sens mortel disiplin.
Li qui es tient durendart uelt ferir un pain.

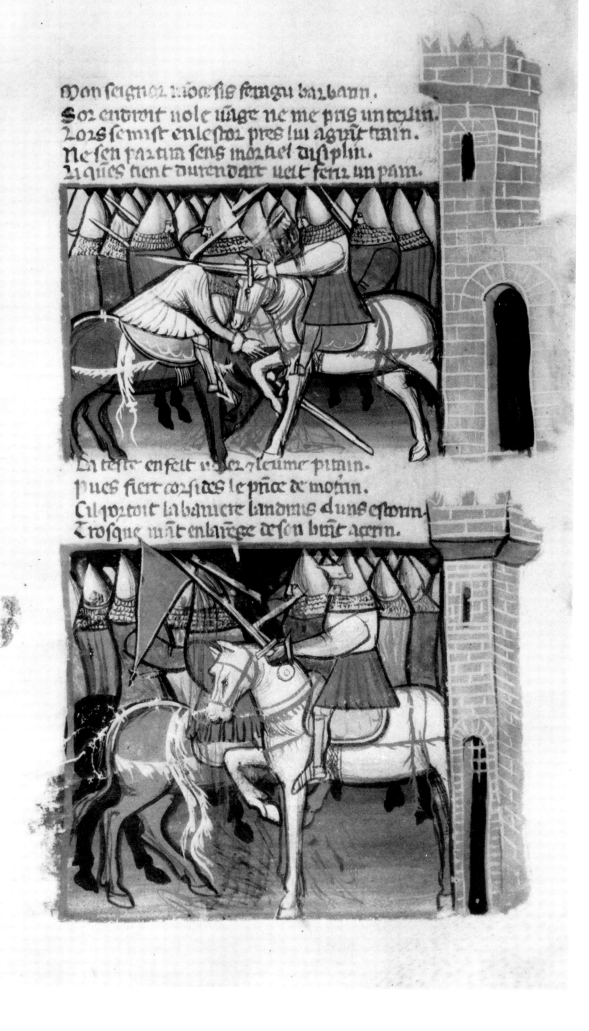

La teste en feit uoler greume pitain.
Pues fiert corsides le prince de morin.
Cil portoit la baniere landrus duns estorin.
Trosque mat en lairege deson brui acrin.

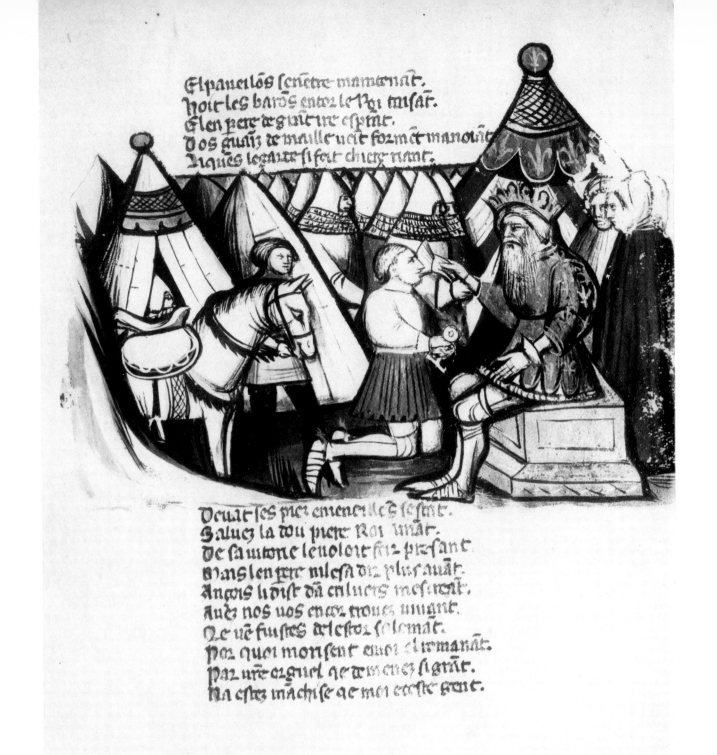

255. Charlemagne striking Roland in the face.

Miniature. *L'Entrée d'Espagne*. Venice, Biblioteca Marciana, cod. fr. XXI, fo. 216 ro.

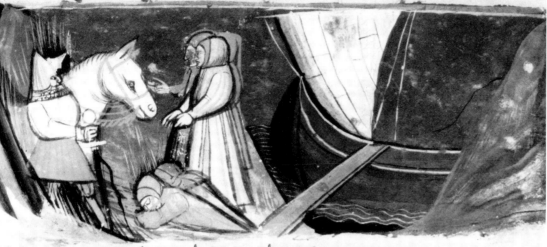

Elong enlaguife dourcigne und il fiince.
P. le uoit le ius loz atozhee.
Aine ge fuffent li paiens aprofinee.
Eft le ftozmant deuant lui genoilee.
Enfon legnie dift cin ennore.

vertues home la duune bontee.
De tous dyables mais chaii deliuree.
Ois mandient cils glotons menacee.
Donar poz qoi neul uoie ameniee.
Enloz pais cia auoient uiuee.

Li cozs liniee mozt labat auteran.
Epues recoure efiert le primeran.
Si poz le pis ge mozt labat deplan.

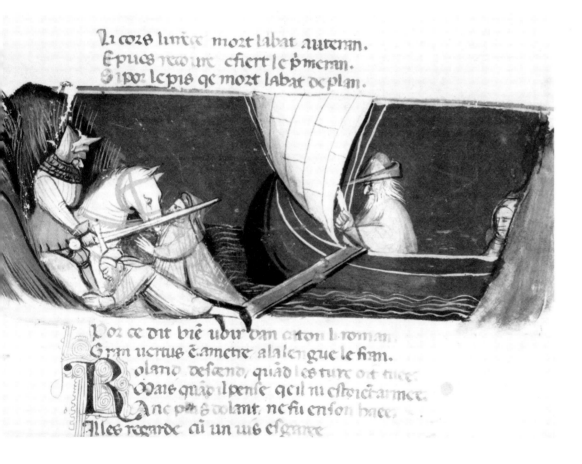

Poz ce dit bie udur dan aiton li roman.
Grm uertus tamene alalengue le fini.
Roland defeend, quad les turc ot tuee.
Mais quad il penfe qeil ni eftoich armee.
Ane pas uolant ne fu enfon bace.
Illes regarde ai un ius efgaree.

256-257. Roland arriving at the shore.
Miniatures. *Ibid.*, fo. 225 vo. - 226 ro.

Outraged by Charlemagne's insult, Roland left the
Frankish camp in search of adventure in distant East-
ern lands. On his return he joyfully greeted Charle-
magne, Oliver and the other peers, who were still
fighting in Spain.

els chols tronne Rollant acele in traille
aume nichoife m valt une toaille.
acies ce trence a lachoife cefmaille

plus dune prume trefplaife lauentaille.
ozt letrebuce dauant lui tint q paille.
Ozt est leturch poz fa definefurance.
e c fenefie que cefchuns fait infane.
Que otre ozoit motre ozgoil nebubace.
rant ace fait lenies amoi cefiance.
on par ozgoil mais poz fenefiance.
oubzant fue foz lepain letiance.
moi fan torne que noit giat aleace.
il chors cefchuns ce giant pufance.
uont mchuntre chun mlt giat reuerace.
oue labelle plus ncnfoille que rince.
bun plus ce treuite puncele ce iouance.
ezunt lapreife uers lebazons furance

258-259. Roland defeating his
adversary in the
presence of the Sultan
of Persia and his
daughter. The whole
court congratulating
him.

Miniatures. *L'Entrée d'Espagne*. Ve-
nice, Biblioteca Marciana, cod. fr. XXI,
fo. 254 ro.

e fils des gentils home ⁊te plus ners per.
i fut des ioin in ioin perters ⁊barder.

t manuier insamble ⁊despandre moner.
bunn plus en treus abite mes lipoit anuier.
t non anore mie alin sonent aller.
u chambre alle roine ⁊asa fille perler.
t mostrers ses paroles ausi cun perdnorer.
ouant fut laponcele por amor suspirer.
t perorees les paroles ⁊le color muer.
n le cief douterer mois dor pausant puitouer.
ue sut alles les afaire malqdant espier.
etorneerent ameeh auroi soudar noncier.
ue ses neuus mortels fisoient iuorer.
etotes part lor home lor fut soudar uiter.
ntenant por rolant que au uegne pler.
Rolant ⁊li barons que plus sage furent.
A uroi uont cunsiler que lor adit coment

260-261. Roland teaching the
 Sultan of Persia's son
 to tilt at the quintain.
 He becomes the
 Sultan's adviser.
Miniatures. *Ibid.*, fo. 265 vo.

A ſes tent le peça ſin iſi une falor.
t eſt qe dela mezuoille il ſe garda dentor.
A l angle eſanſon eu a uortes pluſor.
E li dit douſe nuit meine mō ſegnor.
D e le plus noble frutu qe lentrouiſt ancor.
V ore mat tel fu cil qe le noſtre anceſor.
M eina por ꝗſeil de li chatiue auſor.
N en ſomes aucus qe le miagie paſtor.
E u paradis tereſtre nos amenes cift ior.
S eie meæ æus por teu le creator.
I a mais ne partirons car il ſeroit follor.

S Anſon le fil ſoldan prent la pome eu mant.
T oſt qil euoit goſte ſi dit bien maꝛtit.
Q e li plus noble coſe nō uit home uiuat.
B ien uaut un tiel pomez tot le regne pſant.
I len paruit goſter mais iteneant.

Q Vant furet ſaules li dui aloꝛ talit.
S egnor ce dit langle tormes ſeguiremit.
E ꝑ ie ſeria li garde eanoimie nueb guiat.
L eueres agrictet tioſqué laube parint.
I l li reſpōdirēt tot aueſtre comant.
A ſ deuaus tonēt loire li tous aigue coꝛit.
P ues li choeba æſcū for ſun eſcu peſint.
L e angle leſſigna por un tel couenit.

En contre liestoit uenus, lenief alduc bernart.
Por dauit sen genoille, alduc alcors gaillart.
Le cuer oit si tendr, che de parller fu tart.
Ues celui le rebrace, che noit port d'resgart.
Or le cosel d'naume, le loi dus.
Estoit le rois, sor palafroi crenus.
Seli auere, les altres est corus.
Seguirent lui legrat clar menus.
Ke por ledit ramere furet tisut emus.
Lenief li. auoit p'mer ueus.
Deles lafontaine de sor lelber folus.
Onc nul nus, che no fust reuestus.
E coplie ioie merciat liut uhs.
Sa dolz mer, che porta le loi fius.
Done tot, ti de grace esallus.
Poront ueoir lon sor crenus.
E soit son spoir, quisse ecler lus.
Quad. Ro. esgarde, p'me le pre erbus.
Ausi Rainer che ca estoit desendus.
El bo destrer, eduilt luy destendus.
E saluer, oit le cors si in clus.
Ke apoine puet dir, bie soies uos uenus.
Rolant le ques, en tre braf lont piedus.

Doumat la colle, unot le drece sus.

263. Roland and Oliver meet again.
Miniature. *Ibid.*, fo. 296 vo. - 297 ro.

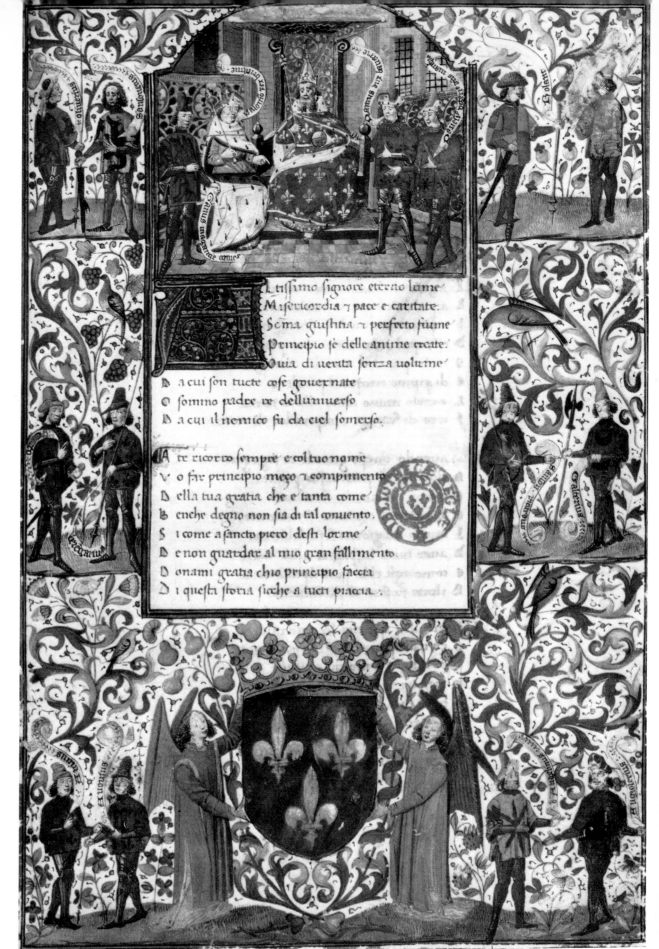

264. Charlemagne's court and the twelve peers.

Miniature. *La Spagna.* Paris, Bibliothèque Nationale, ms. Ital. 567, fo. 72. Second half of 14th century.

265. Charlemagne and Roland riding to Spain.

Miniature. *Pseudo-Turpin.* Paris, Bibliotèque de l'Arsenal, ms. 3516, fo. 281 ro. Second half of 13th century.

266. Charlemagne and Roland taking a Saracen city in Spain.

Historiated initial. *Pseudo-Turpin.* Paris, Bibliothèque de l'Arsenal, ms. 5201 Réserve, fo. 189 ro. Second half of 13th century.

267. Roland trying to break his sword. Roland blowing his horn.

Historiated initial. *Ibid.,* fo. 215 ro.

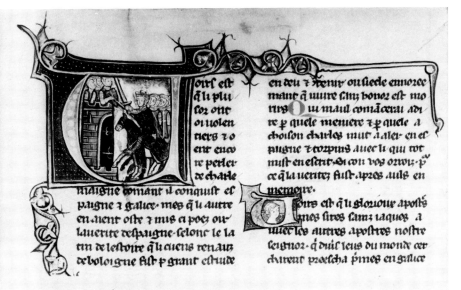

There were a number of French translations of the Latin chronicle attributed to Archbishop Turpin. Several of the manuscripts of these versions are illustrated.

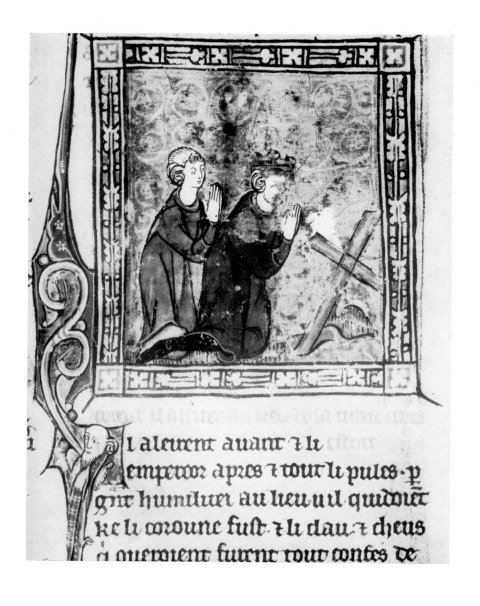

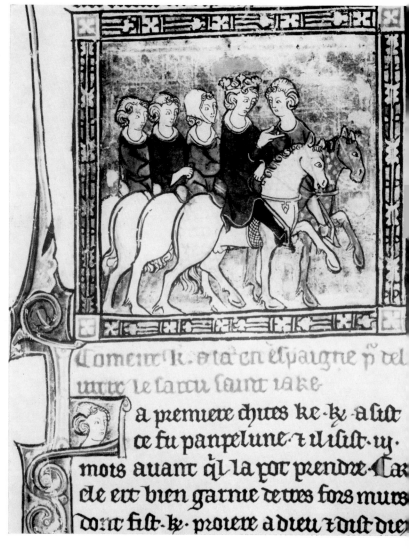

l alerent auant 7 li
emperor apres 7 tout li pules · p
gnt humilier au lieu u il quidoiēt
ke li coroune fust · 7 li clau · 7 cheus
q oueroient fuient tout confes de

a premiere cites ke k · a sist
ce fu panpelune · 7 il i sist · iij ·
mois auant q̃l la pot prendre · car
ele ert bien garnie de tres fors murs
dont fist · k · proiere a dieu 7 dist dieu

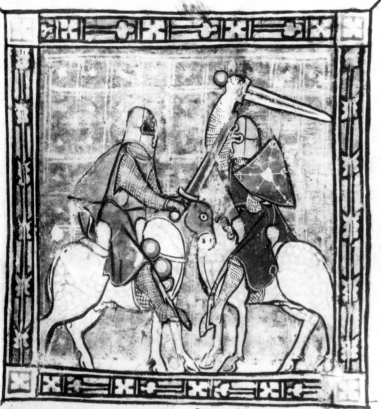

touua el cors touue fors lentfeuduie.
Adont comencha li paiens a apeleir
son dieu maho et dist socor moi ie me
muir. Enteil maniere fu li paiens o

268. Charlemagne and Roland worshipping the True
 Cross in Jerusalem.

Miniature. *Pseudo-Turpin*. Florence, Biblioteca Lauren-
ziana, ms. Ashburnham 52, fo. 121 vo. Early 14th century.

269. Charlemagne and Roland riding towards Spain.

Miniature. *Ibid.*, fo. 122 vo.

270. Roland fighting with Ferragut.

Miniature. *Ibid.*, fo. 129 vo.

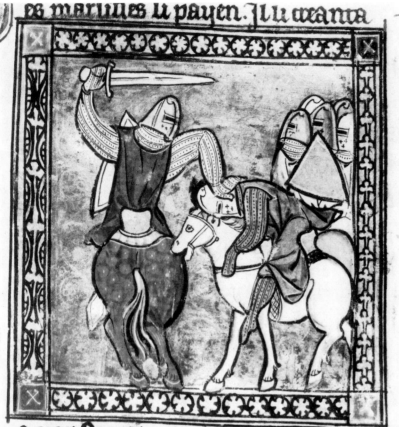

os marulles li payen. Ili oranta

amonstreir. z il a la auoec le payen
z il li monstra le payen marsile.

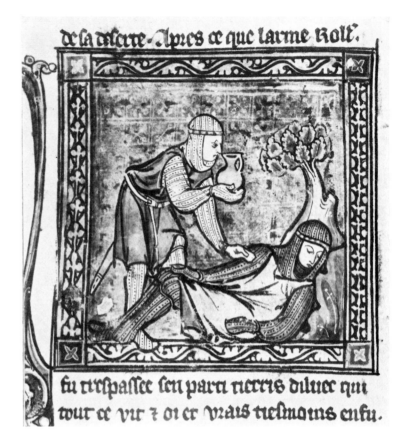

de la oelerte. Apres ce que larme Roll.

su trrspassee seu parti rierris diluer qui
tour ce vir z oi er vrais tesmoins eusu.

271. Roland cutting off Marsile's arm.
Miniature. *Pseudo-Turpin.* Florence, Biblioteca
Laurenziana, ms. Ashburnham 52, fo. 131 ro.

272. Baudouin bringing a drink to the dying Roland.
Miniature. *Ibid.,* fo. 132 vo.

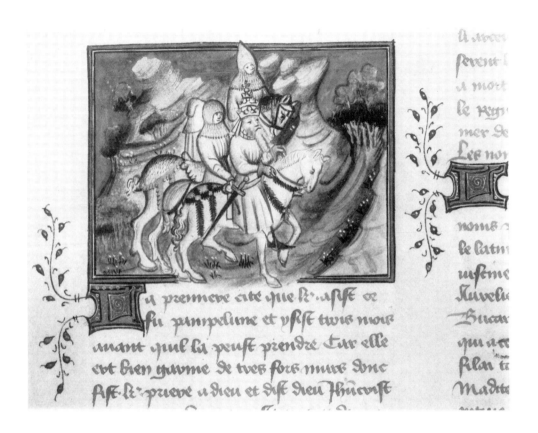

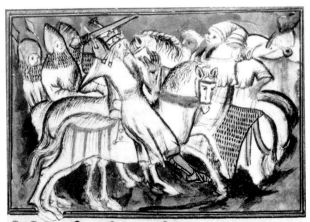

273. Charlemagne and Roland riding towards Spain.
Miniature. *Pseudo-Turpin.* Paris, Bibliothèque Nationale, f. fr. 573, fo. 148 vo. 15th century.

274-275. Roland fighting with Ferragut.
Miniatures. *Ibid.,* fo. 154 ro. - 155 vo.

276. Roland killing Marsile.
Miniature. *Ibid.,* fo. 157 vo.

277. Charlemagne killing Baligant.
Miniature. *Ibid.,* fo. 159 vo.

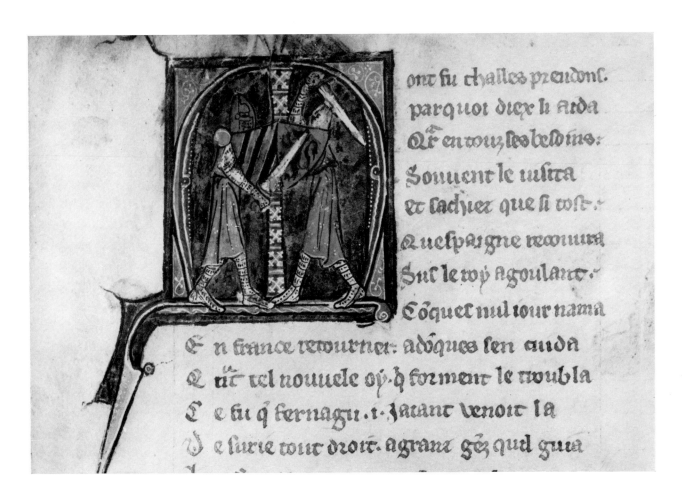

ont fu challes prendonc.
parquoi dier li Arda
Qr en tour, les besoins:
Souuent le uistra
et sachiez que si tost.
Quespargne recouura
Sur le roy Agoulante.
Conquec nul iour nama
En france retourner: adonques sen auda
Qui tel nouuele ot. q forment le troubla
Ce fu q fernagu .i. Jaiant venoit la
De furie tout droit. agrant gês qui gua

278. St. Roland and St. Oliver, guardians of the road
 to Santiago de Compostela.
Ink and wash. *Pseudo-Turpin.* Paris, Bibliothèque Natio-
nale, f.fr. 4991, fo. 8 vo. Late 15th century.

279. Roland fighting with Ferragut.
Historiated initial. *Charlemagne* by Girart d'Amiens. Paris,
Bibliothèque Nationale, ms. 778, fo. 143 vo. First quarter
of 14th century.

280. Charlemagne, Roland and his barons watching the
engulfing of the heathen city of Luiserne.

Miniature. *Les Grandes Chroniques de France.* London,
British Museum, Royal 16 G VI, fo. 166 ro. Second quarter
of 14th century.

The Grandes Chroniques de France, *annals of the
French monarchy, take their chapters on Charlemagne
from the Pseudo-Turpin.*

fin et efmeir faite en forme ome. En la
deftre main tient une clef. la face tornee de
uers miedi. Si ont forti les fauralms que
relle clef li doit choor. de la mam en tele an
nee que uns rois de france fera nez en fran

la ate daxa et la ate de fait jehan de forges:
feur le chemin as pelerms. Et la. v. aufii de
famt jaque en la ate de paris: entre le flun
de fame et mont martre. Et eglifes 7 abaies
q̃ il eftora et foda fanz nōbre parmi le monde.

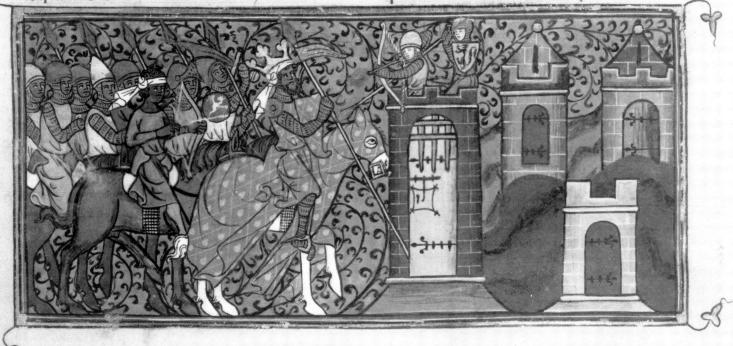

281. Roland defending a city against Agolant.
Miniature. *Ibid.*, fo. 167 ro.

loiaument scront combatuz contre les pr
dnez. Et aussi comme les dis kalin.
moururent en bataille: aussi deuons nous
mourir quaut as uiccs: et uiure ou mon
de en saintes uertuz. si que nous puissōs

des trauaus que il ait contre agoulant.
Comeut agoulant sen tour. Comeue klin.
retourna en france pour rassembler ses oz.
Et puis parole des nons des haus hommes
que il mena auecques li en celle uoie.

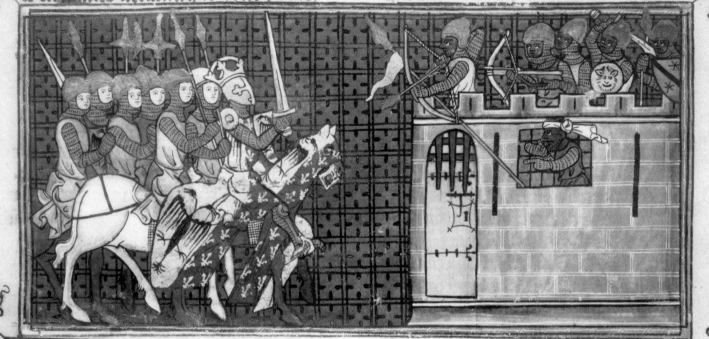

Et tant de temps comme klin.
demoura en france pour ses oz
assembler: Agoulaut se pour
chaca de toutes pars et assem
bla merueilleusement grant oz de diuer
ses nations morsmoabithiens. ethio
piens. sarrans. thurs. affricans. et per
sans. et tant de rois et de princes sarra

bille. et lamiracour de cordres. Ainsi uint
agoulant a tout ses oz iusques a une cite
de gascoigne qui a non aggenu et par force
la prist. Lors manda Agoulant a klin. que
il ueuist a lui paisiblement a petite compa
gnie de clis. en promettant que il li donroit
oz et argent. et lx. chenaus charchiez dau
tres richeces se il uouloit tant seulement

282. The city of Agen besieged by Charlemagne,
 Roland, Oliver and other nobles.

Miniature. *Les Grandes Chroniques de France.* London,
British Museum, Royal 16 G VI, fo. 168 vo.

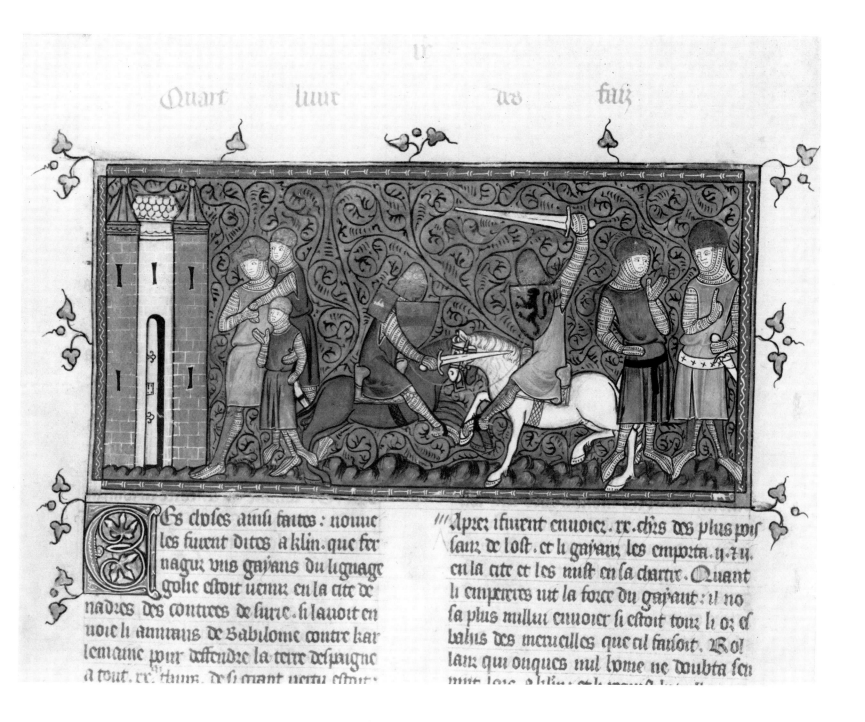

Es choses ainsi faites : nouue les furent dites a klin. que fer nagu, uns gaians du lignage golie estoit uenur en la cite de nadres des contrees de sure. si lauoit en noie li amirans de babilome contre kar lemaine pour deffendre la terre despaigne a tout. xx. thuiz. de si grant uertu estoit :

Apres isurent enuoiez. xx. chrs des plus pois sauz de lost. et li gaianz les emporta. ij. et ij. en la cite et les mist en sa chartre. Quant li empereres uit la force du gaiaut : il no sa plus nullui enuoier si estoit touz li or. et baliuz des meruailles que al faisoit. Rol lanz qui onques nul home ne doubta sen uint lors a klin. et li proia kar il

283. Roland and Ferragut fighting on horseback.
 They begin a disputation.
Miniature. Ibid., fo. 172 vo.

comenca à lui pour tenir la loi xpiane.
Comment li gaaneur le geta soiz lui. mes
il sen leua tost à laide de dieu. Et coment la
citez fu prise quant li raianz fu occis.

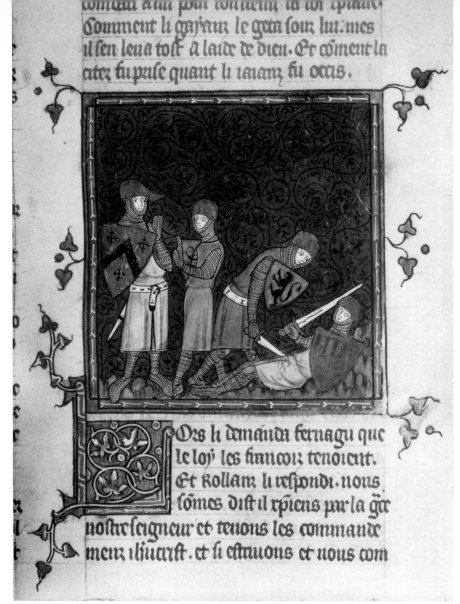

Ors li demanda fernagu que
le loy les francoiz tenoient.
Et Rollam li respondi. nous
sômes dist il xpiens par la grace
nostre seigneur et tenons les commande
menz ihucrist. et si estmions et nous com

rois toute, se combatit à eus. et tenta out
la gent furent occis. et puis de ceulz qui
mourrent sans bataille.

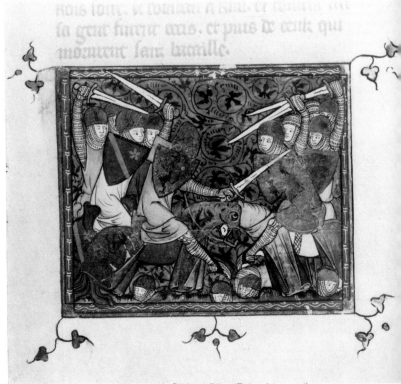

men̄t de barons. Comment il rendi graces
au benoit martyr saint denys. et li dona
et laissa en garde toute france en la presen
ce des barons. Et puis comment il sen ala

sen ala il aussi comme tout espouente: par
les miracles quil uit. Ci commence le pre
mier chapitre du .v. liure. dela bataille de
ronceuaus. et de la mort rollant.

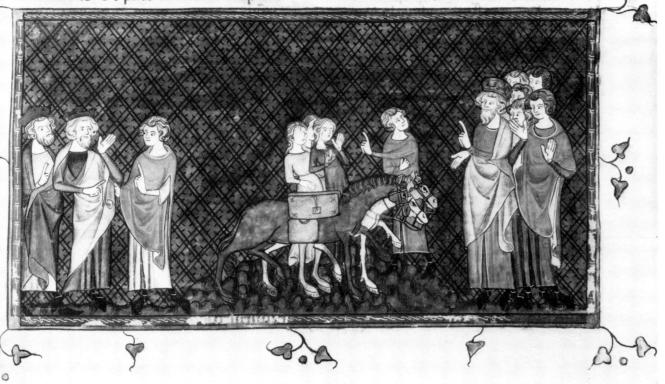

284 286

285

284. Roland continues his disputation with Ferragut,
then kills him.

Miniature. *Les Grandes Chroniques de France.* London,
British Museum, Royal 16 G IV, fo. 173 ro.

285. Roland fighting the heathen in Spain.

Miniature. *Ibid.,* fo. 171 ro.

286. Ganelon plotting treason with the two kings of
Saragossa and bringing Charlemagne the fatal
gifts.

Miniature. *Ibid.,* fo. 175 vo.

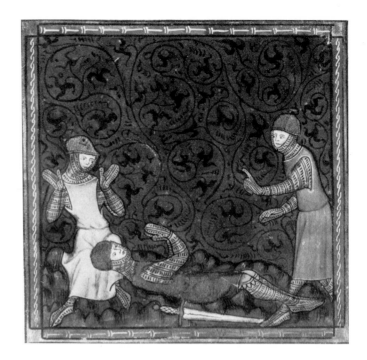

287. The death of Roland, with Baudouin and Tierry at his side.

Miniature. *Les Grandes Chroniques de France.* London, British Museum Royal 16 G IV, fo. 179 ro.

288. Tierry bearing witness of Roland's death while Turpin recounts his vision of the battle of Roncevaux to Charlemagne and his barons. Charlemagne finding Roland's body.

Miniature. *Ibid.,* fo. 180 vo.

289. Charlemagne mourning by Roland's bier. Punishment of Ganelon.

Miniature. *Ibid.,* fo. 181 vo.

287 289

288 290

290. Roland's body is laid to rest in the church of Saint-Romain at Blaye, while Charlemagne mourns him and the other heroes, also brought back to Blaye.

Miniature. *Ibid.,* fo. 182 vo.

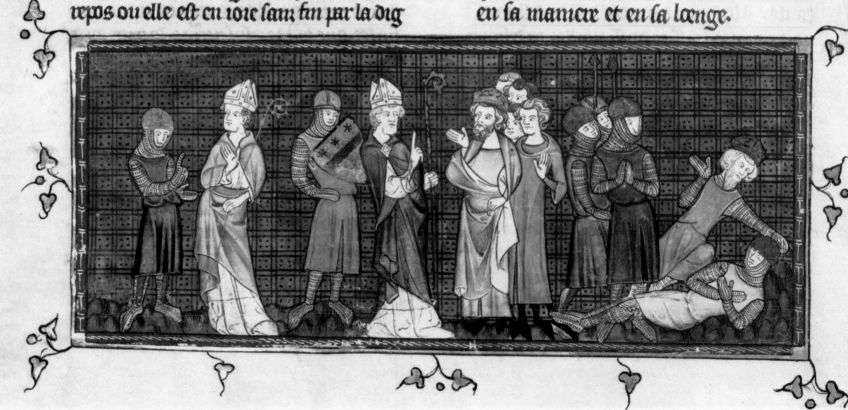

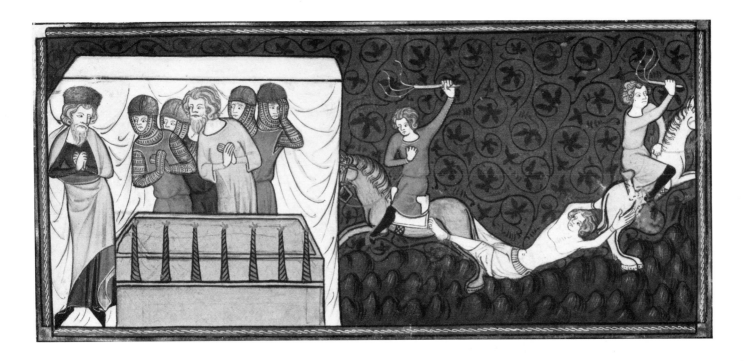

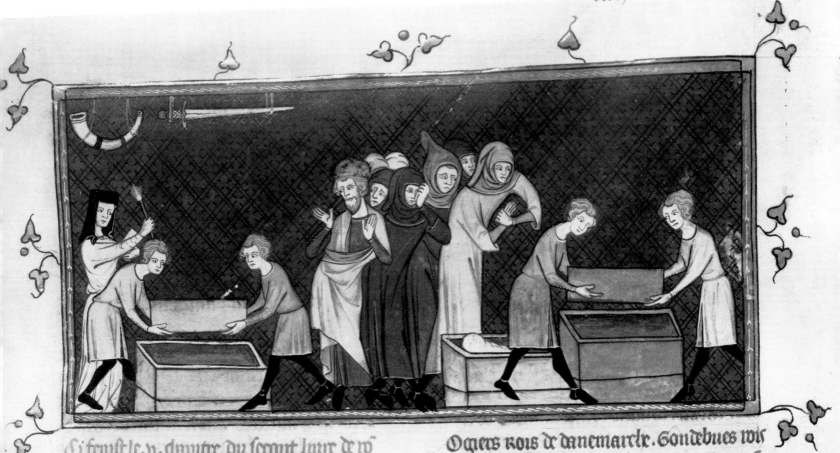

291. Roland killing Ferragut.

Miniature. *Les Grandes Chroniques de France.* Paris, Bibliothèque Nationale, f. fr. 2813, fo. 118 ro. Between 1375 and 1379.

292 A. Charlemagne receiving the fatal gifts which the kings of Saragossa sent by Ganelon.

B. Roland striking Marsile at the battle of Roncevaux.

Miniatures. *Ibid.,* fo. 121 ro.

293. Death of Roland (haloed).

Miniature. *Ibid.,* fo. 122 vo., col. 2.

294. Turpin's vision of the death of Marsile.

Miniature. *Ibid.,* fo. 123 vo., col. 1.

295 A. Charlemagne killing Baligant.

B. Ganelon's punishment.

Miniatures. *Ibid.,* fo. 124 ro.

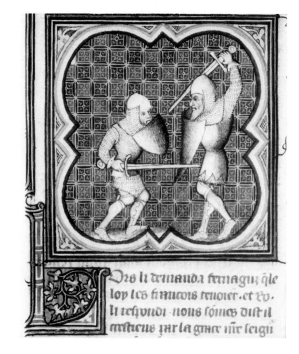

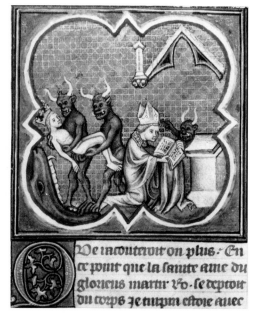

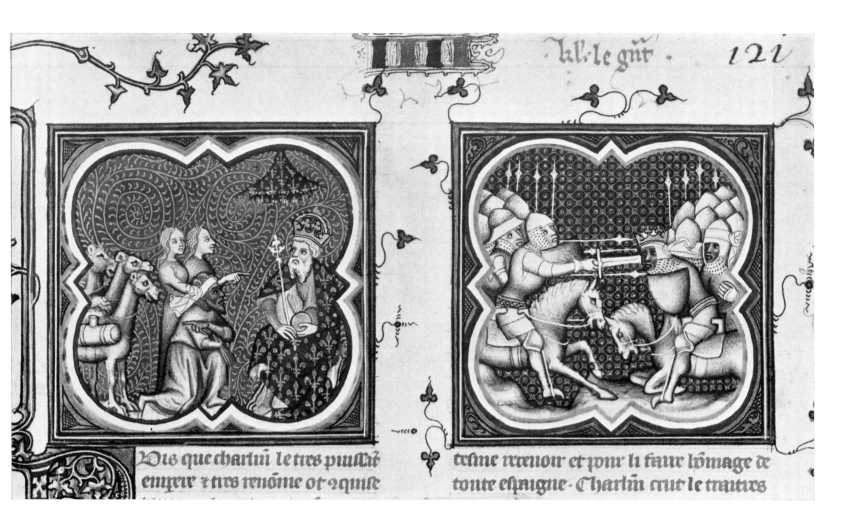

Dis que charlñi le tres puissãt
empere z tres renõme ot aquise

tesme recenoir et pour li faire hõmage de
toute espaigne · Charlñi crut le traitres

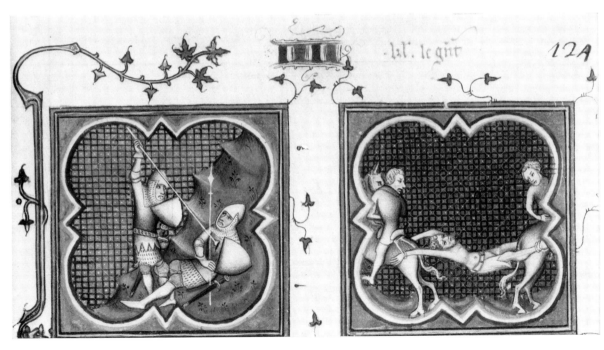

296. St. James appearing to Charlemagne. Capture of
Pamplona.

Miniature. *Les Grandes Chroniques de France.* Paris, Bi-
bliothèque Nationale, f. fr. 6465, fo. 104 vo., col. 2. About
1460.

297. Battle of Roncevaux.

Miniature. *Les Grandes Chroniques de France.* Brussels,
Bibliothèque Royale, ms. 2, fo. 118 ro. 14th century.

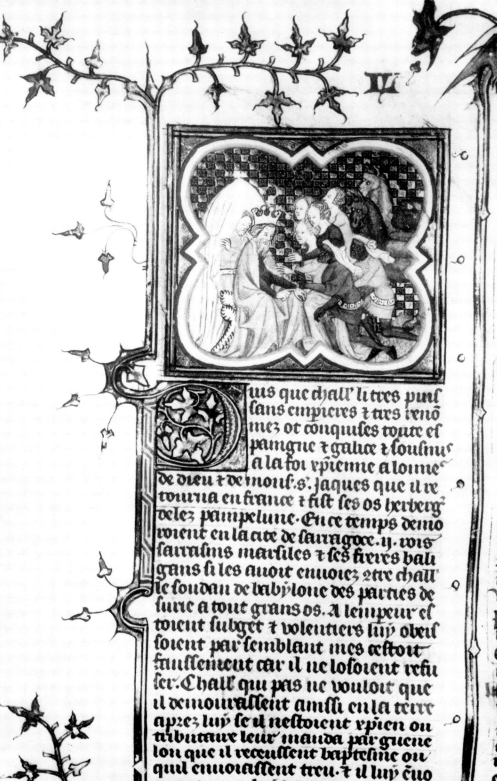

us que cħall' li tres puiſ
ſans empieres z tus rⁱenõ
mez ot conquiſes toute eſ
paingne z galice z touſiuſ
a la foi xpⁱenne a loñe
de dieu z de monſ. s'. iaques que il re
tourña en france z fiſt ſes os herberg⁊
velez pampelune. En ce temps demo
roient en la cite de ſarragoce. ij. rois
ſarraſins marſiles z ſes fⁱeres bali
grans ſi les auoit enuoiez z tre cħall'
le ſoudan de bꝟbⁱloñe des parties de
ſurie a tout grans os. A lempeur eſ
toient ſubget z volentiers luȳ obeiſ
ſoient par ſemblant mes ceſtoit
fauſſement cꝛr il ne loſoient refu
ſer. Cħall' qui pꝛs ne vouloit que
il demourꝛſſent ainſi en la terre
apꝛez luȳ ſe il neſtoient xpⁱen ou
tⁱbutaire leur mꝛnda pꝛr guerre
lon que il receuſſent bapteſme ou
quil enuoiꝛſſent treu. z il luȳ ẽuo
ierent pour luȳ deceuoir xxx cħeuau

retourña a
rⁱcħeſſes qⁱ
ient z diſt q
eſtre xpⁱẽ
pour veñuⁱ
teſme receu
mage de toⁱ
rut le traït
leur z ordeñ
les pors de a
france. Par
da a ꝟoulꝛ
z cote de blꝛ
paⁱngñon
tres combꝛⁱ
raſſent en
francois po
uſques ꝛ tⁱ
les pors de
plus grꝛñt
le vin tant
ſin auoient
niz peuple
pourre que
ient eſtre pu
vin ſarraſⁱ
pecħie es ſaⁱ
mes xpⁱem
auoient aⁱ
nie ſires qu
faille lentⁱ
les pꝛeſens
uoient eſtoit
uoient les
mes que il
en yureſe z

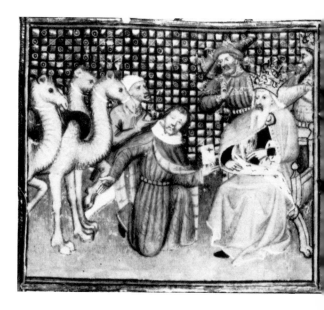

298. The fatal gifts of the kings of
Saragossa to Charlemagne.

Miniature. *Les Grandes Chroniques de France.*
Lyons, Bibliothèque Municipale, ms. 880, fo.
130 vo. 14th century.

299. Ganelon returning with the fatal
gifts of the hings of Saragossa.

Miniature. *Les Grandes Chroniques de France.*
Berlin, Staatsbibliothek, Phillipps 1917, fo. 142
vo., col. 2. About 1410.

300. Ferragut arriving by sea.

Woodcut. *Les Grandes Chroniques de France*. Paris, Vérard, 1493. Bibliothèque Nationale, Réserve L 35/7, vol. 1, fo. 141 vo.

301. Ferragut arriving by sea.

Painted woodcut. Same edition as fig. 300. London, British Museum, Vellum C 22 f.

302. Ferragut arriving by sea.

Miniature. Same edition. Paris, Bibliothèque Nationale, Réserve Vélin 728.

303. Roland fighting with Ferragut.

Miniature. Same edition. Paris, Bibliothèque Nationale, Réserve Vélin 725, fo. 141 vo.

304. Roland killing Ferragut.

Woodcut. *Les Grandes Chroniques de France*. Same edition as preceding plates. Paris, Bibliothèque Nationale, Réserve L 35/7, vol. 1, fo. 142 ro.

305. Disputation between Roland and Ferragut.

Miniature painted over woodcut. Same edition. London, British Museum, Vellum C 22 f, fo. 142 ro.

306. Disputation between Roland and Ferragut.

Miniature. Same edition. Paris, Bibliothèque Nationale, Vélin 728, fo. 142 ro.

307. Roland killing Ferragut.

Miniature. Same edition. Paris, Bibliothèque Nationale, Vélin 725, fo. 142 ro.

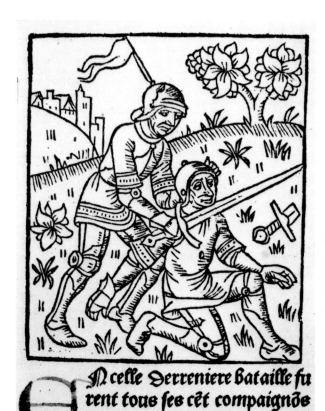

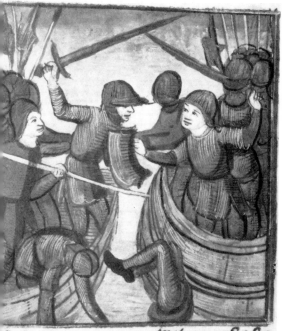

de la cite tout arme. Et demanda ba
lle dung seul cheualier corps a corps.
Dremierement enuoia charlemaigne

et de la cite tout arme. Et demanda ba
taille dung seul cheualier corps a corps.
Premierement enuoia charlemaigne

et de la cite tout arme. Et demanda ba
taille dung seul cheualier corps a corps.
Premierement enuoia charlemaign

de se dieu.

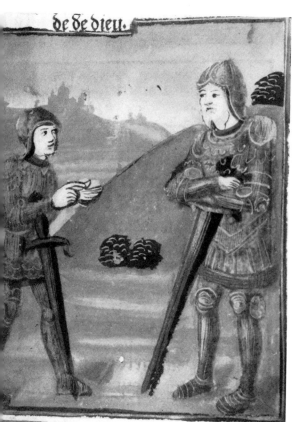

Quant fernagus eut asses dor
my il sesueilla et se tint en seat
et rolant se assist delez lui. Et

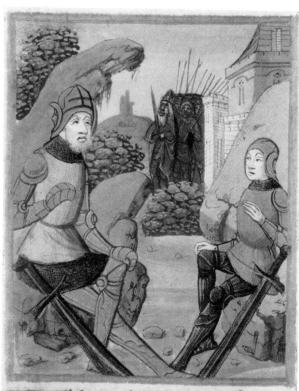

Quant fernagus eut asses dor
my il sesueilla et se tint en seat
et rolant se assist delez lui. Et

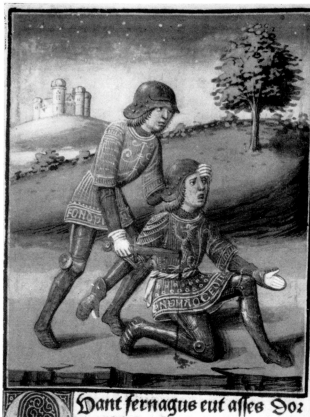

Quant fernagus eut asses dor
my il sesueilla et se tint en seat
et rolant se assist delez lui. Et

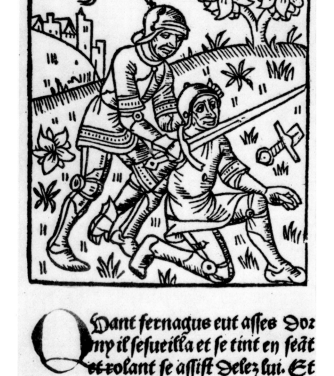

308. Roland killing Marsile.

Woodcut. Same edition. Paris, Bibliothèque Nationale, Ré-serve L 35/7 vol. 1, fo. 146 vo.

309. Roland killing Marsile.

Painted woodcut. Folio missing in the British Museum copy; not illustrated.

310. Roland blowing his horn.

Miniature. Same edition. Paris, Bibliothèque Nationale. Vélin 728, fo. 146 vo.

311. Roland trying to break his sword.

Miniature. Same edition. Paris, Bibliothèque Nationale, Vélin 725, fo. 146 vo.

312. Roland exterminating the Saracens.

Woodcut. Same edition. Paris, Bibliothèque Nationale. Réserve L 35/7, vol. 1, fo. 147 vo.

313. Roland exterminating the Saracens.

Painted woodcut. Same edition. London British Museum, Vellum C 22, fo. 147 vo.

314. Roland praying before his death.

Miniature. Same edition. Paris, Bibliothèque Nationale, Vélin 728, fo. 147 vo.

315. Roland praying before his death.

Miniature. Same edition. Paris, Bibliothèque Nationale, Vélin 725, fo. 147 vo.

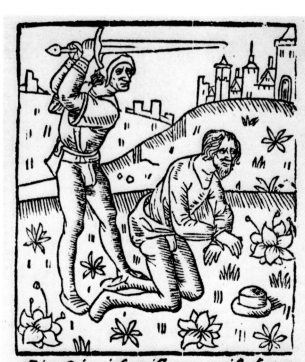

N celle derreniere bataille fu
rent tous ses cent compaigndes
occis Lui mesmes fut naure de

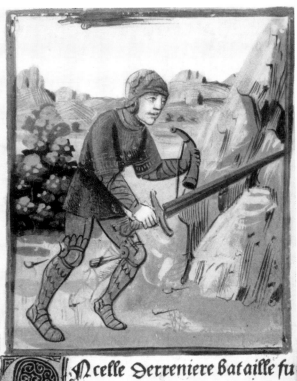

N celle derreniere bataille fu
rent tous ses cent compaigndes
occis Lui mesmes fut naure de

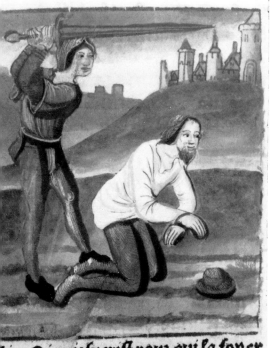

ire Dieu iesucrist pour qui la foy ex
ser iay delaisse mon pays et suis ve
en ceste estrange contree pour confo

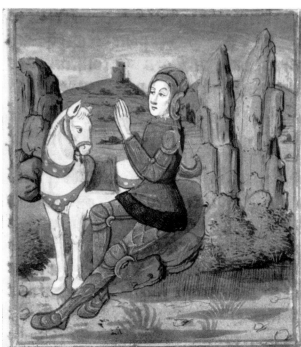

Sire Dieu iesucrist pour qui la foy ex
aulser iay delaisse mon pays et suis ve
nu en ceste estrange contree pour confo

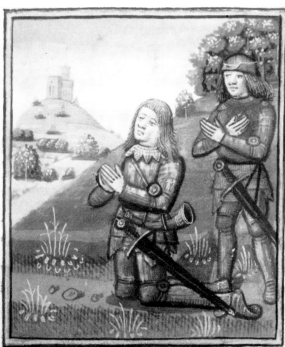

Sire Dieu iesucrist pour qui la foy ex
aulser iay delaisse mon pays et suis ve
nu en ceste estrange contree pour confo

316 317 318 319
320 321 322 323

et apporta Sraues nouuelles et
racôpta la maniere de la mort
rolant.

316. Mass for the dead of Roncevaux.

Woodcut. Same edition. Paris, Bibliothèque Nationale, Réserve L 35/7, vol. 1, fo. 148 ro.

317. Mass for the dead of Roncevaux.

Painted woodcut. Same edition. London, British Museum, Vellum C 22, fo. 148 ro.

318. Turpin's vision.

Miniature. Same edition. Paris, Bibliothèque Nationale, Vélin 728, fo. 148 ro.

319. Turpin's vision.

Miniature. Same edition. Paris, Bibliothèque Nationale, Vélin 725, fo. 148 ro.

320. Charlemagne encamping his army on the battlefield of Roncevaux.

Woodcut. Same edition. Paris, Bibliothèque Nationale, Réserve L 35/7, vol. 1, fo. 148 vo.

321. Charlemagne encamping his army on the battlefield of Roncevaux.

Painted woodcut. Same edition. London, British Museum, Vellum C 22, fo. 148 vo.

322. Charlemagne encamping his army on the battlefield of Roncevaux.

Miniature. Same edition. Paris, Bibliothèque Nationale, Vélin 728, fo. 148 vo.

323. Charlemagne encamping his army on the battlefield of Roncevaux.

Miniature. Same edition. Paris, Bibliothèque Nationale, Vélin 725, fo. 149 vo.

Quant charlemaigne eut ainsi
regrette rolant il commãda a
tendre trefs et pauillons en ce

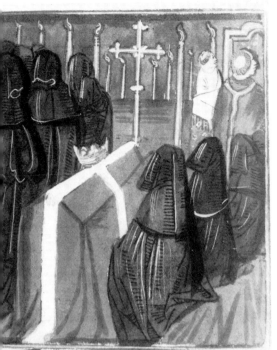

Or vous compteroit on/en tan
dis que la glozieuse ame de ro
lant le glozieur martir. se para

et baudouin, comment il suruit
et apporta Szaues nouuelles et
racompta la maniere de la mort
rolant.

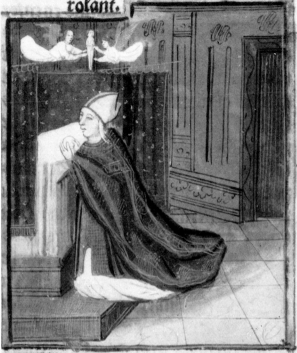

et apporta Szaues nouuelles et
racompta la maniere de la mort
rolant.

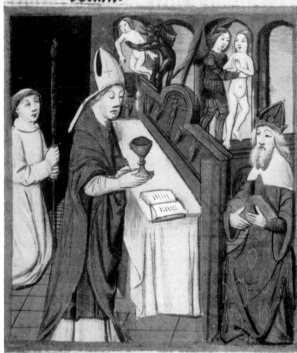

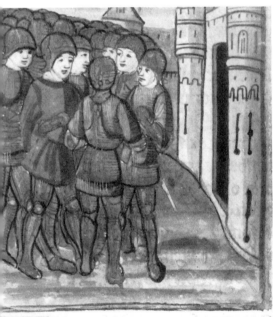

Quant charlemaigne eut ainsi
regrette rolant il commãda a
tendze trefs et pauillons en ce
u mesme ou le corps rolãt gisoit mozt
se reposa loft celle nuyt. Charlemai

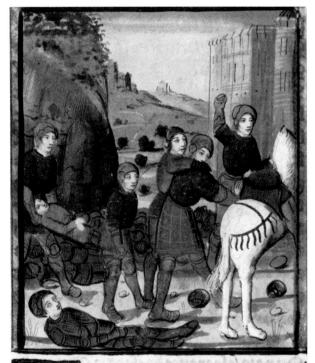

Quant charlemaigne eut ainsi
regrette rolant il commãda a
tendze trefs et pauillons en ce

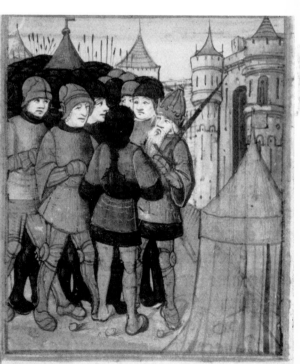

Quant charlemaigne eut ainsi
regrette rolant il commãda a
tendze trefs et pauillons en ce

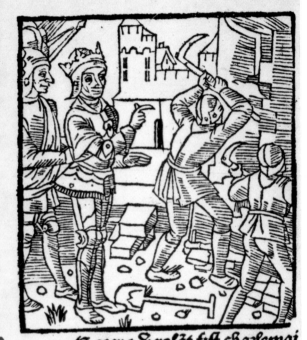

ta leglife. Et puis parle de diuers lieux ou oliuier et les autres furent portes

E corps de rolāt fist charlemaigne porter en la cite de blesues fur deur mules en bieze dore couuerte de riches poilles de foye en legli fe faint rōmain quil audit fondee et mis dedens chanoines reguliers. La le fift

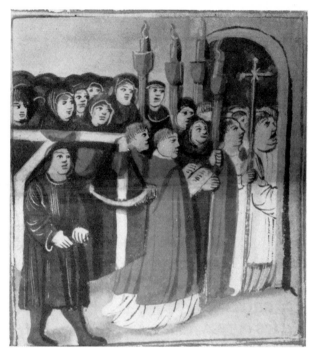

324 325 326

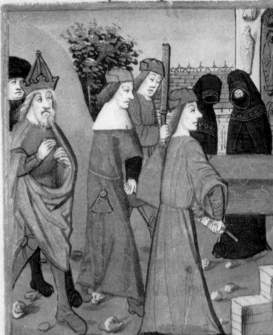

ta leglife. Et puis parle de uers lieux ou oliuier et les tres furent portes

E corps de rolāt fist charlen gne porter en la cite de blef fur deur mules en bieze do couuerte de riches poilles de foye en le fe faint rōmain quil audit fondee et n dedens chanoines reguliers. La le

324. Roland's funeral at Blaye.

Woodcut. Same edition. Paris, Bibliothèque Nationale, Réserve L 35/7 vol. 1, fo. 149 vo.

325. Roland's funeral at Blaye.

Painted woodcut. Same edition. London, British Museum, Vellum C 22, fo. 149 vo.

326. Roland's funeral at Blaye.

Miniature. Same edition. Paris, Bibliothèque Nationale, Vélin 728, fo. 149 vo.

327. Roland's funeral at Blaye.

Miniature. Same edition. Paris, Bibliothèque Nationale, Vélin 725, fo. 149 vo.

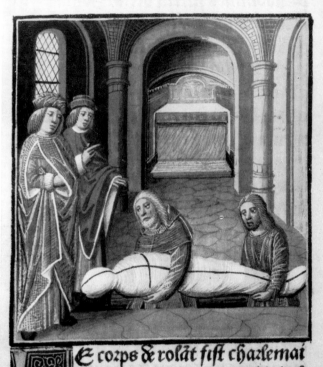

E corps de rolãt fist charlemaigne porter en la cite de blesues fur deux mules en biere dorze couuerte de riches poilles de foye en legli se saint rõmain quil auoit fondee et mis dedens chanoines reguliers. La le fist

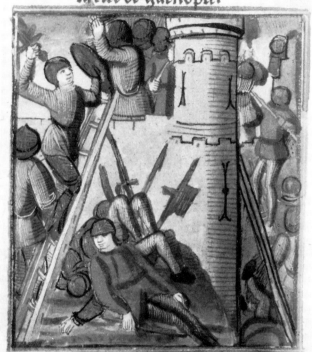

Our bon exemple donner aux roys et aux princes qui guerre ont a mener cõtre les ennemis de la chrestiente on ne doit cy endroit oublier vne merueilleuse aducnture qui ad

328. Roland taking the city of Garnople (Noble).
Painted woodcut. Same edition. London, British Museum,
Vellum C 22, fo. 152 vo.

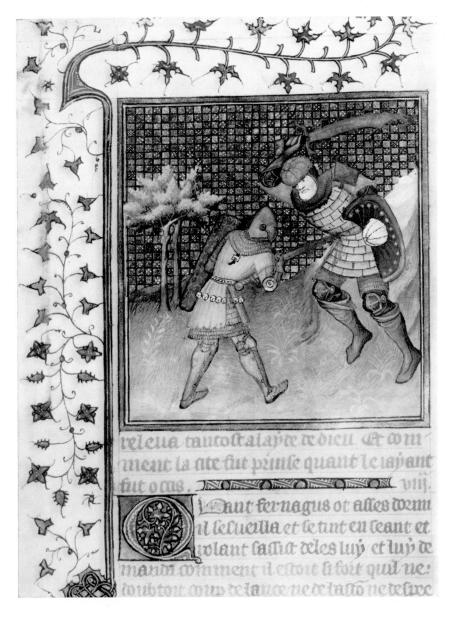

329. Roland killing Ferragut.
Miniature. *Les Grandes Chroniques de France.* London, British Museum, Cotton Nero E II, fo. 124, col. 1. Late 14th century.

330. Roland killing Ferragut.
Miniature. *Les Grandes Chroniques de France.* Berlin, Staatsbibliothek, ms. Hamilton 150, at present at Marburg, Westdeutsche Bibliothek, fo. 114 vo. Late 15th century.

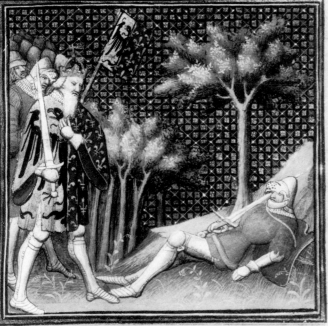

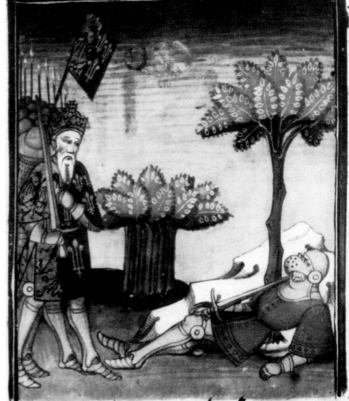

331. Charlemagne finding Roland's body.
Miniature. *Les Grandes Chroniques de France.* London, British Museum, Cotton Nero E II, fo. 130, col. 2. Late 14th century.

332. Charlemagne finding Roland's body.
Miniature. Berlin, Staatsbibliothek, ms. Hamilton 150, at present at Marburg, Westdeutsche Bibliothek, fo. 120 vo. Late 14th century.

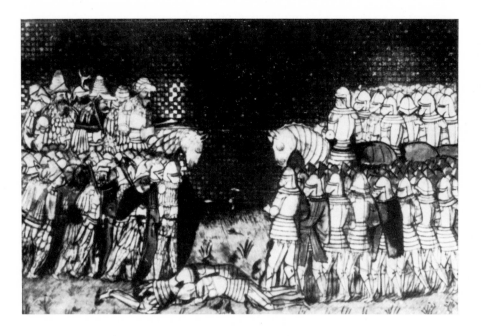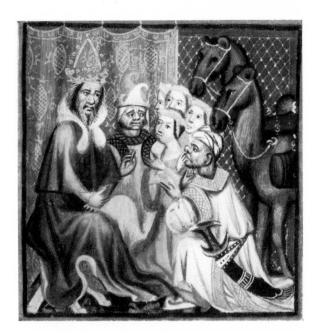

333 334 336
335

333. Battle of Roncevaux.

Miniature. *Les Grandes Chroniques de France.* Leningrad,
Public Library, cat. no. unknown. 15th century, fo. 30 vo.

334. Charlemagne receiving the fatal gifts.

Miniature. *Les Grandes Chroniques de France.* Paris, Bi-
bliothèque Nationale, fr. 2608, fo. 147 vo., col. 1. About
1400.

335. Roland killing Ferragut.

Miniature. *Les Grandes Chroniques de France.* Leningrad,
Public Library, cat. no. not known. 14th century.

336. Roland fighting with Ferragut.

Historiated initial. *Les Grandes Chroniques de France.* Brus-
sels, Bibliothèque Royale, ms. 14561-4, fo. 124 ro., col. 1.
14th century.

ne vault que leur merites fussent perdues.
car ia soit che que il ne fussent pas o-
chis par les glaiues de leur anemis
ne perdirent il pas pour che la victoi-
re de martyre · Quant tournus ⁊ sa
gent furent ainsi ochis · klemaines
prist le castel de moniardin ⁊ toute la
terre de nauarre · Chi se fenist li · vi · chapi-
stres des fais desplaigne · et se comenche li
xviij · chapistres · et quient Rolans se combati
a fernagu ·

hes co-
les qui
si furet
nonne
les fu-
rent
dites
Able-
maine
que
ferna-
gus
vns
gaians
du li-
gnage

Golie estoit venus enlachite de nadres
des contrees de ...

daule espine. et li gaians le prist a vn
seul brach · ⁊ lemporta en sa chartre.
Apres ralerent constentius li preuos
de Rome · ⁊ hoiaus li quens de nantes.
et il les saisi a · ij · bras ensamble · ⁊ les
emporta ambedeus en sa chartre · Apres
churent enuoie · xx · cheualiers des plus
puissant de lost · ⁊ li gaians les emporta
tous · ij · ⁊ · ij · en la chite ⁊ les mist en
sa chartre · ¶ Quant li empereres
vit la force du gaiant il nosa plus
nullui enuoier si estoit tous li os es-
bahis des merueilles que chil faisoit.
Rolans qui onques nul home ne douta
sen vint lors a klemaine et li requist la
bataille contre fernagu · Et li empere-
res qui tel se douta la li otroia a grans
proieres ¶ Rolans sarma ⁊ ala contre
li · Et quant li gaians le vit venir il
ala vers li et le prist tantost a la main
destre ⁊ le leua legierement seur le col
du cheual · Eu che que il lemportoit vers
la chite Rolans le prist par le menton
et li tourna la teste si forment che de-
uant derriere que il chairent ambedoi
a terre · Tantost saluerent sus ⁊ mon-
terent seur les cheuaus · Vers li sen
vint Rolans lespee traite car il le ai-
...

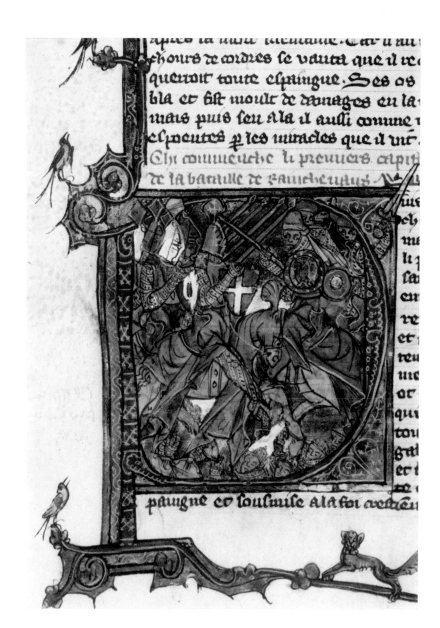

337 338

339

337. Battle of Roncevaux.

Historiated initial. *Les Grandes Chroniques de France.* Brussels, Bibliothèque Royale, ms. 14561-4, fo. 127 vo., col. 1.

338. Baudouin and Tierry with the dying Roland.

Miniature. *Les Grandes Chroniques de France.* Brussels, Bibliothèque Royale, ms. 5, fo. 144 ro. 14th century.

339. Charlemagne and his army finding the bodies of Roland and the peers who fell of Roncevaux.

Miniature. *Ibid.,* fo. 145 vo.

The fighting is so fierce that swords sometimes slash through the frame of the miniature to where the patient scribe has set out the account of the battle.

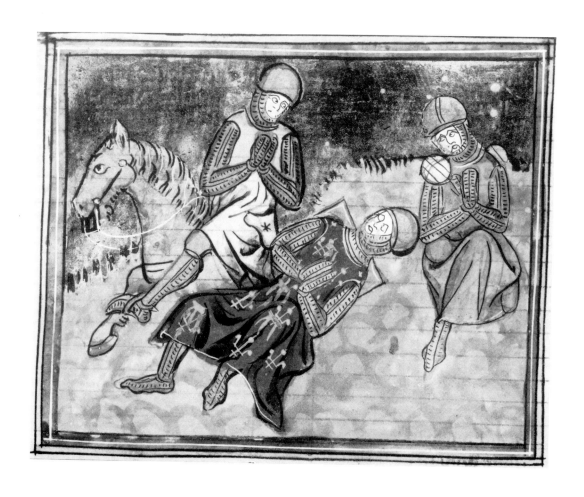

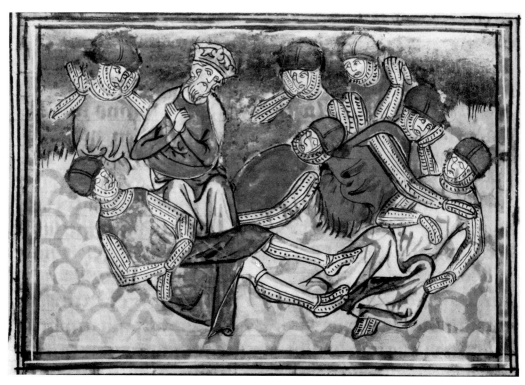

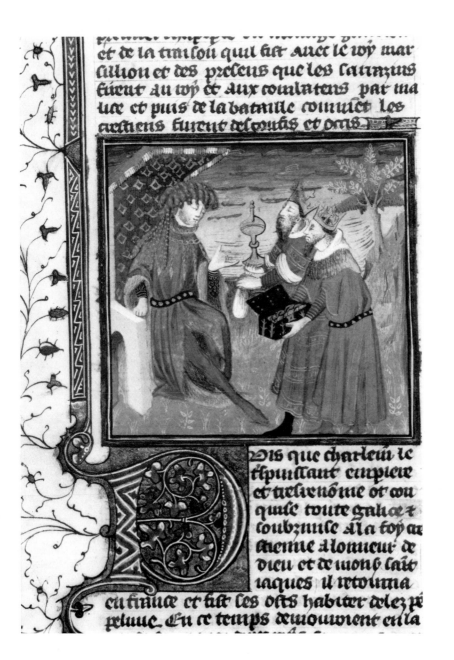

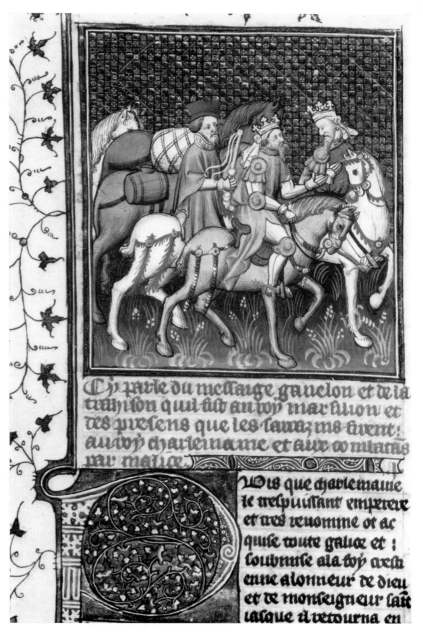

340. The kings of Saragossa giving presents to Ganelon.

Miniature. *Les Grandes Chroniques de France.* Brussels, Bibliothèque Royale, ms. 1, fo. 112 vo., col. 1. Early 15th century.

341. The kings of Saragossa escorting Ganelon with the fatal gifts.

Miniature. *Les Grandes Chroniques de France.* Brussels, Bibliothèque Royale, ms. 3, fo. 109 vo., col. 1. Early 15th century.

342. Eginhard and Turpin writing the life and glorious deeds of Charlemagne.

Miniature. *Ibid.,* fo. 76 vo., col. 1.

340 341 342

343

343. Ferragut carrying off Christian knights. Roland killing Ferragut.

Miniature. *Les Grandes Chroniques de France.* Leningrad, Public Library, fr.F.v.IV.1. Between 1449 and 1460.

Cy endroit parle qui ait fu qui la geste
descript et la maniere de viure des roys . j.

R dit vnquques egincaulx
chapellam et noury ou
palays le victorien prin
ce et le tres renomme
emperere charlemaine
jay proprose adelaur les
meurs et sa vie alay de
de nostre seigneur au

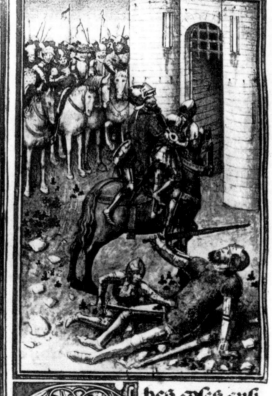

hes vses ausi
fautes nouue
les fuxent di
xes que serua
tius vnirs lu

en spaunie long taimps apres
la mort charlemamie · Ceste histoi
re demoustre la bataille que charlemamie
ot en ramceuaulx · par le traison du traitre

guenelon qui presenta au roy cheuaulx
ǝ armes dor · et argent · Et comment
Rollant oaist le roy marsille · et coment
il moeut · De la vision ǝ lartœuess turpin but
en cantant messe · et de la iustice guenelon ·

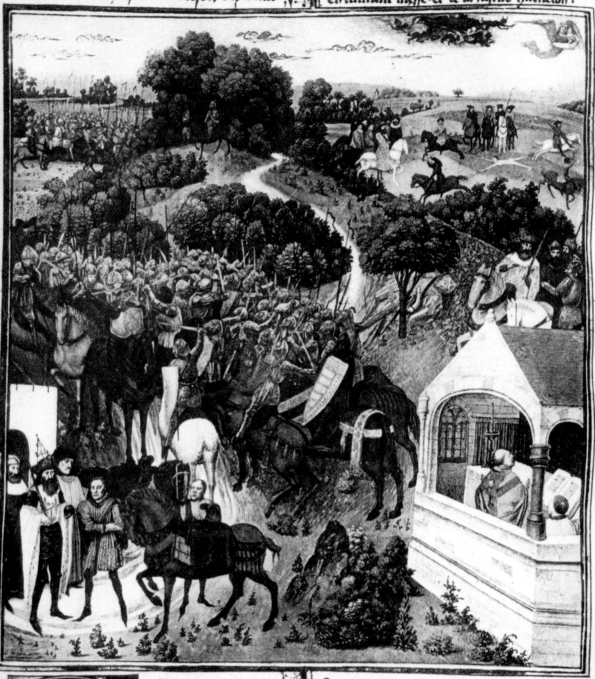

Lpuis que
charlemames
li tresponssiaus
emperœres et
tres renomes
ot conquise toute italie et tou
te la terre despautrie et sousmi

se a la foy xpristienne alonnor
ǝe dieu et ǝe monsinior saint
Jaque il retourna en fraince · et
fist ses ostz herbercmer ǝeleis la
cite de pampelune · En ce taimps
ǝemourement en la cite de saint
trouce ǝoi roy sarrazin marsille

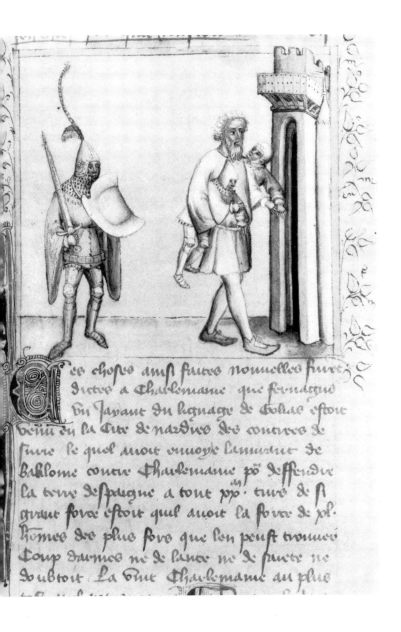

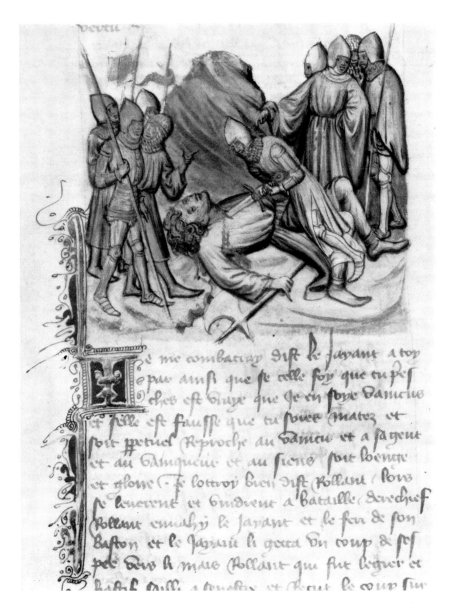

344. Treason of Ganelon, the battle of Roncevaux, the
death of Roland, Turpin's vision and Ganelon's
punishment all shown in one scene.

Miniature by Simon Marmion. *Les Grandes Chroniques de
France.* Leningrad, Public Library, fr.F.v.IV.1, fo. 154 ro.

345. Roland watching Ferragut carry off two Christian
knights.

Monochrome drawing. *Les Grandes Chroniques de France.*
London, British Museum, Sloane 2433, vol. 1, fo. 120 ro.,
col. 1. Late 14th century.

346. Roland cutting Ferragut's throat.

Monochrome drawing. *Ibid.,* fo. 121 vo.

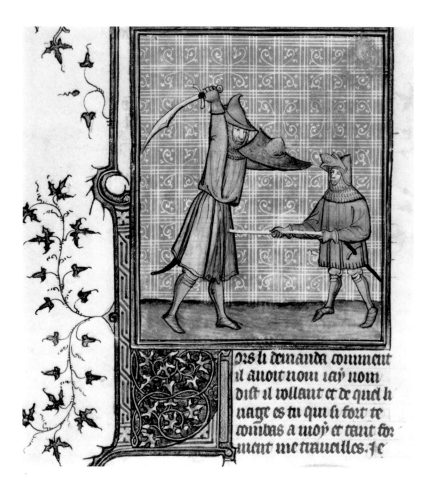

347. Roland killing Ferragut.

Miniature. *Les Grandes Chroniques de France.* Paris, Bibliothèque Nationale, fr. 20.350, fo. 106 vo. 14th century.

348 A. Roland fighting with Ferragut.

Ink and wash. *Les Grandes Chroniques de France.* Paris, Bibliothèque Nationale, f.fr. 2606, fo. 116 ro. Late 14th – early 15th century.

348 B. Disputation between Roland and Ferragut.

Ink and wash. *Ibid.*, fo. 122 ro.

349. Roland fighting with Ferragut.

Miniature. *Les Grandes Chroniques de France.* Oxford, Bodleian Library, ms. Douce 217, fo. 108 vo. First half of 15th century.

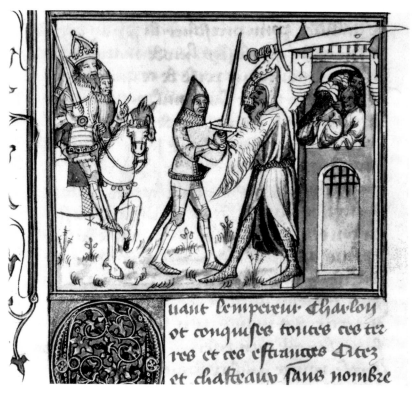

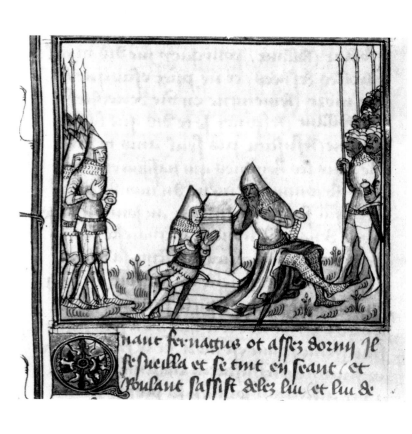



...les gens senefient ceulx
...ombatent cont le mon
...ne ceulx qui retourne
...res des mors quils avoi
...us par convoitise des
...et furent occis de leurs
...il de ceulx qui les biens
...et ia en ont fait pencta
...pas retourner aus biens
...res des diables p man
...come ceulx retourne
...es despoulles perdrent
...recevent laide mort
...ne de relicion qui ceste
...tuerpi et puis retour
...mes hommes tels
...udent perdent la cele
...acent la mort pardura
...Dit acharlon que p
...qui foutre avoit nom
...aille cont lui se estoit en
...sur la montaigne da
...wlon et les sarrazins se
...uxlui leronu denant
...lle fist charlon prieue
...tous ceulx qui en cel
...nourir senssent son
...es et quant lost se fut
...p fist miracles et telle
...gnor ils senssent son
...ouctes apparurent pas
...sur les espaulles de
...bataille se denoiet mon
...ua charlemaine des au
...en une chappelle pour
...t occis. Que bons

Right column (top):

...poise le chastel de momadom et toute la
terre de nanarre aussi le pn chappit ple
arment servaisin le papen vint cont charle
maine donstre mer et parle desa fource de
sa grandeur et puis qment il emporta les
barons de charlemaine en la cite de nadres
lun apos lant et qment boullant se comba
ty alui toute iour et puis qment il prist
brenes avoulant pour dormir.

Right column (bottom):

lll' ab choses ainsi faittes
Nouuelles furent dittes achar
lemaine que servaisius un Jay
ant du lichnage goliab estoit
venus en la cite de nadres des
contrees de surie si lauoit encoxe lennant
de babiloine contre charlemaine pour def
fendre la terre desspaigne atout vn mille
tures desi grant fource estoit qui lauoit la
fource de quarante homes des plus fors q
len puest trouner coup darmes ne de f...

Et cil embusca les trenes auant quil cust
deffie estoit parcroit ocis ~ Le .bme. de
la disputeuson dela foy catholique que
roullant fusoit aupayen fernagu et
coment roullant se combati alui pour
soustenir la foy crestienne, et coment le
getta subuz lui mais il se releua tosta
laide de dieu et aconent la cite su prise

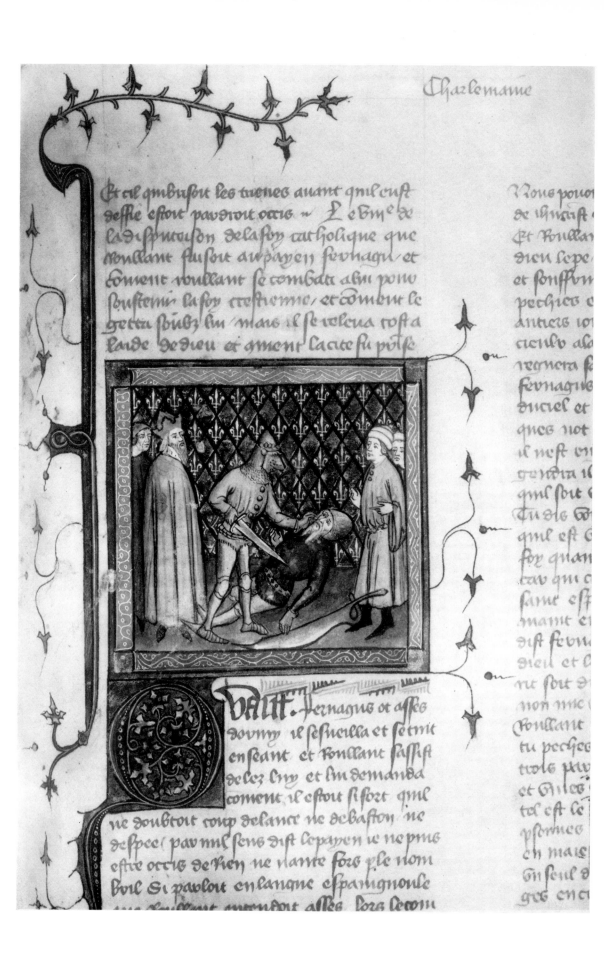

VALIF. Fernagus et asses
dourmy il sesueilla et se mit
en seant et roullant lassist
delez luy et lui demanda
coment il estoit si fort quil
ne doubtoit coup delance ne debaston ne
despee par nul sens dist lepayen ie ne puis
estre occis de rien ne nante fors q̃le nom
boil Si parloit en langue espaignoule
que roullant entendoit asses Lora lecom

Nous pouoir
de ihucrist
Et roullan
dieu lepe
et souffrir
pechies o
antiers io
cieulx alo
regnera se
fernague
duciel et
ques not
il nest on
vendra il
quil soit o
tu dis co
quil est o
soy quan
tav qui c
fame est
maint et
dist feru
dieu et c
ru soit di
non mie
roullant
tu pechec
trois per
et filles i
tel est le
psorneo
en mais
en seul d
qes en c

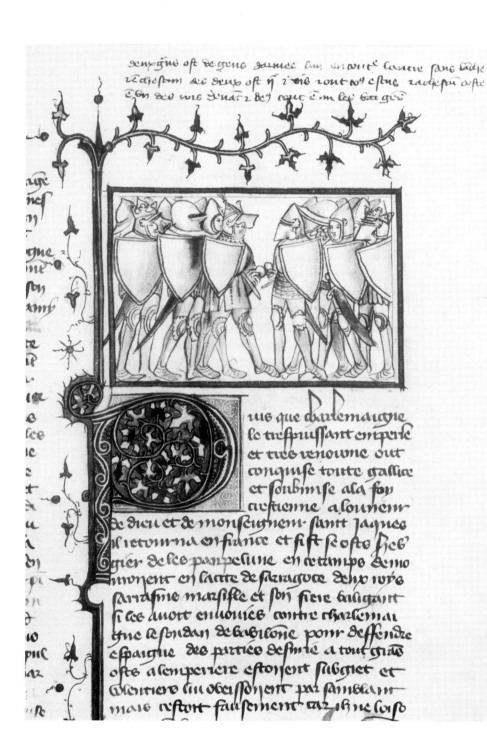

350. Roland killing Ferragut.

Miniature. *Les Grandes Chroniques de France.*
Munich, Staatsbibliothek, Cod. Gall. 4, fo. 110 ro.
15th century.

351. Dispuatation between Roland and
Ferragut.

Drawing with touches of colour. *Les Grandes
Chroniques de France.* Valenciennes, Bibliothè-
que Municipale, ms. 637, fo. 137 vo. 15th century.

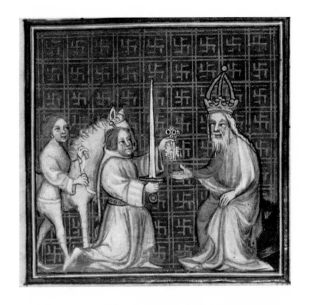

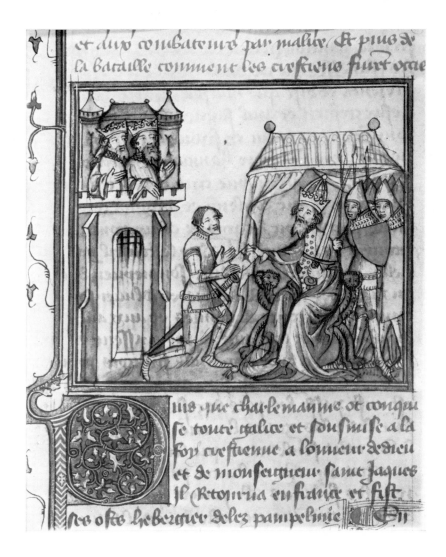

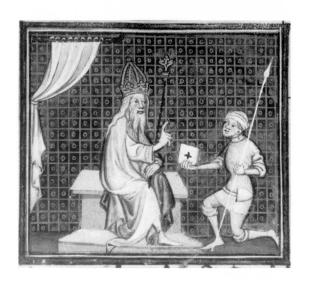

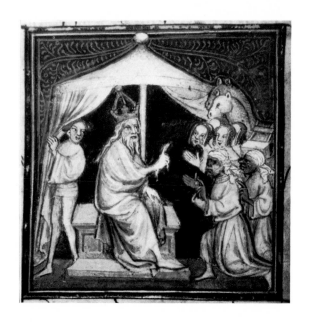

352. The provoŝt of Saragossa offering peace to
Charlemagne.

Grisaille with touches of colour. *Les Grandes Chroniques de
France.* Vienna, Nationalbibliothek, ms. 2564 (Eug. f. 76),
fo. 118 ro. 14th century.

353. Charlemagne appointing Ganelon ambassador to
Marsile.

Grisaille with touches of colour. *Ibid.,* fo. 121 vo.

354. Charlemagne receiving the gifts from Marsile.

Grisaille with touches of colour. *Ibid.,* fo. 140 vo.

355. Charlemagne appointing Ganelon ambassador to
the two kings of Saragossa. Behind him are
Roland and Oliver.

Ink and wash. *Les Grandes Chroniques de France.* Paris,
Bibliothèque Nationale, f.fr. 2606, fo. 125 ro. Late 14th –
early 15th century.

356. Ganelon bringing Charlemagne Marsile's message
and the fatal gifts.

Miniature. *Les Grandes Chroniques de France.* Paris, Bi-
bliothèque Mazarine, ms. 2028, fo. 124 ro. About 1400.

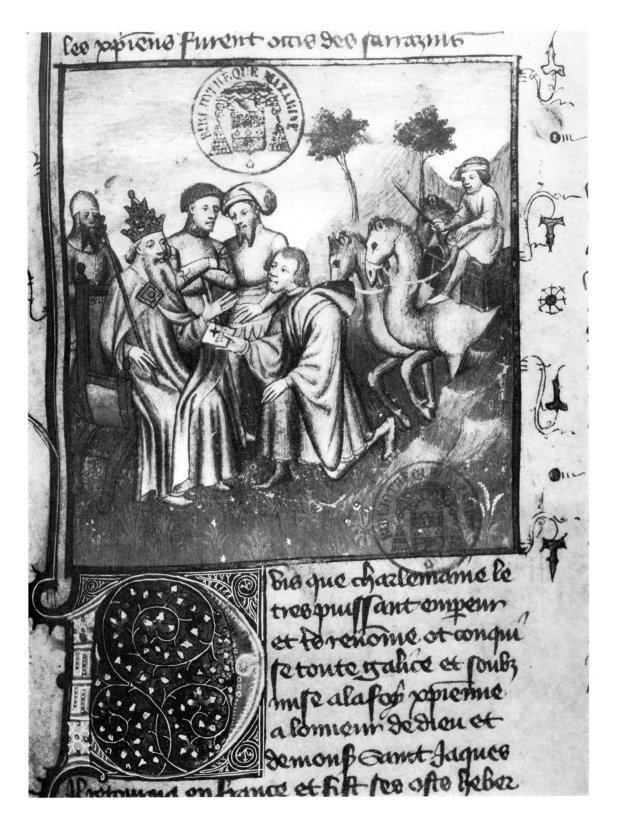

352 355 356

353

354

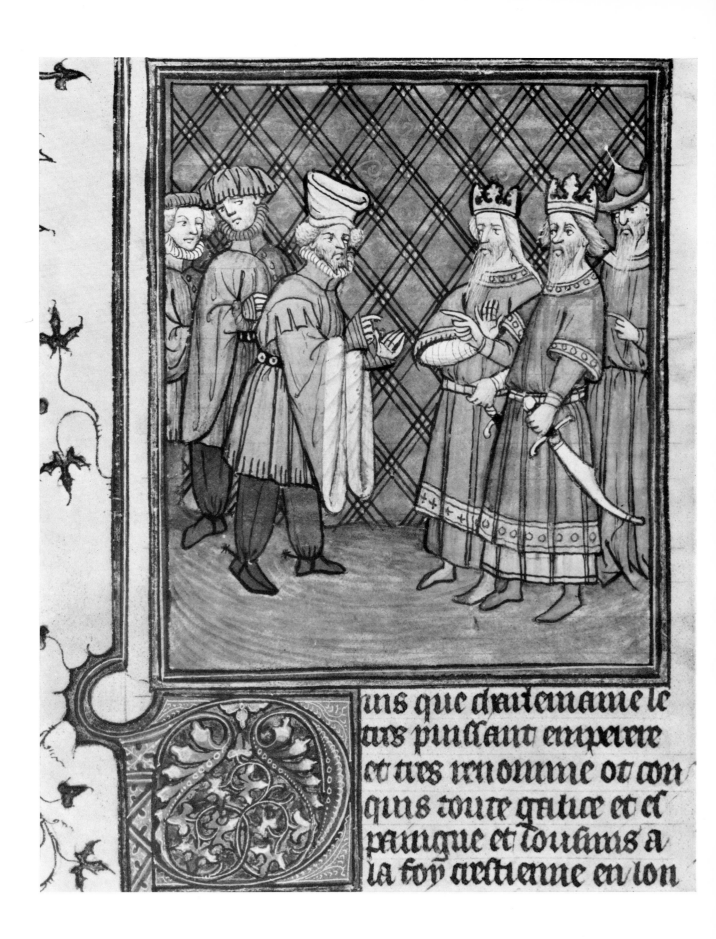

ins que chaitemaine le
tus pinssant empeire
et tues renomme oi con
quis toute gatice et es
paingue et tousims a
la for aiestienne en son

357. Ganelon before the kings of Saragossa.
Miniature. *Les Grandes Chroniques de France.* Paris, Bi-
bliothèque Nationale, f.fr. 20350, fo. 109 vo. About 1380.

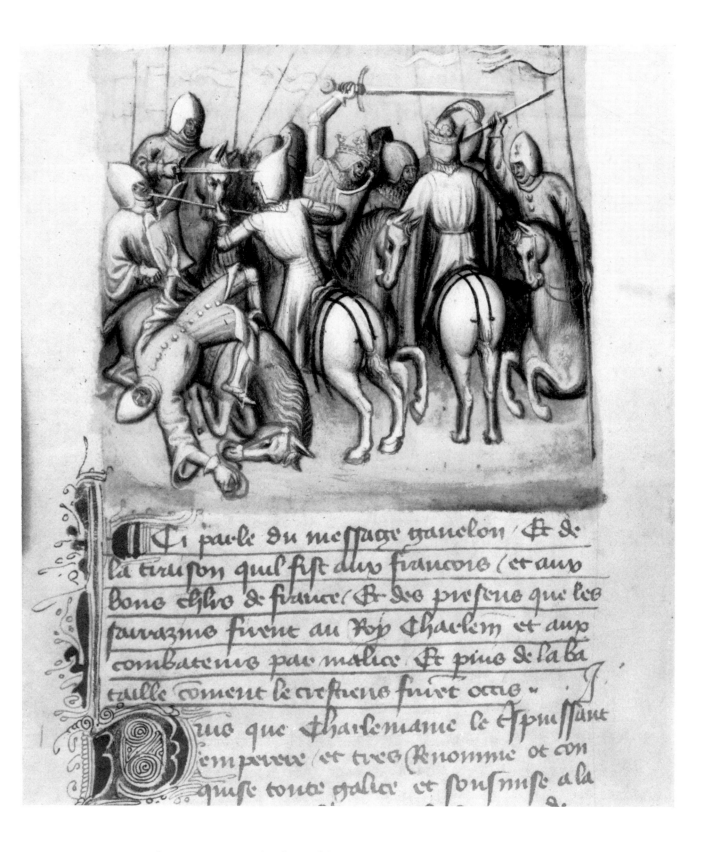

358. Battle of Roncevaux. Roland attacking King
 Marsile.

Miniature. *Les Grandes Chroniques de France.* London,
British Museum, Sloane 2433, fo. 123 vo. Late 14th century.

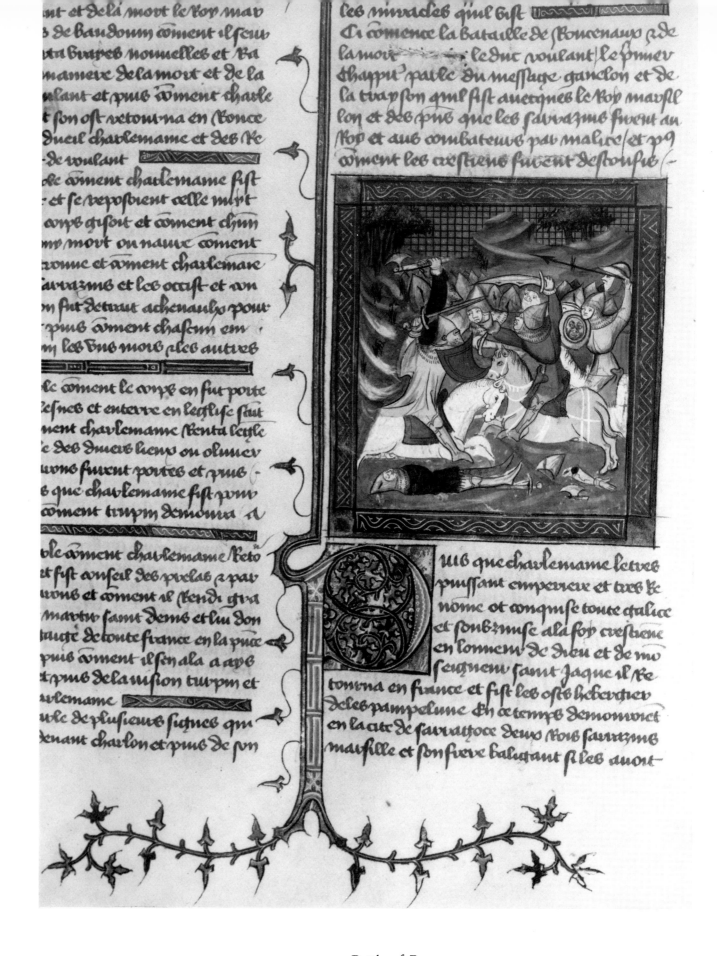

359. Battle of Roncevaux.

Miniature. *Les Grandes Chroniques de France.* Oxford, Bodleian Library, ms. Douce 217, fo. 112 ro. First half of 15th century.

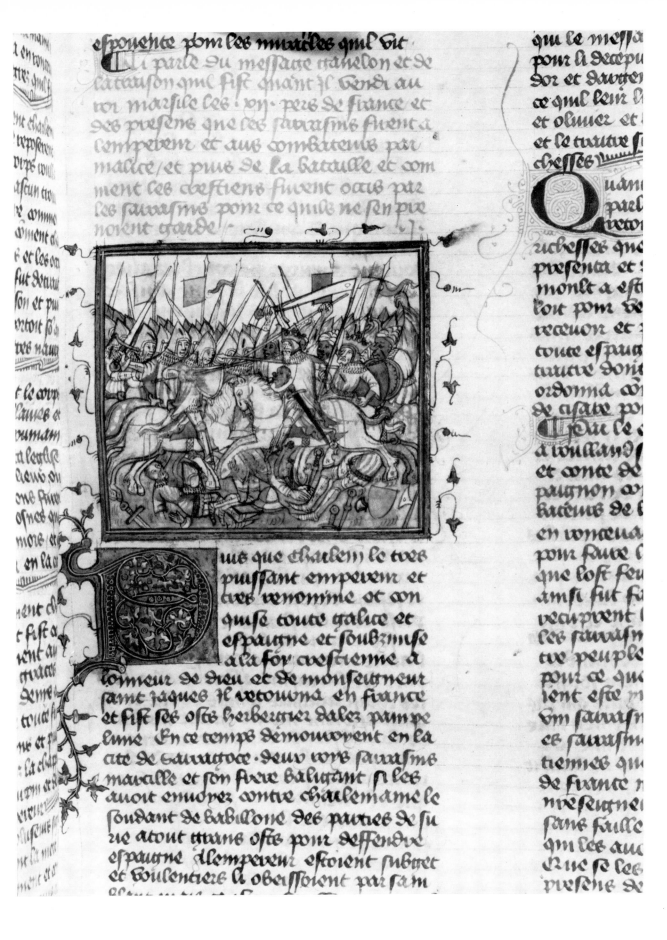

360. Battle of Roncevaux.

Ink and wash. *Les Grandes Chroniques de France.* Paris
Bibliothèque Sainte-Geneviève, ms. 783, fo. 117 ro. 15th
century.

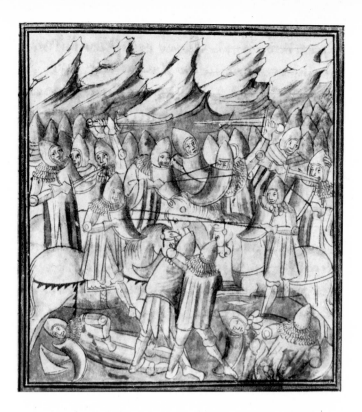

361A
361B 362

361 A. Battle of Roncevaux.

Miniature. *Les Grandes Chroniques de France.* Paris, Bibliothèque Nationale, f.fr. 2597, fo. 130 vo. 15th century.

361 B. Roland attacking Marsile.

Ink and wash. *Les Grandes Chroniques de France.* Paris, Bibliothèque Nationale, f.fr. 20352, vol. I, fo. 131 vo. 15th century.

362. Roland attacking Marsile.

Miniature. *Les Grandes Chroniques de France.* Munich, Staatsbibliothek, Cod. Gall. 4, fo. 129 ro. 15th century.

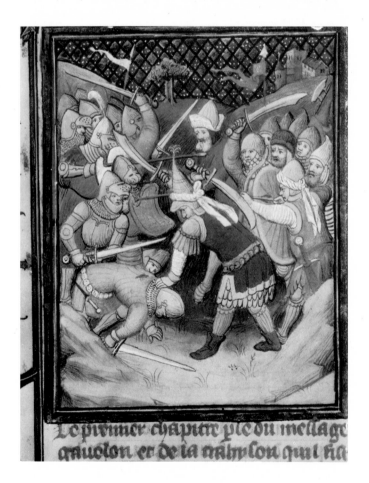

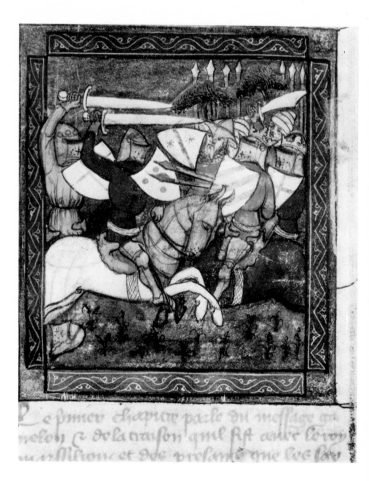

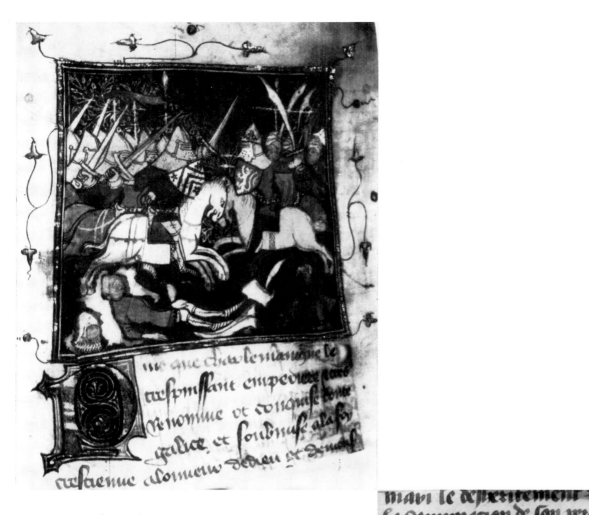

363. Roland attacking Marsile.
Miniature. *Les Grandes Chroniques de France.* Turin, Biblioteca Nazionale, ms. L. II 8, fo. 263 ro. Late 15th century.

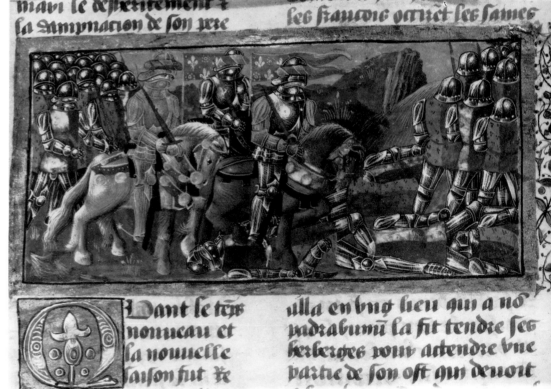

364. Roland riding through the Pyrenees (?)
Miniature. *Les Grandes Chroniques de France.* Paris, Bibliothèque Nationale, f.fr. 2610, fo. CII ro. 15th century.

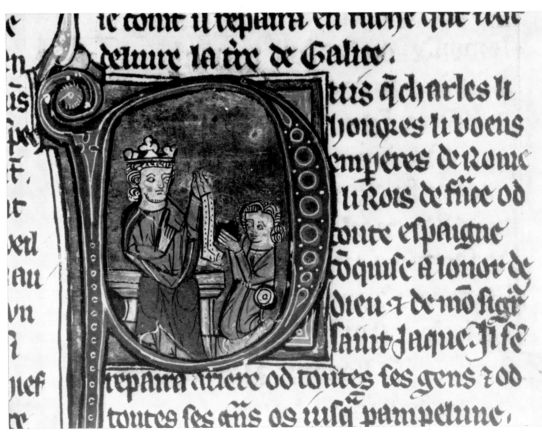

365. Roland attacking Ferragut who is
carrying away a Christian.

Historiated initial. *Chronique de l'Anonyme
de Béthune.* Paris, Bibliothèque Nationale,
nouv. acq. fr. 6295, fo. 16 vo. Second half of
13th century.

366. Charlemagne giving Ganelon the
message for Marsile.

Historiated initial. *Ibid.,* fo. 20 vo.

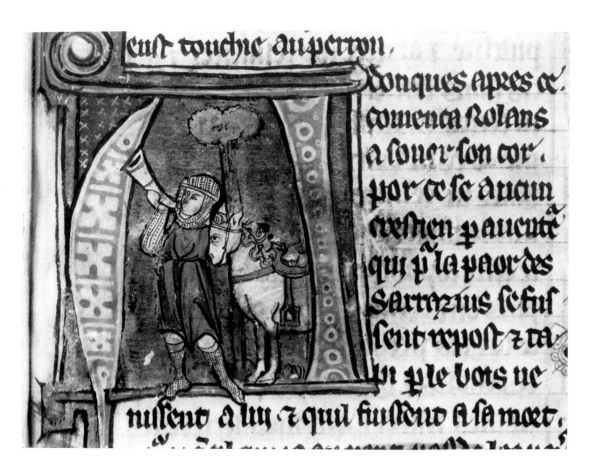

eust touchie au perron.
donques apres ce
comenca Rolans
a soner son cor.
por ce se aucun
cresmen p auicute
qui p la paor des
Sarrazius se fus
sent repost z ta
un p le vois ue
nissent a lui z quil fuissent a sa mort.

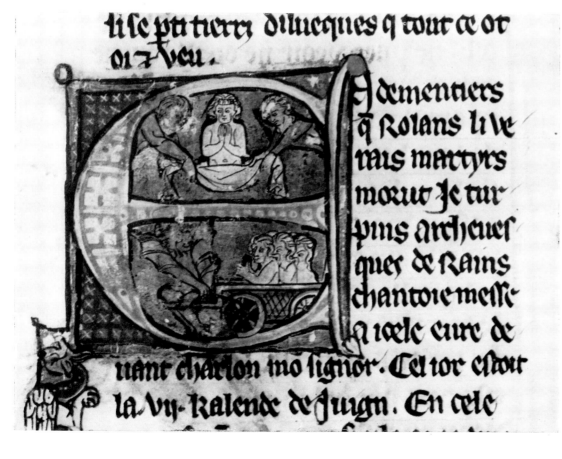

li se pri terra dilueques q tout ce ot
oi z veu.
dementiers
q Rolans li ve
rais martyrs
morut Je tur
pins archeues
ques de Rains
chantoie messe
a icele eure de
uant charlon mo signor. Cel ior estoit
la .vij. kalende de fuign. En cele

367. Roland blowing his horn beside his
 wounded horse.
Historiated initial. *Ibid.*, fo. 29 ro.

368. Turpin's vision : Roland's soul carried
 heavenwards by two angels.
Historiated initial. *Ibid.*, fo. 29 vo.

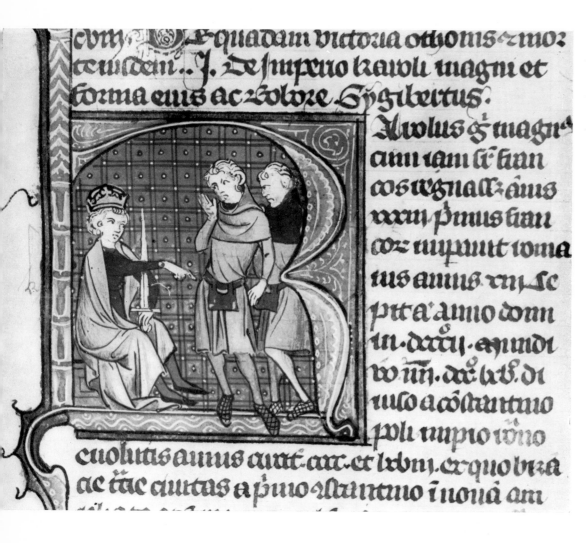

The famous Speculum historiale of Vincent of Beauvais, an important source of mediaeval iconography, is not very rich in illustrations, but this is not true of its French and Flemish translations, the Miroir historial of Jean de Vignay and Spieghel historiael of Jacob van Maerlant.

369

370 371

369. Charlemagne appointing Ganelon ambassador to Marsile; Roland is behind Ganelon.

Historiated initial K. *Speculum historiale* of Vincent de Beauvais. Madrid, Escorial, ms. O 1. 4, fo. 1 vo.

370. Ganelon taking leave of Marsile and Baligant.

Miniature. *Chronicle attributed to Baudouin d'Avesnes.* Chantilly ,Musée Condé, ms. 869, fo. 188 vo. About 1500.

371. Charlemagne appointing Ganelon ambassador to Marsile.

Historiated initial K. *Speculum historiale* of Vincent de Beauvais. Toulouse, Bibliothèque Municipale, ms. 449, fo. 3 ro. Late 13th century.

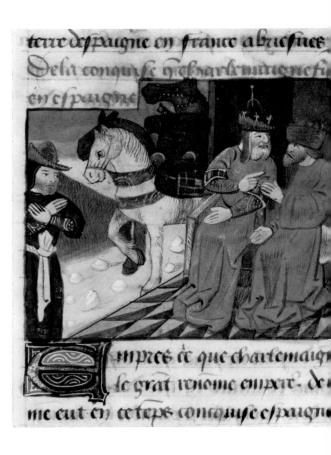

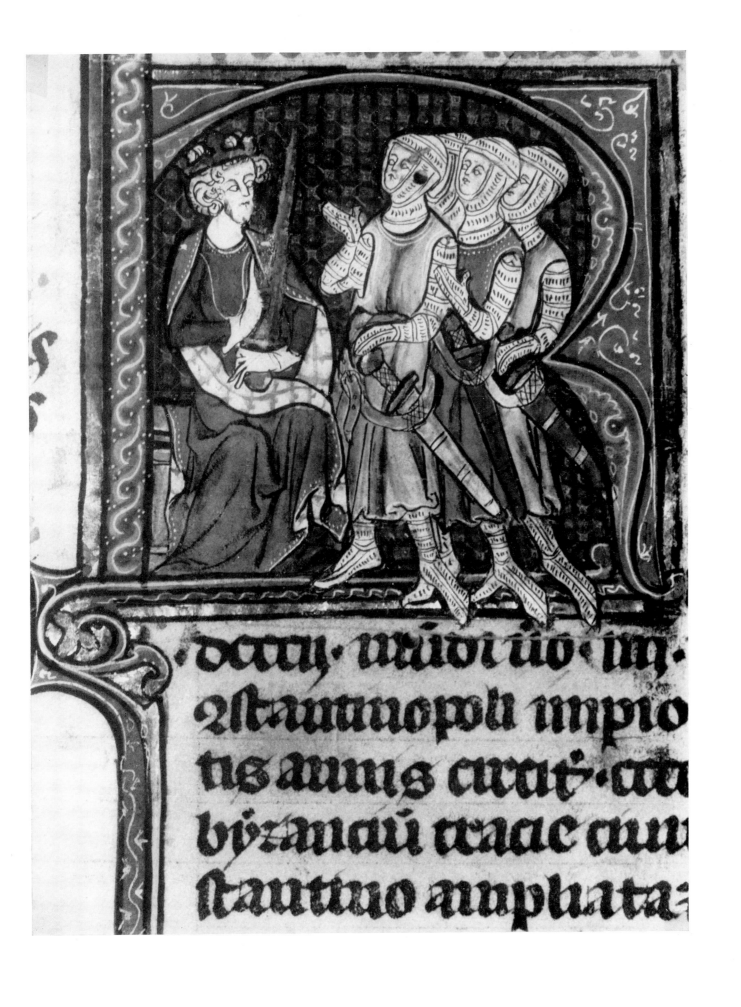

dcatu̇ · uiudi uo · uij ·
2ſtantuopoli umpio
tis auius curaſ · ca
bizmauü tract cuu
ſtautuuo auphuta:

372. Charlemagne and Roland fighting against Agolant's troops. Miniature. *Spieghel historiael* of Jacob van Maerlant. The Hague, Koninklijke Bibliotheek, Ak. xx, fo. 213 vo. First half of 14th century.

373. Roland fighting with Ferragut.
Miniature.
Ibid., fo. 214 vo.

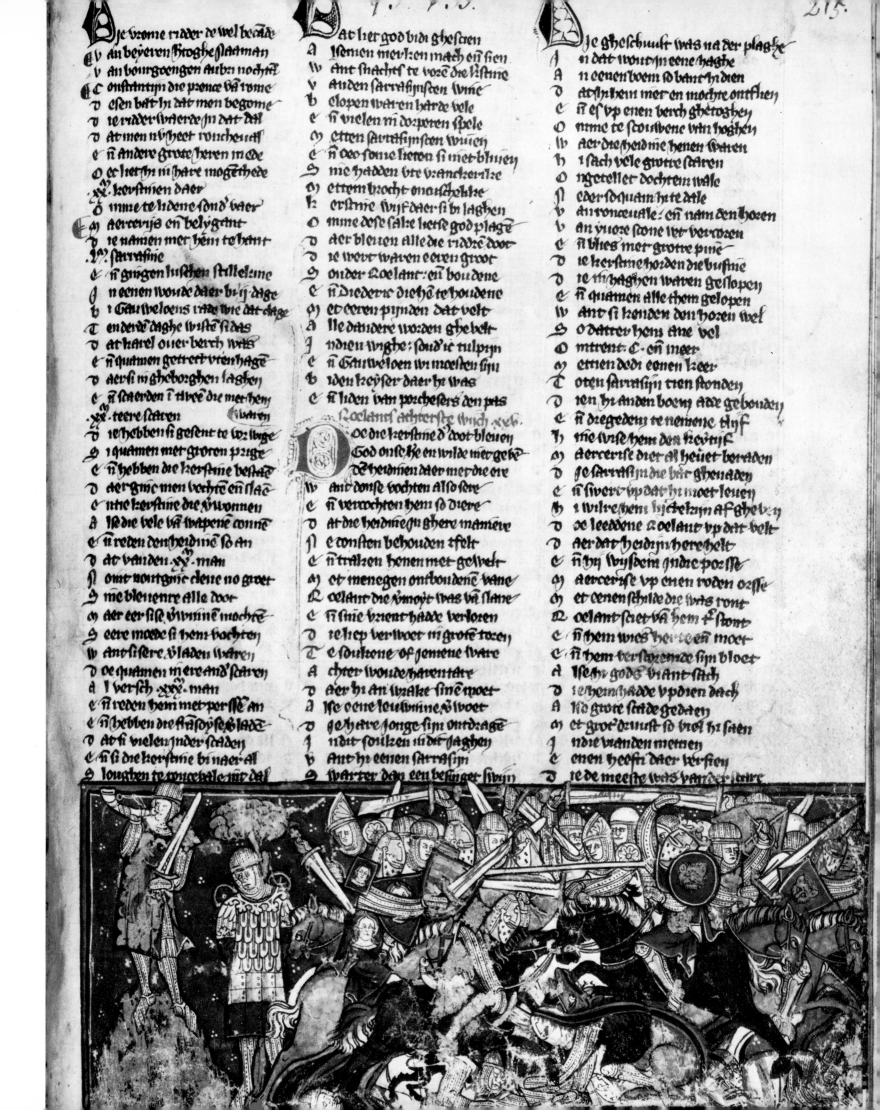

374. Battle of Roncevaux. Roland attacking and
 killing Marsile.

Miniature. *Spieghel historiael* of Jacob van Maerlant. The Hague,
Koninklijke Bibliotheek, Ak. xx, fo. 215 ro.

375 A. The heroes' funeral procession.

 B. Ganelon's punishment.

Miniature. *Ibid.,* fo. 216 ro.

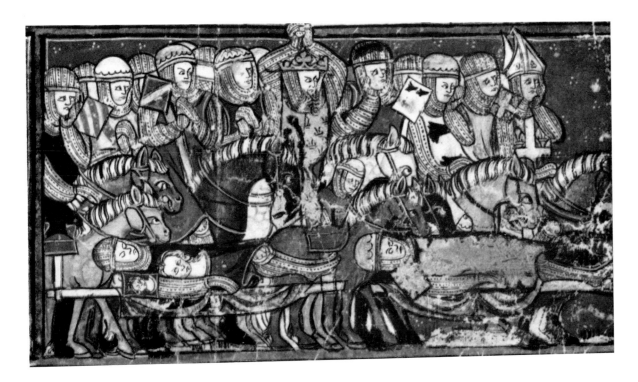

376

 379 381

377

378 380

376. Mounted combat between Roland and Ferragut.
Gouache. *Miroir historial* of Jean de Vignay. Paris, Bibliothèque Nationale, f.fr. 314, fo. 11 vo. 1496.

377. Roland killing Ferragut.
Gouache. *Ibid.*, fo. 12 ro.

378. Battle of Roncevaux.
Gouache. *Ibid.*, fo. 12 vo.

379. Roland fighting with Ferragut.
Grisaille with touches of colour. *Miroir Historial* of Jean de Vignay. Paris, Bibliothèque Nationale, f.fr. 310, fo. 368 ro. 1455

380. Charlemagne mourning Roland and Oliver.
Grisaille with touches of colour. *Ibid.*, fo. 370 vo.

381. Battle of Roncevaux.
Ink and wash. *Miroir Historial.* Paris, Bibliothèque Nationale, f.fr. 52, fo. 7 vo.

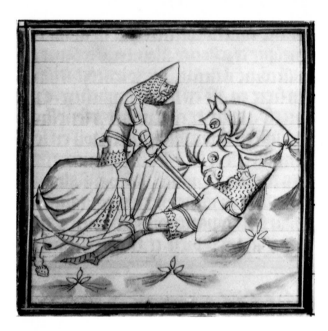

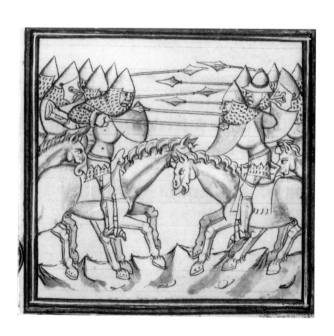

uecques .m̅. des siens et charles reuint
a son oratoire il trouua mors ceulr quil
y auoit enclos

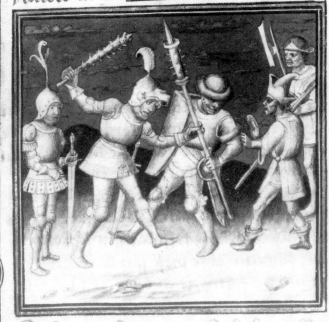

De fernagu le geant et de la bataille

tres apostres establis de dieu appellez en
ses secrez. De la trayson qui menelon en
la bataille de Rainelenaulr. vij.

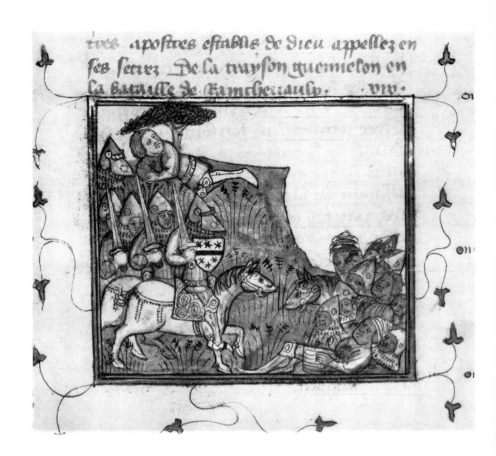

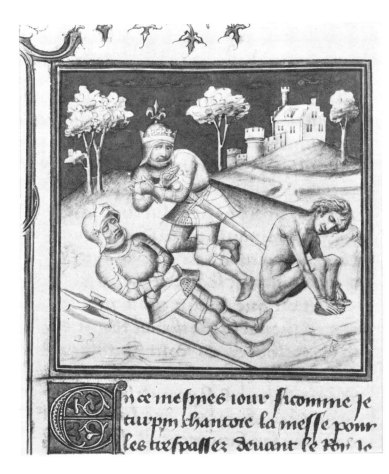

En ce mesmes iour sicomme se
turpin chantoie la messe pour
les trespassez deuant le Roy se

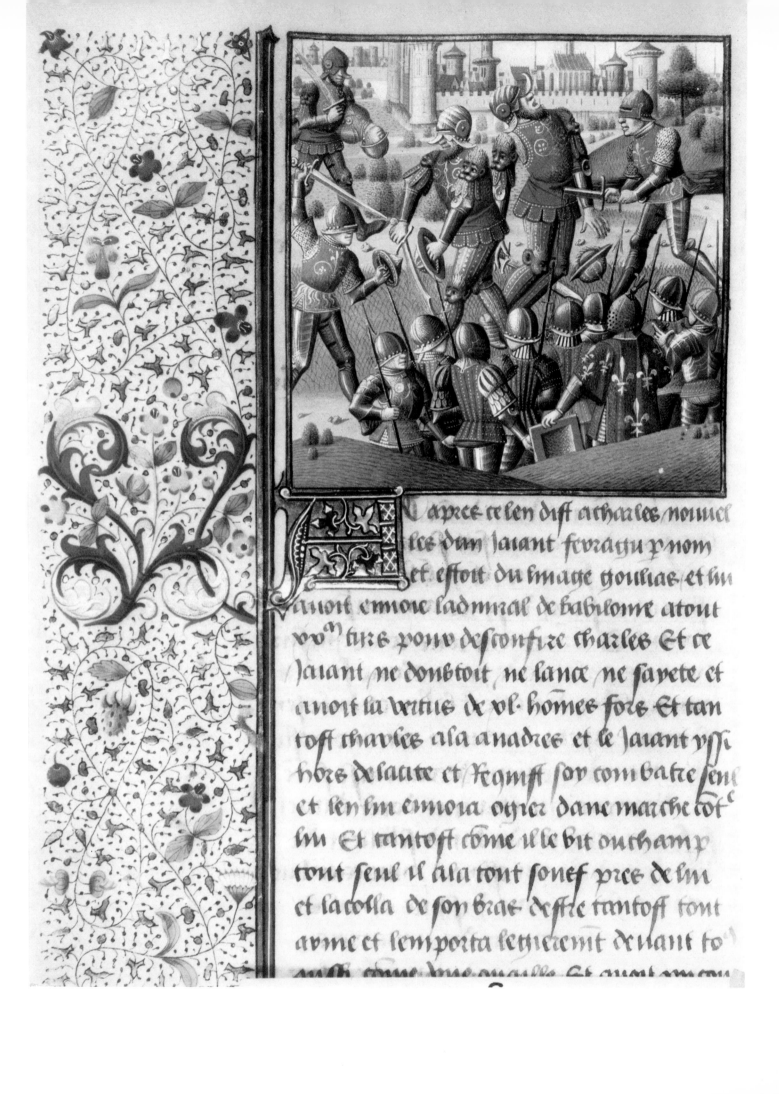

N apres ce len diff a charles nouuel
les dun saiant ferrail y nom
et estoit du image gtouliae et lui
auoit enuoie ladmiral de babiloine atout
vo m turs pour desconfire charles Et ce
saiant ne doubtoit ne lance ne sayete et
auoit la vertus de vi· homes fors Et tan
tost charles ala anadres et le saiant ysi
hors de la cite et segnist soy combatre seul
et len lui enuoia ogier dane marche tot
lui Et tantost come il le vit ou champ
tout seul il ala tout sonef pres de lui
et lacolla de son brae destre tantost tout
arme et semporta legierement delant to
auffi come vne ouaille Et auant en

gna z emporta sonneur soustenant lac
cusement vray quil auoit fait. Lors le
Roy commanda prendre gannes p les
quatre membres z atacher a quatre che
uaulx trans chascun dune part qui le
desmembrerent z ainsi fina miserablemt
ses iours .

Doncques estoient deux cymi
tieres principaulx Cest assauoir
lung a arelate/lautre a burdegalle les
quelz nostre seigneur auoit cousacrez
par les mains de sept saincts antistes
cest assauoir de maximin euesque de ac
quense de trop fin a telatence/de pol de
nerbône/de saturnin de thoulouze/ De
fronton de pierregort/de marcial de ly
moges z de eutrope de sainctes/en ces
deux cymitieres sut enseuelie la plus
grant ptie des mors/mais le roy char
lemaigne fist emporter Polland sur ii
mulletz en une litiere dozee couuerte
de poesles de drap dor z de saye iusques
a blaye z en leglise de môseigneur saict
rômain/laqlle il auoit fait faire z fon
der chanoines reiglez le fist enseuelir/z
puis en sonneur de iesucrist fist pendre
lespee dudit Polland sur sa teste z la tô
be dyuiere aux piez. Toutessoiz depuis
ung autre indigniemêt transporta cel
le tôbe a burdegalle en leglise de saict sy
meon/a belly furent enterrez oliuier/
gôdebauld roy de frise z roger roy de da
ce/arrastame roy de bretaigne z guert
duc de lorraine z plusieurs autres fu
rent enterrez a burdegale/cest assauoir
gayser roy du lieu/angelier duc dacqui
taine/lâbert roy de biturice/z gallere re
gnauld auec v . mil autres/pour les a
mes desquelz charlemaigne donna en
aumosne douze mille onces ou plus

De la sepulture des
cheualiers tuez a ro
ceuaulx ꝟ xxj .

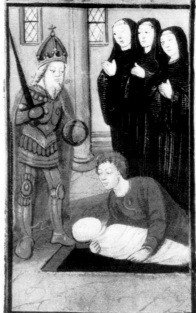

382. Roland fighting with Ferragut.

Miniature. *Miroir Historial* of Jean de Vignay. Chantilly, Musée Condé, ms, 722, fo. 110 vo. 1469-1473.

383. Burial of the knights killed at Roncevaux.

Miniature. *Miroir Historial* of Jean de Vignay. Paris, Antoine Vérard, 1495-1496. Paris, Bibliothèque Nationale, Réserve Vélin 650, fo. 129 ro.

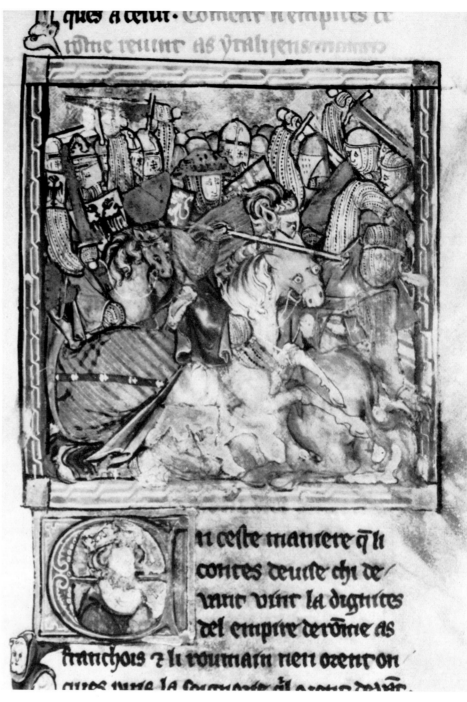

384. Roland killing Eaumont.

Miniature. *Trésor* of Brunetto Latini. Paris, Bibliothèque Nationale, f.fr. 567, fo. 20 ro. Late 13th – early 14th century.

385. Roland destroying the heathen idols.

Miniature. *Trésor* of Brunetto Latini. Paris, Bibliothèque Nationale f.fr. 573, fo. 29 vo. Mid-15th century.

386. Roland destroying the heathen idols.

Miniature. *Trésor* of Brunetto Latini. Florence, Biblioteca Laurenziana, ms. Ashburnham 52, fo. 31 ro.

Brunetto Latini, an Italian who was a staunch defender of the French language, gave no place to Roland in his encyclopedia. Nevertheless Roland appears in the illustrations to certain manuscripts of the Trésor.

ꝫ sousmist les persans a la loy de rome. ꝫ puis
tfu li mauuais pechieres mahomes qui fu
moines ꝫ les retraist de la foi ꝫ les mist e error

Comment lewis de france fu empere de rome

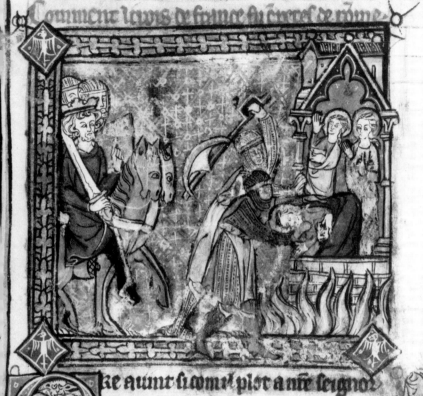

...ke auint si com il plot a nre seignor
...q sainte yglise en haucha ꝫ crut de lor
... en lor. s ceismemeut por la force ꝫ por
la seignorie qui fu al tans siluestre aquise. mais
li autre empereor qui aps constentin furent ne
storent mie si tous ne si debonaire. comil fu. auc
recouurissent volentiers ce q constentins auoi

prescheur mahommet qui fut mome et les
retrait de la foy et les mist en error Coment
le Roy de france fut empereur de Romme..

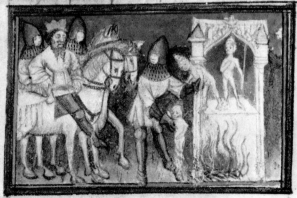

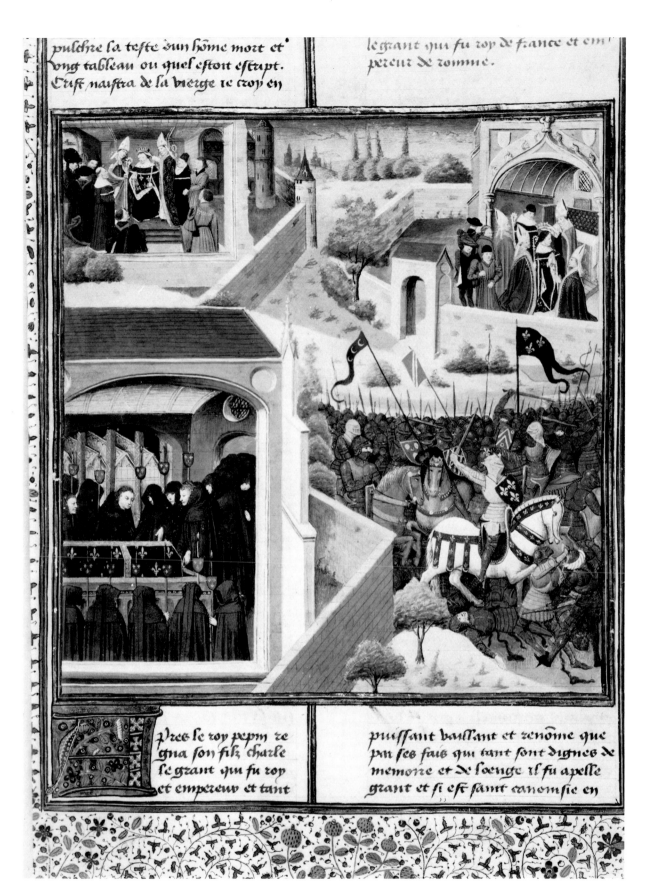

387. Charlemagne and Roland fighting against Agolant.
Miniature by Simon Marmion. *La Fleur des Histoires* of Jean
Mansel. Brussels, Bibliothèque Royale, ms. 9232 vol. II, fo.
337 vo. About 1455.

There is a wealth of material relating to Charlemagne and Roland in La Fleur des Histoires *of Jean Mansel.*

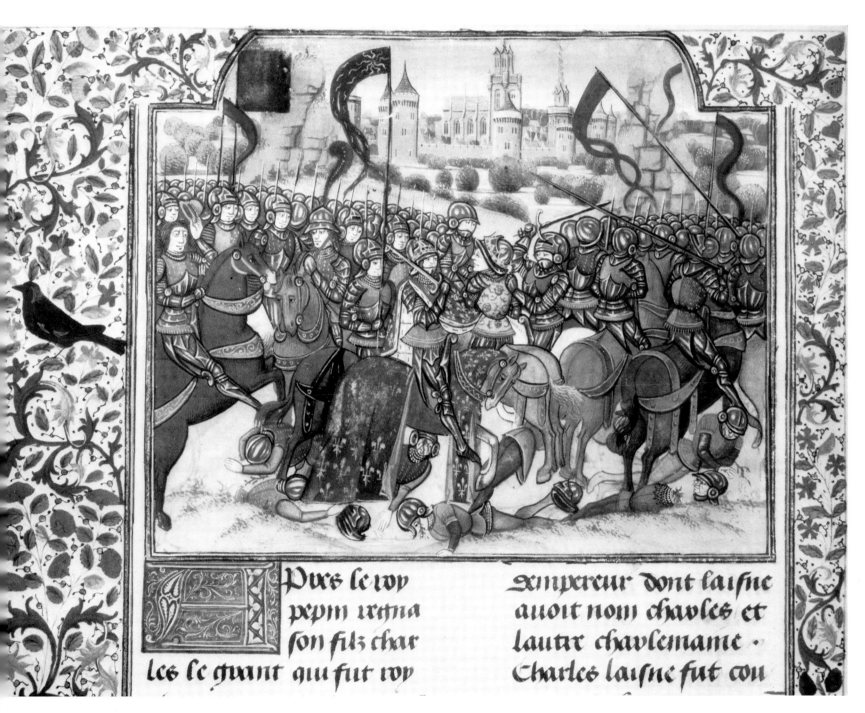

388. Roland saving the life of Charlemagne who is
being threatened by Eaumont.

Miniature. *La Fleur des Histoires* of Jean Mansel. Copen-
hagen, Royal Library, Thott 568, fo. 102 vo. Second half of
15th century.

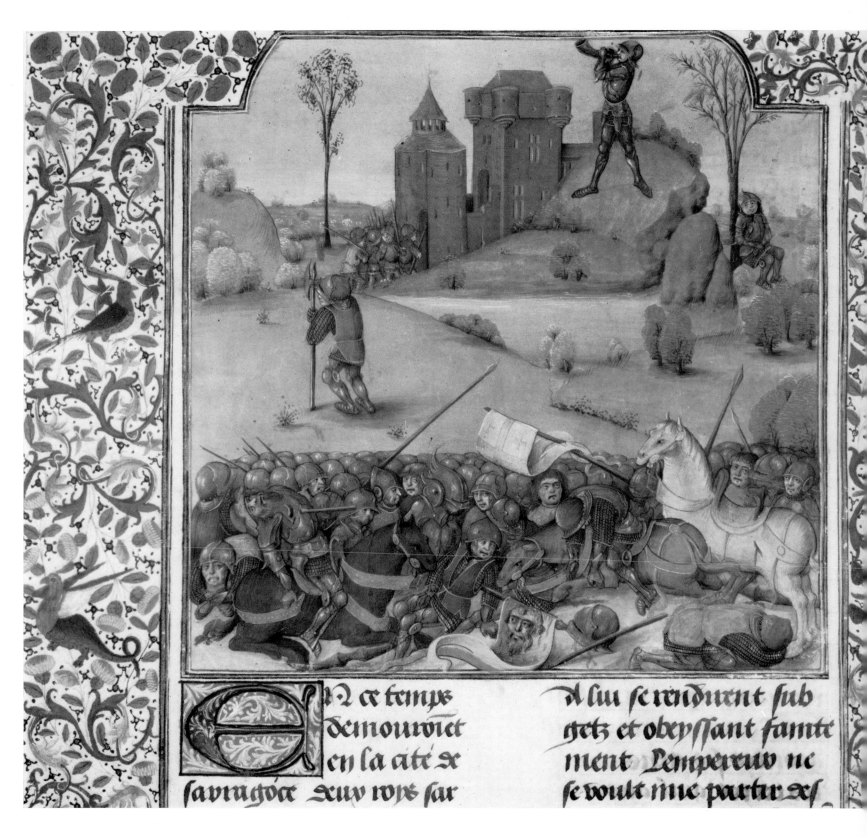

En ce temps
demouroit
en la cité de
saurragoce ceuy royx sar

A lui se rendirent sub
getz et obeyssant faine
ment Lemperur ne
se voult mie partir des

389. Scenes from the battle of
Roncevaux. Roland blowing his
horn.

Miniature. *La Fleur des Histoires* of Jean
Mansel. Copenhagen, Royal Library, Thott
568, fo. 121 vo.

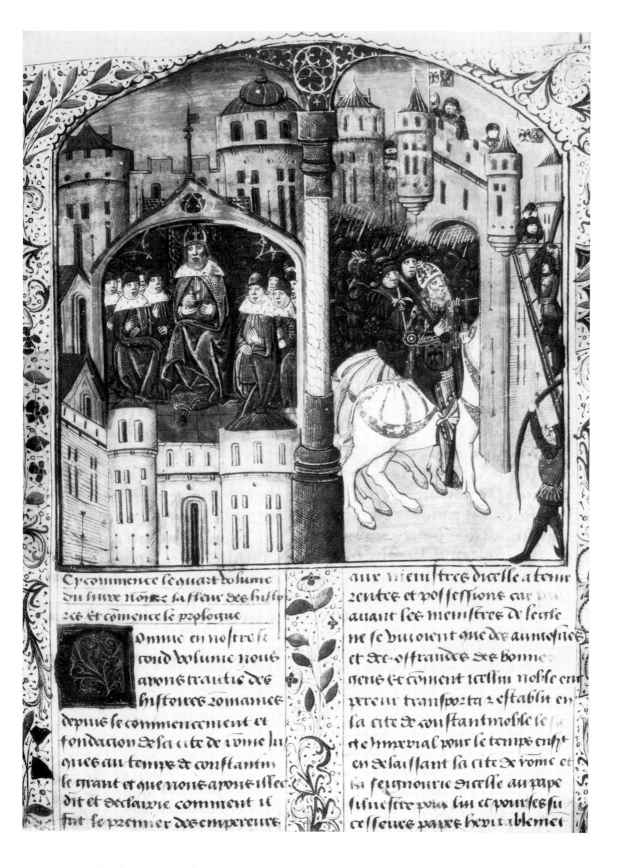

390. Charlemagne and his peers.
 Siege of a heathen city.

Miniature. *La Fleur des Histoires* of Jean
Mansel. Bern, Burgerbibliothek, ms. 31-
32, fo. 13 ro. Late 15th century.

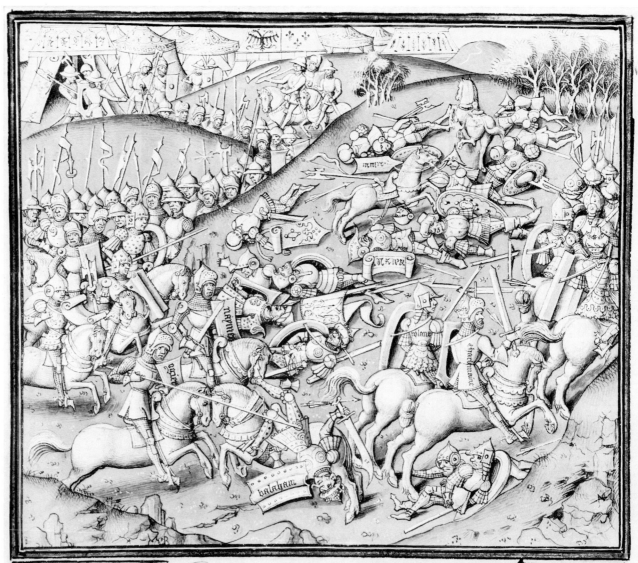

391. Charlemagne and Roland preparing to fight
Eaumont.

Grisaille. *Croniques et Conqueſtes de Charlemaine* of David
Aubert, illuſtrated by Jean le Tavernier. Bruſſels, Bibliothè-
que Royale ms. 9066, fo. 303 ro. About 1460.

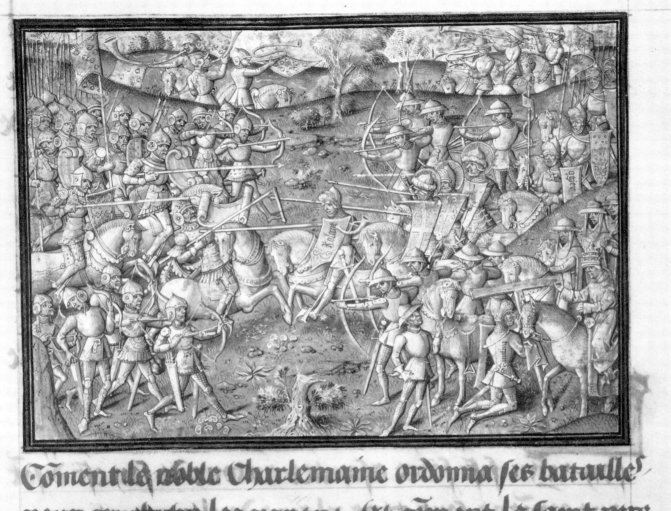

Coment le noble Charlemaine ordonna ses batailles
pour combatre les paÿens · Et coment le saint pere
ottroia a tous largueses de porter de tour la croix /

Istoire contient que auant le noble

392. Roland fighting the heathen king Agolant with the
help of St. George.

Grisaille. *Ibid.,* fo. 326 vo.

*This history of Charlemagne, a prose version drawn
from several* chansons de geste, *follows the story of the
Emperor's nephew from his youth to his death. Thus
the grisaille paintings of Jean Tavernier give a contin-
uous narrative which one could call the 'Chronicles and
Conquests of Roland'.*

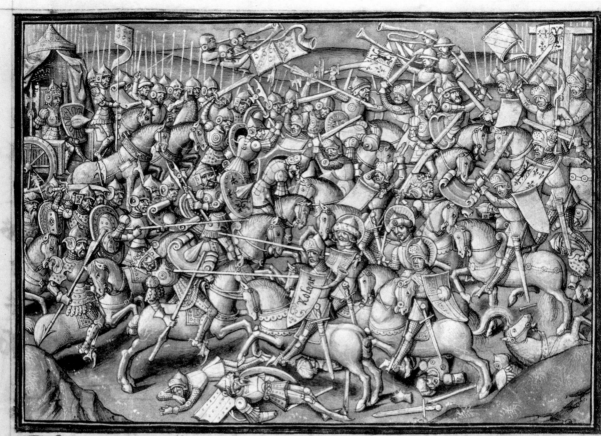

393. Roland killing the heathen king Iapher with the
 help of St. George.

Grisaille. *Chroniques et Conquestes de Charlemaine* of David
Aubert, illustrated by Jean le Tavernier. Brussels, Bibliothè-
que Royale ms. 9066, fo. 334 ro.

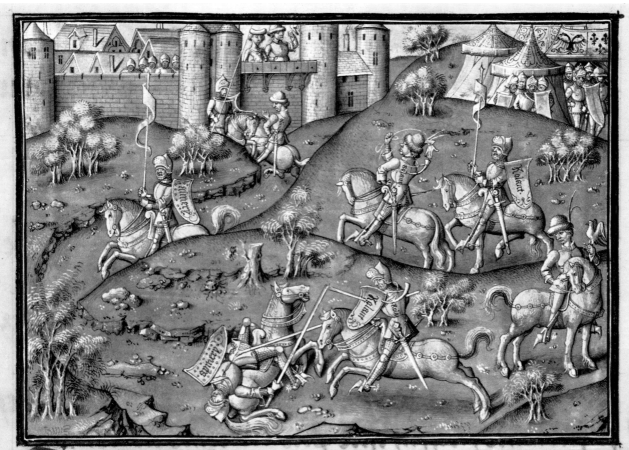

Comment rolant et oluuer sentreconqneu
rent et accointerent premerement ensemble
Et comment annerr de beaulande Jousta contre
rolant et fu abatu deuant la belle ande ꝛꝛ.

394. Roland meeting Oliver and Aude for the first time
 under the walls of Vienne in Dauphiné.
Grisaille. *Ibid.*, fo. 367 vo.

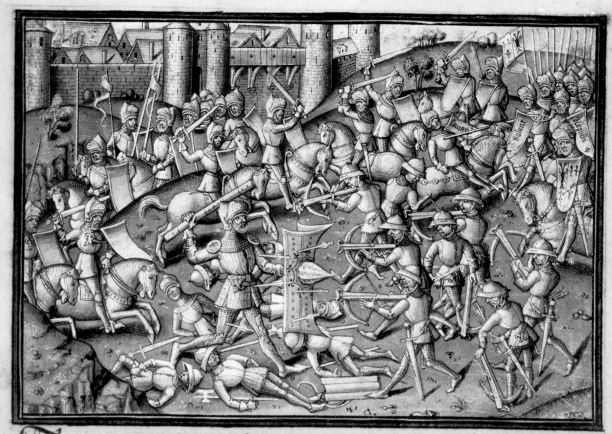

Comment le noble empereur et le duc rolāt
se rebouterent en la bataille.
G noble duc veant son oncle arme
et mis en pomt se partr du tref
ou il estoit car moult desiroit estre en lieu

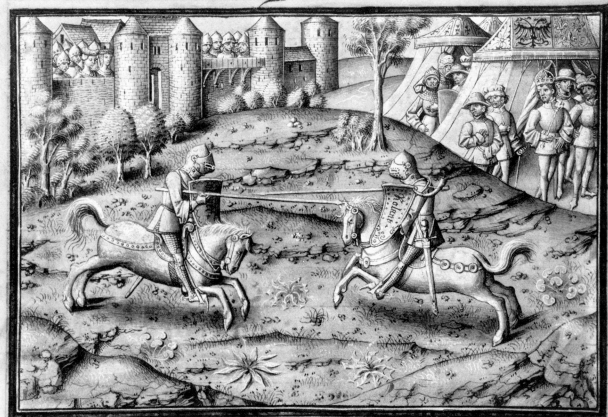

et cheuaucha droit vers le lieu ouquel le conte
oliuier lauoit Ia longuement attendu •

Comment le duc rolant / et oliuier de vienne se
combatirent / et menerent luy lautre Jusques

395. Roland fighting beneath the walls of Vienne.

Grisaille. *Chroniques et Conquestes de Charlemaine* of David
Aubert illustrated by Jean le Tavernier. Brussels, Bibliothè-
que Royale ms. 9066, fo. 386 ro.

396. The fight between Roland and Oliver under the
walls of Vienne.

Grisaille. *Ibid.,* fo. 427 ro.

397

398 399

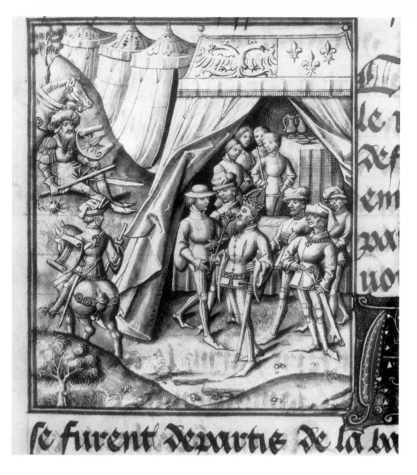

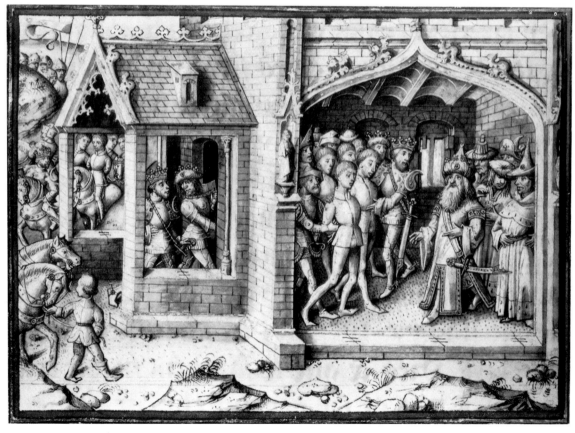

397. Roland witnessing Fierabras' challenge to
 Charlemagne.

Grisaille. *Chroniques et Conqueſtes de Charlemaine* of David
Aubert, illuſtrated by Jean le Tavernier. Brussels, Bibliothè-
que Royale ms. 9067, fo. 27 ro.

398. Roland and Oliver taken prisoner and brought
 before the king of the heathen.

Grisaille. *Ibid.,* fo. 44 vo.

399. Roland at the surrender of Renaut de Montauban.

Grisaille. *Ibid.,* fo. 182 ro.

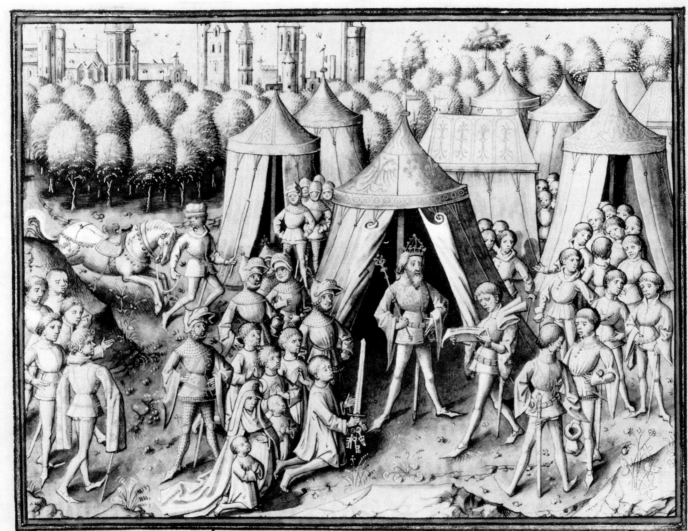

Comment le duc regnault ſe partr de la cite
de treſmoigne puis paſſa la mer conquiſt la

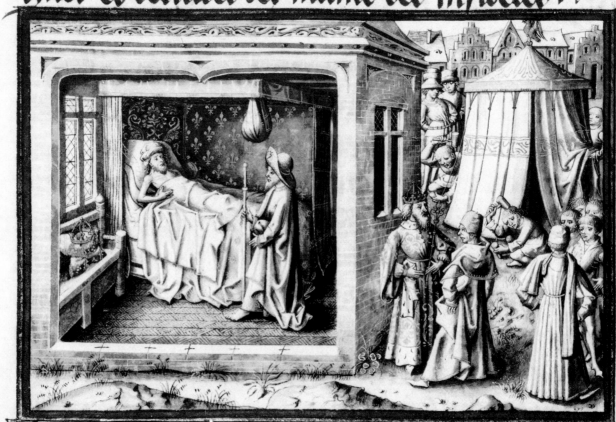

Istoire raconte que depuis que lem
pereur charlemaine fu parti du bon
pays de france et entre en allemaigne
ou il se tenoit voulontiers selon les besoingnes et

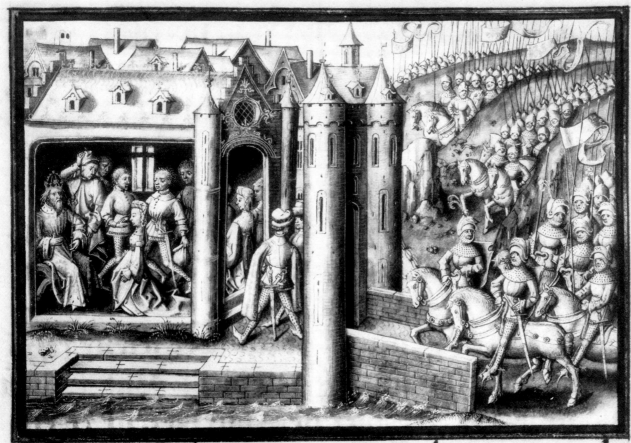

Lomment les grans oftz de lempereur char
lemaine faffamblerent au iour deuant dit
pour aler conquerir les espaignes / ℈◦
Iftoire maintient que au chief de

400. St. James appearing to Charlemagne.

Grisaille. *Chroniques et Conquestes de Charlemaine* of David
Aubert, illustrated by Jean le Tavernier. Brussels, Bibliothè-
que Royale ms. 9067, fo. 189 vo.

401. Roland and Oliver bringing to Charlemagne the
 troops which are about to leave for Spain.
 Betrothal of Aude and Roland.

Grisaille. *Ibid.,* fo. 193 ro.

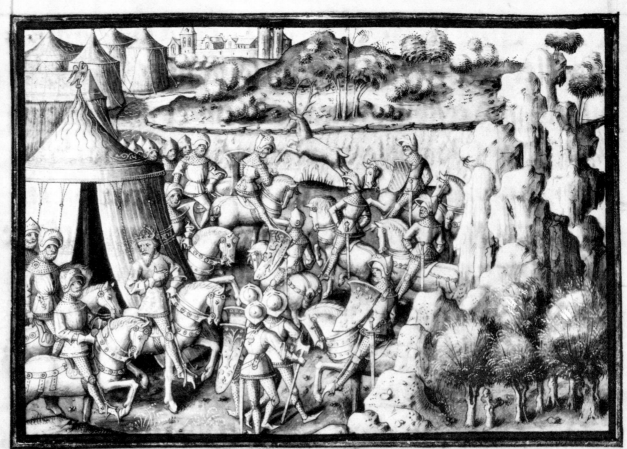

Comment les francois passerent geronde par
la grace de dieu et conquirent bordelle la cite a
lemprise du noble duc rolant·

Vant le noble charlemame ver le

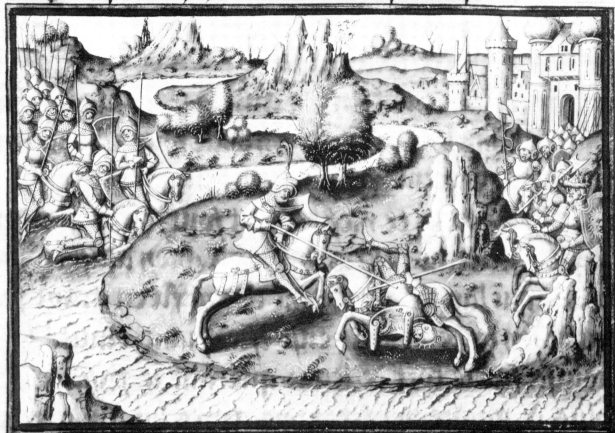

onqueß ſarrazin ne lauoit ainſi abuſe.

Comment le roy fourre fu occiß contre le gre de lē
pereur par oliuier de vienne qui venga la mort
de ſon frere gerier que fourre auoit occiß Et
...

402. Charlemagne, Roland and the Franks following an
 enchanted hind across the Gironde.

Grisaille. *Chroniques et Conqueſtes de Charlemaine* of David
Aubert, illuſtrated by Jean le Tavernier. Brussels, Bibliothè-
que Royale ms. 9067, fo. 198 ro.

403. Roland fighting in the meadows by the city of
 Noble.

Grisaille. *Ibid.,* fo. 205 ro.

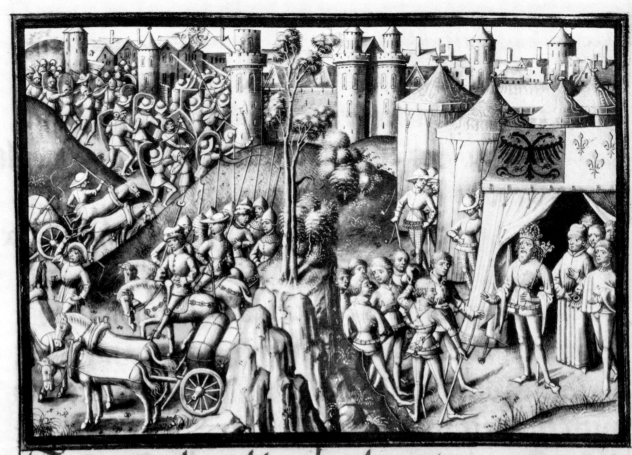

Comment le noble charlemaine reconquist
pampelune par la prouesse et entreprise du
duc rolant et des iennes chalieres
Vant les nobles barons et chalieres

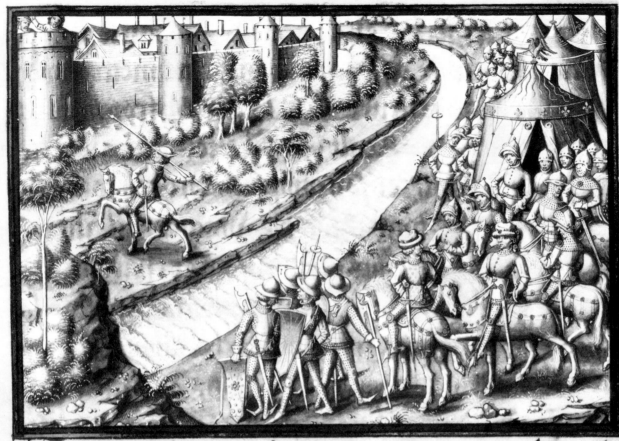

Ɩomment pampelune fu assegie par le noble
empereur Charlemaine qui y fu long temps
Es citez villes et chasteaux despaigne
fu la premiere que charlemaine voult

404. Charlemagne and Roland making final prepara-
 tions for the siege of Pamplona.

Grisaille. *Chroniques et Conquestes de Charlemaine* of David
Aubert, illustrated by Jean le Tavernier. Brussels, Bibliothè-
que Royale ms. 9067, fo. 214 ro.

405. Roland and Oliver at the siege of Pamplona.

Grisaille. *Ibid.,* fo. 218 vo.

tumeret dauoir guerres ne assaulz·

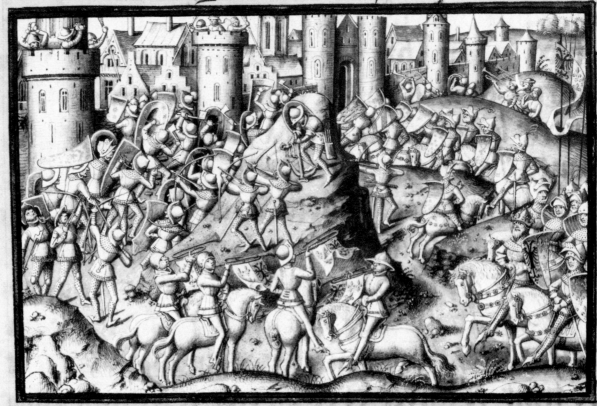

Comment la cite de pampelune fu prinse p
assault et puis rebaillie aux paiens par lem
pereur qui les pensoit conuertir par amour·
¶z bruit fu grant des cris en pampe
lune trant des femes come des enfans

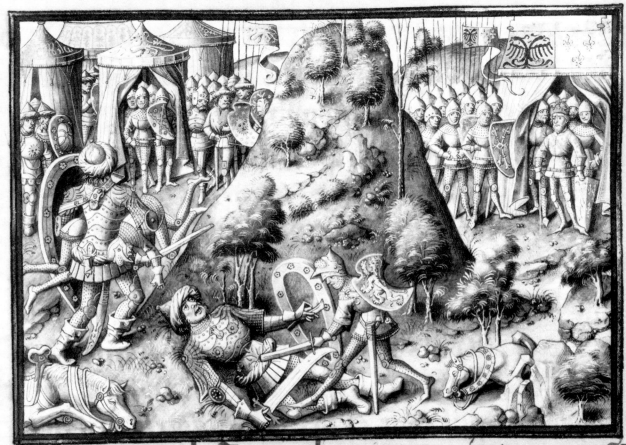

Lomment le duc rolant conquist vng iauād
terrible nomme fernagud et conquist nadzeß
la grant cite et de ses emprises.
Istoire dist que le noble duc conqst

406. Roland leading the final attack on Pamplona.
Grisaille. *Chroniques et Conquestes de Charlemaine* of David
Aubert, illustrated by Jean le Tavernier. Brussels, Bibliothè-
que Royale ms. 9067, fo. 221 ro.

407. Roland killing Ferragut.
Grisaille. *Ibid.,* fo. 227 vo.

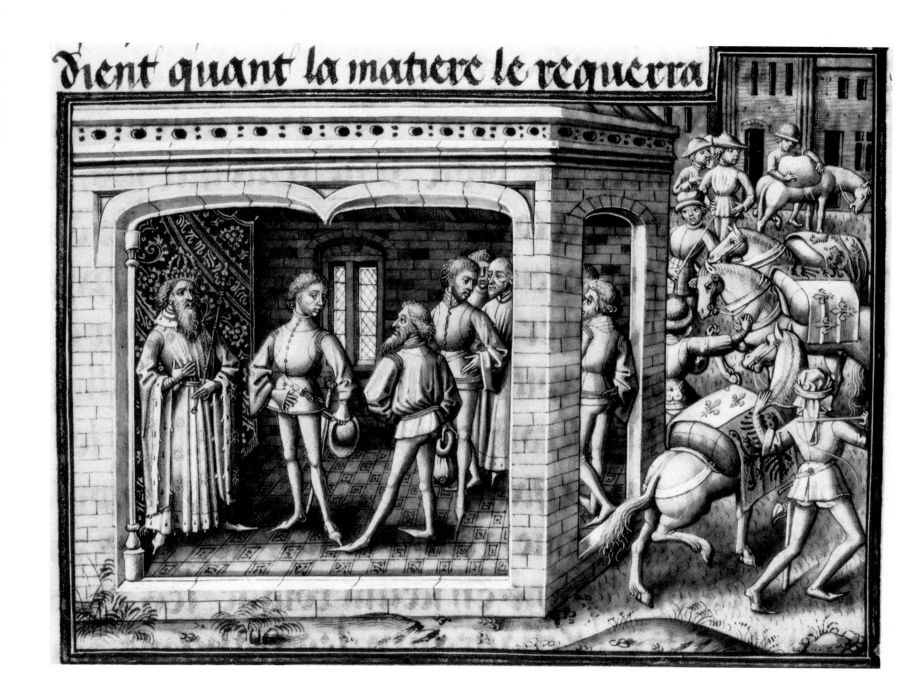

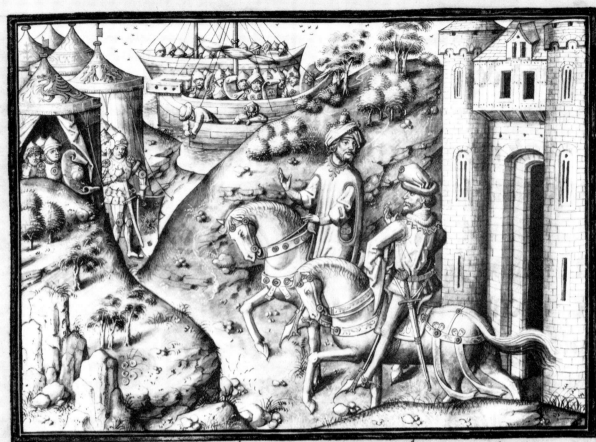

Lomment la trahison de raincheuaulx fu com
pilee accordee et bastie par mazalle de sarragoce
et guennelon le conte des pans de champagne
Jstoire tesmoingne beritablement

408. Charlemagne and Roland receiving the fatals gifts
 which Ganelon has brought back from Saragossa.
Grisaille. *Chroniques et Conquestes de Charlemaine* of David
Aubert, illustrated by Jean le Tavernier. Brussels, Bibliothè-
que Royale ms. 9067, fo. 238 vo.

409. Ganelon conspiring with Marsile.
Grisaille. *Ibid.,* fo. 252 vo.

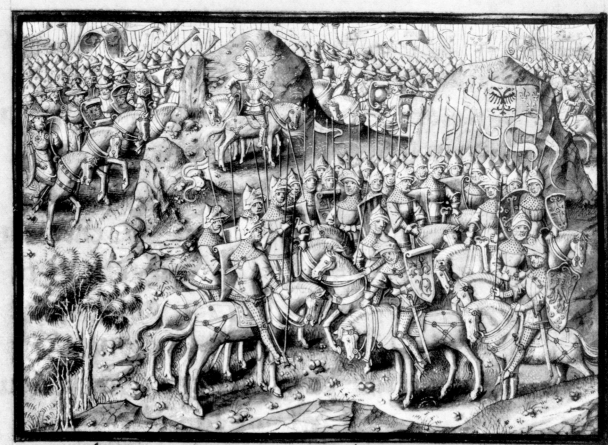

pour le mieulx. Et conclurent ensemble que
des icelle nuit se partiroient eulz et leurs gens
et se logeroient secretement en lieu dont ilz

ma mozt lequel nous a faulsement trahr.

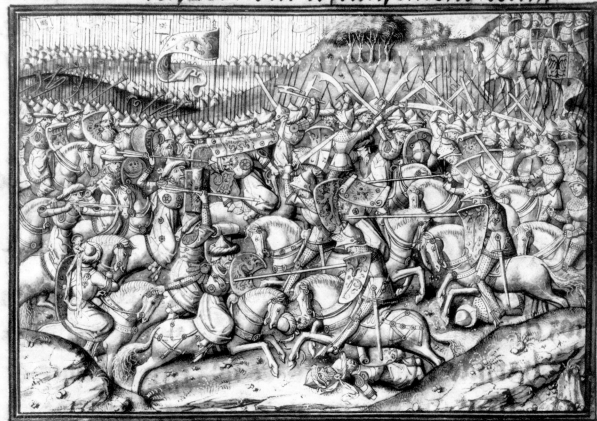

Comment le noble duc rolant le conte oluuer
et les douze pers de france se combatirent a lad
miral marsille qui les faisoit guaittier en la
vallee de ramcheuaulx acompaignes de les gens

410. The ambush at Roncevaux.

Grisaille. *Chroniques et Conquestes de Charlemaine* of David
Aubert, illustrated by Jean le Tavernier. Brussels, Bibliothè-
que Royale ms. 9067, fo. 271 ro.

411. Roland in the thick of the battle at Roncevaux.

Grisaille. *Ibid.,* fo. 275 vo.

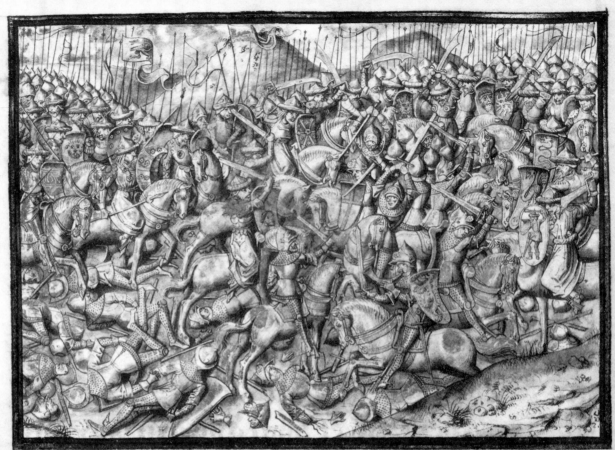

Comment le duc rolant sonna son olifant contre
la voulente de oluier son compaignon lequel
len auoit par auant requis tant Instamment

Istoire certiffie que quant le bon

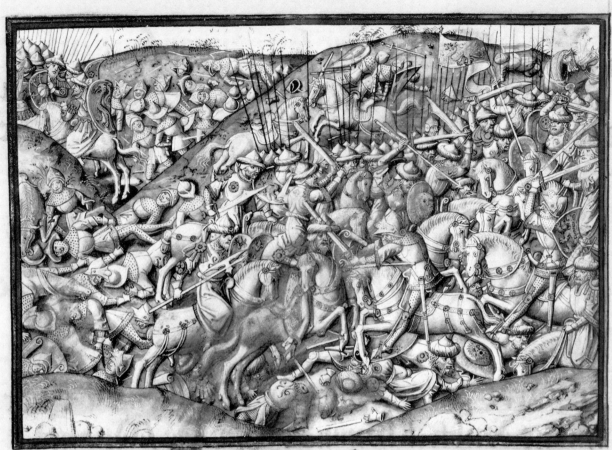

Comment le noble duc rolant et oliver le vail
lant conte mozurent en ramcheuaulx/par la
trahyson et pourchas du desteal guennelon.
Uftoire racompte que rolant sonna

412. Roland blowing his horn.

Grisaille. *Chroniques et Conqueftes de Charlemaine* of David
Aubert. Brussels, Bibliothèque Royale ms. 9068 fo. 1 ro.

413. Roland wounding King Marsile.

Grisaille. *Ibid.,* fo. 6 vo.

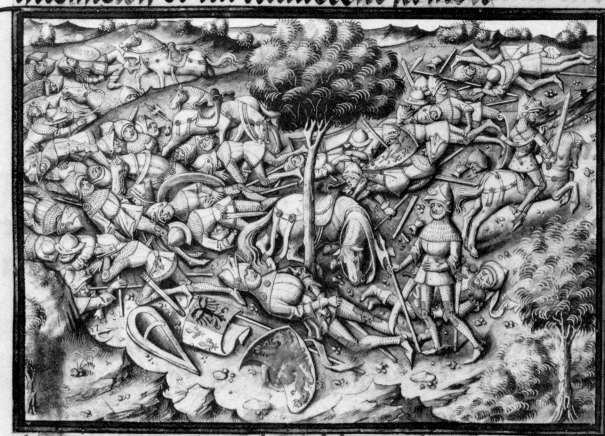

Comment rolant le noble combatant mozu
en la tresdoloureuse iournee de raincheuaux

Our ce que listoire des quatre filz
hemon nest point a mettre aucase

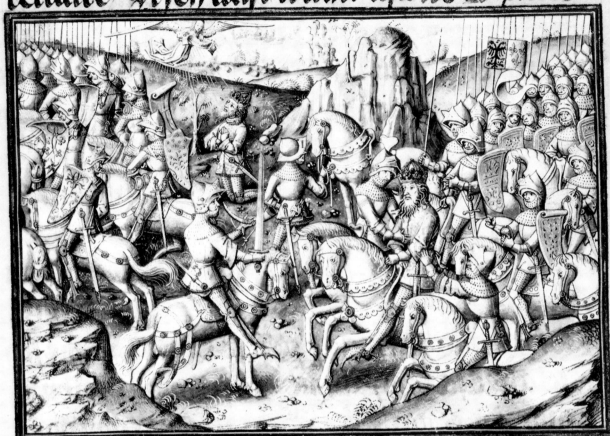

choit le soir pourquor thiervr ne se sauoit ou
retraire Si sen tuist a tant listoire et parle .

Comment le tres puissant et victozieux
empereur charlemame sceut la trahyson

414. Baudouin with the dying Roland.

Grisaille. *Chroniques et Conquestes de Charlemaine* of David
Aubert. Brussels, Bibliothèque Royale ms. 9068, fo. 12 vo.

415. Charlemagne learning of Roland's death and
 receiving Durandal from Baudouin. An angel
 telling Charlemagne of the miracle of the sun
 halted in its course.

Grisaille. *Ibid.,* fo. 20 ro.

ne demy ame mozu de dueil amsi que cy apzes
sera dit Et atant sen taist listoire et deuise.

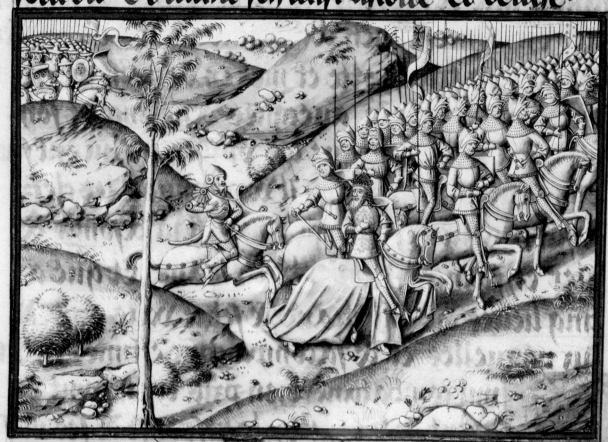

Comment baligant fu desconst et mozt en ba
taille par charlemaine et conquis sarragoce.
Istoire dist que quant mazalle et

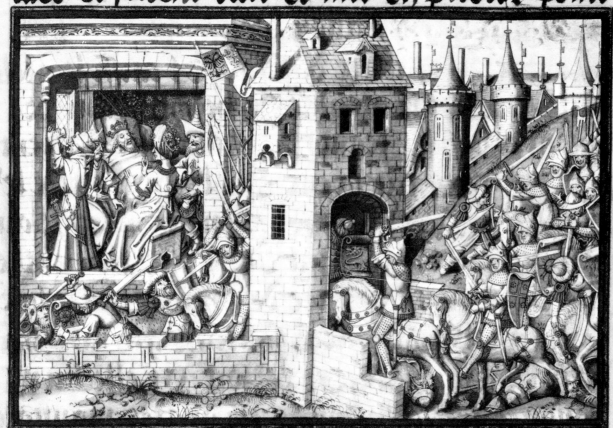

endoz et qui ne peurent fuir demourerent
illec et furent vais et mis en piteux point·

Comment la cite de sarragoce fu conquise et
comment le roy mazalle mozu de couroux·/

416. Charlemagne is challenged by Baligant and
prepares to fight him.

Grisaille. *Chroniques et Conquestes de Charlemaine* of David
Aubert. Brussels, Bibliothèque Royale ms. 9068, fo. 27 vo.

417. Marsile dying at Saragossa, as the Christians take
the city.

Grisaille. *Ibid.,* fo. 37 vo.

cognoiffance / comme de la bataille et ou iuge
ment fera cy apzes faitte mention au long .
Si fe taift a tant liftoire de la piteufe defco
fiture de ramcheuaulx et deuife

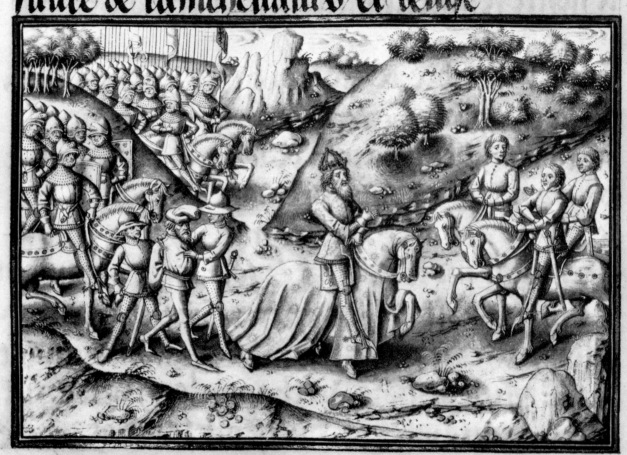

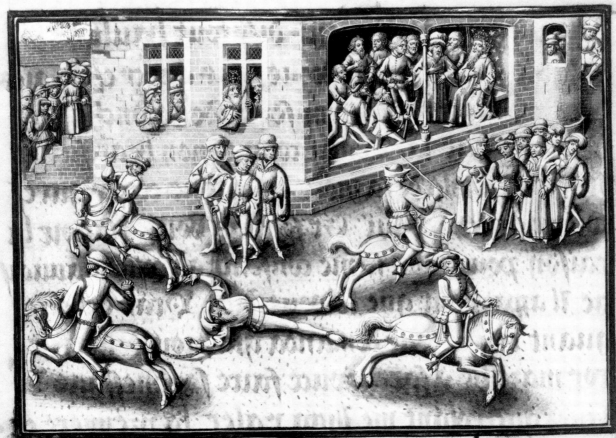

Comment guennelon conte de champaigne
fu iugie a morir honteusement par les pn
ces et barons de la court du bon charlemaine
... Iour anxes le champ et descon

418. Charlemagne arresting Ganelon and handing him
over to the kitchen-boys.

Grisaille. *Chroniques et Conquestes de Charlemaine* of David
Aubert. Brussels, Bibliothèque Royale ms. 9068, fo. 45 ro.

419. Ganelon's trial and punishment.

Grisaille. *Ibid.,* fo. 94 ro.

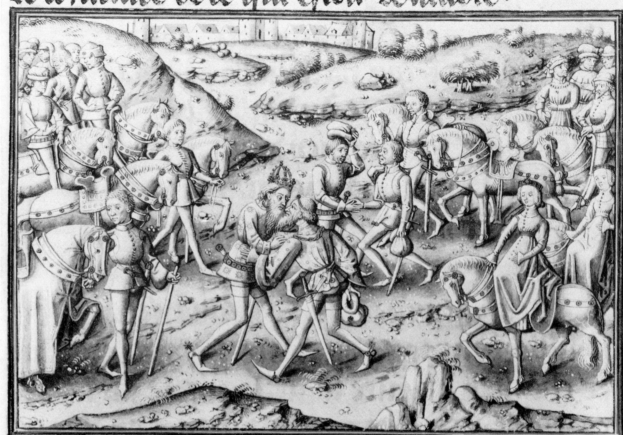

le contraire de ce qui estoit veritable.

Comment le puissant empereur ala au deuant du noble duc gerard de bienne et de sa mepce ande la suer du conte oliuier. Charlemaine sachant certamen̄t

420. Aude and Girart de Vienne coming before
 Charlemagne.

Grisaille. *Chroniques et Conquestes de Charlemaine* of David
Aubert. Brussels, Bibliothèque Royale ms. 9068, fo. 59 vo.

421. Charlemagne and Roland on horseback.

Pen-drawing. *L'Histoire de Charlemagne en forme d'Heures.*
Paris, Bibliothèque Nationale, f. fr. 4970, fo. 2 ro. Late 15th
century.

bien en amer la vie vient de la pierre
aimentee vndes et par baptesme lee
gens mundes

ar ait tu plores les dius par
nature et aussi les murs en
braues puerts les bons dedics les mau
uais o lespre desfies

es aculx o trsdigne boire seru
teur prudent feal montioie
bien sest garni de tour et de cite et au
lieu de paix est asse

ouge donc le ror ou le fer et le
font vif nous fay veoir prie
a dieu piteusement quil nous soit a
sauuement

la trinite soit louenge la maieste
et honneur a sa vnite laquelle
par vertu principal droictement regne
en esgal. Amen. Chappitre

enes filles de iherlin auances
vous filles de sron et boiez le

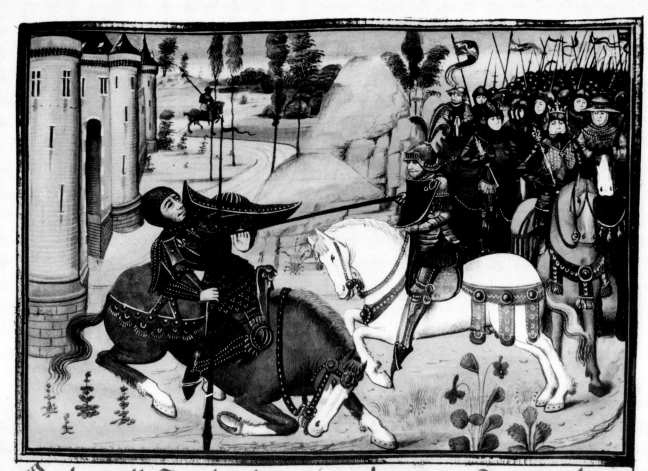

La bataille de Charlemaine alencontre de agoulant
& de Jaumont son filz et dautres faiz·

[initial B] ien auez ouy dessus coment Charlemaine
roy de france fu couronne a empereur par
la main de pape lion en la cite de romme·

Mais quant il fu retourne en france et quil y eut seione
vne espace· nouuelles luy vindrent que agoulant vng
puissant prince dauffrique auoit enuoie Jaumont son filz
en espaigne pour conquerir toute la terre·Il auoit si tres
grant nombre de sarrazins auec luy qua grant redoubt
lousoit nulluy attendre·Lempereur Charlemaine ne voult
pas longuement seiourner aincois semonst ses oftz et ala
celle part a grosse puissance·Il le trouua en aspremont et
le combatr tant quil le desconfit et occist luy et la plus part
de ses gens et le remanant se mist en fuite·▬

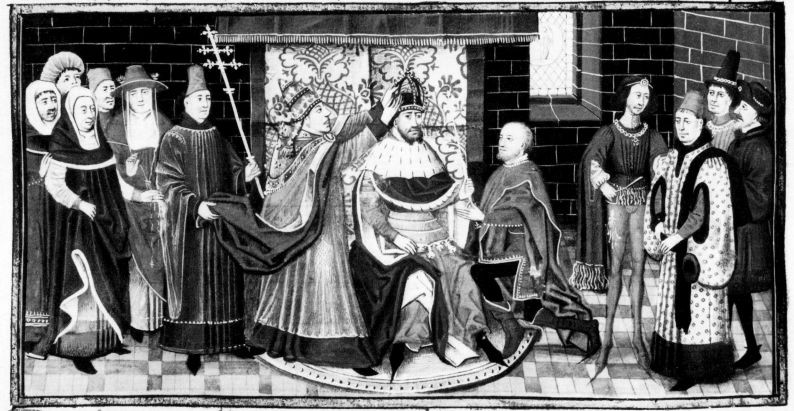

or lauons a parler de lempereur melxeforum Si bous parle
rons des haultes œuures du noble Charlemaine ror de franc

De plusieurs batailles que Charlemaine eut alencontre

422. Roland as Charlemagne's champion.

Miniature by Loyset Liédet. *Chronicle of Baudouin d'Avesnes.*
Paris, Bibliothèque de l'Arsenal, ms. 5089, fo. 168 vo. 1462.

423. The young Roland attends Charlemagne's
 coronation by the Pope.

Miniature by Loyset Liédet. *Chronicle of Baudouin d'Avesnes.*
Ibid., fo. 162 vo.

Angelicus pastor de quo supra dictum est qui coronat
karolum regem francie impatorem corona spinea
respuentem coronam auream ob reuerentiam xpi
coronati corona spinea.

: fi da per conofer uare la fanita effa fara tale riprentione
naro po che e digefto & fmaltito da tale nutriméto al cor

RTIA CANTICA DIDANTHE.

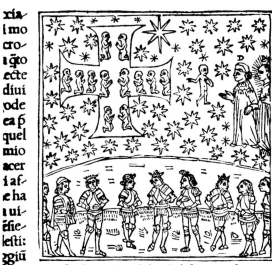

xia
l mo
cro
l gto
ecte
diui
ode
ea p
quel
mio
acer
i af
e ha
l ui
ctie
lefti:
ggiu
l in
lice.
a tal
loue
.i. a

g

la fi godea folo del fuo uerbo
gllo fpechio beato &io giuftaua:
lomio téprando có dolce lacerbo
Et quella donna chadio mi menaua.

_Par conduicte de Beatrix
De Mars les bons chlrs monftée
pour la croix purs au ael iours
Les Juftes Juges nons remonftee._

424. Roland as a youth at Charlemagne's coronation by the Pope.

Ink and wash. *Cronicon Imperatorum et Pontificum.* Modena, Biblioteca Eſtense.

425 A. Roland placed beside Charlemagne in the fifth Heaven of Paradise.

Woodcut. Dante, *La Divina Commedia.* Venice, Pietro de Piasi, 1491, 18th November. Liège, Bibliothèque de l'Université, XV cent., B.183.

425 B. Roland placed beside Charlemagne in the fifth Heaven of Paradise.

Woodcut. Dante, *La Divina Commedia.* Venice, Math. Capcasa, 1493, 29th November. Liège, Bibliothèque de l'Université, XV cent., B.182.

426. Roland placed beside Charlemagne in the fifth Heaven of Paradise.

Miniature. Dante, *Divine Comedy,* French translation by François Bergaigne. Paris, Bibliothèque Nationale, nouv. acq. fr. 4119, fo. 101 vo.

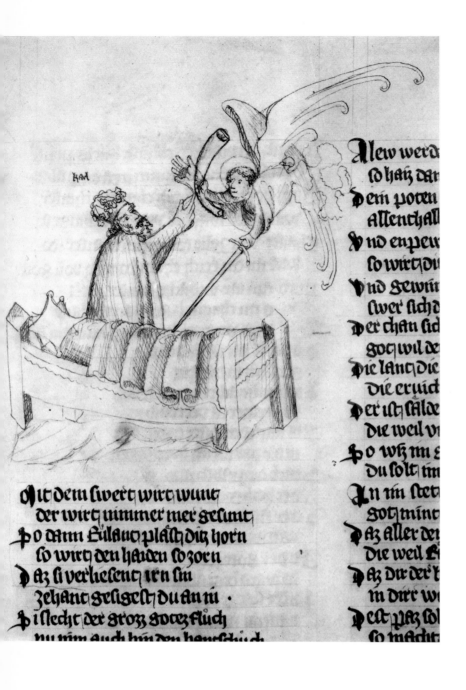

olt dem swert wirt wunt
der wirt nimmer mer gesunt
o dann Rulant plast dir horn
so wirt den haiden so zorn
az si verliesent iren sin
zehant gesigest du an in .
i slecht der groz gotes fluch
nu nim auch hin den hantschuch

lew werd
so haz dar
dem poten
Allenthall
nd enpeu
so wirt du
nd gewin
swer sich d
der chan sich
got wil de
die lant die
die erwich
der ist salde
die weil v
o wiz in g
du solt im
In im stet
got min
az aller der
die weil k
az dir der k
in dir w
en waz sol
so macht

dirz horn hartzt auch Oliuant
iz chlamor gib Rulant penden
ich sag dir welcher haiden
it dem siwt wirt wunt
der wirt nimmi mer gesunt
o dann Rulant plast dir horn
so wirt den haiden so zorn
az si verliesent irn sin
zu hant gesigst du an in
i slecht der groz gotes fluch
nu nim hin den hantschuch
nd stoz den an dein hant
so du varst in die lant

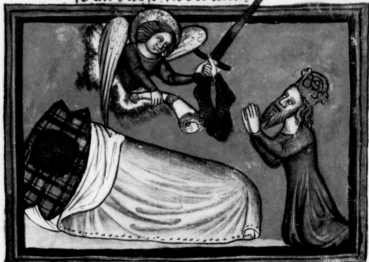

nd dien nach deinem lon
die ewis chron
alt du zu himel tragen
daz hier dir got dir umb sagen
az an leib und leben

427. An angel giving Charlemagne the sword and horn
 destined for Roland.

Pen-drawing. *Weltchronik* by Henry of Munich. Munich,
Staatsbibliothek, ms. sgm. 7377, fo. 262 vo.

428. An angel giving Charlemagne the sword and horn
 destined for Roland.

Miniature. *Christherrechronik.* New York, Pierpont Morgan
Library, ms. 769, fo. 338 vo.

429. Charlemagne and Roland receiving a messenger.

Ink and wash from the workshop of Diebold Lauber. *Sieben
Weise und Martin von Troppau Chronik,* Heidelberg, Univer-
sitätsbibliothek, Palat. Germ. 149, fo. 184 ro. About 1450.

Eij

Diß saget vns von dem Römischen keyser dem gro=
ssen karolo

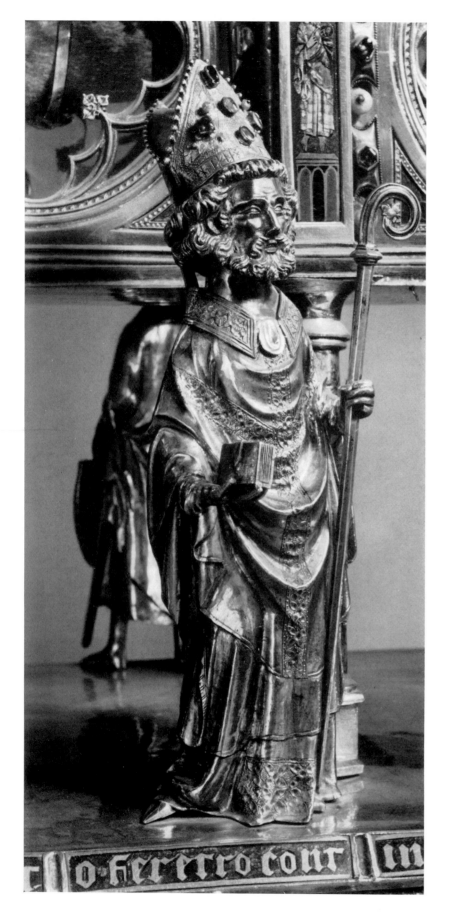
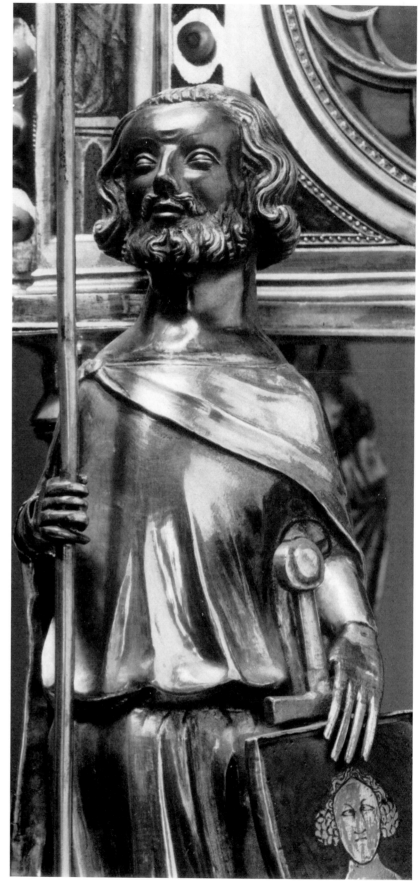

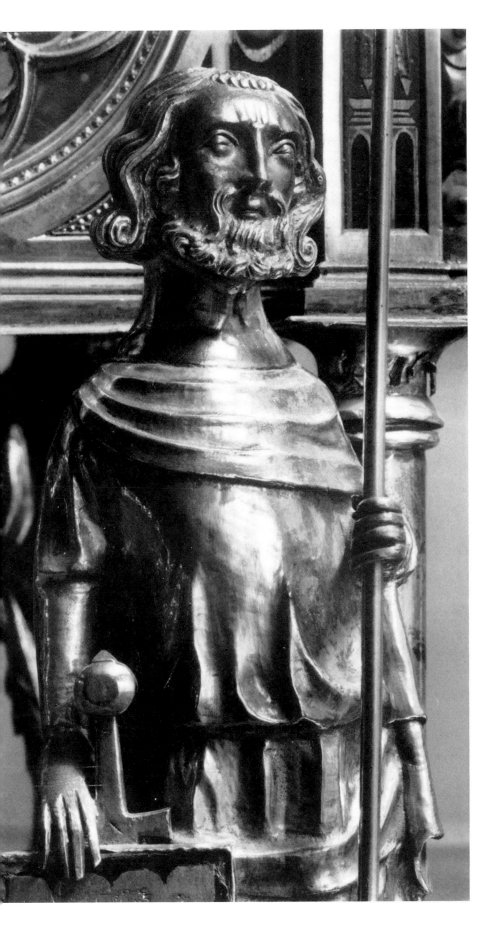

Roland and Oliver can be identified by the arms on their shields.

430. Turpin.
Silver statuette from the Reliquary of St. Charlemagne. Aix-la-Chapelle, Cathedral treasury. About 1360.

431. Oliver.
Silver statuette from the Reliquary of St. Charlemagne.

432. Roland.
Silver statuette from the Reliquary of St. Charlemagne.

433. Roland's coat of arms.
Detail, reliquary of St. Charlemagne.

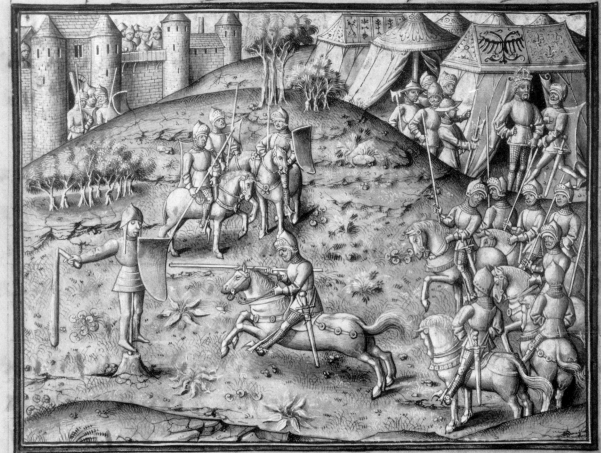

Coment le duc rolant fist dresser une qntaine deuāt
la cite de biēne et comēt oliuier la bouta par tre, puis
print prisonnir lambert de mascon q̃ lui fu propice.

434. Roland has a quintain erected outside the city of
 Vienne.

Grisaille by Jean le Tavernier. *Croniques et Conquestes de
Charlemaine* of David Aubert. Brussels, Bibliothèque Royale,
ms. 9066, fo. 414 vo. About 1460.

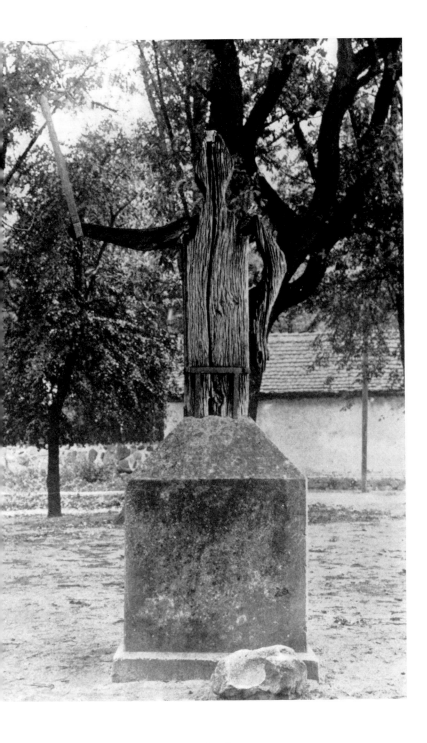

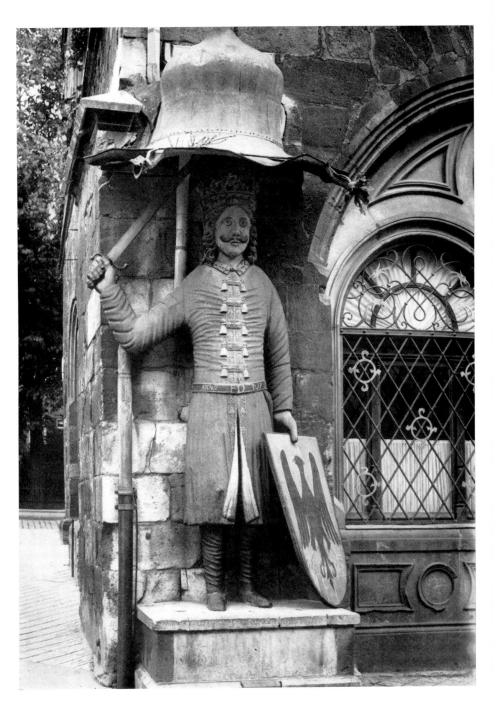

435. The Potzlow Roland.
Woodcarving. Restored after 1806.

436. The Nordhausen Roland.
Woodcarving. Restored in 1717.

The giant statues of Roland in Germany are complex symbols. They are found especially in the regions around the Elbe. From the 14th century onwards they inspired similar statues in Bohemia, Franche-Comté and Dalmatia.

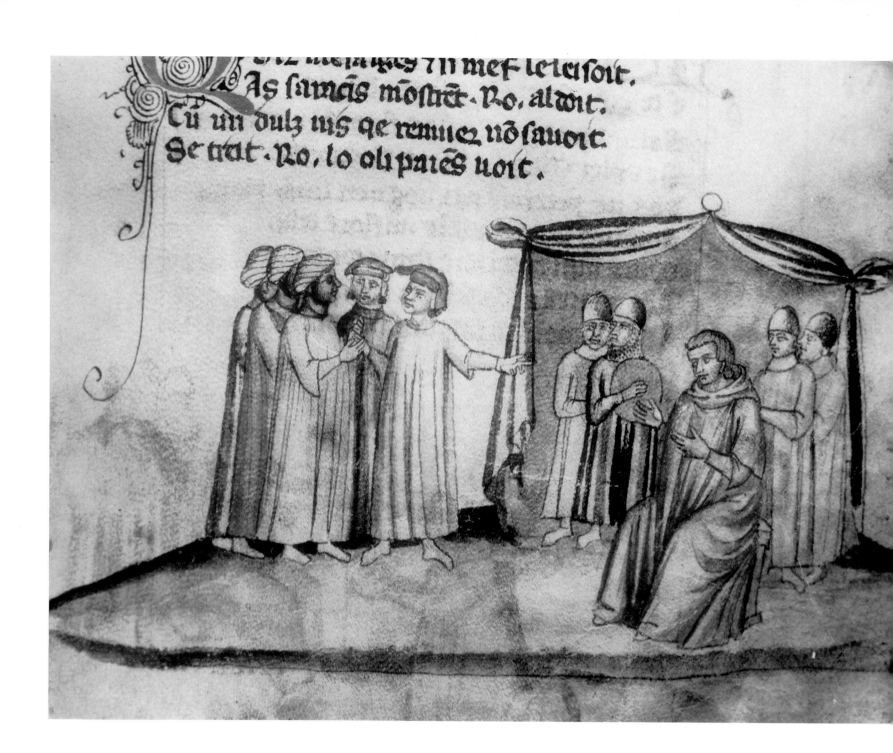

437. Roland promising to spare the life of all citizens
 of Nájera who agree to be baptized.

Miniature. *L'Entrée d'Espagne.* Venice, Biblioteca Marciana,
cod. fr. XXI, fo. 82 ro. About 1350.

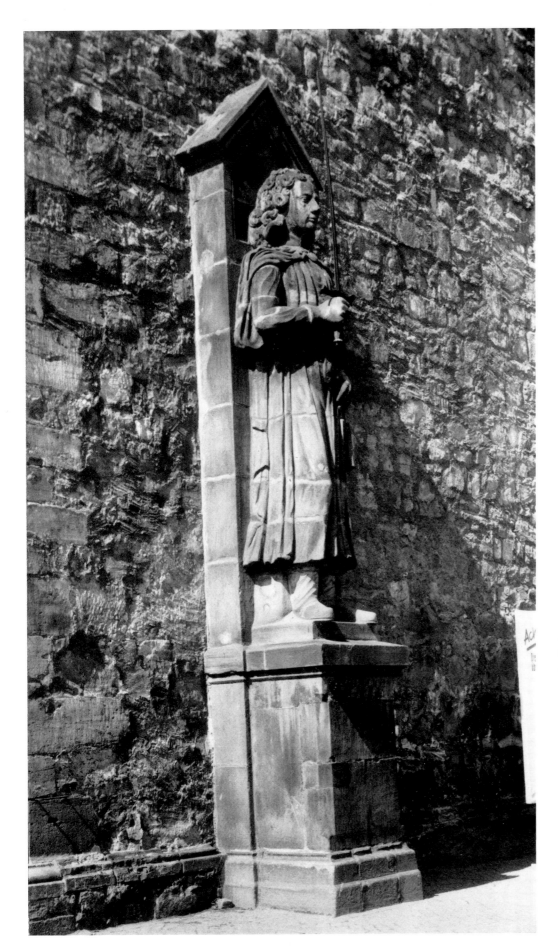

438. The Halle Roland.
Sandstone copy of 14th century wooden statue.
After 1719.

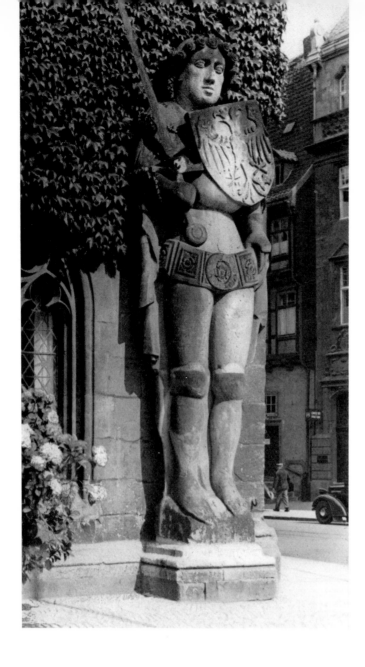

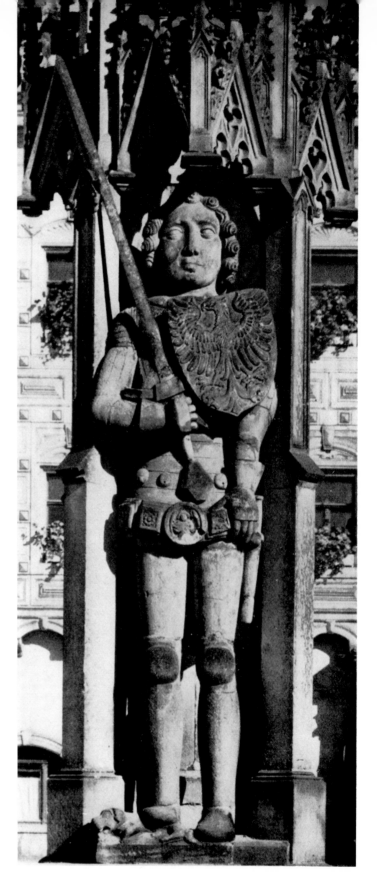

439 441

440

439. The Halberstadt Roland.
Stone statue. 1433.

440. The Hamburg Roland.
Stone statue. First half of 14th
century after (Preyer).

441. The Zerbst Roland.
Stone statue. About 1445.

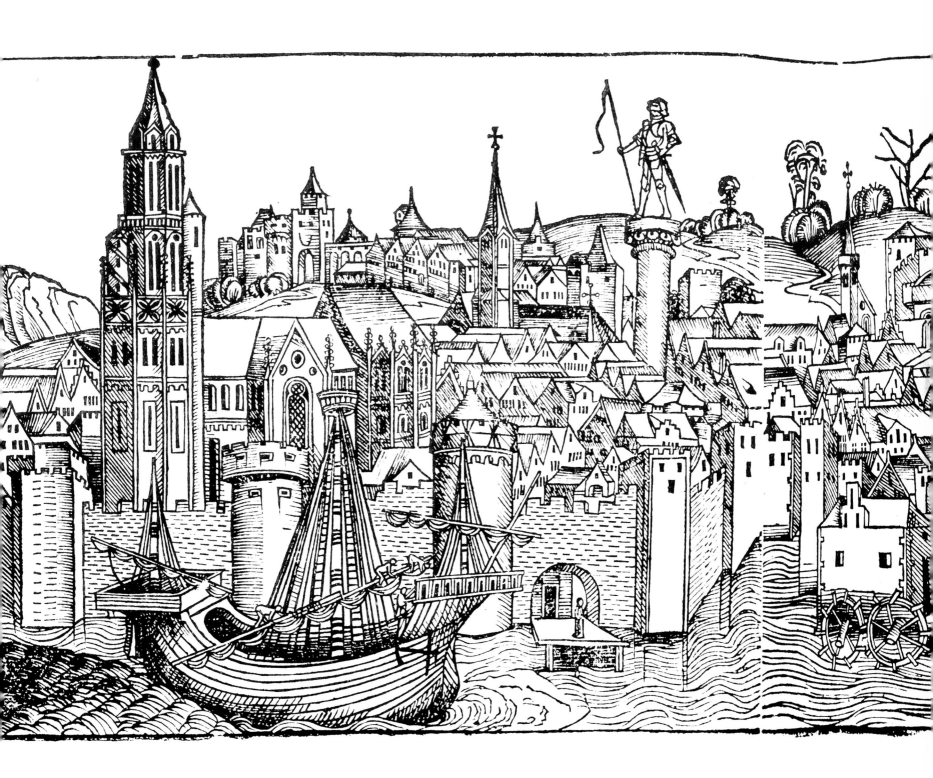

442. The Magdeburg Roland.
Panoramic view of the town with the statue. Woodcut. Hart-
mann Schedel, *Chronica Chronicorum*, Nuremberg, 1493.

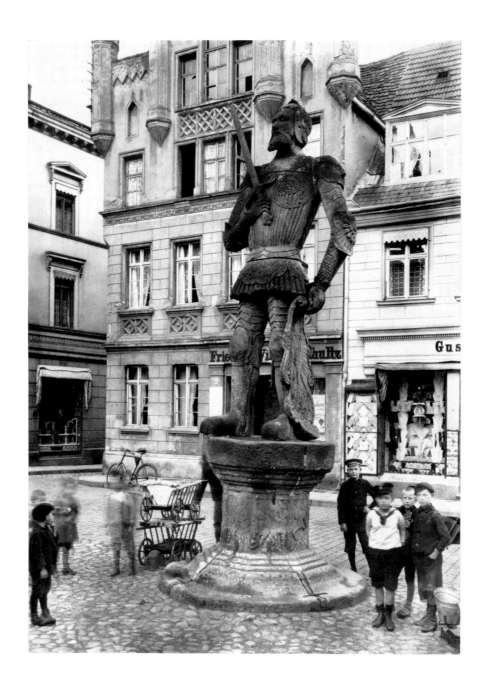

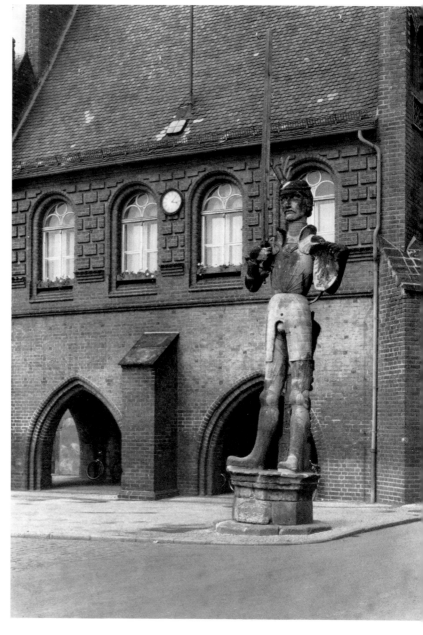

443. The Perleberg Roland.
Stone statue. About 1498.

444. The Stendal Roland.
Stone statue. 1525.

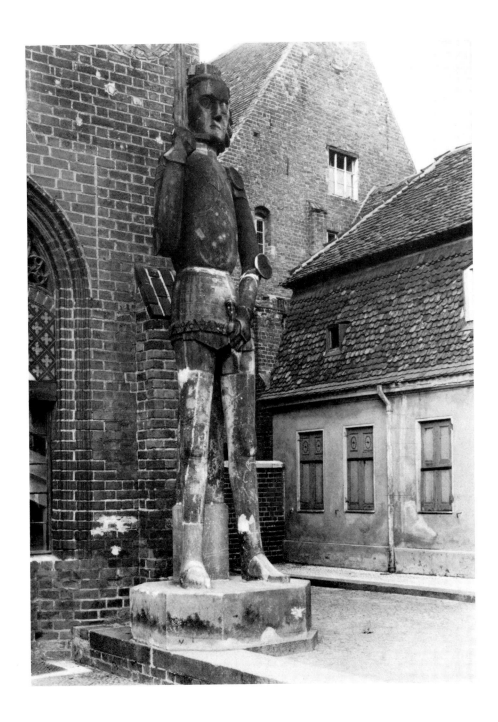

445. The Brandenburg Roland.
Stone statue. 1474.

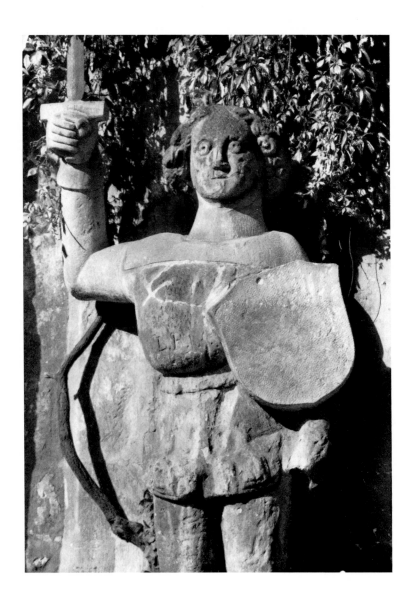

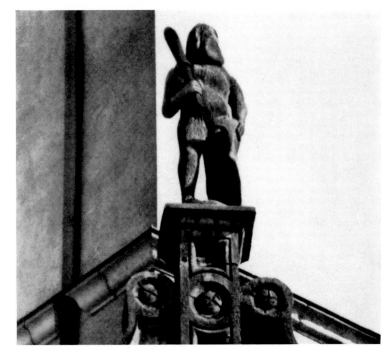

446. The Quedlinburg Roland.
Stone statue. About 1460.

447. Head of the Prenzlau Roland.
Stone. 1496. Municipal museum.

448. The Litoměrice Roland.
Stone statue. 1539.

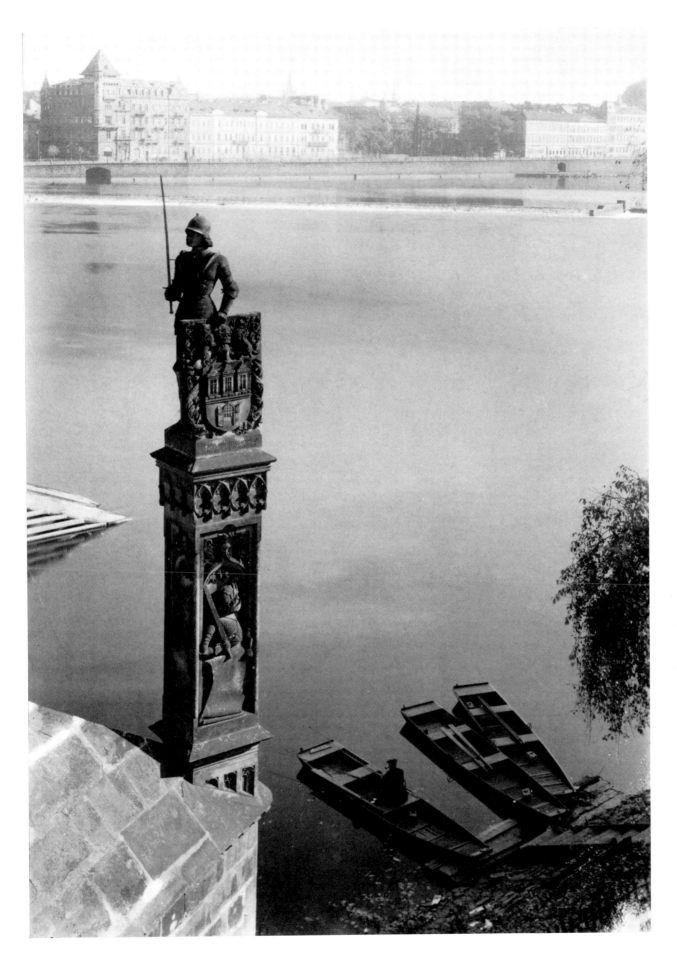

449. The Prague Roland.
19th century. Stone statue replacing one of the late 14th century.

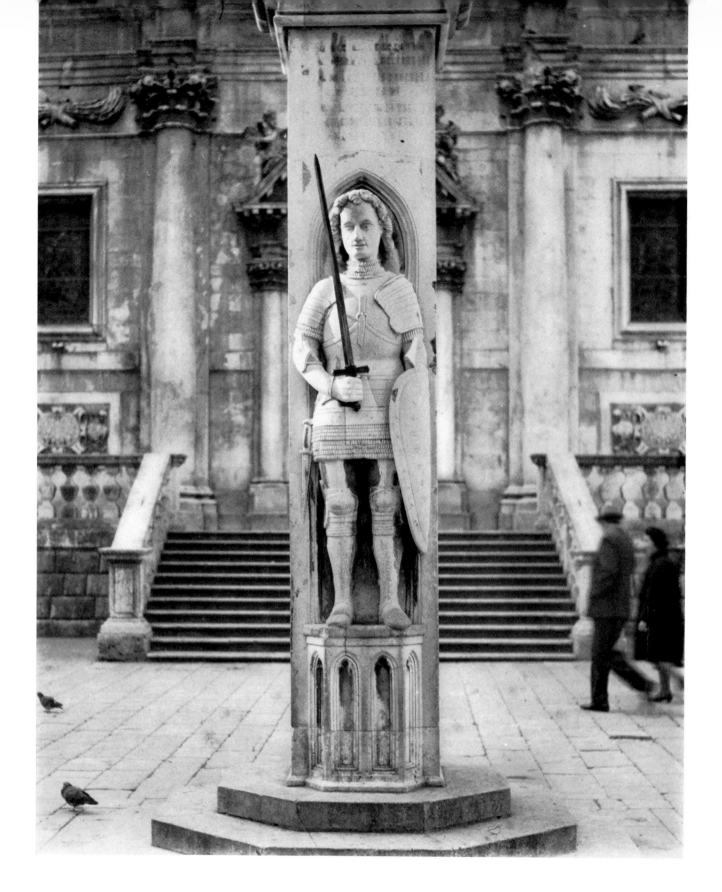

450. The Ragusa Roland.
Stone statue. About 1420. (Dubrovnik.)

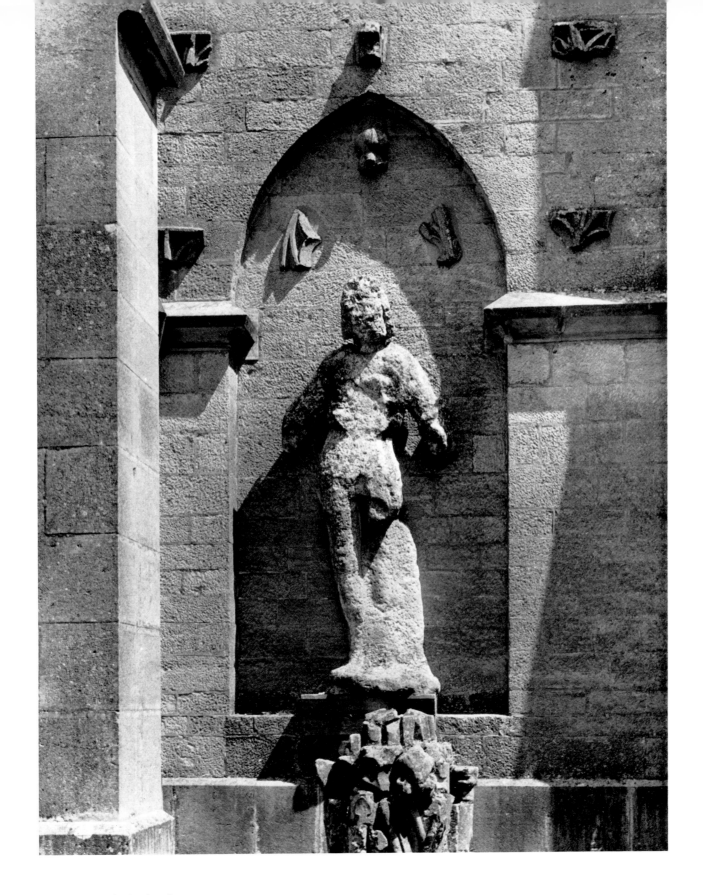

451. The Dole Roland.
Stone statue. About 1400.

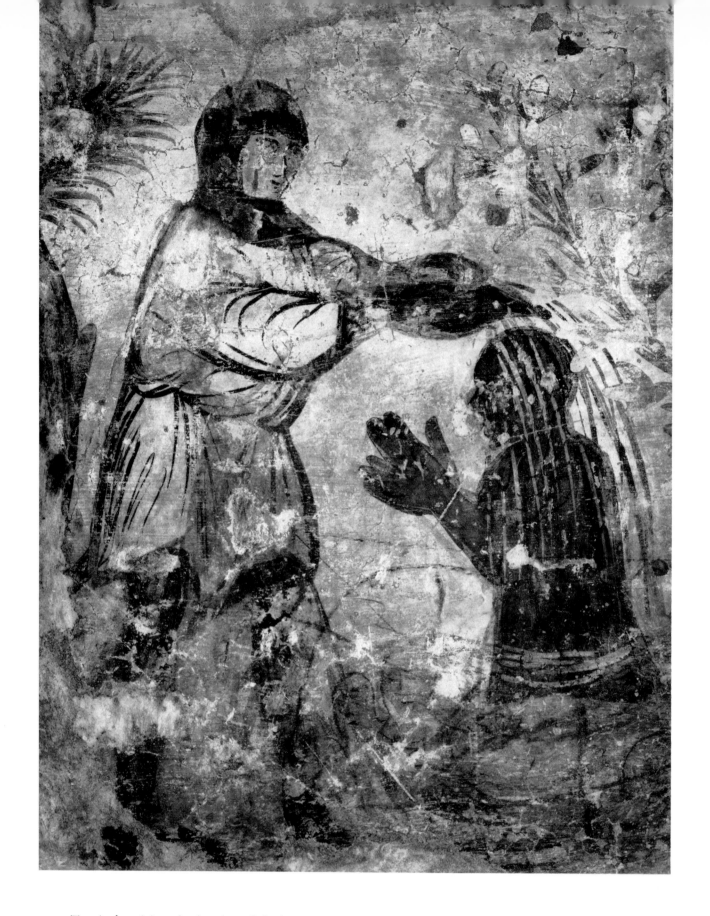

452. Turpin baptizing the heathen Otinel.

Detail of a fresco at Treviso, Museo Civico. Last quarter of
14th century.

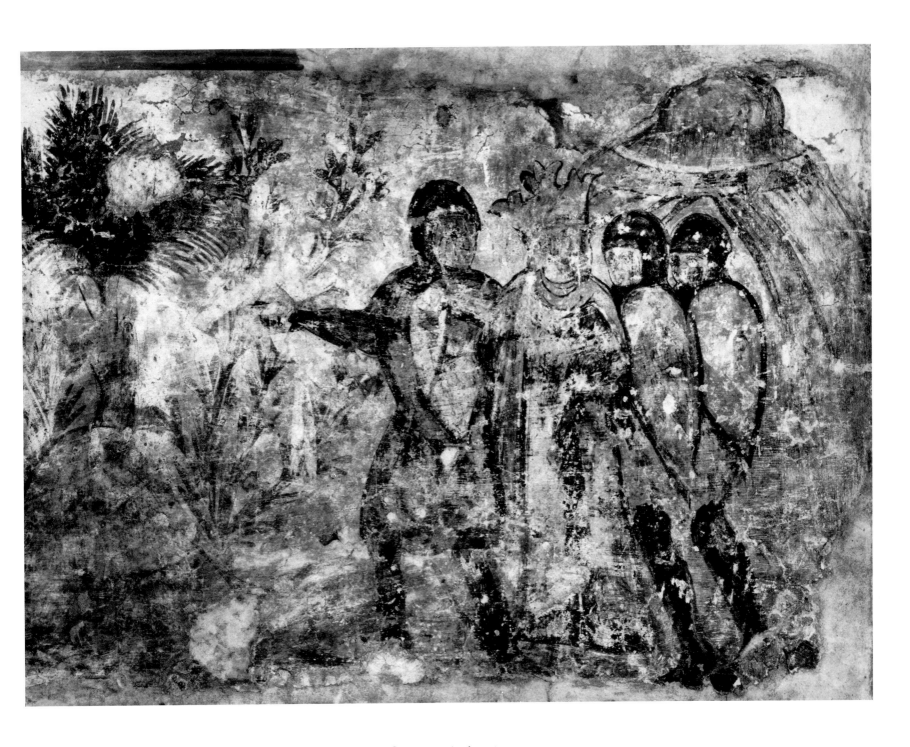

453. Charlemagne and Roland at Otinel's baptism.
Detail of the fresco.

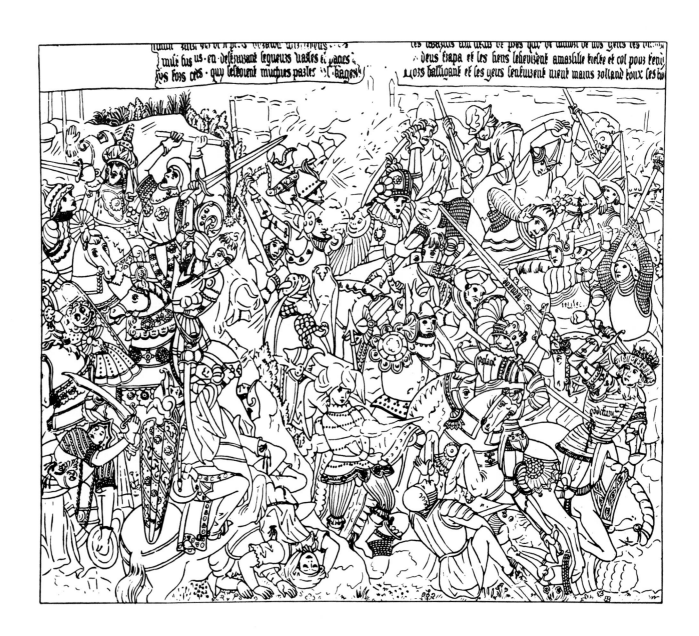

454 A and B. Reconstruction of a Tournai tapestry,
showing the battle of Roncevaux.

After Helbig.

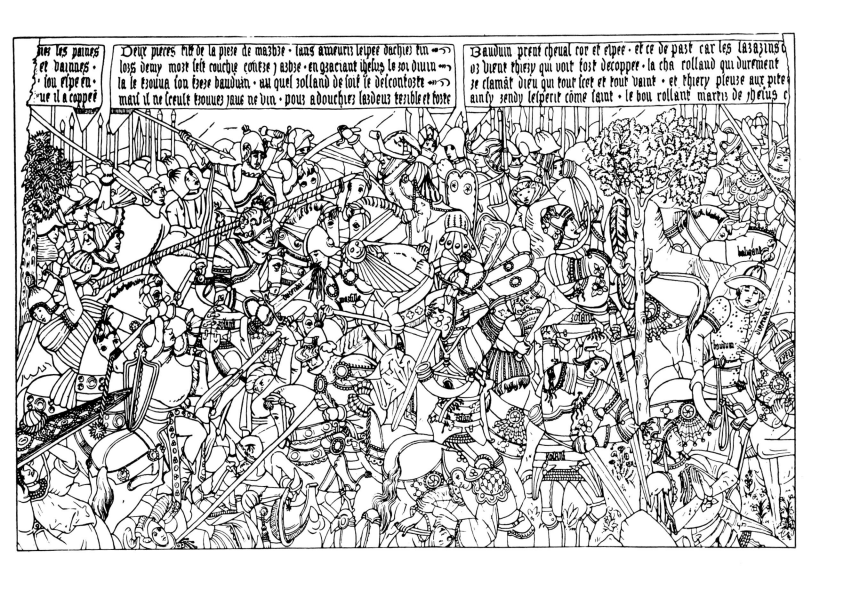

nez les paines
et baines·
lou elpe en
ue il a coppeé

Deux pieces fist de la piere de mabre · lans ameuris lelpee dachier lin
lors demy mort lest couchie contre i asbre · en graciant ihelus le roi diuin
la le trouua lon frere bauduin · au quel rolland de loif le delcontorte
mais il ne lceult trouuer jaue ne vin · pour adouchier las deus terible et torte

Bauduin prent cheual cor et elpee · et ce de part car les lasasins
oz vient thiery qui voit tost decoppee · la cha rollauð qui durement
re clamāt dieu qui tout lcet et tout vaint · et thiery pleure aur pite
ainsy sendy lelperit côme faint · le bou rollant martis de ihelus c

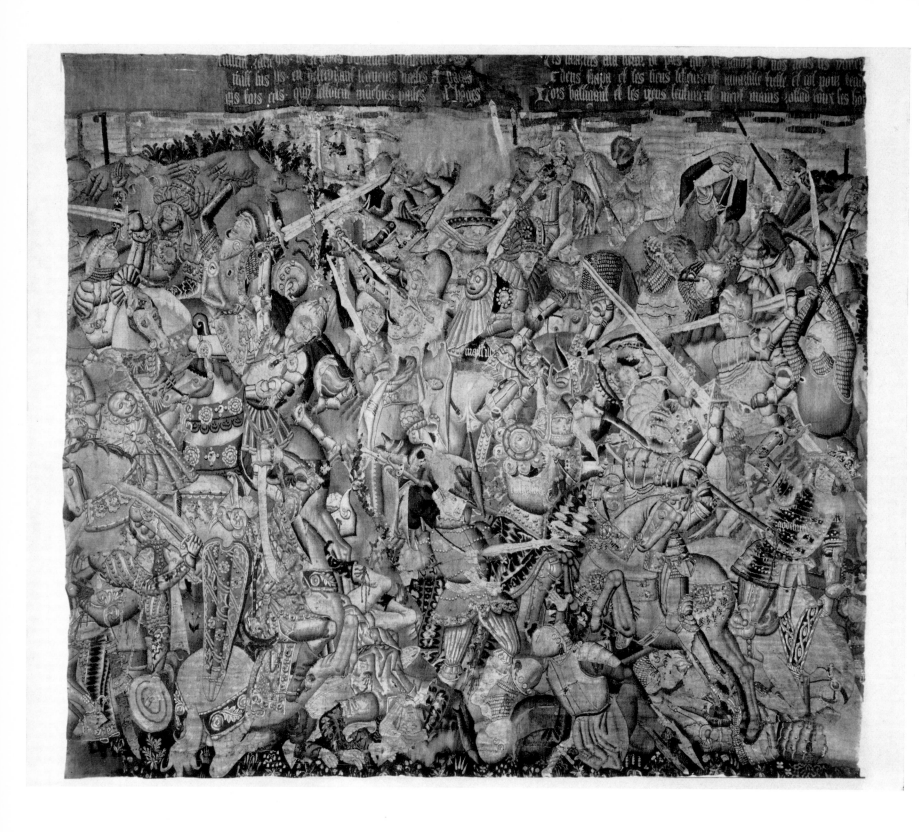

455. First section of the Roncevaux tapestry.
Florence, Museo Nazionale. About 1455-1470.

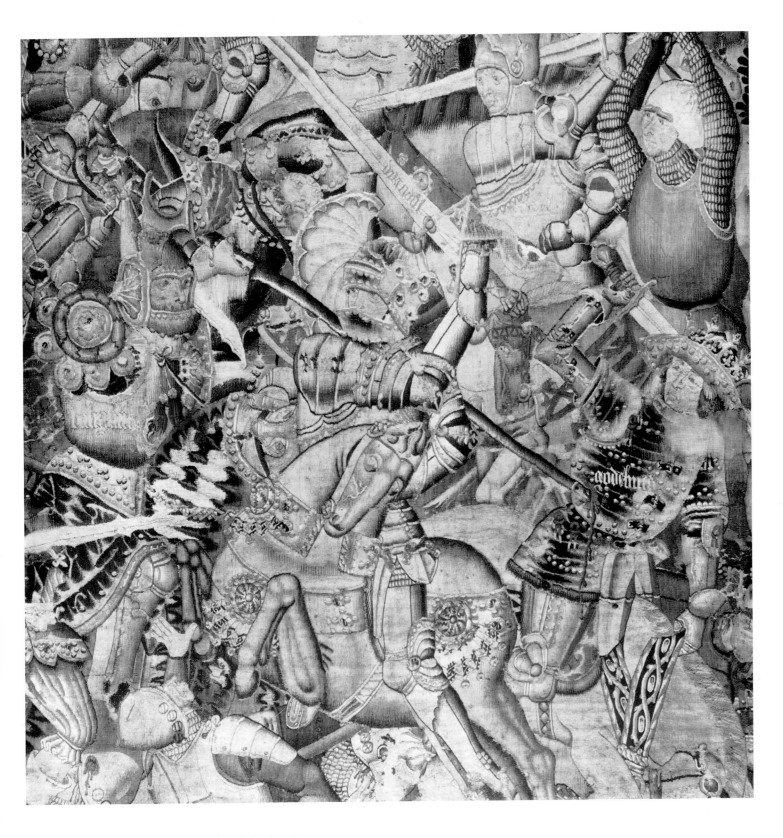

456. Roland in the thick of the battle.
Detail. *Ibid.*

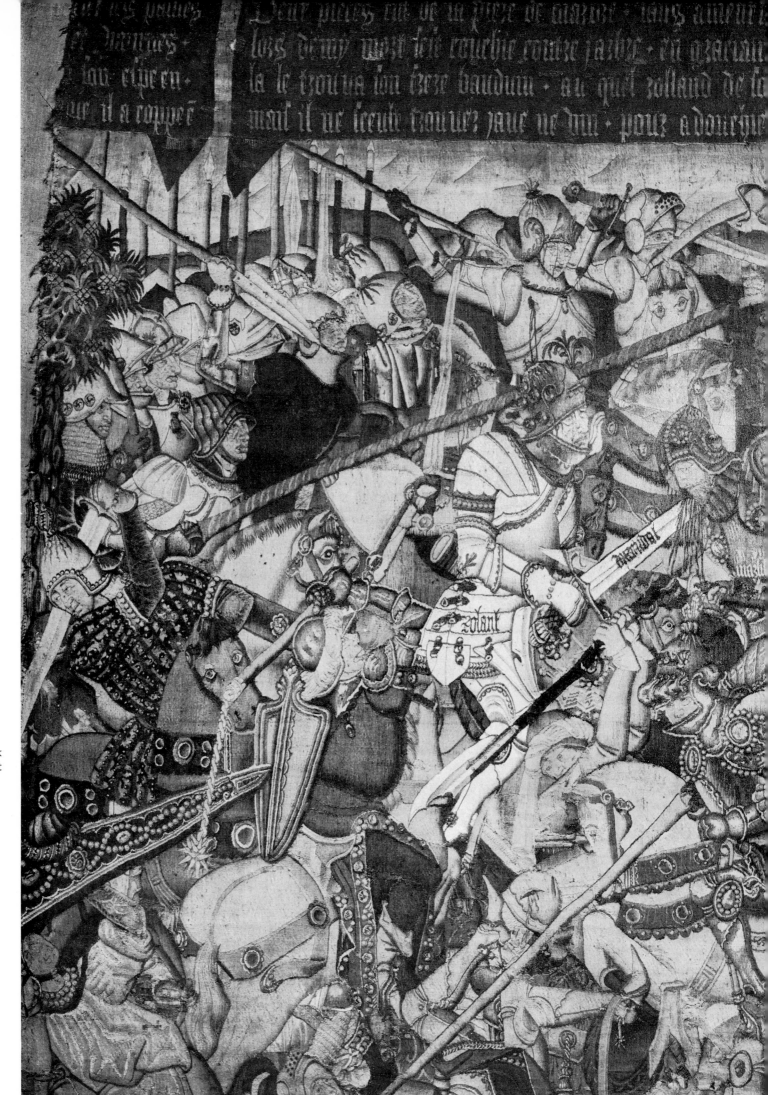

457. Second section
of the tapestry.
Brussels. Musées Royaux
d'Art et d'Histoire. About
1455-1470.

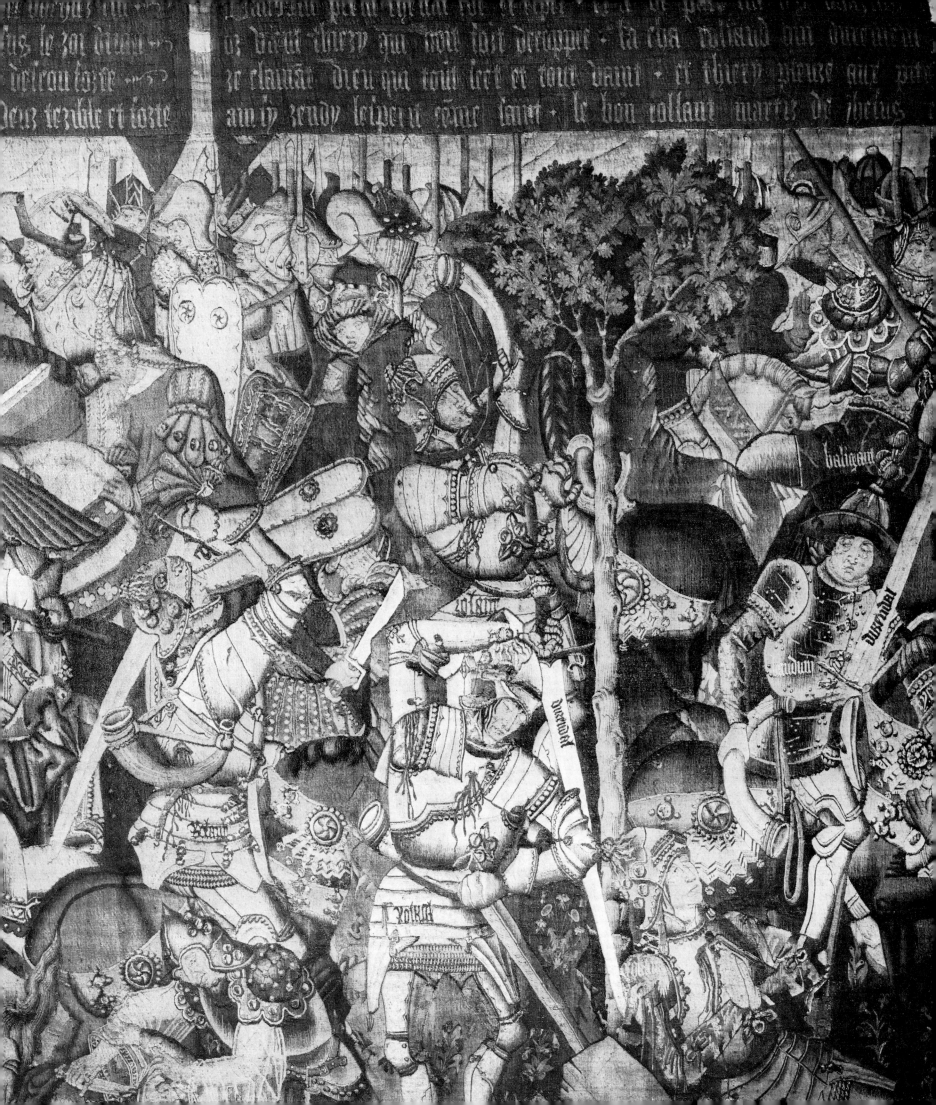

us le roi dauni ·
detrou toite ·
deuz terible et forte

oz bren therzy qui nou fort deroupre · la eua roliaud qui dur aitui
ze clamae dieu qui toit lert et tout vaini · et therzy pieure auz peu
am iy zendy leipern come saint · le bon rollaut martee de ihetus

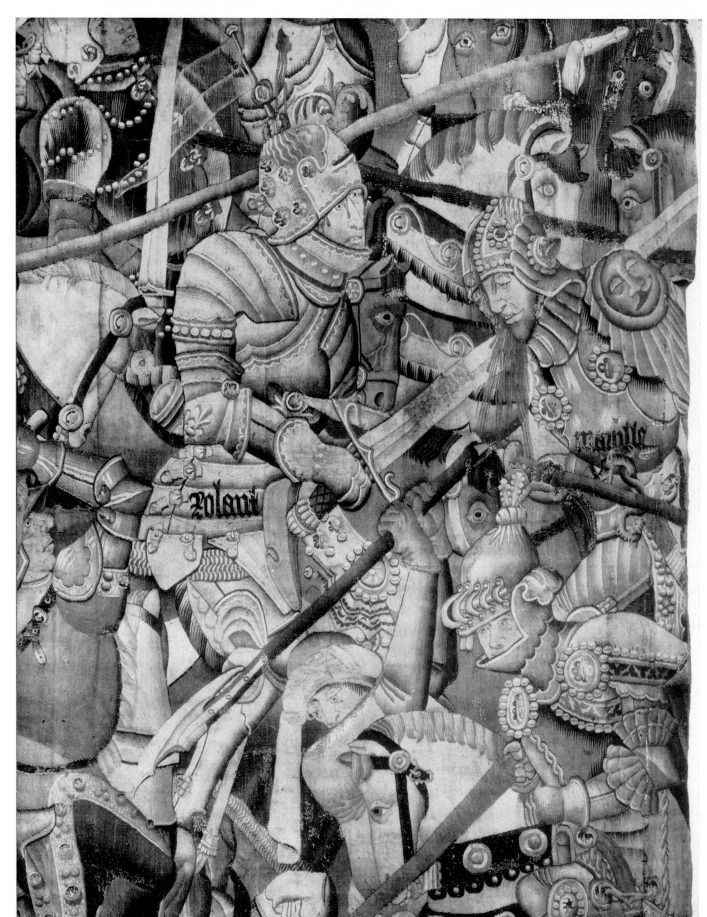

458. Roland killing King Marsile.

Detail of a second Tournai tapestry. London, Victoria and Albert Museum. About 1455-1470.

459. Baudouin and Tierry attend the dying Roland.

Another detail of the same tapestry. London, Victoria and Albert Museum.

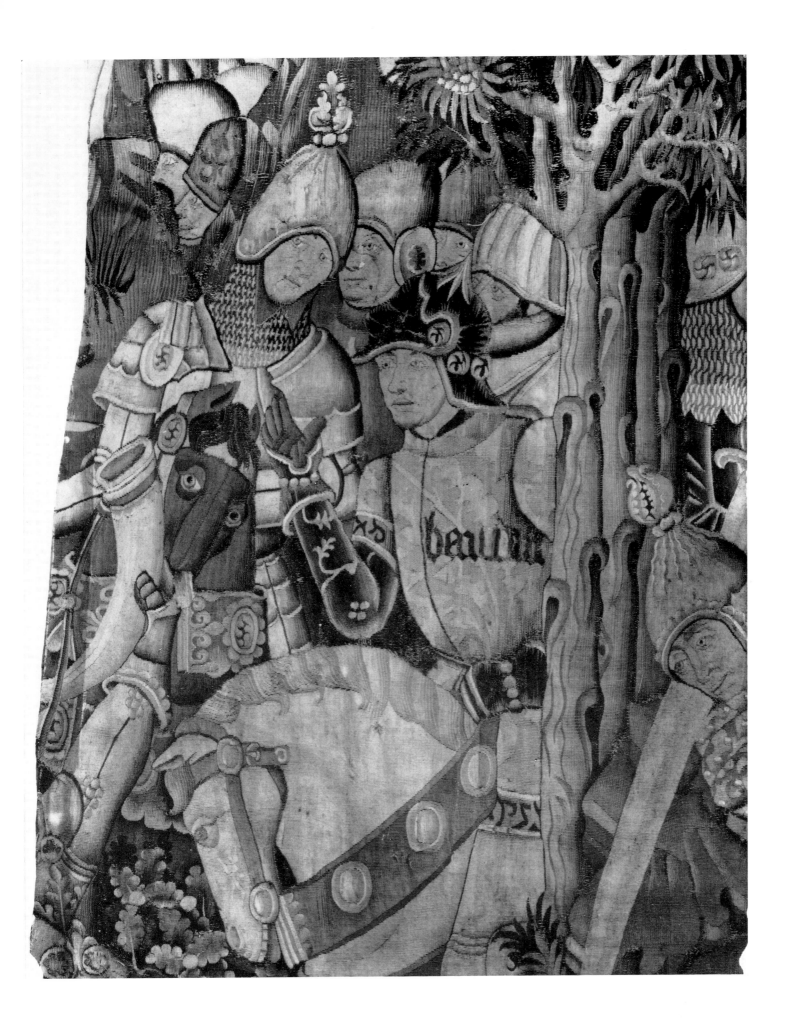

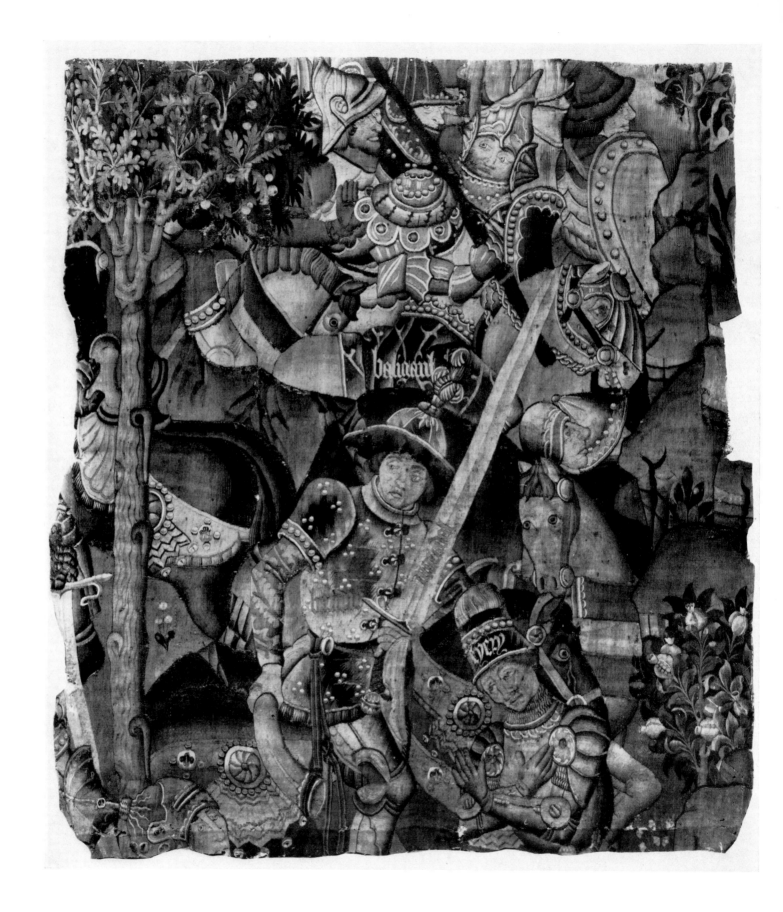

460. Baudouin and Tierry attend the dying Roland.
Fragment of a third Tournai tapestry. Private collection.
About 1455-1470.

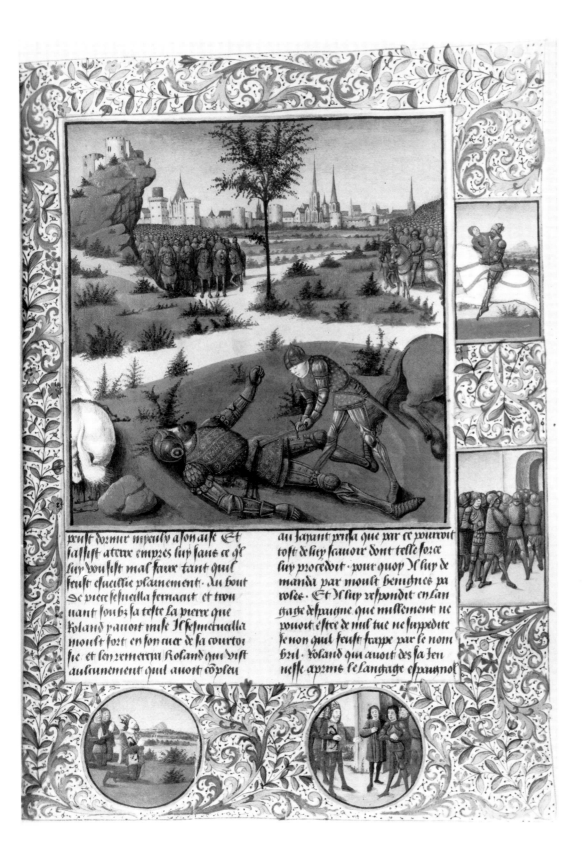

au fapant pria que par ce pourroit
toft de luy fauoir dont telle force
luy procedit · pour quop Il luy de
manda par moult benignes pa
roles · Et Il luy refpondit enlan
gage defpaigne que nullement ne
pouoit estre de nul tue ne fuppedite
se non quil feust frappe par le nom
bril · Roland qui auoit des fa ien
nesse apprins le langaige espaignol

preust dormir mpeulx a son aise Et
fassist ateux emprez luy fans ce gl
luy voulsist mal faire tant quil
feust esueillie plainement · Au bout
se piece sesueilla fernacur et trou
uant soubz sa teste La pierre que
Roland pauoit mise Il sesmerueilla
moult fort en son cuer de fa courtoi
sie · et sen remercia Roland qui vist
aultrement quil auoit coipleu

461. Roland killing Ferragut.

Miniature by Jean Colombe. *Histoire et faits
des Neuf Preux* of Sebastien Mamerot. Vienna,
Österr. Nationalbibliothek, cod. 2577, vol. 1,
fo. 127 ro. Between 1480 and 1489.

*Roland makes only a fleeting appearance
among the Nine Worthies. He figures in
Sébastian Mamerot's work only because he
is included in the story of Charlemagne.*

462 463

464 465

462-463. Roland and Oliver.
Medallions carved in wood. Saint-Bernard-de-Comminges.
Decoration of choir. Early 16th century.

There is an interesting similarity between certain medallions shown here from Toulouse and some pieces of niello of Italian workmanship.

464. Roland and Oliver.
Niello. Paris, Bibliothèque Nationale, Cabinet des Estampes,
Ec. 27 rés. Early 16th century.

465. Roland.
Niello. Florence, Biblioteca Marucelliana. Early 16th century.

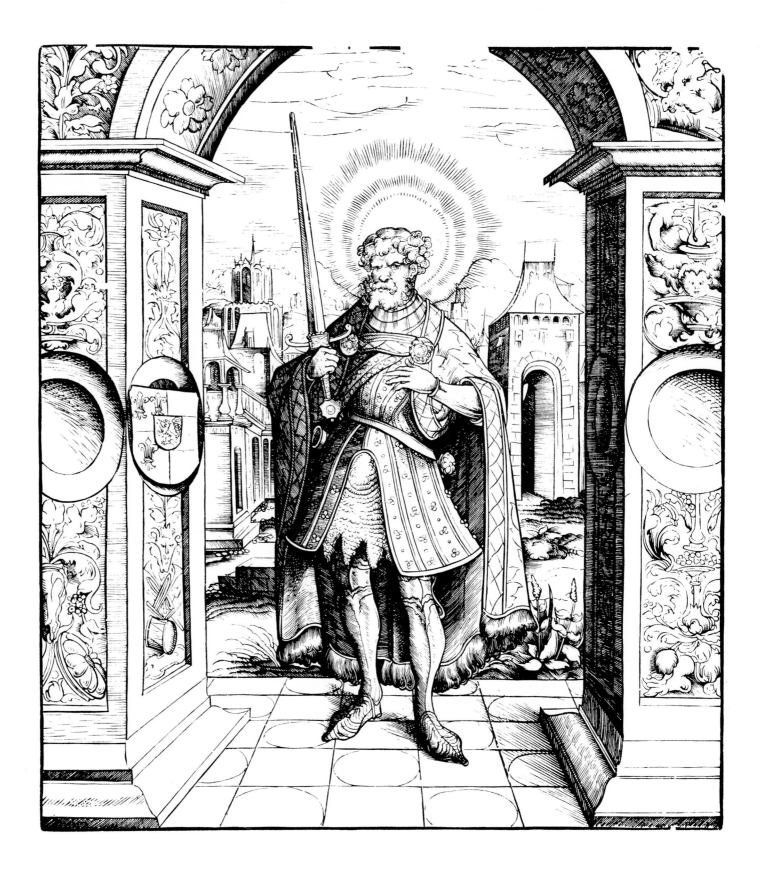

466. St. Roland.

Woodcut by Leonhard Beck. *Die Heiligen aus der Sipp-,
Mag- und Schwägerschaft des Kaisers Maximilians I.* About
1510.

¶ Cronique et histoire faicte et composee par
reuerend pere en dieu Turpin archeues⸗
que de Reims/lung des pairs de frāce
Contenant les prouesses et faictz
darmes aduenuz en son temps
du tres magnanime Roy
Charles le grāt/ autre⸗
mēt dit Charlemai⸗
gne:⸗t de son neps
ueu Rolād
Lesquelles
il redi⸗
gea
comme cōpilateur dudit oeuure⸗

¶ Imprime a Paris pour Regnauld Chauldiere
libraire demourant a la grant rue sainct Ja⸗
ques/a lenseigne de lhomme sauluage.

Cum priuilegio.

*The character of Roland figures in the illustrations to
the earliest printed books, but these appearances are less
spectacular than in the manuscript miniatures.*

467. The Pseudo-Turpin Chronicle.

Title-page. Edition by Regnauld Chauldiere,
Paris, [1514]. Châteauroux, Bibl. Municipa-
le, B. 214.

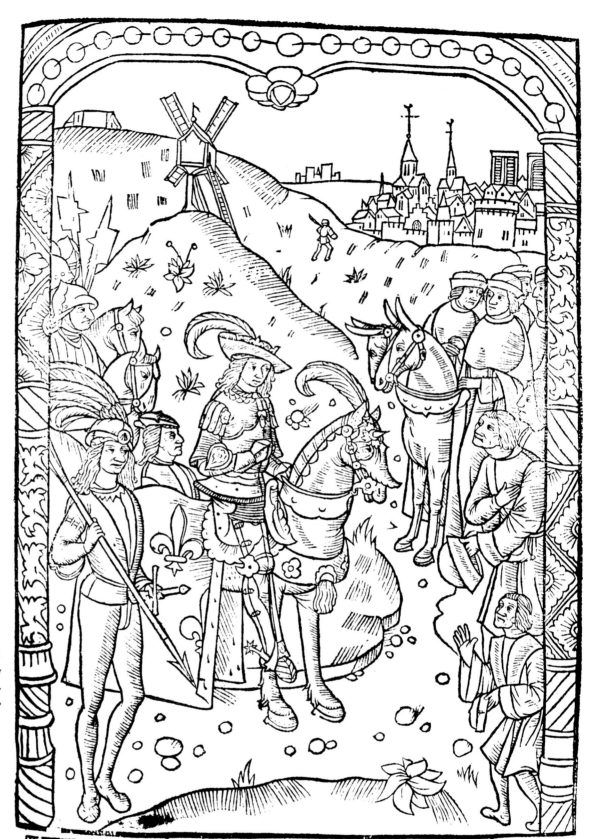

468. Roland on foot beside
 Charlemagne on horseback (?)
Woodcut. *Pseudo-Turpin*. Edition by
Regnauld Chauldiere, Paris, [1514].
Châteauroux, Bibliothèque Municipale,
B. 214.

Cy commencët ses faitz et sa vie du
uloreuy prince charlemaigne/en
partie par sa main egmaus son

chappellain et en partie par lestude de turpin
larcheuesque de reims qui presens furent a/
uecques luy en tous ses faitz en diuers tëps

o i

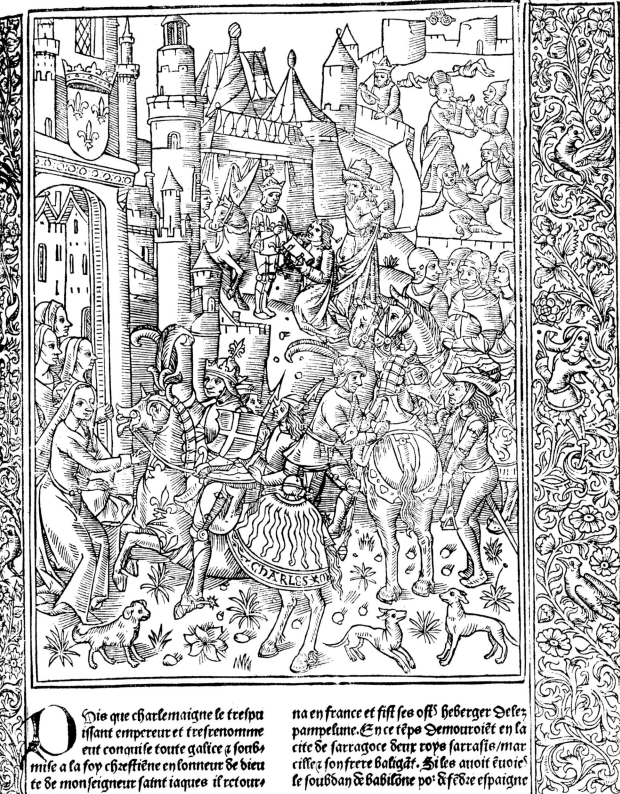

Dis que charlemaigne le trespu
issant empereur et tresrenomme
eut conquise toute galice a soub;
mise a la foy chrestiene en lonneur de dieu
te de monseigneur saint iaques il retour;

na en france et fist ses osts heberger de lez
pampelune. En ce teps demouroiet en la
cite de sarragoce deux roys sarrafis/mar
cille: son frere baligat. Si les auoit euoies
le soubdan de babilone po: de fedze espaigne

469. Charlemagne's
 conquest of Spain.
Woodcut. *Les Grandes Chro-
niques de France*. Paris, An-
toine Vérard, 1493. Paris, Bi-
bliothèque Nationale, Réserve
L 35/7, vol. I, fo. 145 ro.

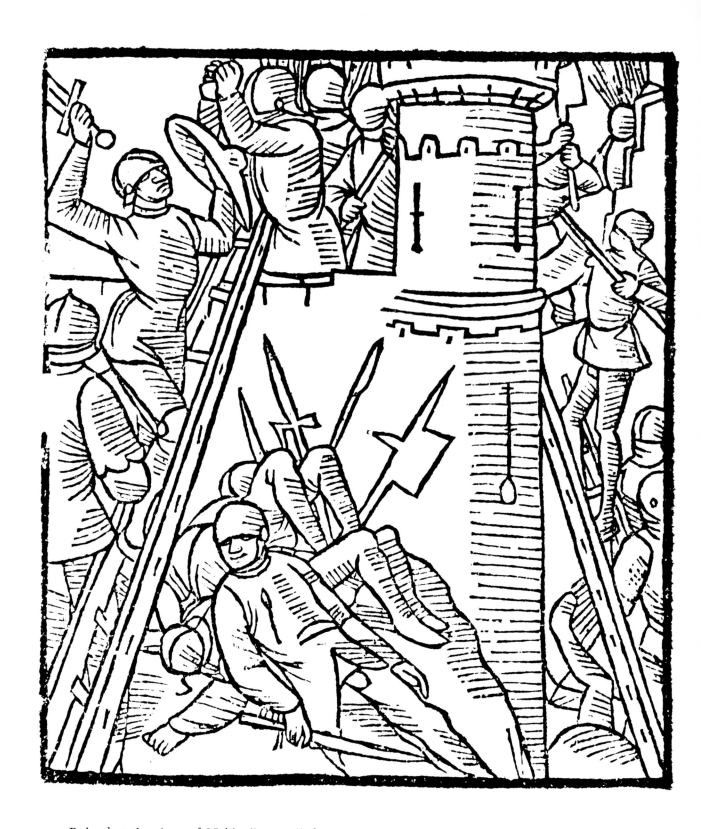

470. Roland at the siege of Noble (here called
　　　Garnople).

Woodcut (enlarged). *Les Grandes Chroniques de France.*
Paris, Guillaume Euſtache, 1514. Châteauroux, Bibliothèque
Municipale, B. 405, fo. 114 ro.

471. Ganelon swearing to deliver Roland into the
　　　hands of the kings of Saragossa.

Woodcut (enlarged). *Ibid.,* fo. 109 vo.

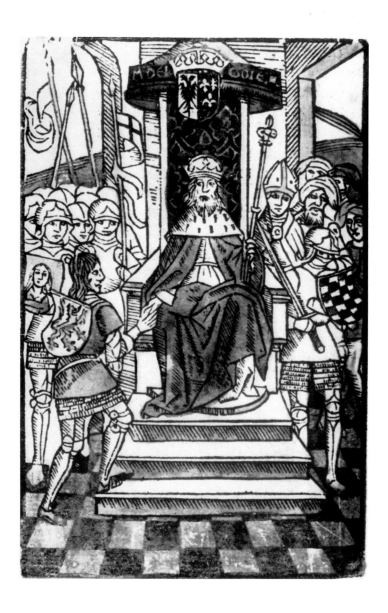

472. Charlemagne, Roland, Oliver, Turpin and the
other peers.

Painted woodcut. *Die alder excellentiſte Cronyke van Bra-
bant*. Antwerp, Roland van den Dorpe, 1497. Liège, Bi-
bliothèque de l'Université, xvᵉ s. B. 6, fo. 83 vo.

473. Combat between Roland and Ferragut.

Painted woodcut. *Ibid.*, fo. 87 ro.

474. Roland attacking Marsile at Roncevaux.

Painted woodcut. *Ibid.*, fo. 90 vo.

475. Roland blowing his horn.

Painted woodcut. *Ibid.*, fo. 203 vo.

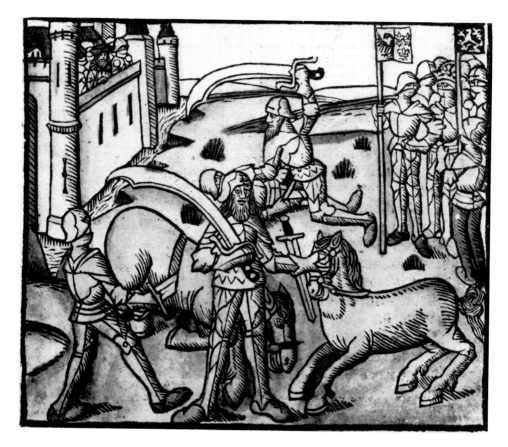

472 475

473 474

*The Chriſtian name of a printer in Antwerp prompted
this fine series of woodcuts illuſtrating the legend of
Roland.*

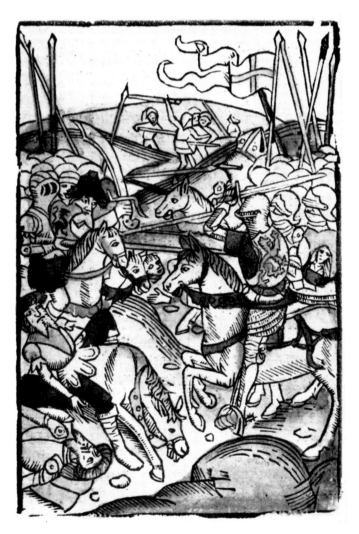

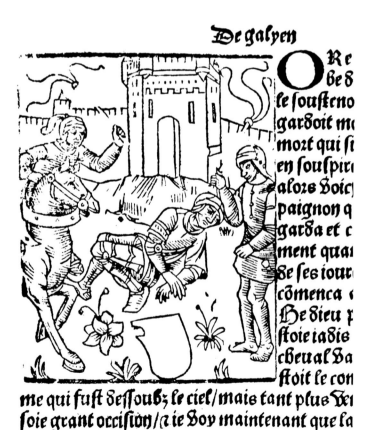

A Tant ſe
gues en le
lemaigne a lui
failloit acompl
auoiēt pꝛomis
Si aduiſa pmi
moult gꝛāt eff
gneur hier au ſ
teniez ma fille
quoy q̄ quize fo
gnie deuant q̄ f
Zꝛay diſt oliuie
ꝣoꝰme ferez eſſ
te nacōplis ce q̄
trencher la teſte
hugues par le ſ

la ꝣoꝰ bailleray / maiſ ſe ꝣoꝰ faillez le ꝣoꝰ mettray en t
en perdꝛez / ꝛoliuier lui acoꝛda. Loꝛs le roy lui fiſt appar
Et quāt la nuyt fut ꝣenue fut la belle iaqueline coucb

De galyen

O Re
be 8
le ſouſteno
gardoit mo
moꝛt qui ſi
en ſouſpiꝛ
aloꝛs ꝣoic
paignon q
garda et c
ment quā
ſe ſes iouꝛ
cōmença
He dieu p
ſtoie iadis
cheual ꝣa
ſtoit le con

me qui fuſt deſſoubz le ciel / maiſ tant pluſ ꝣei
ſoie grant occiſiō / a ie ꝣoy maintenant que la

T Ant fiſt
lui aida
ſtrier a aux pꝛi
les aultres per
galyen acomp
que turpin, de
a de ſalmon ſe
les ꝣingt mile
auoit laiſſez a
dꝛe ſe truage
dꝛ moure que
cy deſſus nōm
ceſtui tant fu
ne fuſt naure
moꝛt foꝛs ꝛoſa
bie ſe poꝛta qu

ne naureure. Adonc quant les ſix barons deuantdit
leurs deſtriers ꝣindꝛent a foꝛce deſperōner leurs cheua
ens pour ſecourir le ꝣaillant cheualier galyen ꝛetboꝛ
uoit apupe contre la roche a ne pouoit reculer ne aler
les paiens qui lauoient ainſi auirōne / maiſ contre par
pꝛoeſſe que ceſtoit merueilles. Si toſt que les barons

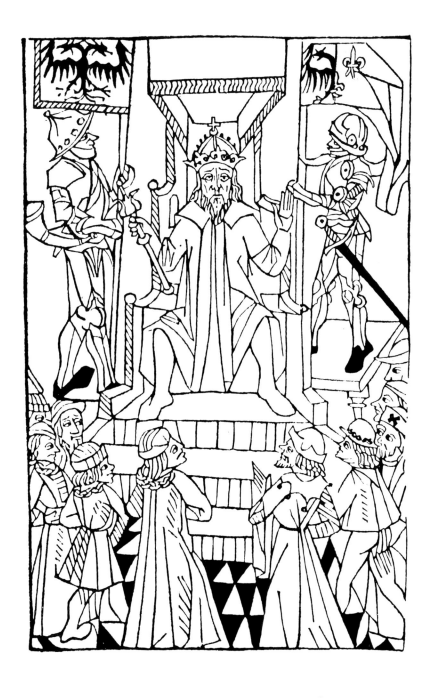

*Guillaume le Roy, a printer from Liège working at
Lyons shows a distinct predilection for tales of chivalry.*

476. Oliver saying goodbye to the daughter of King
 Hugo of Constantinople.

Woodcut. *Galien Réthoré.* Paris, Antoine Vérard, 12th
December 1500. Paris, Bibliothèque Nationale, Réserve Y^2
332, fo. 19 vo.

477. Battle of Roncevaux.

Woodcut . *Ibid.,* fo. 48 vo.

478. Galien, with Roland, watching over the dying
 Oliver.

Woodcut. *Ibid.,* fo. 51 vo.

479. Roland and Oliver at Charlemagne's court.

Woodcut. *Fierabras.* Lyons, Guillaume le Roy, about 1483.
Liège, Bibliothèque de l'Université, XV^e s. B. 119.

Cõmēt lēdemain rollãd τ ferragus bataillerēt et diſputerēt de la foy τ par lequel moyen ferragus fut occis τ tue par rollãd.

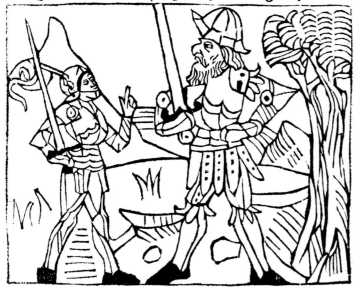

E Jour enſuyuant au matin rolland et ferragus ſint.

de la traiſon faite par ganeſſon et de la mort des pers de france.
Le premier chapitre.
Comment la traiſon fut cõpriſe par ganeſſon. et de la mort des chreſtiens .et cõment ganeſſon eſt repris par lacteur.

e Acelluy tēps eſtoyent en ceſarie deup roys ſarrazins moult puiſſãs .lũg ſe diſoyt marſerius. et laultre telle gandus ſon frere q̃ furēt enuoyez de par ladmiral de ba

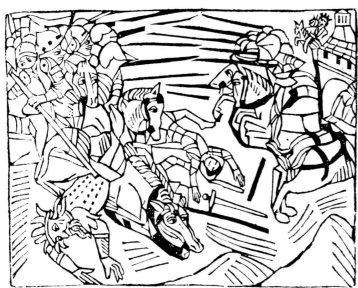

Ilz ſe mirent a Batailler par grãde fierte les payens et ſarrazins cõtre les chreſtiēs Et fut faicte ſy grãde deſtruction cellup Jour des ſarrazins que les chreſtiens eſtoyent empeſchez τ tranuerſes

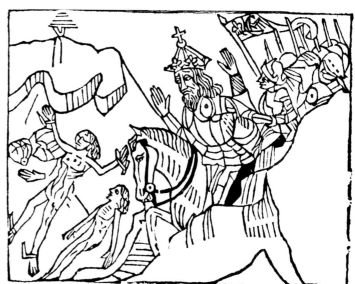

que le ſoleil renuiaſt aulcunemēt τ trouuerēt pres du fleuue q̃ ſe diſoit ebra les ſarraſins en ceſarie q̃ ſe repoſoyēt et biuuoyent τ mangoyent a leur ayſe ſans eulp deffier de riens et ſint ſur eulp charles et ſes gens ſy Jmpetueuſement que en peu dure p furent mors quattre mille et les aultres ſe ſauuerēt puis lēpereur toyant

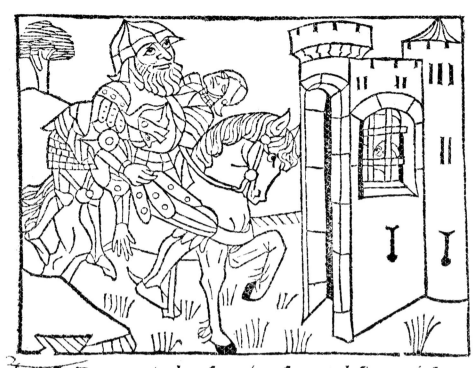

Apres que aigolant fut occis et furre et plusieurs roix sarra/

et p ql moyen ferrag⁹ estoit occis p rollant · ¶Le · xij · chapitre·

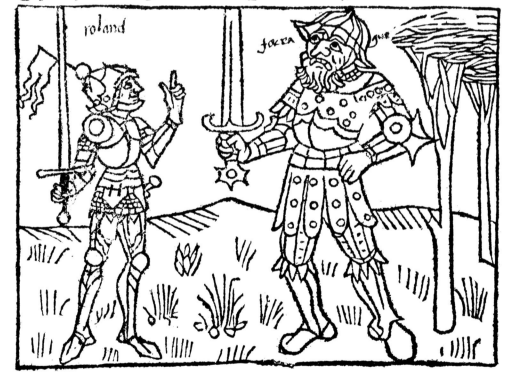

480 481 484
482 483 485

480. Disputation between Roland and Ferragut.
Woodcut. *Fierabras.* Lyons, Loys Garbin, 1483. London, British Museum, Incunable C. 6, B. 12.

481. Ganelon's message. Ganelon plotting with the kings of Saragossa.
Woodcut. *Ibid.*

482. Battle of Roncevaux.
Woodcut. *Ibid.*

483. Charlemagne finds Oliver's body.
Woodcut. *Ibid.*

484. Ferragut carrying away two Christian knights under his arms.
Woodcut. *Fierabras.* Lyons, Guillaume Le Roy, 1487. London, British Museum, Incunables IB 41525.

485. Disputation between Roland and Ferragut.
Woodcut. *Ibid.*

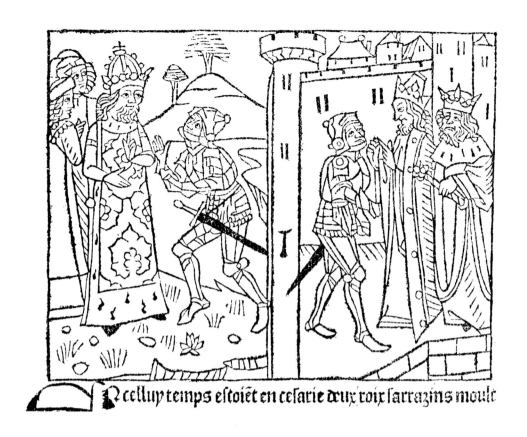

Pcelluy teinps eftoiét en cefarie ðux roix farrazins moult

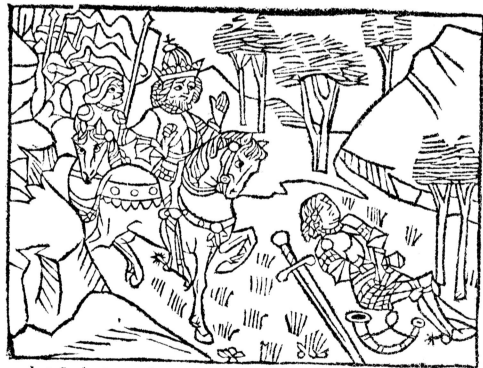

uaulx ðefoubz bng arbze en bng beau pze Quãt il fut a terre il regar

486. Ganelon's message. Ganelon plotting with the kings of Saragossa.
Woodcut. *Fierabras.* Lyons, Guillaume Le Roy, 1487. London, British
Museum, Incunables IB 41525.

487. Charlemagne finds the body of Roland.
Woodcut. *Ibid.*

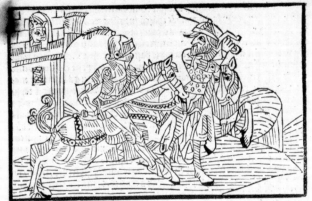

mift deffoubz la tefte a cefte fin q peult mieulx dozmir a fő aife. Et apzes ql
eut vng petit dozmy ꝙ ql fut efueille il fe dzeffa ꝙ le noble rolät fe vit feoir au
pzes de lup ꝙ lup dift. Je fuis tout efbahy de ton fait cőment tu es tant fort
ꝙ́ő ne te peult naute ne faire dăgier au cozps ne pour efpee ne pour bafton
ne pour pierres ne auftremět. le geât ꝙ́ ploit efpaignoil dift. Je ne puis eftre
occis finon p le lőbzil. Quāt rolät fourt il fit femblät ql ne lauoit poit entēdu
puis lup demāda ferrag̃ cőmēt il auoit nő ꝙ de ql lignaige il eftoit. rolät lup

488

489

490 491

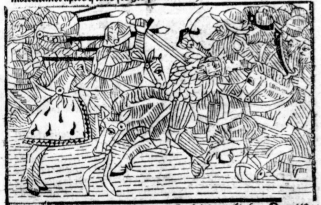

et mis amozt. De langoiffe ꝙ charles attēdit ne fault pas parler. car de foy
mefmes elle fe peut bien entendze. Le.ii. chapitre.

❡ De la mozt du roy Marfurio ꝙ cőmēt rolät fut naure de quatre lances
moztellemēt apzes ꝙ tous fes gēs furent moztz.

❡ã bataille comme iay dit deuanteftre faicte moult afpze. Quant Ro
lant qui eftoit moult laffe retournoit il rencontra en fon chemin vng
farrazin moult fier. et le pzint tantoft a lentree dung boys et leftacha
a qtre poztes bien eftroit fans lup faire aultre mal. ꝙ puis mőta en vng hault
arbze pour veoir loft des farrazins ꝙ les creftiens ꝙ fen eftoyent fuys ꝙ veit

488. Roland fighting Ferragut.

Woodcut. *Le conqueste du grant roy Charlemaine des Es-*
paignes et les vaillances des douze pers de France, et aussi celles
du vaillant Fierabras. Lyons, Pierre Maréchal and Barnabé
Chaussard, 4th April 1497. Paris, Bibliothèque Nationale,
Réserve Y² 993, fo. Ivij.

489. Roland killing Marsile.

Woodcut. *Ibid.,* fo. Kii.

490. Charlemagne finds the body of Roland.

Woodcut. *Ibid.,* fo. Kiii.

491. Richard of Normandy bringing Charlemagne the
news of Roland's death.

Woodcut. *Ibid.,* fo. Giii vo.

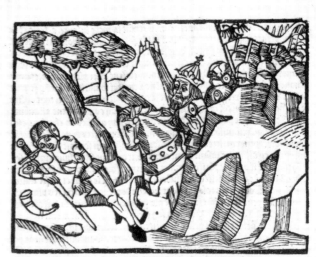

belle et richemět faicte. le mäche auoit de bericle fin relupfant a merueilles
en hault auoit vne croix doz en laqlle le nom de Jhus eftoit efcript. Si bon-
ne et fi fine elle eftoit ꝙ pluftoft faulbzoit le bzas ꝙ la tiět aultremět ꝙ lefpee
Al la mift hoze du fozreau ꝙ la vit mőlt refulfäte. ꝙ moztät ꝙ commencait alle

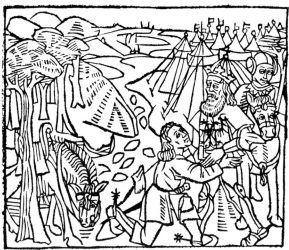

puis bien mener dueil quāt de pfent ie laiffe les hőmes ꝙ iamoye au mőde
plus ꝙ mē vois quāt ie les deuffe veger a bon droit. ici feray tenu pour fol
ꝙ vitupere. O rolät cőe ie vo9 ay arme. pourra iamais tät viure voftre on-
cle ql voye voftre mozt veger. ne plaife pas a dieu ꝙ iamais ie pozte couron
ne fur mő chief veu la pourete de mő fait. Ceci difät a peu ql ne cheut a ter
re de la defplaifäce ql eut. Grāt dueil fut fait a celle heure. Helas dift char-

aoiumptu maxima qƷ viii auri atɞ argenti a francis in gallia tranlportata. ɤu vic itatus reƷ in gallia eiƷ
romani aduerſus leonē pontifice coniurationē ineūt ɒe ɋ in ſequentibus. ꝛ geſtis caroli poſt coronatiõem
auguſtalem fit mentio.

Rolandus palatin⁹ comes caroli ex ſoꝛoꝛe nepos.
vir pſtans foꝛtitudine incõpabilis ꝛ vtutis ac ma
gnitudinis. cui⁹ foꝛtia facta p vniuerſum oꝛbē celebꝛan/
tur. ɤū carolus exercitū in galliā reduceret ꝓpe pyrenei
iuga in vaſconū inſidias incidit. Et ꝓlio inter eos inito
poſt ingentē hoſtium cladem. cecidere in ea pugna volo
hoſtiū nõ vtute cõmiſſa anſhelmus ꝛ Egibard⁹ ſummi
in bello duces. Rolandus quoɞ cecidit. Sūt qui dicãt
eū ſiti nõ vulnere perericlitatū. qui duces belli tutatus
fuit. Paulo autem poſt ij populi ac eoꝛuƷ reges a carolo
vomiti. meritas perfidie ſue ɒebitaſɞ penas dedere.

ɤAxilo bauarie dux vxoꝛis. vt tradūt ſtimulis cõci
tatus. copias cogit. bis tempoꝛibus finitimas gē
tes ſollicitat. hūnos. qui ea parte qua bauaria in oꝛientē ſpectat ſibi ꝓfines erant
ſocietate ꝛ federe iūgit. Erat ei ꝓiux ɒeſiderij regis longobardoꝛ filia. ɋ foꝛtunaƷ
pꝛis iniquo animo ferens. nec nocte nec interdiu virū cõquieſcere pati. monere vt
meminiſſe vellet ſoceꝛ ſuū moꝛte miſerioꝛe vitam ducere. Neminē eſſe pꝛeter eū.
qui poſſet ei libertatem vendicare. Hijs mulieribus inſtructus furijs exercitū pa
rabat carolus celeriter pꝛofectus in fines bauarie venit. ɤaxilo ꝓterritus tandeƷ
parere conſtituit ꝛ ɒeditionem fecit. obſides ɒedit. In hijs theonē filiū ſuū alioſ
ɞ per multos lectiſſimos iuuenes.

ALdegiſius ɒeſiderij filius. ɋ ante expugnationē papie e citrapadanis in gre
ciam confugerat hijs tpꝛibus grecoꝛ multoꝛ auxilio fretus. cuƷ magna ma
nu ad repetendū paternū regnum in ytaliā venit. qui multū ꝓflictus a francis au
ſpicio pꝛefectoꝛ ſuperatus ꝛ captus. ac multis ſupplicijs affectus. tandem vitam
miſeram in toꝛmentis finiuit.

492. Roland.

woodcut. Hartmann Schedel, *Chronica chronicorum.* Nu-
remberg, Anton Koberger, 12 July 1493. Liège, Bibliothè-
que Universitaire, XVᵉ s. A.7.

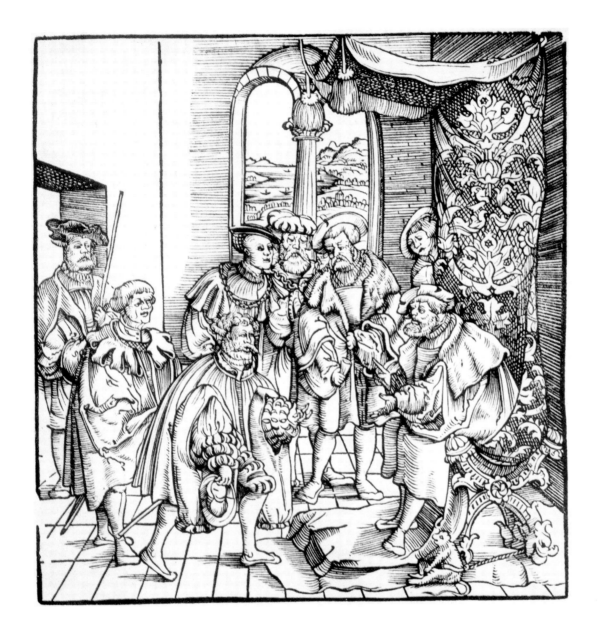

493. Charlemagne welcoming Roland and Oliver to his
 court.

Woodcut. *Fierabras*. 1533. London, British Museum,
Incunables C. 125.e.16, fo. Dij.

The workshop of the German Michael Wolgemuth
produced this masterpiece of 15th century engraving.
Roland appears here only as a conventional figure.

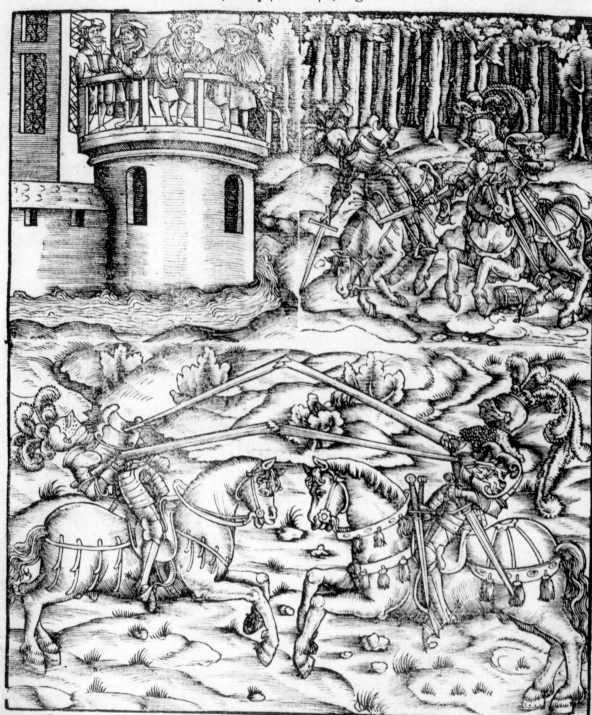

selbigen Balsams/ vnnd wie der Heyd Oliuiern
sein Pferd erschlug.

Nach diesem ruckt Fierrabras vnnd Oliuier von eynan
der/ doch ee sie jre Pferd zusamen lauffen liessen/ sprach Fierrabras/
mein freundt Oliuier/ ich bit dich drinck zuuor meines Balsams/
daū durch sein crafft wirdestu an stund deiner wunden gesunt/ vnnd

B ij

494. Mounted combat between Oliver
and Fierabras.

Woodcut. *Fierabras*, 1533. London, Bri-
tish Museum, Incunables C 125.e.16 fo. Bij.

495. Oliver fighting on foot against
Fierabras.

Woodcut. *Ibid.*, fo. B iiij.

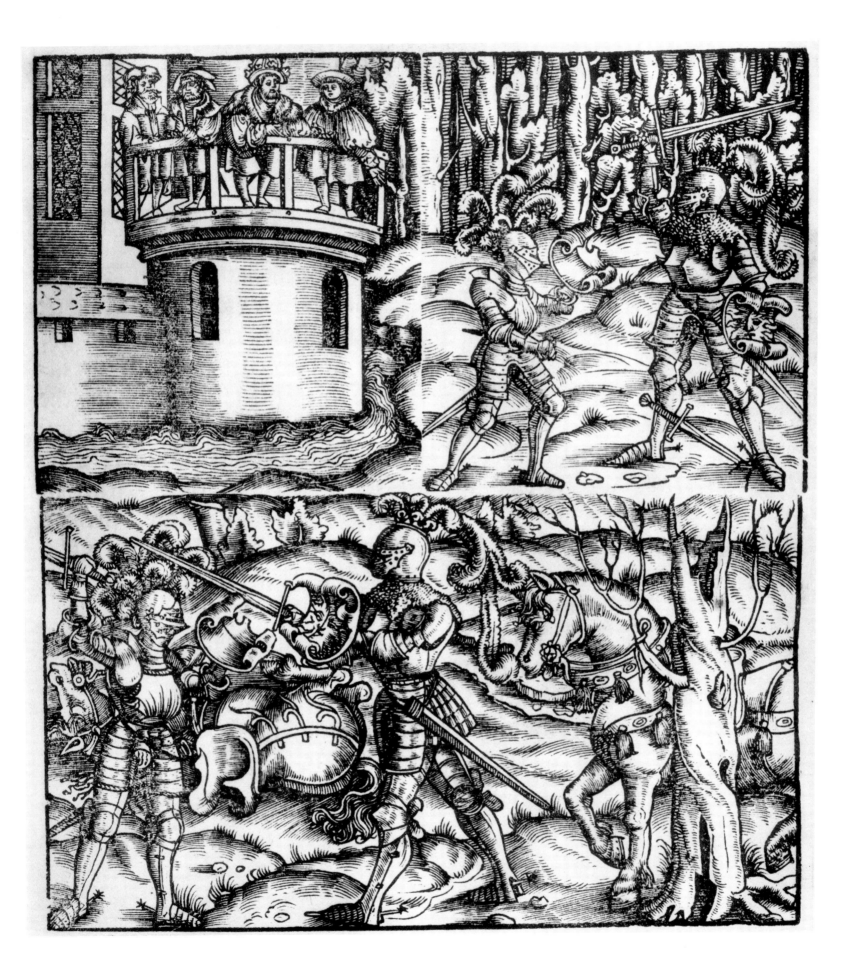

L'anetrir de cauallì, e'm armorare
de' pagan, che veniuan minacciando
ch'ognuo voleua i Christian trangugiare
& sopra tutto Falseron Orlando
parea quando piu forte freme il mare
Scilla, & Caribdi cō Mostri abbaiando,
& tutta l'aria di poluere è piena
come si dice del Mar dell' asia

Quiui erano Zingani, arabi, & Soriani,
dell'Egitto, dell'India, & di Etiopia,
& soprattuto di molti marrani,
che non haueuon fede niuna propria,
di Barbaria d'altri luochi lontani
& Alcuin, che questa istoria copia.
dice che gente di guascogna v'era,
pensa che gente è questa prima schiera

Et hauean pur le piu strane armadure
& piu stran cappellacci quelle genti
certe pellaccie sopra il dosso dure
di Pesci, Coccodrilli, e di serpenti,

& mazzafrusti, & graui accette scure
& molti cō' pi commetton a venti
con dardi, & archi, & sputoni. et labecchi
& catapulse che cauon eli stecchi.

Qui già i vampi l'vn all'altro accosto
da ogni parte si gridaus forte,
chi vuol lesso Maccon, chi l'altro arrosto
ognun voleua del nomico far torte
dunqre vegnamo alla battaglia tosto,
si che io non tenga in disaggio la morte
che con la falce minaccia. & accenna
ch'io moua presto le lancie & la penna.

Orlando haueua alla sua gente detto
della battaglia ognun libero sia
qui non è caualier se non perfetto,
& Micael vi farà compagnia,
Astolfo il primo si mosse in effetto
vennegli incontro Arlotto di Soria
& l'vna & l'altro abbassò sua lancia
& Siragozza si sentiua, o Francia.

A iiij Hor

Incomincia el Libro primo De Orlando Inamorato composto per Mattheo Maria Boiardo Conte de Scandiano Tratto da la Historia de Turpino Arciuescouo remense: et dicato a lo Illustrissimo Signor Hercule estense. B. di Ferrara.

496. An episode in the battle of Roncevaux.

Woodcut. *Rotta di Roncisvalle,* Florence, no date or publisher (early 16th century). Venice, Biblioteca Marciana, Marc. Misc. 1016-14, fo. A iiij.

497. Battle of Roncevaux.

Woodcut. *Orlando Innamorato* of Boiardo. Venezia, Georgio Rusconi, 25-x-1506. Venice, Biblioteca Marciana, Marc. Rari V. 477 (n. 47.009).

LIbro Di Battaglie Nouamente Composto Intitulato Tradimenti di Gano.

GANO

TVTTI LI LIBRI DE ORLANDO INA
MORATO DEL CONTE DE SCAN
DIANO MATHEO MARIA BO
IARDO TRATTI FIDEL
MENTE DAL EMENDA
TISSIMO EXEMPLA
RE NOVAMENTE
STAMPATO

CVM GRATIA ET PRIVILEGIO

498. Ganelon.

Woodcut. *Libro di Battaglie* of Pandolfo de Bonacossi, Firenze, Bernardo Zuchetta, 14.x.1525. Venice, Biblioteca Marciana, Marc. 125. D. 21 (n. 46.423).

499. Roland.

Woodcut. *Orlando Innamorato* of Boiardo. Mediolani, Leonardus Vegius, 23.II.1513. Venice, Biblioteca Marciana, Marc. Rari 532 (n. 46.471).

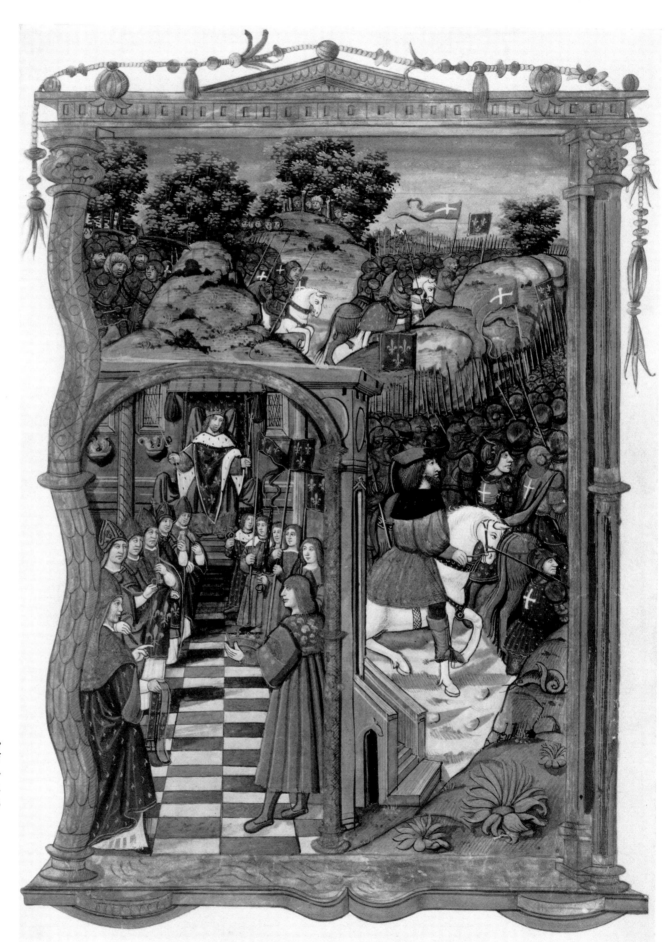

500. Charlemagne
appointing the twelve
peers. Gascon
ambush after
Pamplona.

Miniature. *Recueil sommaire
des cronicques françoyses* of
Guillaume Cretin. Paris, Bi-
bliothèque Nationale, f. fr.
1820, fo. 65 ro. Between 1515
and 1525.

501. Charlemagne's vision
of St. James.
Charlemagne and
Roland outside
Pamplona.

Miniature. *Ibid.,* fo. 70 vo.

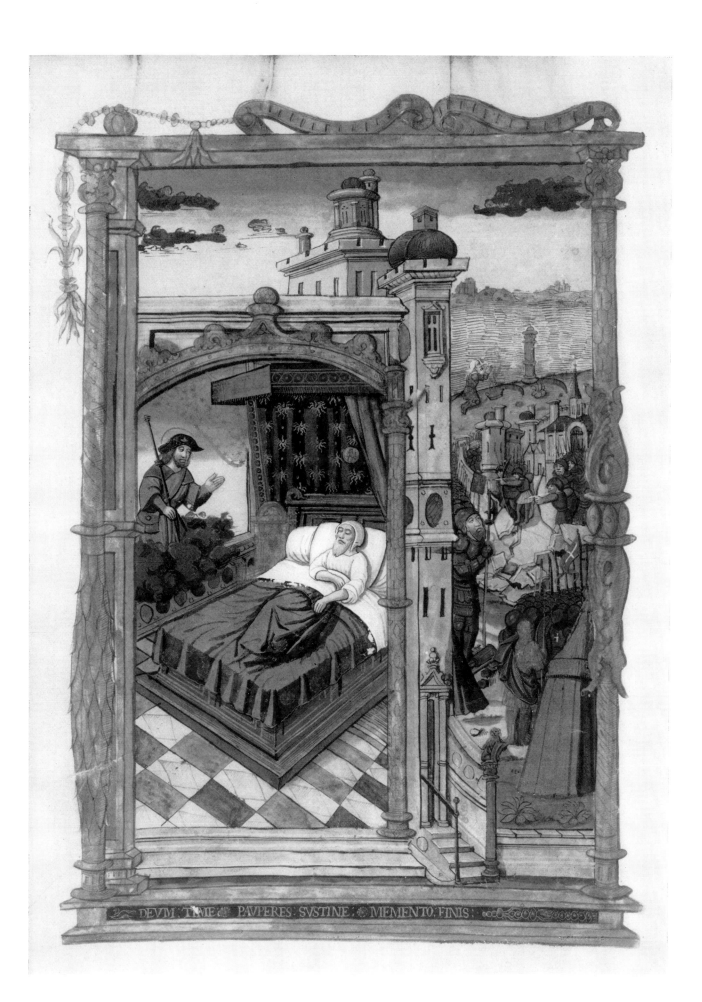

DEVM·TIME·❧·PAVPERES·SVSTINE·❧·MEMENTO·FINIS·❧·

502. Charlemagne
 receiving envoys from
 King Agolant.
 Miracle of the
 flowering lances, and
 battle of Charlemagne
 and Roland against
 Agolant.

Miniature. *Recueil sommaire
des cronicques françoyses* of
Guillaume Cretin. Paris, Bi-
bliothèque Nationale, f. fr.
1820, fos. 85 vo. - 86 ro.

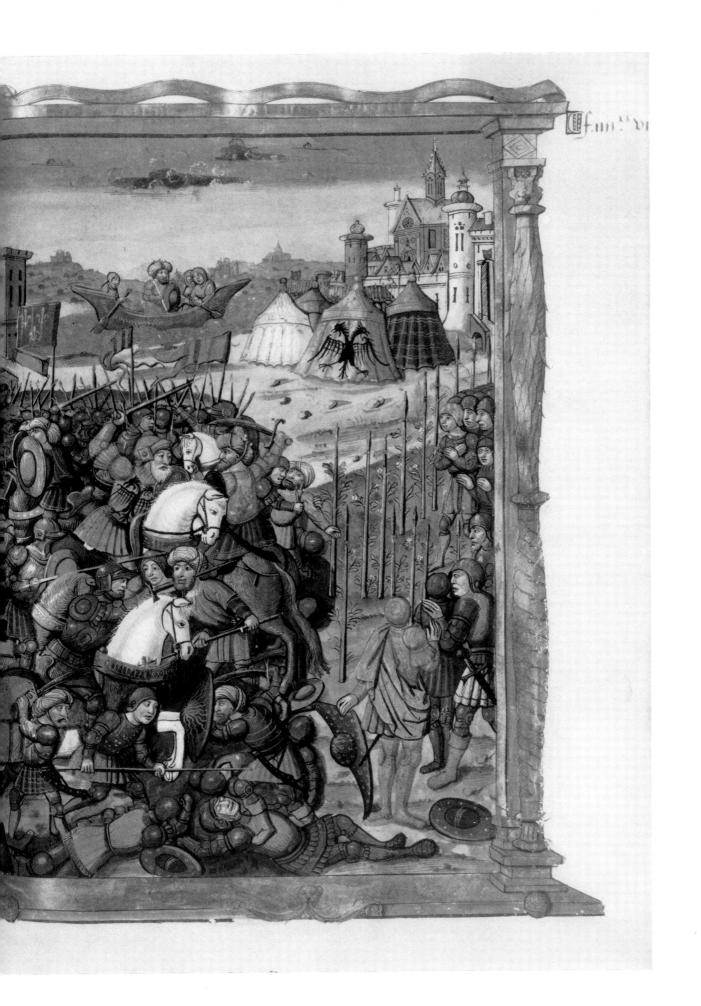

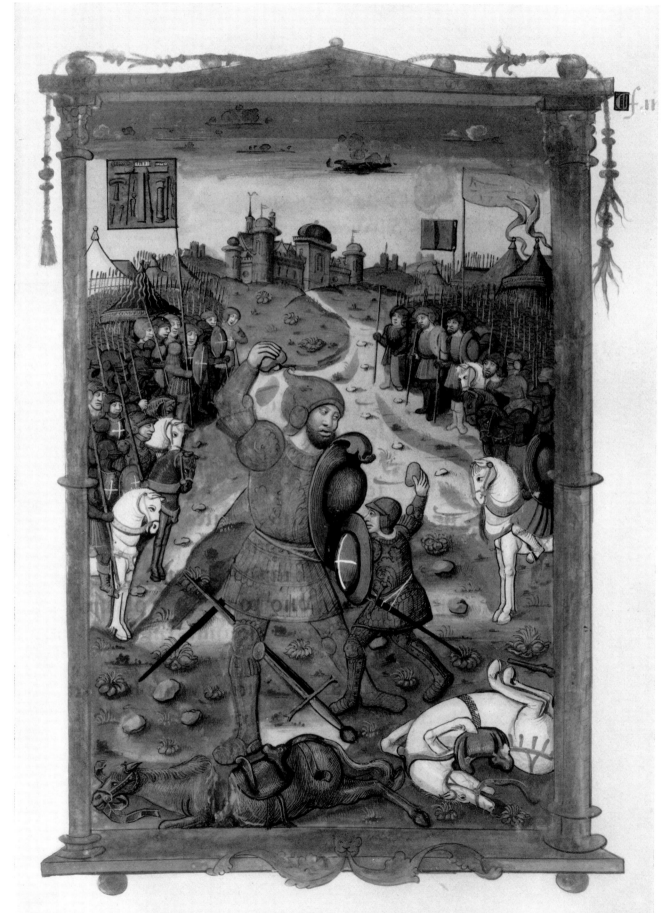

503. Roland fighting with Ferragut.

Miniature. *Recueil sommaire des cronicques françoyses* of Guillaume Cretin. Paris, Bibliothèque Nationale, f. fr. 1820, fo. 99 ro.

504. Roland's fight with Ferragut, second day. Disputation.

Miniature. *Ibid.,* fo. 103 vo.

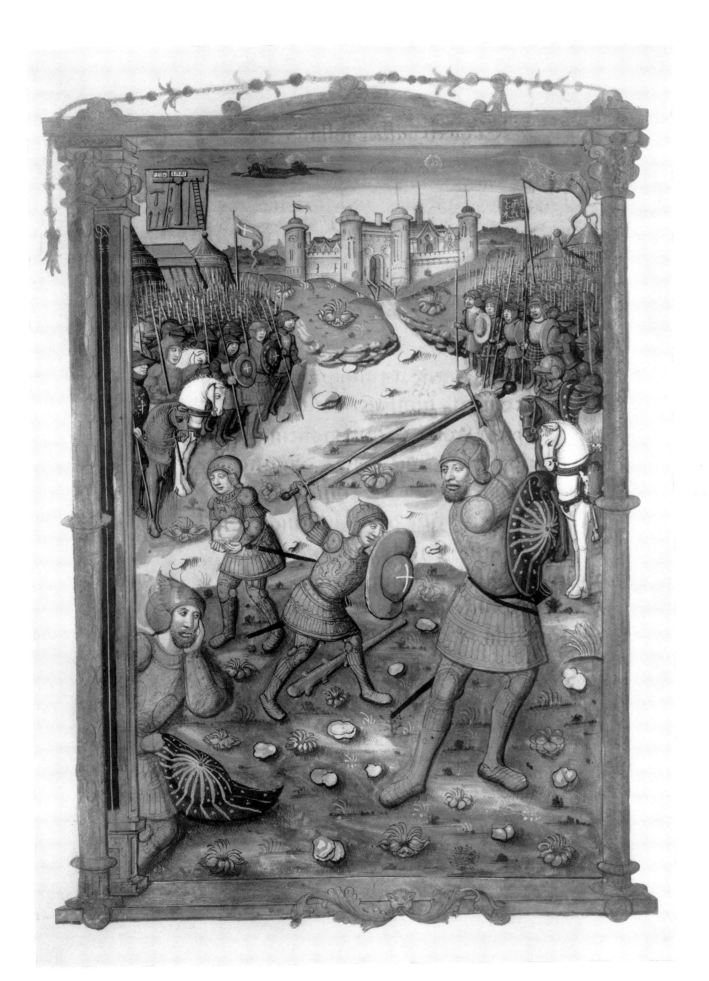

505. Roland's fight with Ferragut. Third day. Roland kills Ferragut.

Miniature. *Recueil sommaire des cronicques françoyses* of Guillaume Cretin. Paris, Bibliothèque Nationale, f. fr. 1820, fo. 107 ro.

506. Ganelon is paid for his treason. Heathen ambush and first victorious charge of Roland and Oliver.

Miniature. *Ibid.,* fo. 118 ro.

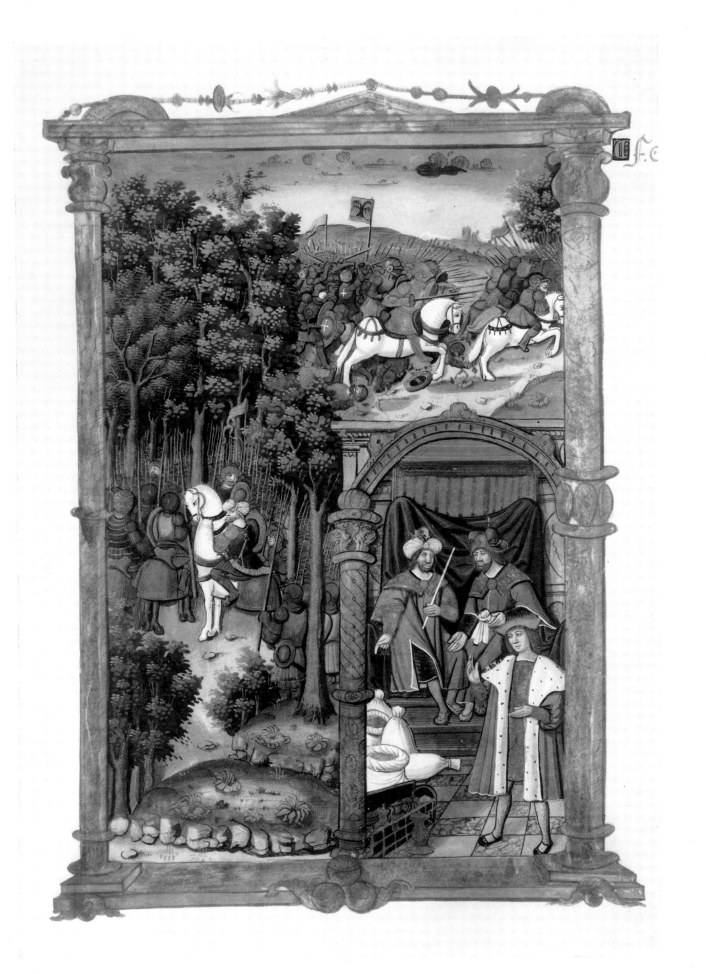

507. Roland forcing a
Saracen to point out
Marsile to him.
Roland charging with
Oliver. Roland
blowing his horn.

Miniature. *Recueil sommaire
des cronicques françoyses* of
Guillaume Cretin. Paris, Bi-
bliothèque Nationale, f. fr.
1820, fo. 124 ro.

508. Roland trying to
break Durandal.
Death of Roland.

Miniature. *Ibid.,* fo. 127 vo.

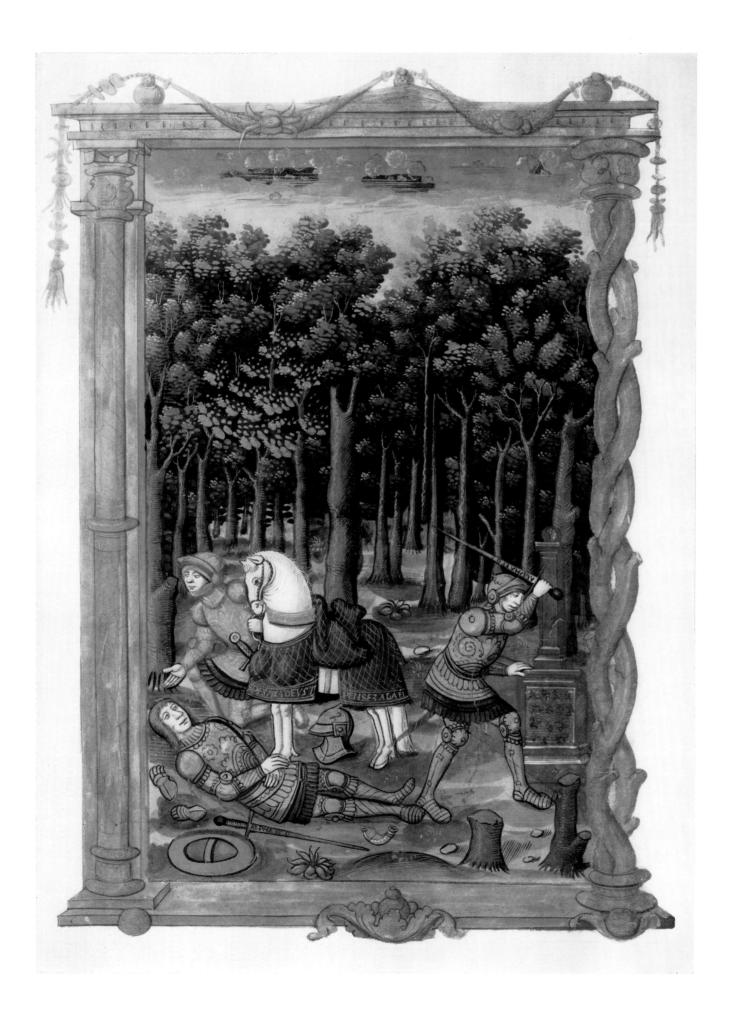

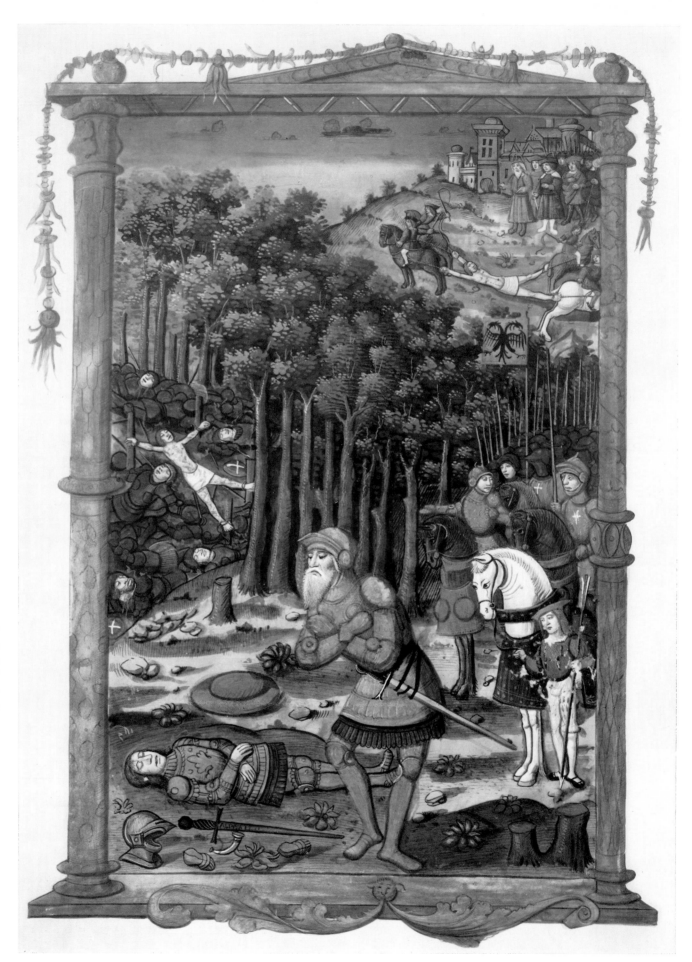

509. Charlemagne mourning for Roland. Ganelon's punishment.

Miniature. *Recueil sommaire des cronicques françoyses* of Guillaume Cretin. Paris, Bibliothèque Nationale, f. fr. 1820, fo. 133 vo.

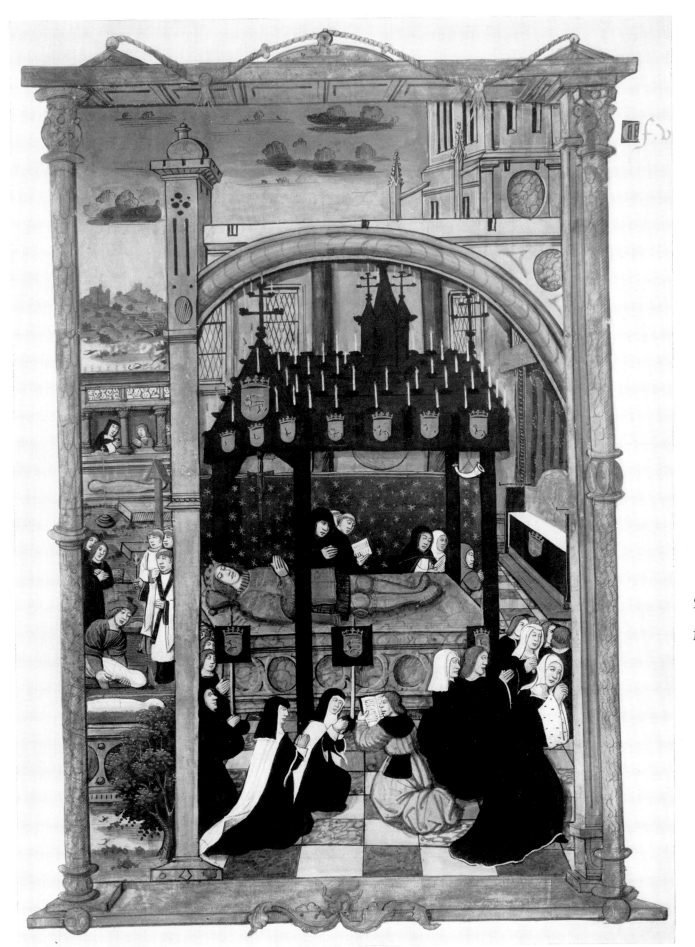

510. Roland's funeral at
 Blaye.
Miniature. *Ibid.*, fo. 141 vo.

APPENDIXES

Episodes in the Life of Roland

EPISODE	TECHNIQUE	DATE	PLATE NO.
Roland born at Imola.	woodcut	early 16th century	136
– taken by Milo, his father to Sutri.	woodcut	early 16th century	136
– brought up by Milo in the forest.	stone sculpture	about 1200	133 B
– attends Charlemagne's banquet.	wash drawing	early 13th century	135
	woodcut	early 16th century	136
– attends his parents' marriage.	wash drawing	13th century	137
– returns to France with Charlemagne.	stone sculpture	about 1200	134
– makes ready to fight Eaumont.	grisaille	about 1460	391
– present at the meeting of Charlemagne and Eaumont before their duel.	miniature	1445	XX
– saves Charlemagne's life at Aspremont and wins Durandal.	wash drawing	first half of 13th century	163
	miniature	second half of 15th century	388
– kills a heathen with the help of St George.	historiated initial	late 13th century	162
	grisaille	about 1460	393
– kills Eaumont.	wash drawing	first half of 13th century	163
	miniature	late 13th – early 14th century	384

EPISODE	TECHNIQUE	DATE	PLATE NO.
– Roland receives from Charlemagne the sword Durandal and the horn Oliphant.	miniature	about 1300	XXIV
– is knighted by Charlemagne.	wash drawing	first half of 13th century	XIX 165 165 A
	historiated initial	late 13th century	161
– goes to Mass after being knighted.	wash drawing	first half of 13th century	167
– goes to war with his minstrel Graelant.	historiated initial	third quarter of 13th century	170
– defends a city against Agolant.	miniature	second quarter of 14th century	281
– besieges town of Agen.	miniature	second quarter of 14th century	282
– witnesses the miracle of the flowering lances.	goldsmith's work	1200-1215	VI 147-148
	stained glass	early 13th century	X
	miniature	second quarter of 14th century	LV
	miniature	1515-1525	502
– takes part in the battle following the miracle, fights or kills Agolant.	goldsmith's work	1200-1215	150-151
	stained glass	early 13th century	XI
	wash drawing	first half of 13th century	168-169
	miniature	second quarter of 14th century	LV, 372
	miniature	second quarter of 14th century	285
	miniature	about 1455	387
	grisaille	about 1460	392
	miniature	1515-1525	502
– meets Oliver and Aude by the walls of Vienne.	grisaille	about 1460	394
– fights and spares a relative of Oliver as Aude looks on.	grisaille	about 1460	395
– present when Oliver comes as envoy to Charlemagne.	historiated initial	second half of 13th century	171
	miniature	about 1300-1350	172
– has a quintain erected by the walls of Vienne.	grisaille	about 1460	434
– Charlemagne's champion in a fight with Oliver, champion of Girart de Vienne.	grisaille	about 1460	396

344

EPISODE	TECHNIQUE	DATE	PLATE NO.
– Roland has his fight with Oliver stopped by an angel.	grisaille	about 1460	LVII
– takes part in Charlemagne's reconciliation with Girart de Vienne.	miniature	first half of 14th century	173
– is betrothed to Aude.	stone sculpture	about 1200	141
	grisaille	about 1460	401
– at Charlemagne's banquet.	wash drawing	early 14th century	174
– struck in the face by Charlemagne (episode from *Fierabras*).	wash drawing	early 14th century	175
– puts King Balan to flight.	wash drawing	early 14th century	176
– fights the Saracens as Princess Floripas looks on.	wash drawing	early 14th century	177
– saves Guy de Bourgogne from hanging.	wash drawing	early 14th century	178
– is besieged and decides to make a sally.	wash drawing	early 14th century	179
– present at the departure of Richard of Normandy.	wash drawing	early 14th century	180
– destroys the heathen idols.	wash drawing	early 14th century	181
	miniature	mid-14th century	385
	miniature	14th century	211
	miniature	mid-14th century	386
– is Charlemagne's champion.	miniature	1462	422
– present with Charlemagne at the scene of Fierabras' challenge.	grisaille	about 1460	397
– made prisoner and taken with Oliver before King Laban.	wash drawing	mid-14th century	XXI
	grisaille	about 1460	398
– present when Turpin restores the stolen relics to Charlemagne.	wash drawing	early 14th century	182
– is put into an enchanted sleep by Maugis who steals his sword.	miniature	about 1460	XXII
	miniature	about 1460	192
	grisaille	1460	190
	grisaille	about 1460	191
– advises Charlemagne after Maugis' theft.	miniature	about 1450	189
– knights Yonet de Montauban.	miniature	about 1450	XXIII
– discusses with Renaut de Montauban the conditions of Maugis' submission to Charlemagne.	miniature	about 1446	188
– receives a message for Charlemagne from Renaut de Montauban.	grisaille	about 1460	194
– present at the submission of Hernaut.	miniature	15th century	193

EPISODE	TECHNIQUE	DATE	PLATE NO.
– Roland present at the submission of Renaut de Montauban.	miniature	about 1460	195
	grisaille	about 1460	399
– besieges Arles with Charlemagne.	pen-drawing	about 1375	196
– takes part in the council of the Franks to decide on the expedition to Spain.	pen-drawing	1180-1190	90
	pen-drawing	1180-1190	91
– brings to Charlemagne the troops about to leave for Spain.	grisaille	about 1460	401
– leaves for Spain with Charlemagne's army.	miniature	late 12th century	I, 33
	stained glass	early 13th century	VII
	miniature	13th century	34
	miniature	about 1300	265
	miniature	early 14th century	269
	miniature	mid-15th century	273
– crosses the Gironde after a white hind.	grisaille	about 1460	402
– takes part in the destruction of Luiserne.	miniature	first half of 14th century	280
– grants his own arms to Guillaume de Gavre.	wash drawing	about 1456	LIV
– sees Ferragut carrying away a Christian knight.	historiated initial	second half of 13th century	365
	monochrome drawing	end of 14th century	345
	miniature	1463	382
– offers to fight the giant.	miniature	15th century	461
– challenges Ferragut.	wash drawing	about 1350	XXIX B
– is carried away by Ferragut.	miniature	first half of 14th century	373
	wash drawing	about 1350	238
– in mounted combat with Ferragut.	sculpture (bas-relief)	1138	47
	sculpture (capital)	about 1140	65
	sculpture (capital)	1150-1165	62-63
	sculpture (capital)	last quarter of 12th century	67
	stained glass	early 13th century	XII
	miniature	early 14th century	270
	miniature	first half of 14th century	283
	wash drawing	about 1350	240
	miniature	first half of 15th century	349
	miniatures	mid-15th century	274-275
	gouache	1496	376
	woodcut	1497	488

EPISODE	TECHNIQUE	DATE	PLATE NO.
– Roland fights on foot against Ferragut on horseback.	wash drawing	about 1350	241
– attends Mass before the fight begins again.	wash drawing	about 1350	242
– allows Ferragut to rest and brings a stone to support his head.	wash drawing	about 1350	243
	miniature	1515-1525	504
– sups in the tent of Solomon, Duke of Brittany.	wash drawing	about 1350	239
– engages in a theological discussion with Ferragut.	miniatures	second quarter of 14th century	283-284
	wash drawing	about 1350	244
	wash drawing	late 14th – early 15th century	348 B
	colour-washed drawing	15th century	351
	woodcut	1483	480
	woodcut	1487 ?	485
	miniatures	1493	305-306
	gouache	1496	376
	miniature	1515-1525	504
– continues fighting on foot.	sculpture	1150-1165	64
	sculpture	12th century	66
	miniature	first quarter of 14th century	279
	miniature	first half of 14th century	373
	miniature	first half of 14th century	283
	wash drawing	about 1350	241
	historiated initial	14th century	336
	wash drawing	late 14th – early 15th century	348 A
	grisaille with touches of colour	1455	379
	miniature	1469-1473	382
	miniature	1493	303
	miniature	1515-1525	503
– strikes Ferragut in the navel and kills him.	sculpture	1138	48
	stained glass	early 13th century	XIII
	miniature	second quarter of 14th century	284
	miniature	first half of 14th century	373
	miniature	1375-1379	291

EPISODE	TECHNIQUE	DATE	PLATE NO.
– Roland strikes Ferragut in the navel and kills him (continued).	miniature	late 14th century	329
	miniature	late 14th century	347
	miniature	late 14th century	330
	miniature	15th century	334
	miniature	15th century	350
	miniature	1449-1460	343
	grisaille	1460	407
	miniature	1480-1489	461
	miniature	late 15th century	330
	gouache	1496	377
	painted woodcut	1497	473
	miniature	1515-1525	505
– kills Ferragut (otherwise than by striking him in the navel).	monochrome drawing	late 14th century	346
	miniature	14th century	347
	miniature	15th century	350
	woodcut	1493	304
	miniature	1493	307
– looks at Ferragut's corpse.	wash drawing	about 1350	245
– spares the lives of the people of Nájera who agree to be baptised.	miniature	about 1350	437
– leaves Nájera to besiege Pamplona.	miniature	about 1350	246
– settles a fight between Christians.	miniature	first half of 14th century	XXX
– blows his horn on the morning of a battle.	miniature	first half of 14th century	250
– blows his horn to cause panic among the heathen.	miniature	about 1300	200
– takes a Saracen city.	historiated initial	second half of 13th century	266
– takes Tortolosa.	miniature	about 1300	200
– destroys the heathen idols.	miniature	late 13th century	386
	miniature	14th century	211
	miniature	mid-15th century	385
– champions Charlemagne.	miniature	1462	422
– takes part in a siege of Pamplona.	numerous miniatures	about 1350	XXX XXXI XXXII 247-249
– rides towards Noble.	miniature	about 1350	XXXIV

EPISODE	TECHNIQUE	DATE	PLATE NO.
– Roland fights in the meadows near Noble.	grisaille	1468	403
– before the gate of Noble.	miniature	about 1350	XXXV
– takes the city of Noble.	stained glass	early 13th century	IX
	miniature	about 1300	251
	miniature	14th century	XXXIX
	painted woodcut	1493	328
	woodcut	1514	470
– sees a heathen army from the top of a tower at Noble.	miniature	about 1350	252
– takes part in several fights to keep Noble.	numerous miniatures	about 1350	253-254
– struck in the face by Charlemagne after taking Noble.	miniature	about 1350	255
– leaves the Emperor's court.	miniature	about 1350	XXXVI
– reaches the sea.	miniature	about 1350	256-257
– embarks.	numerous miniatures	about 1350	not shown
– triumphs over an enemy as the Sultan and his daughter look on.	miniatures	about 1350	258-259
– teaches the young Persians to tilt at the quintain.	miniatures	about 1350	260-261
– attends the wedding of the Sultan's daughter with Anséis de Blois.	miniature		not shown
– makes a pilgrimage to Jerusalem.	miniature		–
– embarks at Beirut for Spain.	miniature		–
– disembarks in Spain.	miniature		–
– meets with robbers.	miniature		–
– arrives at a hermitage.	miniature		–
– is the object of a miracle : an angel takes his shape and tells his companions that tomorrow they will see Charlemagne's camp.	miniature	about 1350	262
– meets Oliver again.	miniature	about 1350	263
– makes final preparations for the siege of Pamplona.	grisaille	about 1460	404
– besieges Pamplona.	miniature	about 1350	XXXIII
	grisaille	about 1460	405
– at the capture of Pamplona.	goldsmith's work	1200-1215	146-147
	stained glass	early 13th century	VIII

EPISODE	TECHNIQUE	DATE	PLATE NO.
– Roland at the capture of Pamplona (continued).	grisaille	about 1460	406
	miniature	late 15th century	390
	miniature	1515-1525	501
– destroys the Saracens.	miniature	second quarter of 14th century	285
	woodcut	1493	312
	painted woodcut	1493	313
– sees Ottinel baptized.	wall-painting	late 14th century	453
– besieges Cordova.	wall-painting	about 1150	89
	pen-drawing	1180-1190	88
– attends Charlemagne's coronation.	miniature	1462	423
	ink and wash	15th century	424
– at Charlemagne's court.	pen-drawing	about 1180-1190	85
	stained glass	about 1200	III
	woodcut	1497	472
	woodcut	1493	493
	painted woodcut	about 1483	479
– receives a messenger with Charlemagne.	ink and wash	about 1450	429
– helps to receive the envoys of Marsile, king of Saragossa.	pen-drawing	1180-1190	87
	pen-drawing	second half of 12th century	91
	miniature	about 1350	237
	grisaille with touches of colour	14th century	352
	wash drawing	late 14th – early 15th century	355
	grisaille	about 1460	408
– advises Charlemagne to appoint Ganelon ambassador.	pen-drawing	1180-1190	92
	pen-drawing	second half of 12th century	93
	historiated initial	late 13th century	370
	historiated initial	late 13th century	371
– is plotted against by Ganelon.	see *Episodes in the Life of Ganelon*		
– with Charlemagne when Ganelon brings back the fatal gifts from Saragossa.	miniature	about 1400	356
	miniature	about 1410	299
	grisaille	about 1460	408
	miniature	about 1468	LIII
– is appointed commander of the rearguard and receives the banner from Charlemagne.	pen-drawing	1180-1190	103
	miniature	about 1300	202
– rides across the Pyrenees.	miniature	second quarter of 14th century	208

EPISODE	TECHNIQUE	DATE	PLATE NO.
– Roland rides across the Pyrenees.	miniature	15th century	364
– takes leave of the Franks at Roncevaux.	miniature	about 1450	202
	ink and wash	about 1450	217
– arms himself.	ink and wash	about 1450	218
– takes Communion before the battle.	pen-drawing	1180-1190	102
	sculpture	late 13th – early 14th century	158
– attacks a heathen temple.	pen-drawing	1180-1190	105
– fights at Roncevaux at the head of his troops.	miniatures	about 1300	203-204
	miniature	first half of 14th century	374
	miniature	14th century	297
	miniature	14th century	363
	historiated initial	14th century	337
	miniature	14th century	381
	wash drawing	late 14th century	358
	miniature	first half of 15th century	359
	miniature	15th century	344
	miniature	15th century	362
	miniature	15th century	335
	wash drawing	15th century	360
	wash drawing	15th century	361 a
	miniature	15th century	361
	miniature	15th century	L
	ink and wash	about 1450	220-222
	miniature	1449-1460	344
	grisaille	about 1460	410-411
	miniature	about 1460	XLII
	miniature	1493	XLIII
	miniature	1493	XLIV
	tapestry	1455-1470	456-457
	gouache	1496	378
	woodcut	1500	477
	miniature	1515-1525	507
– wins the first engagements.	ink and wash	about 1450	222-224
	tapestry	1455-1470	456
– ties a heathen to a tree to make him point out Marsile.	miniature	first half of 14th century	374
	miniature	second quarter of 14th century	XL
	miniature	15th century	344
	miniature	1515-1525	LXIII, 507

EPISODE	TECHNIQUE	DATE	PLATE NO.
– Roland prepares to overthrow Marsile.	wash drawing	late 14th century	XLVIII
– attacks Marsile and cuts off or is about to cut off his arm.	sculpture	about 1120	18
	pen-drawing	1180-1190	110
	miniature	early 14th century	271
	miniature	second quarter of 14th century	XL
	miniature	1375-1379	XLI B, 292 B
	miniature	late 14th century	358
	wash drawing	first half of 15th century	360
	ink and wash	15th century	361 A
	ink and wash	1450	226
– attacks Marsile and wounds or kills him.	miniature	first half of 14th century	374
	miniature	about 1420	XLIX
	grisaille	about 1460	413
	miniature	mid-15th century	276
	miniature	15th century	LVI
	tapestry	1455-1470	458
	woodcuts	1493	308-309
	painted woodcut	1497	474
	woodcut	1497	489
	miniature	1515-1525	LXIII
– quarrels with Oliver who reproaches him for refusing to blow his horn.	mosaic	1178	70
– blows his horn to call Charlemagne.	sculpture	about 1148	54
	sculpture	12th century	57
	stained glass	early 13th century	XIV
	historiated initial	second half of 13th century	367
	miniature	about 1300	204
	miniature	second half of 13th century	267
	miniature	early 14th century	XXXVII A
	miniature	first half of 14th century	374
	coloured pen-drawing	about 1450	XXVIII
	miniature	1449-1460	344
	grisaille	about 1460	412
	miniature	second half of 15th century	389
	tapestry	1455-1470	LIX
	miniature	15th century	335

352

EPISODE	TECHNIQUE	DATE	PLATE NO.
– Roland blows his horn to call Charlemagne (continued).	miniature	1493	310
	painted woodcut	1497	475
	miniature	1515-1525	LXIII
– seeks the bodies of his dead comrades.	mosaic	1178	70
	sculpture	12th century	82(?)
– blessed by Turpin.	pen-drawing	1180-1190	114
– carries away the dying Oliver.	mosaic	1178	71
	pen-drawing	1180-1190	115
– tends the dying Oliver.	woodcut	1500	478
– mourns Oliver's death.	mosaic	1178	72
– avenges Oliver's death.	ink and wash	about 1450	227
– continues fighting.	miniature	about 1300	203
– avenges Waltherius' death.	ink and wash	about 1450	228
– gives his helmet to Turpin.	ink and wash	about 1450	229
– witnesses Turpin's death.	miniature	about 1300	204
– attacked by the heathen.	sculpture (capital)	about 1140	60
	miniature	14th century	XLVII
– tries to break Durandal.	sculpture	first quarter of 12th century	56
	sculpture	about 1148	54
	stained glass	early 13th century	XIV
	historiated initial	second half of 13th century	267
	miniature	about 1300	XXV
	tapestry	1455-1470	LIX
	miniature	1493	311
	miniature	1515-1525	508
– is helped by Baudouin or Tierry or both.	miniature	second quarter of 14th century	287
	miniature	14th century	338
	miniature	about 1460	XLII
	grisaille	about 1460	414
	tapestry	1455-1470	457, 459, 460
	miniature	1480-1489	LIX
	miniature	1515-1525	508
– is tended by Baudouin who brings him a drink.	stained glass	early 13th century	XVI
	miniature	early 14th century	272
– prays before dying.	miniatures	1493	314-315

EPISODE	TECHNIQUE	DATE	PLATE NO.
– Roland strikes a heathen with his horn.	mosaic	1178	74
	pen-drawing	1180-1190	117
	miniature	about 1300	204
	miniature	14th century	209
– offers his glove to St. Michael.	miniature	about 1300	XXV
	miniature	second quarter of 14th century	209
– dies.	miniature	first half of 14th century	287
	miniature	1375-1379	293
	miniature	about 1460	XLII
	miniature	about 1460	L
	miniature	1449-1460	344
	miniature	1467	LII
	tapestry	1455-1470	LX
	miniature	1480-1489	LIX
	miniature	1515-1525	508
– his soul borne up to Heaven.	initial	second half of 13th century	368
	miniature	1449-1460	344
– welcomed into Heaven by Jesus and the Virgin.	miniature	13th century	II
– mourned by Charlemagne.	miniatures	second quarter of 14th century	288-290
	miniature	first half of 14th century	375
	miniature	14th century	339
	miniature	end of 14th century	331
	ink and wash	about 1450	230, 233
	grisaille with touches of colour	1455	380
	miniature	1449-1460	344
	woodcut	1487 ?	487
	woodcut	1497	490
	miniature	end of 15th century	332
	miniature	1515-1525	509
– gives back his sword to Charlemagne.	miniature	about 1350	XXV
– buried ?	sculpture	12th century	83
– buried, wrapped in a shroud.	sculpture	before 1150	127
	miniature	1495-1496	383
– laid in a marble coffin.	miniature	before 1350	290
– buried with Oliver.	ink and wash	about 1450	234

EPISODE	TECHNIQUE	DATE	PLATE NO.
– Roland carried on a bier.	miniature	first half of 14th century	375 A
– buried at Blaye.	miniature	early 14th century	XXXVII B
	miniature	first half of 14th century	290
	miniature	about 1350	207
	miniature	late 14th century	XLVI
	woodcut	1493	324
	miniatures	1493	325-327
	miniature	1515-1525	510
– mourned by Aude.	miniature	about 1350	207
	miniature	14th century	XXVII
	miniature	late 14th century	XLVI
	miniature	1515-1525	510
Turpin's vision.	historiated initial	13th century	II
	miniature	second half of 13th century	368
	miniature	1375-1379	294
	miniature	1449-1460	344
	miniatures	1493	318-319
Roland's apotheosis in the *Paradiso* of the *Divine Comedy*.	woodcut	1491	425 A
	woodcut	1493	425 B
	miniature	1515-1525	426

Episodes in the Life of Ganelon

EPISODE	TECHNIQUE	DATE	PLATE NO.
Ganelon takes part in the council of the Franks.	pen-drawing	second half of 12th century	91
	pen-drawing	1180-1190	90
	ink and wash	about 1450	213
– is appointed ambassador to Marsile.	pen-drawing	second half of 12th century	93
	pen-drawing	1180-1190	92
	miniature	about 1247	XXXVIII
	miniature	second half of 13th century	366
	historiated initial	second half of 13th century	370
	historiated initial	late 13th century	371
	miniature	14th century	210
	grisaille with touches of colour	14th century	353
	wash drawing	late 14th – early 15th century	355
– plots with the kings of Saragossa.	woodcut	1483	481
	woodcut	1487	486
– utters threats on leaving Charlemagne's court.	pen-drawing	1180-1190	94
	ink and wash	about 1450	214
– plots Roland's downfall with Blancandrin.	pen-drawing	1180-1190	95
– holds council with the heathen.	pen-drawing	1180-1190	96
– gives Charlemagne's message to Marsile.	miniature	late 14th century	XLV

356

EPISODE	TECHNIQUE	DATE	PLATE NO.
Ganelon involved in an incident with Marsile.	pen-drawing	1180-1190	97
– swears to Marsile to give Roland into his hands.	pen-drawing	1180-1190	98
	stone sculpture	early 13th century	154 B
	historiated initial	late 13th century	159
	ink and wash	1450	215
	grisaille	about 1460	409
	woodcut	1514	471
– receives Marsile's gifts.	grisaille with touches of colour	14th century	354
	miniature	early 15th century	340
	miniature	early 15th century	341
	woodcut	1514	471
	miniature	1515-1525	506
– plots treason with kings Marsile and Baligant.	miniature	second quarter of 14th century	286
	miniature	about 1380	357
	woodcut	1483	481
	woodcut	1487	486
	miniature	about 1500	369
– brings back the fatal gifts to Charlemagne's court.	miniature	second quarter of 14th century	286
	miniature	1375-1379	XLI A, 292 A
	miniature	14th century	298
	miniature	about 1400	356
	miniature	about 1410	299
	miniature	about 1420	XLIX
	miniature	1449-1460	344
	grisaille	about 1460	408
	miniature	about 1468	LIII
– tries to convince Charlemagne that the sound of Roland's horn means nothing.	stained glass	early 13th century	XV
	miniature	early 14th century	XXXVII
– is arrested on Charlemagne's orders.	grisaille	about 1460	418
– is brought to trial.	pen-drawing	1180-1190	124
	grisaille	about 1460	419
– fights with the Margrave Otto.	wash drawing	about 1450	235
– is quartered.	miniature	first half of 14th century	375 A
	miniature	1375-1379	295 B
	grisaille	about 1460	419
	miniature	1515-1525	509

I.

Charlemagne's army leaving for Spain.

The veterans of the Spanish War at Aix-la-Chapelle.

Miniature divided horizontally. *Codex Calixtinus.* Santiago de Compostela, Archivo Catedral, f⁰ 162 v⁰. Late 12th century.

II.

Archbishop Turpin's vision of Roland's death at Roncevaux.

Miniature. *Codex Calixtinus.* Salamanca, Biblioteca Universitaria, Ms 2631 f⁰ 90 v⁰.

III.

Charlemagne between Roland and Oliver.

Window from the Romanesque cathedral of Strasbourg. Strasbourg, Musée de l'Œuvre Notre-Dame. About 1200.

IV.

Marriage of Gisela, Charlemagne's sister and later Roland's mother, to Duke Milo.

Charlemagne's incest revealed to Saint Giles as he is about to celebrate Mass; the Divine pardon.

Wall painting in St. Lawrence's Chapel at Le Loroux-Bottereau (Loire-Atlantique). About 1200.

V.

Gisela and Charlemagne. Charlemagne's incest revealed to St. Giles as he is about to celebrate Mass; Divine pardon.

Miniature. Psalter attributed to Lambert le Bègue, Liège, Bibliothèque de l'Université, Ms. 431. About 1255-1260.

VI.

Charlemagne, Milo and Roland, and the miracle of the flowering lances.

Gilded copper relief. Reliquary of Saint Charlemagne, Cathedral of Aix-la-Chapelle. 1200-1215.

VII.

Charlemagne, Roland and Archbishop Turpin leaving for Spain to liberate the pilgrim route to Compostela.

Detail of a stained glass window in the Cathedral of Notre-Dame, Chartres. North section of the ambulatory. Early 13th century.

VIII.

Charlemagne praying for the fall of Pamplona. Roland is behind him bearing his standard.

Detail of a stained glass window in the Cathedral of Notre-Dame, Chartres. North section of the ambulatory. Early 13th century.

IX.

Roland taking the heathen city of Noble.

Detail of a stained glass window in the Cathedral of Notre-Dame, Chartres. North section of the ambulatory. Early 13th century.

X.

Roland and the miracle of the flowering lances.

Detail of a stained glass window in the Cathedral of Notre-Dame, Chartres. North section of the ambulatory. Early 13th century.

XI.

Roland killing a heathen king in the fight following the miracle of the flowering lances.

Detail of a stained glass window in the Cathedral of Notre-Dame, Chartres. North section of the ambulatory. Early 13th century.

XII.

Roland and the giant Ferragut fighting on horseback.

Detail of a stained glass window in the Cathedral of Notre-Dame, Chartres. North section of the ambulatory. Early 13th century.

XIII.

Roland killing the heathen champion Ferragut, thus achieving sanctity, as the halo shows.

Detail of a stained glass window in the Cathedral of Notre-Dame, Chartres. North section of the ambulatory. Early 13th century.

XIV.

End of the battle of Roncevaux. Roland, mortally wounded, trying to break his sword Durandal, and blowing his horn to warn Charlemagne.

Detail of a stained glass window in the Cathedral of Notre-Dame, Chartres. North section of the ambulatory. Early 13th century.

XV.

Charlemagne hears Roland's horn.
Detail of a stained glass window in the Cathedral of Notre-Dame, Chartres. North section of the ambulatory. Early 13th century.

XVI.

Ganelon's son Baudouin bringing drink to his dying half-brother Roland.
Detail of a stained glass window in the Cathedral of Notre-Dame, Chartres. North section of the ambulatory. Early 13th century.

XVII.

Baudouin bringing Charlemagne the news of Roland's death.
Detail of a stained glass window in the Cathedral of Notre-Dame, Chartres. North section of the ambulatory. Early 13th century.

XVIII.

St. Giles celebrating Mass. An angel is giving the saint a document revealing Charlemagne's mortal sin and granting him pardon for his misdeed.
Detail of a stained glass window in the Cathedral of Notre-Dame, Chartres. North section of the ambulatory. Early 13th century.

XIX.

Charlemagne knighting the young Roland.
Wash drawing. *Chanson d'Aspremont*. London, British Museum, Ms. Lansdowne 782 f° 23 v°. First half of 13th century.

XX.

Roland at Charlemagne's meeting with the heathen Eaumont before the battle.
Miniature. *Chanson d'Aspremont*. London, British Museum Ms. Royal 15 E VI f° 43 r°. About 1445.

XXI.

Roland and Oliver brought captive before the heathen king Laban.
Wash drawing. *Fierabras*. London, British Museum, Ms. Egerton 3028 f° 93 r°. Middle of 14th century.

XXII.

The enchanter Maugis stealing the swords of Charlemagne, Roland and the other peers.
Miniature. *Renaut de Montauban*. Paris, Bibliothèque Nationale, f. fr. 764 f° 52 v°. About 1440.

XXIII.

Roland knighting Yonet, son of Renaut de Montauban.
Miniature. *Renaut de Montauban*. Paris, Bibliothèque de l'Arsenal, Ms. 5072, f° 102 v°. About 1450.

XXIV.

An angel gives Charlemagne the sword Durandal and the horn Oliphant.
Miniature divided horizontally. *Karl der Grosse* of Der Stricker. Saint-Gall. Stadtbibliothek (Vadiana) Ms. 302 f° 3 v°. About 1300.

XXV.

The dying Roland, tries to break his sword. Roland gives his glove to Saint Michael. The hand of the dead Roland gives back Durandal to Charlemagne. An angel appears to Charlemagne and proclaims that Joshua's miracle of the sun stayed in its course has been renewed.
Miniature divided horizontally. *Karl der Grosse* of Der Stricker. Saint Gall, Stadtbibliothek (Vadiana) Ms. 302 f° 52 v°. About 1300.

XXVI.

Charlemagne and the infidel Palligan (Baligant) fighting on foot. Charlemagne striking Palligan dead.
Miniature divided horizontally. *Karl der Grosse* of Der Stricker. Saint Gall, Stadtbibliothek (Vadiana) Ms. 302 f° 662. About 1300.

XXVII.

Death of Aude.
Miniature. *Karl der Grosse* of Der Stricker. Berlin, Deutsche Staatsbibliothek Ms. Germ. fol. 623, f° 23 r°. (At present kept at Tübingen, Universitätsbibliothek.) Second quarter of 14th century.

XXVIII.

Charlemagne hears Roland's horn at Roncevaux.
Pen and wash. *Karl der Grosse* of Der Stricker. Bonn. Universitätsbibliothek S. 500, f° 136 r°. About 1450.

XXIX.

A. One of the many knights conquered by the giant Ferragut.
B. Roland presenting himself for battle with Ferragut.
Miniature. *L'Entrée d'Espagne*. Venice, Biblioteca Marciana, cod. fr. XXI, f° 50 v°. About 1350.

XXX.

Charlemagne and Roland supervising preparations for the siege of Pamplona.
Miniature. *L'Entrée d'Espagne*. Venice, Biblioteca Marciana, cod. fr. XXI, f° 136 v°. About 1350.

XXXI.

Roland slaughtering the infidel at the siege of Pamplona.
Left-hand section of a double-page miniature. *L'Entrée d'Espagne*. Venice, Biblioteca Marciana, cod. fr. XXI, f° 160 v°. About 1350.

XXXII.

Troop movements during the siege of Pamplona.

Right-hand section of a double-page miniature. Venice, Biblioteca Marciana, cod. fr. XXI, f° 161 r°. About 1350.

XXXIII.

Fighting beneath the walls of Pamplona.

Miniature. *L'Entrée d'Espagne.* Venice, Bibliotheca Marciana, cod. fr. XXI, f° 161 v°. About 1350.

XXXIV.

Charlemagne fighting beneath the walls of Pamplona. Roland refuses to take part, leaves the army and goes to besiege Noble, another heathen city.

Miniature. *L'Entrée d'Espagne.* Venice, Bibliotheca Marciana, cod. fr. XXI, f° 162 r°. About 1350.

XXXV.

An episode in Roland's siege of Noble. The hero points out the city to be taken.

Miniature. *L'Entrée d'Espagne.* Venice, Bibliotheca Marciana, cod. fr. XXI, f° 189 r°. About 1350.

XXXVI.

Roland, struck in the face by Charlemagne after the capture of Noble, leaving Charlemagne's camp for the Orient.

Miniature. *L'Entrée d'Espagne.* Venice, Bibliotheca Marciana, cod. fr. XXI, f° 217 r°. About 1350.

XXXVII.

A. Charlemagne hears Roland's horn at Roncevaux.

B. Charlemagne making grants to the canons of Blaye, in the crypt where Roland lies.

Miniatures. *Pseudo-Turpin.* Florence, Biblioteca Laurenziana, Ms. Ashburnham 52, f° 133 r°. Early 14th century.

XXXVIII.

Charlemagne appointing Ganelon ambassador to the heathen kings of Saragossa.

Miniature. *Les Grandes Chroniques de France.* Paris, Bibliothèque Sainte-Geneviève, ms. 782 f° 152 r°. About 1274.

XXXIX.

Roland taking the heathen city of Noble.

Miniature. *Les Grandes Chroniques de France.* London, British Museum, Royal 16 G VI, f° 184 r°. Second quarter of the 14th century.

XL.

Battle of Roncevaux. Roland tying a Saracen to a tree and forcing him to point out King Marsile. Roland attacking the king.

Miniature. *Les Grandes Chroniques de France.* London, British Museum. Royal 16 G VI, f° 178 v°. Second quarter of the 14th century.

XLI.

A. Ganelon bringing the fatal gifts of the heathen kings back to Charlemagne.

B. Roland striking Marsile at the battle of Roncevaux.

Miniatures. *Les Grandes Chroniques de France.* Paris, Bibliothèque Nationale, f. fr. 2813, f° 121 r°. 1375-1379.

XLII.

The battle of Roncevaux. Roland's death, tended by his half-brother Baudouin.

Miniature by Jean Fouquet, *Les Grandes Chroniques de France.* Paris, Bibliothèque Nationale, f. fr. 6465, f° 113 r°. About 1460.

XLIII.

Battle of Roncevaux.

Miniature. *Les Grandes Chroniques de France.* Paris, Antoine Vérard, 1493. Paris, Bibliothèque Nationale, Rés. vélin 728.

XLIV.

Battle of Roncevaux.

Miniature. *Les Grandes Chroniques de France.* Paris, Antoine Vérard, 1493. Paris, Bibliothèque Nationale, Rés. vélin 728.

XLV.

Ganelon giving Marsile, the heathen king of Saragosse, a message from Charlemagne.

Miniature. *Les Grandes Chroniques de France.* London, British Museum, Cotton Nero E II, f° 127 r°. End of 14th century.

XLVI.

Charlemagne and Aude at Roland's funeral at Blaye.

Miniature. *Les Grandes Chroniques de France.* London, British Museum, Cotton Nero E II, f° 131 r°. Late 14th century.

XLVII.

Roland attacked by the heathen at Roncevaux.

Miniature. *Les Grandes Chroniques de France.* Brussels, Bibliothèque Royale, ms. 5, f° 142 v°. 14th century.

XLVIII.

Roland pursuing King Marsile.

Wash drawing. *Les Grandes Chroniques de France.* Paris, Bibliothèque de l'Arsenal, ms. fr. 5223, f° 121 r°. Late 14th century.

XLIX.

Ganelon returning to Charlemagne with the fatal gifts. Battle of Roncevaux. Roland killing Marsile.

Miniature. *Les Grandes Chroniques de France.* Toulouse, Bibliothèque Municipale, ms. 512, f° 114 v°. About 1420.

L.

Battle of Roncevaux. Roland killing Marsile. Roland lying dead beside his sword Durandal.

Miniature. *Les Grandes Chroniques de France.* London, British Museum Add. 15269, f° 124 v°. 15th century.

LI.

Battle of Roncevaux.

Miniature by Loiset Liédet. *Chronicle attributed to Baudouin d'Avesnes.* Paris, Bibliothèque de l'Arsenal, ms. 5089, f° 169 v°.

LII.

Battle of Roncevaux. Roland blowing his horn. The death of Roland.

Miniature. *Chroniques de Hainaut* of Jean Wauquelin. Paris, Bibliothèque Nationale, f. fr. 20128, f° 233 v°. 1467.

LIII.

Charlemagne and Roland receiving the fatal gifts brought by Ganelon from Saragossa.

Miniature by Guillaume Vrelant. *Chronique de Hainaut* of Jean Wauquelin, Brussels, Bibliothèque Royale, ms. 9243, f° 214 r°. About 1468.

LIV.

Roland grants Guillaume de Gavre the honour of bearing the same arms as his own.

Colour-washed drawing, by the Master of Wavrin. *Histoire des Seigneurs de Gavre.* Brussels, Bibliothèque Royale, ms. 10238, f° 2 r°. 1456.

LV.

Roland, Oliver and Milo fighting after the miracle of the flowering lances.

Miniature. *Spieghel historiael* of Jacob van Maerlant. The Hague, Koninklijke Bibliotheek, Ak. xx, f° 211 v°. Second quarter of 14th century.

LVI.

Roland killing King Marsile.

Miniature by Maître François (Fouquet ?) *Miroir historial* of Jean de Vignay. Chantilly, Musée Condé, ms. 722, f° 111 r°. 1469-1473.

LVII.

An angel stops the fight between Roland and Oliver beneath the walls of Vienne in Dauphiné.

Grisaille by Jean le Tavernier. *Croniques et Conquestes de Charlemaine* of David Aubet. Brussels, Bibliothèque Royale, ms. 9066, f° 437 r°.

LVIII.

Roland's statue at Bremen.

Stone statue. 1404.

LIX.

Roland at Roncevaux. He fights, blows his horn, tries to break his sword and finally dies.

Detail of tapestry from Tournai. Brussels, Musées Royaux d'Art et d'Histoire. About 1455-1470.

LX.

Death of Roland.

Miniature by Jean Colombe. *Histoire et faits des Neuf Preux et des Neuf Preues* of Sebastian Mamerot. Vienna, Österr. Nationalbibliothek, cod. 2577 vol. 1, f° 130 r°. Between 1480 and 1489.

LXI.

Saint Roland.

Colour-washed pen-drawing. *Die Heilige aus der Sipp- und Magschaft Maximilians I.* Vienna, Österr. Nationalbibliothek, ser. nov. 2627. About 1510-1515.

LXII.

Roland as the Knave of Diamonds.

Playing-card (made in Rouen ?). Rouen, Archives départementales de la Seine-Maritime. Early 16th century.

LXIII.

Roland forcing a Saracen to point out King Marsile. Roland charging with Oliver. Roland blowing his horn.

Miniature. *Recueil sommaire des croniques françoyses* by Guillaume Cretin. Paris, Bibliothèque Nationale f. fr. 2820, f° 124 r°. Between 1515 and 1525.

List of black and white illustrations

1. Confronted knights.
Conques, Rouergue. Church of Sainte-Foy. Gallery capital. Between 1087 and 1119. Photo : Yan (Jean Dieuzaide), Toulouse.

2. Bust of telamon and confronted knights.
Ibid. High-relief and capital. Photo : Archives Photographiques.

3. Confronted knights separated by a figure.
Fruniz, Biscay. Church of San Salvador. Capital at doorway. 12th century. Photo : Goiccechea, Munguia.

4. Crowned king surrounded by dignitaries and prelates.
Ibid. Capital at doorway. 12th century. Photo : Goiccechea, Munguia.

5. Men blowing horns.
Conques, Rouergue. Church of Sainte-Foy. Gallery capital. Between 1087 and 1119. Photo : Yan-Zodiaque.

6. Two warriors fighting on foot.
Conques, Rouergue. Church of Sainte-Foy. Gallery capital. Between 1087 and 1119. Photo : Yan-Zodiaque.

7. Confronted knights and Samson wrestling with the lion.
Front of Doña Sancha's sarcophagus. Jaca, Benedictine Convent. End of 11th century. Photo : Peñarroya, Jaca.

8. Confronted knights and Samson wrestling with the lion.
"La Belle Pierre". Cluny, Musée Ochier. About 1160. Photo : Archives Photographiques, Paris.

9. Confronted knights.
Miniature. *Psalter of San Millán de la Cogolla.* Madrid, Biblioteca de la Academia de la Historia. 11th century. Photo : Archivo Mas, Barcelona.

10. Battle between Christians and infidels.
Pavia, Museo Civico (from the Church of San Giovanni in Borgo). Bas-relief. Second quarter of 12th century. Photo : Museo Civico, Pavia.

11. A Christian knight fighting with an Arab.
Detail of Doña Sancha's sarcophagus. Photo : Jean Dieuzaide, Toulouse.

12. Original façade of St. Peter's Cathedral, Angoulême.
Engraving. Angoulême, Musée de la Ville. Photo : Belzaux-Zodiaque.

13. Present façade of St. Peter's Cathedral, Angoulême.
Photo : Belzaux-Zodiaque.

14. Three apostles. The preaching of the Gospel.
Angoulême. St. Peter's Cathedral. Tympanum of the first blind doorway on the right of the main door. About 1120. Photo : Gilbert, Jarnac.

15. Lintel of the tympanum, Angoulême Cathedral.
Detail of fig. 14. Photo : Gilbert, Jarnac.

16. Archbishop Turpin fighting the heathen Abisme.
Angoulême. Detail of the lintel. Photo : Gilbert, Jarnac.

17. Roland cutting off the arm of the heathen king Marsile.
Angoulême. Detail of the lintel. Photo : Gilbert, Jarnac.

18. Marsile fainting outside his capital Saragossa.
Angoulême. Detail of the lintel. Photo : Gilbert, Jarnac.

19. Stag-hunt.
Angoulême. Lintel of the second blind doorway on the right of the main door. About 1120. Photo : Gilbert, Jarnac.

20. Frescoes of the Charlemagne cycle.
Rome. Church of Santa Maria in Cosmedin. Central nave, left-hand wall. Between 1119 and 1123. Photo : Gabinetto fotografico nazionale, Rome.

21. Charlemagne receiving Haroun-al-Raschid's gifts.
Ibid. Scene 9 of the cycle. Photo : Gabinetto fotografico nazionale, Rome.

22. Charlemagne receiving Haroun-al-Raschid's gifts.
Reconstruction by G.B. Giovenale. Photo : Bibl. Vaticana.

23. Charlemagne arriving in Jerusalem.
Charlemagne before the Holy Sepulchre.
Fresco. Rome. Santa Maria in Cosmedin. Photo : Gabinetto fotografico nazionale, Rome.

24. Charlemagne arriving in Jerusalem
 Charlemagne before the Holy Sepulchre.
Reconstruction by G.B. Giovenale. Photo : Bibl. Vaticana.

25. An angel appears to Charlemagne to give him the
 task of liberating the tomb of St. James.
Fresco. Rome, Santa Maria in Cosmedin. Photo : Gabinetto
fotografico nazionale, Rome.

26. An angel appears to Charlemagne to give him the
 task of liberating the tomb of St. James.
Reconstruction by G.B. Giovenale. Photo : Bibl. Vaticana.

27. Charlemagne weeps. Miracle in his favour.
Reconstruction by G.B. Giovenale. Photo : Bibl. Vaticana.

28. Christ judging and absolving Charlemagne.
Reconstruction by G.B. Giovenale. Photo : Gabinetto fotografico nazionale, Rome.

29. Portrait of the apostle St. James (?).
Fresco. Rome, Santa Maria in Cosmedin. Photo : Gabinetto
fotografico nazionale, Rome.

30. Archbishop Turpin.
Historiated initial T. *Codex Calixtinus*, Santiago de Compostela,
Archivo Catedral, f° 163 r°. Second half of 12th century. Photo:
Archivo Mas, Barcelona.

31. St. James appearing to Charlemagne.
Miniature. *Codex Calixtinus. Ibid.* f° 162 r°. Photo : Archivo
Mas, Barcelona.

32. St. James appearing to Charlemagne.
Miniature. *Codex Calixtinus.* Rome, Biblioteca Vaticana, Arch.
S. Pietro, ms. C 128, f° 133 v°. 14th century. Photo : Bibl.
Vaticana.

33. Departure of Charlemagne's army for Spain.
Miniature. *Codex Calixtinus.* Santiago de Compostela, Archivo
Catedral, f° 162 v°. Photo : Archivo Mas, Barcelona.

34. St. James appears to Charlemagne.
 Charlemagne's army leaving for Spain.
 Charlemagne and the Spanish War veterans at
 Aix-la-Chapelle.
Miniature. *Codex Calixtinus,* Salamanca, Biblioteca Universitaria, ms. 2631, f° 90 r°. 13th century. Photo : Mrs Hibberd-Loomis.

35. Façade of the Cathedral of Verona (1139).
Irifoto, Verona.

36. Statues of Roland and Oliver.
Verona. Cathedral. Side view of the main entrance. 1139.
Irifoto, Verona.

37. Prophets, side view with prophet on the door
 jamb.
Detail of main doorway, left-hand side. Irifoto, Verona.

38. Statue of Roland, frontal view.
Detail of doorway, left-hand side. Irifoto, Verona.

39. Statue of Oliver, frontal view.
Detail of doorway, right-hand side. Irifoto, Verona.

40. The inscription 'Durindarda' on Roland's sword.
Detail of the statue. Irifoto, Verona.

41. Dedicatory inscription in Waha church.
Belgium, province of Luxembourg. 1050. Photo : Clément
Dessart, Liège.

42. Last Judgement.
Conques, Rouergue. Church of Sainte-Foy. Detail of tympanum.
Beginning of 12th century. Photo : Apa-Poux, Albi.

43. Head of Oliver.
Detail. Verona, Cathedral. Irifoto, Verona.

44. Head of Roland.
Detail. Verona, Cathedral. Irifoto, Verona.

45. Façade of the church of Santo Zeno, Verona.
Main doorway. About 1138. Irifoto, Verona.

46. Theodoric the Visigoth hunting.
Verona. Church of Santo Zeno. Bas-relief on the façade, to the
right of the doorway. Bildarchiv Foto, Marburg.

47. Mounted combat between Roland and the heathen
 Ferragut.
Verona. Church of Santo Zeno. Bas-relief on the façade, to the
left of the doorway. Irifoto, Verona.

48. Roland and Ferragut fighting on foot. Roland kills
 Ferragut.
Ibid. Irifoto, Verona.

49. General view of the fight between Roland and
 Ferragut.
Verona. Church of Santo Zeno. Bildarchiv Foto, Marburg.

50. Fight between 'le Fol' and 'le Fel'.
Mosaic at Vercelli, Museo Leone. About 1148. Photo : Museo
Leone, Vercelli.

51. Santa Maria della Strada at Matrice.
Molise, Italy. Photo : E.P.U., Zürich.

52. Façade of the church of Santa Maria della Strada.
About 1148. Photo : E.P.U., Zürich.

53. An episode from the chanson de geste 'Floovant'.
Matrice. Santa Maria della Strada, tympanum on the left of the
main doorway. About 1148. Photo : E.P.U., Zürich.

54. Episodes of the 'Chanson de Roland'. Roland trying to break his sword, his horse lying beside him; Roland blowing his horn.
Ibid. Tympanum on the right of the doorway. About 1148. Photo : E.P.U., Zürich.

55. Dog chasing a stag.
Limoges, Musée des Beaux-Arts. From the façade of the church of Notre-Dame-de-la-Règle at Limoges. First third of the 12th century. Photo : Jove, Limoges.

56. Roland brandishing his sword.
Limoges, Musée des Beaux-Arts. From the façade of the church of Notre-Dame-de-la-Règle at Limoges. First third of the 12th century. Photo : Franceschi, Paris.

57. Roland blowing his horn.
Cluny. Carved stone incorporated in the wall of a house. 12th century. Photo : Musée Ochier, Cluny.

58. Roland's horse sinking to the ground.
Limoges, Musée des Beaux-Arts. From the façade of the church of Notre-Dame-de-la-Règle at Limoges. First third of the 12th century. Photo : Jove, Limoges.

59. Roland's horse sinking to the ground.
Detail. Matrice, Santa Maria de la Strada. Photo : E.P.U., Zürich.

60. Roland fighting beside his dying horse.
Cunault (Indre-et-Loire) Church of Notre-Dame. Capital in the choir. 12th century. Photo : Jacques Mallet, Angers.

61. Façade of the palace of the Dukes of Granada at Estella (Navarre).
Between 1150 and 1165. Photo : Jean Dieuzaide, Toulouse.

62. Mounted combat between Roland and Ferragut.
Estella. Palace of the Dukes of Granada. Capital on the façade (left-hand side), frontal view. Photo : Archivo Mas, Barcelona.

63. Mounted combat between Roland and Ferragut.
Ibid. Left-hand side of the capital. Photo : Montoya, Estella.

64. Roland and Ferragut fighting on foot.
Ibid. Right-hand side of the capital. Photo : Montoya, Estella.

65. Mounted combat between Roland and Ferragut.
Brioude (Haute-Loire). Church of St. Julian. Capital in the nave. About 1140. Photo : Mappus, Le Puy.

66. Roland and Ferragut fighting on foot.
Tarragona. Capital in the cloister. Photo : Archivo Mas, Barcelona.

67. Mounted combat between Roland and Ferragut.
Salamanca. Catedral Vieja. Gallery capital. After 1160-1165. Photo : Archivo Mas, Barcelona.

68. Border of the mosaic in Brindisi Cathedral (1178).
Copy by Schultz. Photo : Bibl. Université, Louvain.

69. Quarrel between Roland and Oliver at Roncevaux.
Detail of the Brindisi mosaic. Copy by Millin. Photo : Bibl. Nationale, Paris.

70. Quarrel between Roland and Oliver. Roland bringing back the bodies of his dead comrades.
Details of the Brindisi mosaic. After the copy by Schultz. Photo : Charles Gothier, Liège.

71. Roland carrying the dying Oliver.
Ibid. after Schultz. Photo : Bibl. Universitaire, Liège.

72. Roland mourning by Oliver's body.
Ibid. after Schultz. Photo : Charles Gothier, Liège.

73. The dying Roland striking down an infidel who is trying to steal his sword.
Detail of the Brindisi mosaic. Copy by Millin. Photo : Bibl. Nationale, Paris.

74. Detail of the Battle of Roncevaux.
After Schultz. Photo : Charles Gothier, Liège.

75. The tower of Modena Cathedral known as La Ghirlandina.
About 1169-1179. Photo : Caval. Orlandini, Modena.

76. Roland as sword-bearer.
La Ghirlandina, Modena. Bas-relief. About 1169-1179. Photo : Caval. Orlandini, Modena.

77. Roland blowing his horn.
Ibid. Bas-relief. Photo : Caval. Orlandini, Modena.

78. Man blowing horn.
Minho (Portugal), unidentified church. 12th century. Photo : Pelicano, Braga.

79. Man blowing horn.
Braga Cathedral. Transept capital, right-hand side. 2nd half of 12th century. Photo : Pelicano, Braga.

80. Man blowing horn.
Ibid., frontal view. Photo : Pelicano, Braga.

81. Rebeck player.
Rio Mau (Portugal). Capital in the church. Second half of 12th century. Photo : António de Azevedo, Braga.

82. Burial of Roland (?).
Ibid. Photo : António de Azevedo, Braga.

83. Roland carrying one of his dead comrades (?).
Ibid. Photo : António de Azevedo, Braga.

84. Archbishop Turpin baptizing the Spanish infidels.
Pen-drawing. *Ruolantes Liet* of Conrad the Priest. Heidelberg, Universitätsbibliothek, Pal. Germ. 112, f° 5 r°. About 1180-1190. Photo : Bildstelle, Heidelberg.

85. Charlemagne seated between Roland and Oliver the wise.
Pen-drawing. *Ibid.* f⁰ 5 v⁰. Photo : Bildstelle, Heidelberg.

86. Marsile, the heathen king of Saragossa, in council.
Pen-drawing. *Ibid.* f⁰ 6 r⁰. Photo : Bildstelle, Heidelberg.

87. Marsile's emissaries offer Charlemagne a false peace.
Pen-drawing. *Ibid.* f⁰ 8 v⁰. Photo : Bildstelle, Heidelberg.

88. The legendary capture of Corderes (Cordova) by Roland and Oliver.
Pen-drawing. *Ibid.* f⁰ 11 v⁰. Photo : Bildstelle, Heidelberg.

89. The siege of Cordova by Charlemagne's army.
Wall painting. Le Puy Cathedral, former chapterhouse. About 1150. Photo : Monuments Historiques, Paris.

90. The council of the Franks presided over by Turpin.
Pen-drawing. *Ruolantes Liet* of Conrad the Priest. Heidelberg, Universitätsbibliothek, Pal. Germ. 112, f⁰ 15 v⁰. Photo : Bildstelle, Heidelberg.

91. The general council of the Franks. Debate between Turpin and Ganelon.
Pen-drawing. *Ruolantes Liet* of Conrad the Priest. Second half of 12th century. Strasburg, Bibliothèque Nationale et Universitaire (ms. burnt in 1870). Photo : Bildstelle, Heidelberg.

92. Charlemagne appointing his brother-in-law Ganelon, Roland's stepfather, ambassador to Marsile.
Pen-drawing, *Ruolantes Liet* of Conrad the Priest. Heidelberg, Universitätsbibliothek, Pal. Germ. 112 f⁰ 19 r⁰. Photo : Bildstelle, Heidelberg.

93. Charlemagne appointing Ganelon ambassador to Marsile.
Pen-drawing. *Ruolantes Liet* of Conrad the Priest. Second half of 12th century. Strasburg, Bibliothèque Nationale et Universitaire (ms. burnt in 1870). Photo : Bildstelle, Heidelberg.

94. Ganelon uttering threats as he leaves Charlemagne's court with an emissary from Marsile.
Pen-drawing, *Ruolantes Liet* of Conrad the Priest. Heidelberg, Universitätsbibliothek. Pal. Germ. 112 f⁰ 21 v⁰. Photo : Bildstelle, Heidelberg.

95. Ganelon plotting with the heathen Blancandrin.
Pen-drawing. *Ibid.* f⁰ 24 r⁰. Photo : Bildstelle, Heidelberg.

96. Ganelon holding council with the infidels.
Pen-drawing. *Ibid.* f⁰ 26 r⁰. Photo : Bildstelle, Heidelberg.

97. Marsile and Ganelon.
Pen-drawing. *Ibid.* f⁰ 29 v⁰. Photo : Bildstelle, Heidelberg.

98. Ganelon swearing on an idol to hand over Roland.
Pen-drawing. *Ibid.* f⁰ 32 v⁰. Photo : Bildstelle, Heidelberg.

99. Charlemagne's dreams before returning to France.
Pen-drawing. *Ibid.* f⁰ 41 v⁰. Photo : Bildstelle, Heidelberg.

100. Marsile handing over the standard to Cernubile.
Pen-drawing. *Ibid.*, f⁰ 43 v⁰. Photo : Bildstelle, Heidelberg.

101. Marsile and another heathen king.
Pen-drawing. *Ibid.*, f⁰ 49 v⁰. Photo : Bildstelle, Heidelberg.

102. Turpin giving communion to Roland and the peers before the battle of Roncevaux.
Pen-drawing. *Ibid.*, f⁰ 47 r⁰. Photo : Bildstelle, Heidelberg.

103. Charlemagne handing over the standard to Roland, making him overlord of conquered Spain.
Pen-drawing. *Ibid.*, f⁰ 43 v⁰. Photo : Bildstelle, Heidelberg.

104. Turpin blessing the Franks at Roncevaux.
Pen-drawing. *Ibid.*, f⁰ 53 v⁰. Photo : Bildstelle, Heidelberg.

105. Roland attacking a heathen temple.
Pen-drawing. *Ibid.*, f⁰ 57 v⁰. Photo : Bildstelle, Heidelberg.

106. Miraculous dew falling on the Franks.
Pen-drawing. *Ibid.*, f⁰ 61 v⁰. Photo : Bildstelle, Heidelberg.

107. Christians and heathen fighting.
Pen-drawing. *Ibid.*, f⁰ 65 r⁰. Photo : Bildstelle, Heidelberg.

108. Knights leaving for battle.
Pen-drawing. *Ibid.*, f⁰ 66 v⁰. Photo : Bildstelle, Heidelberg.

109. Knights leaving for battle.
Pen-drawing. *Ibid.*, f⁰ 71 v⁰. Photo : Bildstelle, Heidelberg.

110. Roland pursuing the heathen king Marsile.
Pen-drawing. *Ibid.*, f⁰ 74 v⁰. Photo : Bildstelle, Heidelberg.

111. Oliver smiting the heathen Justin.
Pen-drawing. *Ibid.*, f⁰ 76 v⁰. Photo : Bildstelle, Heidelberg.

112. Heathen warriors sounding their horns.
Pen-drawing. *Ibid.*, f⁰ 80 v⁰. Photo : Bildstelle, Heidelberg.

113. Charlemagne's grief at hearing Roland's horn.
Pen-drawing. *Ibid.*, f⁰ 93 v⁰. Photo : Bildstelle, Heidelberg.

114. Roland leads away the dying Oliver.
Pen-drawing. *Ibid.*, f⁰ 89 r⁰. Photo : Bildstelle, Heidelberg.

115. Turpin blessing Roland.
Pen-drawing. *Ibid.*, f⁰ 84 r⁰. Photo : Bildstelle, Heidelberg.

116. The heathen attack Turpin.
Pen-drawing. *Ibid.*, f⁰ 91 v⁰. Photo : Bildstelle, Heidelberg.

117. The dying Roland kills with his horn a heathen who is trying to steal his sword.
Pen-drawing. *Ibid.*, f⁰ 85 v⁰. Photo : Bildstelle, Heidelberg.

118. An angel appearing to Charlemagne.
Pen-drawing. *Ibid.*, f⁰ 98 r⁰. Photo : Bildstelle, Heidelberg.

119. Emir Baligant's fleet.
Pen-drawing. *Ibid.*, f° 100 r°. Photo : Bildstelle, Heidelberg.

120. Baligant conferring with the Saracen kings.
Pen-drawing. *Ibid.*, f° 102 r°. Photo : Bildstelle, Heidelberg.

121. Charlemagne praying before his fight with Baligant.
Pen-drawing. *Ibid.*, f° 108 v°. Photo : Bildstelle, Heidelberg.

122. Baligant entrusting his son Malprime with the command of the infidel army.
Pen-drawing. *Ibid.*, f° 109 v°. Photo : Bildstelle, Heidelberg.

123. Baligant slain by Charlemagne.
Pen-drawing. *Ibid.*, f° 114 v°. Photo : Bildstelle, Heidelberg.

124. Ganelon appearing before Charlemagne.
Pen-drawing. *Ibid.*, f° 119 r°. Photo : Bildstelle, Heidelberg.

125. Charlemagne, victorious, accepting the surrender of Queen Bramimonde and the town of Saragossa.
Pen-drawing. *Ibid.*, f° 117 r°. Photo : Bildstelle, Heidelberg.

126 A. and B. A Christian king welcomed by a lady who is handing him the key of a town.
Capital from a church in the Holy Land. Paris, Musée du Louvre. 12th century. Photo : Monuments Historiques, Paris.

127. St. Giles, celebrating Mass, is given evidence of Charlemagne's sin. St. Giles at the embalming of the heroes' bodies at Roncevaux.
Capital. Luna (Province of Saragossa), church of San Gil. About 1150. Photo : Archivo Mas, Barcelona.

128. Façade of the cathedral of Borgo San Donnino (Fidenza, Italy).
About 1200. Photo : Bonatti, Fidenza.

129. Frieze on a corner tower.
About 1200. Photo : Orzi and Pedretti, Fidenza.

130. Second frieze on the corner tower.
Borgo San Donnino (Fidenza). About 1200. Photo : Orzi and Pedretti, Fidenza.

131. Pepin the Short facing a lion.
Ibid. Detail of the frieze. Bas-relief. Photo : Orzi and Pedretti, Fidenza.

132. Bertha, Pepin's daughter, and the knight Milo making illicit love while Charlemagne is out hunting.
Ibid. Photo : Orzi and Pedretti, Fidenza.

133 A. Roland as a child, following his father, now a woodcutter, through the forest.
 B. Bertha and Milo in a forest shortly before Roland's birth.
Ibid. Photo : Orzi and Pedretti, Fidenza.

134. The young Roland on horseback, heading the Emperor's procession returning to France.
Borgo San Donnino (Fidenza). Detail of the second frieze. Photo : Orzi and Pedretti, Fidenza.

135. Young Roland invited to Charlemagne's table.
Wash drawing. *Les Enfances Roland.* Venice, Biblioteca Marciana, cod. fr. XIII, about 1200. Photo : Bijtebier, Brussels.

136. Roland's childhood at Sutri (Italy).
Seville, Library. Woodcut from a post-incunable, *Nascimento de Orlando.* Early 16th century. Photo : Bibl. Universitaire, Liège.

137. Roland at the marriage of Bertha and Milo, before Charlemagne.
Wash drawing. *Les Enfances Roland.* Venice, Biblioteca Marciana, cod. fr. XIII, about 1200. Photo : Bijtebier, Brussels.

138. The prophet David and the rich man's family, Fidenza Cathedral.
Detail of the cathedral façade, left of the doorway. Statue and bas-relief. About 1200. Photo : Orzi and Pedretti, Fidenza.

139. The prophet Ezekiel and the poor man's family, Fidenza Cathedral.
Detail of the cathedral façade, right of the doorway. Statue and bas-relief. About 1200. Photo : Orzi and Pedretti, Fidenza.

140. Recessed tomb (now destroyed) of Ogier the Dane in the church of St. Faro at Meaux (about 1200).
17th century engraving. Mabillon, *Annales ordinis sancti Benedicti,* vol. II, 1704. Photo : Bibl. Universitaire, Liège.

141. Oliver bestowing his sister Aude upon Roland.
Meaux, Church of St. Faro. Detail of the recess. About 1200. Photo : Bibl. Universitaire, Liège.

142. Head of Ogier the Dane.
Meaux, Musée Municipal. Fragment of Ogier's tomb. About 1140-1160. Photo : Monuments Historiques, Paris.

143. Reliquary of Saint Charlemagne.
Goldsmith's work. Aix-la-Chapelle, Cathedral. 1200-1215. Bildarchiv Foto, Marburg.

144. Charlemagne between Pope Leo III and Archbishop Turpin.
Aix-la-Chapelle, Cathedral. Detail of the reliquary of St. Charlemagne. Bildarchiv Foto, Marburg.

145. Charlemagne offering the chapel of Aix to the Virgin. Behind him is Archbishop Turpin.
Ibid. Relief on the reliquary of St. Charlemagne. Photo : Ann Bredol-Lepper, Aix-la-Chapelle.

146. The siege of Pamplona by the Franks, and the miraculous collapse of the city walls.
Ibid. Relief. Photo : Ann Bredol-Lepper, Aix-la-Chapelle.

147. **Charlemagne praying before Pamplona.**
Detail of above. Photo : Ann Bredol-Lepper, Aix-la-Chapelle.

148. **Milo telling Charlemagne and Roland of the miracle of the flowering lances.**
Reliquary of St. Charlemagne. Detail of a relief. Photo : Ann Bredol-Lepper, Aix-la-Chapelle.

149. **Charlemagne and the miracle of the red crosses.**
Reliquary of St. Charlemagne. Detail of a relief. Photo : Ann Bredol-Lepper, Aix-la-Chapelle.

150. **Battle against the infidel.**
Relief from the reliquary of St. Charlemagne. Photo : Ann Bredol-Lepper, Aix-la-Chapelle.

151. **Battle against the infidel.**
Detail. Photo : Ann Bredol-Lepper, Aix-la-Chapelle.

152 A. **Charlemagne, confessing to St. Giles, does not dare to avow his mortal sin.**
B. **St. Giles learns of Charlemagne's sin.**
Reliquary of St. Charlemagne, relief. Photo : Ann Bredol-Lepper, Aix-la-Chapelle.

153. **Episodes from the legend of St. Charlemagne and St. Roland.**
Chartres, Cathedral of Notre-Dame. Window in the ambulatory (upper part). Early 13th century. Photo : Archives Photographiques, Paris.

154 A. **St. Roland bearing on his shield the fleur-de-lis of the French royal house.**
Chartres, Cathedral of Notre-Dame. South portal. About 1230. Photo : Drillaud, Luisant-lez-Chartres.
B. **Ganelon swearing on an idol to deliver Roland into the hands of King Marsile.**
Pedestal of the statue. Photo : Drillaud, Luisant-lez-Chartres.

155. **Right to left : St. Lawrence, St. Clement, St. Stephen and St. Roland.**
Statues. Chartres, Cathedral, south portal. About 1215-1220 and about 1230. Photo : Giraudon, Paris.

156. **Left to right : St. Vincent, St. Denis, St. Piat and St. George.**
Statues. Chartres, Cathedral, south doorway. About 1215-1220 and about 1230. Photo : Giraudon, Paris.

157. **Interior of Rheims Cathedral, western wall.**
Second half of 13th century. Photo : M. Porret, Rheims.

158. **Turpin giving communion to Roland. On the right is King Marsile.**
Statues. Rheims, Cathedral of Notre-Dame, interior of west doorway. Second half of 13th century. Photo : Giraudon, Paris.

159. **Ganelon at the feet of Marsile.**
Historiated initial C. *Chanson de Roland.* Venice, Biblioteca Marciana, cod. fr. IV, f⁰ 69 r⁰. Late 13th – early 14th century. Photo : Bibl. Marciana, Venice.

160. **The heathen king Agolant crowning his son Eaumont.**
Historiated initial C. *Chanson d'Aspremont.* Venice, Biblioteca Marciana, cod. fr. IV, f⁰ 1 r⁰. Late 13th century. Photo : Bibl. Marciana, Venice.

161. **Charlemagne knighting Roland.**
Historiated initial. *Ibid.,* f⁰ 49 r⁰. Photo : Bibl. Marciana, Venice.

162. **Young Roland, protected by St. George, killing a heathen king.**
Historiated initial. *Ibid.,* f⁰ 54 v⁰. Photo : Bibl. Marciana, Venice.

163. **Young Roland saving Charlemagne's life by killing the heathen Eaumont.**
Wash drawing. *Chanson d'Aspremont.* London, British Museum, Lansdowne 782, f⁰ 12 v⁰. First half of 13th century. Photo : British Museum.

164. **Young Roland with his comrades coming to meet Charlemagne.**
Wash drawing. *Ibid.,* f⁰ 21 v⁰. Photo : British Museum.

165 A. **Naimes and Ogier telling Charlemagne that Roland wishes to be knighted.**
Wash drawing. *Ibid.,* f⁰ 22 r⁰. Photo : British Museum.

165 B. **Charlemagne embracing Roland before knithing him.**
Wash drawing. *Ibid.,* f⁰ 22 v⁰. Photo : British Museum.

166. **Charlemagne knighting several sons of dukes and peers.**
Wash drawing. *Ibid.,* f⁰ 23 v⁰. Photo : British Museum.

167. **The Pope celebrating Mass in honour of the new knights.**
Wash drawing. *Ibid.,* f⁰ 25 r⁰. Photo : British Museum.

168 A and B. **Battle between the armies of Charlemagne and Agolant.**
Wash drawing. *Ibid.,* f⁰ 26 v⁰ - 27 r⁰. Photo : British Museum.

169 A and B. **Another phase of the same battle.**
Wash drawing. *Ibid.,* f⁰ 31 v⁰ - 32 r⁰. Photo : British Museum.

170. **Roland leaving for battle with his minstrel Graelant.**
Historiated initial. *Chanson d'Aspremont.* Nottingham, Muniment Rooms of the University, ms. Mi.L.M. 6, f⁰ 294 r⁰. Third quarter of the 13th century. Photo : University Library, Nottingham.

171. Oliver coming to meet Charlemagne and Roland who are besieging Vienne in Dauphiné.
Historiated initial. *Girart de Vienne*. Paris, Bibliothèque Nationale, ms. fr. 1448, fᵒ 23 vᵒ. Second half of 13th century. Photo : Bibl. Nationale, Paris.

172. Oliver coming to meet Charlemagne and Roland who are besieging Vienne in Dauphiné.
Miniature. *Girart de Vienne*. London, British Museum, ms. Royal 20 D XI, fᵒ 53 vᵒ. First half of 14th century. Photo : British Museum.

173. Girat de Vienne making peace with Charlemagne in the presence of Roland and Aude.
Miniature. *Girart de Vienne*. London, British Museum, ms. Royal 20 D XI, fᵒ 60 rᵒ. First half of 14th century. Photo : British Museum.

174. Roland and Oliver at a banquet given by Charlemagne.
Wash drawing. *Fierabras*. Hanover, Staatsbibliothek, ms. IV 578, fᵒ 24 vᵒ. Early 14th century. Photo : Mimosa, Kiel.

175. Charlemagne striking Roland in the face.
Wash drawing. *Ibid.*, fᵒ 27 rᵒ. Photo : Mimosa, Kiel.

176. Roland brandishing his sword and putting to flight the heathen king Balan.
Wash drawing. *Ibid.*, fᵒ 59 rᵒ. Photo : Mimosa, Kiel.

177. Roland fighting the Saracens with Oliver at his side.
Wash drawing. *Ibid.*, fᵒ 61 vᵒ. Photo : Mimosa, Kiel.

178. Roland liberating Gui de Bourgogne.
Wash drawing. *Ibid.*, fᵒ 65 rᵒ. Photo : Mimosa, Kiel.

179. Roland and Richard besieged in a tower.
Wash drawing. *Ibid.*, fᵒ 70 vᵒ. Photo : Mimosa, Kiel.

180. Roland, still besieged, watching Richard depart.
Wash drawing. *Ibid.*, fᵒ 71 vᵒ. Photo : Mimosa, Kiel.

181. Roland and Oliver destroying the heathen idols.
Wash drawing. *Ibid.*, fᵒ 89 rᵒ. Photo : Mimosa, Kiel.

182. Roland watching Turpin hand over the relics to Charlemagne.
Wash drawing. *Ibid.*, fᵒ 98 vᵒ. Photo : Mimosa, Kiel.

183. Oliver in mounted combat with Fierabras.
Wash drawing. *Fierabras*. London, British Museum, ms. Fr. Egerton 3028, fᵒ 87 rᵒ. Mid-14th century. Photo : British Museum.

184. Oliver continuing to fight Fierabras on foot.
Wash drawing. *Ibid.*, fᵒ 88 rᵒ. Mid-14th century. Photo : British Museum.

185. Oliver wounding Fierabras.
Wash drawing. *Ibid.*, fᵒ 90 rᵒ. Photo : British Museum.

186. Turpin preparing to baptise the heathen King Laban.
Wash drawing. *Ibid.*, fᵒ 117 rᵒ. Photo : British Museum.

187. Ganelon addressing Charlemagne.
Wash drawing. *Ibid.*, fᵒ 110 rᵒ. Photo : British Museum.

188. Renaut refuses to surrender his ally Maugis the enchanter to Charlemagne's envoy Roland.
Miniature. *Renaut de Montauban*. London, British Museum, Royal 15 E VI, fᵒ 176 vᵒ. About 1446. Photo : British Museum.

189. Roland and Naimes advising Charlemagne after his crown has been stolen by Maugis.
Miniature. *Renaut de Montauban*. London, British Museum, Royal 16 G II, fᵒ 40 rᵒ. End of the first half of the 15th century. Photo : British Museum.

190. Maugis stealing the swords of Charlemagne, Roland and the peers.
Grisaille by Tavernier. *Renaut de Montauban* in *Croniques et Conquestes de Charlemaine*, Brussels, Bibliothèque Royale, ms. 9067, fᵒ 125 vᵒ. Photo : Bibl. Royale, Brussels.

191. Maugis stealing the swords of Charlemagne, Roland and the peers.
Grisaille. *Renaut de Montauban*. Pommersfelden, Biblioteca Palatina, ms. 311, fᵒ 360 vᵒ. About 1460. Photo : Bauer, Bamberg.

192. Maugis stealing the swords of Charlemagne and Roland.
Miniature by Loyset Liédet. *Renaut de Montauban*. Paris, Bibliothèque de l'Arsenal, Réserve 5072, fᵒ 271 rᵒ. About 1460. Photo : Bibl. Nationale, Paris.

193. Roland watching as Hernaut surrenders.
Miniature. *Renaut de Montauban. Ibid.*, fᵒ 277 vᵒ. Photo : Bibl. Nationale, Paris.

194. A messenger from Renaut arriving at Roland's tent.
Grisaille. *Renaut de Montauban*. Pommersfelden, Biblioteca Palatina, ms. 311, fᵒ 398 rᵒ. About 1460. Photo : Bauer, Bamberg.

195. Roland watching as Renaut de Montauban surrenders to Charlemagne.
Miniature. *Ibid.*, ms. 312, fᵒ 3 rᵒ. About 1460. Photo : Bauer, Bamberg.

196. Charlemagne and Roland besieging Arles.
Pen-drawing. *Roman d'Arles*. Aix-en-Provence, Bibliothèque Arabaud, ms. M.O. 63, fᵒˢ 69 vᵒ - 70 rᵒ. About 1375. Photo : Pensée Universitaire, Aix-en-Provence.

197. Seal of the master craftsmen of Arles.
13th century. Photo : Bibl. Universitaire, Liège.

198. Turpin pardoning the barons, who have remained
 alive by a miracle.
Arles, cloister of St. Trophime, capital. About 1300-1350 (?).
Photo : Max Ehrer, Arles.

199. Charlemagne, assisted by Roland and Oliver (?),
 condemning six barons of Arles to be hanged.
Arles, cloister of St. Trophime, capital. About 1300-1350 (?).
Photo : Max Ehrer, Arles.

200. Roland, blowing his horn, routs the heathen.
 Roland taking a heathen city.
Miniature divided horizontally. *Karl der Grosse* of Der Stricker.
St. Gall, Stadtbibliothek no. 302, f° 6 v°. Late 13th century.
Photo : Hildegard Morscher, St. Gall.

201 Charlemagne's prophetic dreams before his return
 to France.
 A. The lance broken by Ganelon.
 B. The bear's bite.
 C. The fight between dog and leopard.
Miniature divided horizontally. *Ibid.,* f° 25 r°. Photo : Hildegard Morscher, St. Gall.

202. Charlemagne making Roland overlord of the land
 of Spain, crowning him and giving him the
 standard. Charlemagne and his army taking
 leave of the peers.
Miniature divided horizontally. *Ibid.,* f° 26 v°. Photo : Hildegard Morscher, St. Gall.

203. At Roncevaux, Roland and Turpin attacking the
 heathen with lances. Roland killing a heathen king.
Miniature divided horizontally. *Ibid.,* f° 35 v°. Photo : Hildegard Morscher, St. Gall.

204. Roland and Turpin surrounded by the heathen,
 Roland blowing his horn. Roland saying farewell to
 Turpin. Roland striking with his horn the heathen
 who tries to take Durandal from him.
Miniature divided horizontally. *Ibid.,* f° 50 v°. Photo : Hildegard Morscher, St. Gall.

205. Back in Saragossa, Marsile dies with Queen
 Bramimonde at his side. The Queen ordering
 the destruction of the heathen idols.
Miniature divided horizontally. *Ibid.,* f° 55 r°. Photo : Hildegard Morscher, St. Gall.

206. The chariot of Palligan (Baligant). The heathen
 praying before the battle. First phase of the fight
 on horseback between Charlemagne and Palligan.
Miniature divided horizontally. *Ibid.,* f° 62 r°. Photo : Hildegard Morscher, St. Gall.

207. With the help of a miracle Charlemagne distin-
 guishes the bodies of the Christians from those of
 the heathen. Charlemagne and Aude at the heroes'
 burial in the crypt at Blaye. Beside them is the
 emperor's son Louis.
Miniature divided horizontally. *Ibid.,* f° 71 r°. Photo : Hildegard Morscher, St. Gall.

208. Roland riding through the Pyrenees.
Miniature. *Karl der Grosse* of Der Stricker. Berlin, Deutsche
Staatsbibliothek, ms. Germ. fol. 623, f° 21 v° (at present kept
at Tübingen, Universitätsbibliothek). Second quarter of 14th
century. Photo : Universitätsbibliothek, Tübingen.

209. The dying Roland striking with his horn the
 heathen who tries to take Durandal from him.
 The hero giving his glove to St. Michael.
Miniature. *Ibid.,* f° 22 v°. Photo : Universitätsbibliothek, Tübingen.

210. Charlemagne handing to Ganelon the message for
 Marsile.
Miniature. *Karl der Grosse* of Der Stricker. Wolfenbüttel,
Herzog-August Bibliothek (1. 5. 2 August, 2°), f° 180 v°. 14th
century. Photo : Herzog-August Bibliothek, Wolfenbüttel.

211. Roland breaking the heathen idols – Turpin
 baptizing the heathen.
Miniature. *Karl der Grosse* of Der Stricker. Wolfenbüttel,
Herzog-August Bibliothek (1. 5. 2 August, 2°) f° 179 r°. 14th
century. Photo : Herzog-August Bibliothek, Wolfenbüttel.

212. Marsile's ambassadors before Charlemagne.
Ink and wash. *Karl der Grosse* of Der Stricker. Bonn, Universitätsbibliothek S. 500, f° 17 r°. About 1450. Photo : Universitätsbibliothek, Bonn.

213. The general council of the Franks. Charlemagne
 listens to the dispute between Turpin and Ganelon.
Ink and wash. *Ibid.,* f° 30 r°. Photo : Universitätsbibliothek, Bonn.

214. Ganelon leaving on horseback with the infidel.
Ink and wash. *Ibid.,* f° 37 v°. Photo : Universitätsbibliothek, Bonn.

215. Ganelon swearing to Marsile to hand Roland over
 to him.
Ink and wash. *Ibid.,* f° 41 v°. Photo : Universitätsbibliothek, Bonn.

216. The heathen kings and nobles handing to Marsile
 the fatal gifts destined for Charlemagne.
Ink and wash. *Ibid.,* f° 48 v°. Photo : Universitätsbibliothek, Bonn.

217. The Franks taking leave of Roland at Roncevaux.
Ink and wash. *Ibid.,* f° 54 r°. Photo : Universitätsbibliothek, Bonn.

218. Roland arming.
Ink and wash. *Ibid.,* fo 64 vo. Photo : Universitätsbibliothek, Bonn.

219. A daughter of King Marsile.
Ink and wash. *Ibid.,* fo 75 vo. Photo : Universitätsbibliothek, Bonn.

220. Roland and his army.
Ink and was. *Ibid.,* fo 83 vo. Photo : Universitätsbibliothek, Bonn.

221. Roland at the head of his troops slaughtering the heathen.
Ink and wash. *Ibid.,* fo 88 ro. Photo : Universitätsbibliothek, Bonn.

222. Roland vanquishing a heathen warrior.
Ink and wash. *Ibid.,* fo 93 vo. Photo : Universitätsbibliothek, Bonn.

223. Oliver fighting Falsaron.
Ink and wash. *Ibid.,* fo 98 ro. Photo : Universitätsbibliothek, Bonn.

224. Roland fighting Cernubile.
Ink and wash. *Ibid.,* fo 111 ro. Photo : Universitätsbibliothek, Bonn.

225. Archbishop Turpin fighting.
Ink and wash. *Ibid.,* fo 122 ro. Photo : Universitätsbibliothek, Bonn.

226. Roland, with Oliver, attacking King Marsile and cutting off his right arm.
Ink and wash. *Ibid.,* fo 142 vo. Photo : Universitätsbibliothek, Bonn.

227. Roland avenging Oliver's death.
Ink and wash. *Ibid.,* fo 149 ro. Photo : Universitätsbibliothek, Bonn.

228. Roland and Turpin avenging the death of Waltharius.
Ink and wash. *Ibid.,* fo 154 vo. Photo : Universitätsbibliothek, Bonn.

229. Roland giving Turpin his helmet to protect him.
Ink and wash. *Ibid.,* fo 161 ro. Photo : Universitätsbibliothek, Bonn.

230. Charlemagne and his companions finding Roland and the peers lying dead at Roncevaux.
Ink and wash. *Ibid.,* fo 168 ro. Photo : Universitätsbibliothek, Bonn.

231. An angel appearing to Charlemagne.
Ink and wash. *Ibid.,* fo 174 vo. Photo : Universitätsbibliothek, Bonn.

232. Single combat between Charlemagne and Baligant.
Ink and wash. *Ibid.,* fo 219 r. Photo : Universitätsbibliothek, Bonn.

233. Charlemagne mourning the heroes' death on his return to Roncevaux.
Ink and wash. *Ibid.,* fo 231 ro. Photo : Universitätsbibliothek, Bonn.

234. Charlemagne at the burial of Roland and Oliver.
Ink and wash. *Ibid.,* fo 236 vo. Photo : Universitätsbibliothek, Bonn.

235. Margrave Otto fighting with Ganelon.
Ink and wash. *Ibid.,* fo 252 ro. Photo : Universitätsbibliothek, Bonn.

236. Single combat between Pinabel and Tierry d'Ardenne.
Ink and wash. *Ibid.,* fo 262 ro. Photo : Universitätsbibliothek, Bonn.

237. Marsile sending an ambassador to Charlemagne. The ambassador coming before Charlemagne and Roland.
Miniatures. *L'Entrée d'Espagne.* Venice, Biblioteca Marciana, cod. fr. XXI, fo 8 ro. Mid-14th century. Foto Fiorentini, Venice.

238. Ferragut carrying away Roland on his horse.
Ink and wash. *Ibid.,* fo 34 ro. Foto Fiorentini, Venice.

239. Roland sharing a meal in the tent of Solomon de Bretagne.
Ink and wash. *Ibid.,* fo 40 vo. Foto Fiorentini, Venice.

240. Ferragut attacking Roland with his flail.
Ink and wash. *Ibid.,* fo 44 ro. Foto Fiorentini, Venice.

241. Fight between Roland on foot and Ferragut on horseback.
Ink and wash. *Ibid.,* fo 64 vo. Foto Fiorentini, Venice.

242. Roland attends Mass before the battle is resumed.
Ink and wash. *Ibid.,* fo 58 ro. Foto Fiorentini, Venice.

243. Roland placing a stone beneath the head of Ferragut.
Ink and wash. *Ibid.,* fo 68 ro. Foto Fiorentini, Venice.

244. Disputation between Roland and Ferragut.
Ink and wash. *Ibid.,* fo 69 ro. Foto Fiorentini, Venice.

245. Charlemagne, Roland and other peers looking at Ferragut's corpse.
Ink and wash. *Ibid.,* fo 80 ro. Foto Fiorentini, Venice.

246. Roland leaving Nájera to take up position before Pamplona.
Miniature. *Ibid.,* fo 88 ro. Foto Fiorentini, Venice.

247. An engine of war outside Pamplona.
Miniature. *Ibid.*, f⁰ 140 v⁰. Foto Fiorentini, Venice.

248-249. Siege of Pamplona.
Miniatures. *Ibid.*, f⁰ 161 v⁰ - 162 r⁰. Photo : Bibl. Marciana, Venice.

250. Roland blowing his horn on the morning of battle.
Miniature. *Ibid.*, f⁰ 145 r⁰. Foto Fiorentini, Venice.

251. Battle scene during the siege of Noble.
Miniature. *Ibid.*, f⁰ 176 r⁰. Foto Fiorentini, Venice.

252. Roland in a tower at Noble.
Miniature. *Ibid.*, f⁰ 204 r⁰. Foto Fiorentini, Venice.

253-254. Roland killing two heathen warriors at the siege of Noble.
Miniature. *Ibid.*, f⁰ 209 v⁰. Foto Fiorentini, Venice.

255. Charlemagne striking Roland in the face.
Miniature. *Ibid.*, f⁰ 216 r⁰. Foto Fiorentini, Venice.

256-257. Roland arriving at the shore.
Miniatures. *Ibid.*, f⁰ 225 v⁰ - 226 r⁰. Foto Fiorentini, Venice.

258-259. Roland defeating his adversary in the presence of the Sultan of Persia and his daughter. The whole court congratulating him.
Miniatures. *Ibid.*, f⁰ 254 r⁰. Foto Fiorentini, Venice.

260-261. Roland teaching the Sultan of Persia's son to tilt at the quintain. He becomes the Sultan's adviser.
Miniatures. *Ibid.*, f⁰ 265 v⁰. Foto Fiorentini, Venice.

262. An angel takes Roland's form.
Miniature. *Ibid.*, f⁰ 288 r⁰. Foto Fiorentini, Venice.

263. Roland and Oliver meet again.
Miniature. *Ibid.*, f⁰ 296 v⁰ - 297 r⁰. Foto Fiorentini, Venice.

264. Charlemagne's court and the twelve peers.
Miniature. *La Spagna.* Paris, Bibliothèque Nationale, ms. Ital. 567, f⁰ 72. Second half of 14th century. Photo : Bibl. Nationale, Paris.

265. Charlemagne and Roland riding to Spain.
Miniature. *Pseudo-Turpin.* Paris, Bibliothèque de l'Arsenal, ms. 3516, f⁰ 281 r⁰. Second half of 13th century. Photo : Josse-Lalance, Paris.

266. Charlemagne and Roland taking a Saracen city in Spain.
Historiated initial. *Pseudo-Turpin.* Paris, Bibliothèque de l'Arsenal, ms. 5201 Réserve, f⁰ 189 r⁰. Second half of 13th century. Photo : Josse-Lalance, Paris.

267. Roland trying to break his sword. Roland blowing his horn.
Historiated initial. *Ibid.*, f⁰ 215 r⁰. Photo : Bibl. Universitaire, Liège.

268. Charlemagne and Roland worshipping the True Cross in Jerusalem.
Miniature. *Pseudo-Turpin.* Florence, Biblioteca Laurenziana, ms. Ashburnham 52, f⁰ 121 v⁰. Early 14th century. Photo : Pineider, Florence.

269. Charlemagne and Roland riding towards Spain.
Miniature. *Ibid.*, f⁰ 122 v⁰. Photo : Pineider, Florence.

270. Roland fighting with Ferragut.
Miniature. *Ibid.*, f⁰ 129 v⁰. Photo : Pineider, Florence.

271. Roland cutting off Marsile's arm.
Miniature. *Ibid.*, f⁰ 131 r⁰. Photo : Pineider, Florence.

272. Baudouin bringing a drink to the dying Roland.
Miniature. *Ibid.*, f⁰ 132 v⁰. Photo : Pineider, Florence.

273. Charlemagne and Roland riding towards Spain.
Miniature. *Pseudo-Turpin.* Paris, Bibliothèque Nationale, f. fr. 573, f⁰ 148 v⁰. Mid-15th century. Photo : Bibl. Nationale, Paris.

274-275. Roland fighting with Ferragut.
Miniatures. *Ibid.*, f⁰ 154 r⁰ - 155 v⁰. Photo : Bibl. Nationale.

276. Roland killing Marsile.
Miniature. *Ibid.*, f⁰ 157 v⁰. Photo : Bibl. Nationale, Paris.

277. Charlemagne killing Baligant.
Miniature. *Ibid.*, f⁰ 159 v⁰. Photo : Bibl. Nationale.

278. St. Roland and St. Oliver, guardians of the road to Santiago de Compostela.
Ink and wash. *Pseudo-Turpin.* Paris, Bibliothèque Nationale, f.fr. 4991, f⁰ 8 v⁰. Late 15th century. Photo : Bibl. Nationale, Paris.

279. Roland fighting with Ferragut.
Historiated initial. *Charlemagne* by Girart d'Amiens. Paris, Bibliothèque Nationale, ms. 778, f⁰ 143 v⁰. First quarter of 14th century. Photo : Bibl. Nationale, Paris.

280. Charlemagne, Roland and his barons watching the engulfing of the heathen city of Luiserne.
Miniature. *Les Grandes Chroniques de France.* London, British Museum, Royal 16 G VI, f⁰ 166 r⁰. Second quarter of 14th century. Photo : British Museum.

281. Roland defending a city against Agolant.
Miniature. *Ibid.*, f⁰ 167 r⁰. Photo : British Museum.

282. The city of Agen besieged by Charlemagne, Roland, Oliver and other barons.
Miniature. *Ibid.*, f⁰ 168 v⁰. Photo : British Museum.

283. Roland and Ferragut fighting on horseback. They begin a disputation.
Miniature. *Ibid.*, f⁰ 172 v⁰. Photo : British Museum.

284. Roland continues his disputation with Ferragut, then kills him.
Miniature. *Ibid.*, f° 173 r°. Photo : British Museum.

285. Roland fighting the heathen in Spain.
Miniature. *Ibid.*, f° 171 r°. Photo : British Museum.

286. Ganelon plotting treason with the two kings of Saragossa and bringing Charlemagne the fatal gifts.
Miniature. *Ibid.*, f° 175 v°. Photo : British Museum.

287. The death of Roland, with Baudouin and Thierry at his side.
Miniature. *Ibid.*, f° 179 r°. Photo : British Museum.

288. Tierry bearing witness of Roland's death while Turpin recounts his vision of the battle of Roncevaux to Charlemagne and his barons. Charlemagne finding Roland's body.
Miniature. *Ibid.*, f° 180 v°. Photo : British Museum.

289. Charlemagne mourning by Roland's bier. Punishment of Ganelon.
Miniature. *Ibid.*, f °181 v°. Photo : British Museum.

290. Roland's body is laid to rest in the church of St. Romain at Blaye, while Charlemagne mourns him and the other heroes, also brought back to Blaye.
Miniature. *Ibid.*, f° 182 v°. Photo : British Museum.

291. Roland killing Ferragut.
Miniature. *Les Grandes Chroniques de France.* Paris, Bibliothèque Nationale, f. fr. 2813, f° 118 r°. Between 1375 and 1379. Photo : Bibl. Nationale, Paris.

292 A. Charlemagne receiving the fatal gifts which the kings of Saragossa sent by Ganelon.
 B. Roland striking Marsile at the battle of Roncevaux.
Miniatures. *Ibid.*, f° 121 r°. Photo : Bibl. Nationale, Paris.

293. Death of Roland (haloed).
Miniature. *Ibid.*, f° 122 v°, col. 2. Photo : Bibl. Nationale.

294. Turpin's vision of the death of Marsile.
Miniature. *Ibid.*, f° 123 v°, col. 1. Photo : Bibl. Nationale.

295 A. Charlemagne killing Baligant.
 B. Ganelon's punishment.
Miniatures. *Ibid.*, f° 124 r°. Photo : Bibl. Nationale, Paris.

296. St. James appearing to Charlemagne. Capture of Pamplona.
Miniature. *Les Grandes Chroniques de France.* Paris, Bibliothèque Nationale, f. fr. 6465, f° 104 v°, col. 2. About 1460. Photo : Bibl. Nationale, Paris.

297. Battle of Roncevaux.
Miniature. *Les Grandes Chroniques de France.* Brussels, Bibliothèque Royale, ms. 2, f° 118 r°. 14th century. Photo : Bibl. Royale, Brussels.

298. The fatal gifts of the kings of Saragossa to Charlemagne.
Miniature. *Les Grandes Chroniques de France.* Lyons, Bibliothèque Municipale, ms. 880, f° 130 v°. 14th century. Photo : Moncorgé, Lyons.

299. Ganelon returning with the fatal gifts of the kings of Saragossa.
Miniature. *Les Grandes Chroniques de France.* Berlin, Staatsbibliothek, Phillipps 1917, f° 142 v°, col. 2. About 1410. Photo : Staatsbibliothek, Berlin.

300. Ferragut arriving by sea.
Woodcut. *Les Grandes Chroniques de France.* Paris, Vérard, 1493. Bibliothèque Nationale, Réserve L 35/7, vol. 1, f° 141 v°. Photo : Bibl. Nationale, Paris.

301. Ferragut arriving by sea.
Painted woodcut. Same edition as fig. 300. London, British Museum, Vellum C 22 f. Photo : British Museum.

302. Ferragut arriving by sea.
Miniature. Same edition. Paris, Bibliothèque Nationale, Réserve Vélin 728. Photo : Bibl. Nationale, Paris.

303. Roland fighting with Ferragut.
Miniature. Same edition. Paris, Bibliothèque Nationale, Réserve Vélin 725, f° 141 v°. Photo : Bibl. Nationale, Paris.

304. Roland killing Ferragut.
Woodcut. *Les Grandes Chroniques de France.* Same edition as preceding plates. Paris, Bibliothèque Nationale, Réserve L 35/7, vol. 1, f° 142 r°. Photo : Bibl. Nationale, Paris.

305. Disputation between Roland and Ferragut.
Painted woodcut. Same edition. London, British Museum, Vellum C 22 f, f° 142 r°. Photo : British Museum.

306. Disputation between Roland and Ferragut.
Miniature. Same edition. Paris, Bibliothèque Nationale, Vélin 728, f° 112 r°. Photo : Bibl. Nationale, Paris.

307. Roland killing Ferragut.
Miniature. Same edition. Paris, Bibliothèque Nationale, Vélin 725, f° 142 r°. Photo : Bibl. Nationale, Paris.

308. Roland killing Marsile.
Woodcut. Same edition. Paris, Bibliothèque Nationale, Réserve L 35/7, vol. 1, f° 146 v°. Photo : Bibl. Nationale.

309. Roland killing Marsile.
Painted woodcut. Folio missing in the British Museum copy; not illustrated.

310. Roland blowing his horn.
Miniature. Same edition. Paris, Bibliothèque Nationale. Vélin 728, f⁰ 146 v⁰. Photo : Bibl. Nationale, Paris.

311. Roland trying to break his sword.
Miniature. Same edition. Paris, Bibliothèque Nationale. Vélin 725, f⁰ 146 v⁰. Photo : Bibl. Nationale, Paris.

31. Roland exterminating the Saracens.
Woodcut. Same edition. Paris, Bibliothèque Nationale. Réserve L 35/7, vol. 1, f⁰ 147 v⁰. Photo : Bibl. Nationale, Paris.

313. Roland exterminating the Saracens.
Painted woodcut. Same edition. London, British Museum, Vellum C 22, f⁰ 147 v⁰. Photo : British Museum.

314. Roland praying before his death.
Miniature. Same edition. Paris, Bibliothèque Nationale, Vélin 728, f⁰ 147 v⁰. Photo : Bibl. Nationale, Paris.

315. Roland praying before his death.
Miniature. Same edition. Paris, Bibliothèque Nationale, Vélin 725, f⁰ 147 v⁰. Photo : Bibl. Nationale, Paris.

316. Mass for the dead of Roncevaux.
Woodcut. Same edition. Paris, Bibliothèque Nationale, Réserve L 34/7, vol. 1, f⁰ 148 r⁰. Photo : Bibl. Nationale, Paris.

317. Mass for the dead of Roncevaux.
Painted woodcut. Same edition. London, British Museum, Vellum C 22, f⁰ 148 r⁰. Photo : British Museum.

318. Turpin's vision.
Miniature. Same edition. Paris, Bibliothèque Nationale, Vélin 728, f⁰ 148 r⁰. Photo : Bibl. Nationale, Paris.

319. Turpin's vision.
Miniature. Same edition. Paris, Bibliothèque Nationale, Vélin 725, f⁰ 148 r⁰. Photo : Bibl. Nationale, Paris.

320. Charlemagne encamping his army on the battle-field of Roncevaux.
Woodcut. Same edition. Paris, Bibliothèque Nationale, Réserve L 35/7, vol. 1, f⁰ 148 c⁰. Photo : Bibl. Nationale, Paris.

321. Charlemagne encamping his army on the battle-field of Roncevaux.
Painted woodcut. Same edition. London, British Museum Vellum C 22, f⁰ 148 v⁰. Photo : British Museum.

322. Charlemagne encamping his army on the battle-field of Roncevaux.
Miniature. Same edition. Paris, Bibliothèque Nationale, Vélin 728, f⁰ 148 v⁰. Photo : Bibl. Nationale, Paris.

323. Charlemagne encamping his army on the battle-field of Roncevaux.
Miniature. Same edition. Paris, Bibliothèque Nationale, Vélin 725, f⁰ 149 v⁰. Photo : Bibl. Nationale, Paris.

324. Roland's funeral at Blaye.
Woodcut. Same edition. Paris, Bibliothèque Nationale, Réserve L 35/7, vol. 1, f⁰ 149 v⁰. Photo : Bibl. Nationale, Paris.

325. Roland's funeral at Blaye.
Painted woodcut. Same edition. London, British Museum, Vellum C 22, f⁰ 149 v⁰. Photo : British Museum.

326. Roland's funeral at Blaye.
Miniature. Same edition. Paris, Bibliothèque Nationale, Vélin 728, f⁰ 149 v⁰. Photo : Bibl. Nationale, Paris.

327. Roland's funeral at Blaye.
Miniature. Same edition. Paris, Bibliothèque Nationale, Vélin 725, f 149 v⁰. Photo : Bibl. Nationale, Paris.

328. Roland taking the city of Garnople (Noble).
Painted woodcut. Same edition. London, British Museum, Vellum C 22, f⁰ 152 v⁰. Photo : British Museum.

329. Roland killing Ferragut.
Miniature. *Les Grandes Chroniques de France.* London, British Museum, Cotton Nero E II, f⁰ 124, col. 1. Late 14th century. Photo : British Museum.

330. Roland killing Ferragut.
Miniature. *Les Grandes Chroniques de France.* Berlin, Staats-bibliothek, ms. Hamilton 150, at present at Marburg, West-deutsche Bibliothek, f⁰ 114 v⁰. Late 15th century. Foto-Kino Clement, Marburg.

331. Charlemagne finding Roland's body.
Miniature. *Les Grandes Chroniques de France.* London, British Museum, Cotton Nero E II, f⁰ 130, col. 2. Late 14th century. Photo : British Museum.

332. Charlemagne finding Roland's body.
Miniature. Berlin, Staatsbibliothek, ms. Hamilton 150, at present at Marburg, Westdeutsche Bibliothek, f⁰ 120 v⁰. Late 15th century. Foto-Kino Clement. Marburg.

333. Battle of Roncevaux.
Miniature. *Les Grandes Chroniques de France.* Leningrad, Public Library, cat. no. unknown. 15th century. f⁰ 30 v⁰. Photo : Bibl. Universitaire, Liège.

334. Charlemagne receiving the fatal gifts.
Miniature. *Les Grandes Chroniques de France.* Paris, Bibliothèque Nationale, fr. 2608, f⁰ 147 v⁰, col. 1. About 1400. Photo : Bibl. Nationale, Paris.

335. Roland killing Ferragut.
Miniature. *Les Grandes Chroniques de France.* Leningrad, Public Library, cat. no. unknown. 15th century. Photo : Bibl. Universitaire, Liège.

336. Roland fighting with Ferragut.
Historiated initial. *Les Grandes Chroniques de France.* Brussels, Bibliothèque Royale, ms. 14561-4, f⁰ 124 r⁰, col. 1. 14th century. Photo : Bibl. Royale, Brussels.

337. Battle of Roncevaux.
Historiated initial. *Ibid.*, f° 127 v°, col. 1. Photo : Bibl. Royale, Brussels.

338. Baudouin and Thierry with the dying Roland.
Miniature. *Les Grandes Chroniques de France.* Brussels, Bibliothèque Royale, ms. 5, f° 144 r°. 14th century. Photo : Bibl. Royale, Brussels.

339. Charlemagne and his army finding the bodies of Roland and the peers who fell at Roncevaux.
Miniature. *Ibid.*, f° 145 v°. Photo : Bibl. Royale, Brussels.

340. The kings of Saragossa giving presents to Ganelon.
Miniature. *Les Grandes Chroniques de France.* Brussels, Bibliothèque Royale, ms. 1, f° 112 v°, col. 1. Early 15th century. Photo : Bibl. Royale, Brussels.

341. The kings of Saragossa escorting Ganelon with the fatal gifts.
Miniature. *Les Grandes Chroniques de France.* Brussels, Bibliothèque Royale, ms. 3, f° 109 v°, col. 1. Early 15th century. Photo : Bibl. Royale, Brussels.

342. Eginhard and Turpin writing the life and glorious deeds of Charlemagne.
Miniature. *Ibid.*, f° 76 v°, col. 1. Photo : Bibl. Royale, Brussels.

343. Ferragut carrying off Christian knights. Roland killing Ferragut.
Miniature. *Les Grandes Chroniques de France.* Leningrad, Public Library, fr.F.v.IV.1. Between 1449 and 1460. Photo : Bibl. Universitaire, Liège.

344. Treason of Ganelon, the battle of Roncevaux, the death of Roland, Turpin's vision and Ganelon's punishment all shown in one scene.
Miniature by Simon Marmion. *Ibid.*, f° 154 r°. Photo : Bibl. Universitaire, Liège.

345. Roland watching Ferragut carry off two Christian knights.
Monochrome drawing. *Les Grandes Chroniques de France.* London, British Museum, Sloane 2433, vol. 1, f° 120 r°, col. 1. Late 14th century. Photo : British Museum.

346. Roland cutting Ferragut's throat.
Monochrome drawing. *Ibid.*, f° 121 v°. Photo : British Museum.

347. Roland killing Ferragut.
Miniature. *Les Grandes Chroniques de France.* Paris, Bibliothèque Nationale, fr. 20.350, f° 106 v°. 14th century. Photo : Bibl. Nationale, Paris.

348 A. Roland fighting with Ferragut.
Ink and wash. *Les Grandes Chroniques de France.* Paris, Bibliothèque Nationale, f. fr. 2606, f° 116 r°. Late 14th - early 15th century. Photo : Bibl. Nationale, Paris.
 B. Disputation between Roland and Ferragut.
Ink and wash. *Ibid.*, f° 122 r°. Photo : Bibl. Nationale, Paris.

349. Roland fighting with Ferragut.
Miniature. *Les Grandes Chroniques de France.* Oxford, Bodleian Library, ms. Douce 217, f° 108 v°. First half of 15th century. Photo : Bodleian Library, Oxford.

350. Roland killing Ferragut.
Miniature. *Les Grandes Chroniques de France.* Munich, Staatsbibliothek, Cod. Gall. 4, f° 110 r°. 15th century. Photo : Staatsbibliothek, Munich.

351. Disputation between Roland and Ferragut.
Drawing with touches of colour. *Les Grandes Chroniques de France.* Valenciennes, Bibliothèque Municipale, ms. 637, f° 137 v°. 15th century. Photo : Lefrancq, Valenciennes.

352. The provost of Saragossa offering peace to Charlemagne.
Grisaille with touches of colour. *Les Grandes Chroniques de France.* Vienna, Nationalbibliothek, ms. 2564 (Eug. f 76), f° 118 r°. 14th century. Photo : Öster. Nationalbibliothek, Vienna.

353. Charlemagne appointing Ganelon ambassador to Marsile.
Grisaille with touches of colour. *Ibid.*, f° 121 v°. Photo : Öster. Nationalbibliothek, Vienna.

354. Charlemagne receiving the gifts from Marsile.
Grisaille with touches of colour. *Ibid.*, f° 140 v°. Photo : Öster. Nationalbibliothek, Vienna.

355. Charlemagne appointing Ganelon ambassador to the two kings of Saragossa. Behind him are Roland and Oliver.
Ink and wash. *Les Grandes Chroniques de France.* Paris, Bibliothèque Nationale, f. fr. 2606, f° 125 r°. Late 14th - early 15th century. Photo : Bibl. Nationale, Paris.

356. Ganelon bringing Charlemagne Marsile's message and the fatal gifts.
Miniature. *Les Grandes Chroniques de France.* Paris, Bibliothèque Mazarine, ms. 2028, f° 124 r°. About 1400. Photo : J. Colomb-Gérard, Paris.

357. Ganelon before the kings of Saragossa.
Miniature. *Les Grandes Chroniques de France.* Paris, Bibliothèque Nationale, f. fr. 20350, f° 109 v°. About 1380. Photo : Bibl. Nationale, Paris.

358. Battle of Roncevaux. Roland attacking King Marsile.
Miniature. *Les Grandes Chroniques de France.* London, British Museum, Sloane 2433, f° 123 v°. Late 14th century. Photo : British Museum.

359. Battle of Roncevaux.
Miniature. *Les Grandes Chroniques de France.* Oxford, Bodleian Library, ms. Douce 217, f° 112 r°. First half of 15th century. Photo Bodleian Library, Oxford.

360. Battle of Roncevaux.
Ink and wash. *Les Grandes Chroniques de France*. Paris, Bibliothèque Sainte-Geneviève, ms. 783, fᵒ 117 rᵒ. 15th century. Photo : Giraudon, Paris.

361 A. Battle of Roncevaux.
Miniature. *Les Grandes Chroniques de France*. Paris, Bibliothèque Nationale, f. fr. 2597, fᵒ 130 vᵒ. 15th century. Photo : Bibl. Nationale, Paris.
361 B. Roland attacking Marsile.
Ink and wash. *Les Grandes Chroniques de France*. Paris, Bibliothèque Nationale, f. fr. 20352, vol. 1, fᵒ 131 vᵒ. 15th century. Photo : Bibl. Nationale, Paris.

362. Roland attacking Marsile.
Miniature. *Les Grandes Chroniques de France*. Munich, Staatsbibliothek, Cod. Gall. 4, fᵒ 129 rᵒ. 15th century. Photo : Staatsbibliothek, Munich.

363. Roland attacking Marsile.
Miniature. *Les Grandes Chroniques de France*. Turin, Biblioteca Nazionale, ms. L. II 8, fᵒ 263 rᵒ. Late 14th century. Photo : Bibl. Nazionale, Turin.

364. Roland riding through the Pyrenees (?)
Miniature. *Les Grandes Chroniques de France*. Paris, Bibliothèque Nationale, f. fr. 2610, fᵒ CII rᵒ. 15th century. Photo : Bibl. Nationale, Paris.

365. Roland attacking Ferragut who is carrying away a Christian.
Historiated initial. *Chronique de l'Anonyme de Béthune*. Paris, Bibliothèque Nationale, nouv. acq. fr. 6295, fᵒ 16 vᵒ. Second half of 13th century. Photo : Bibl. Nationale, Paris.

366. Charlemagne giving Ganelon the message for Marsile.
Historiated initial. *Ibid.*, fᵒ 20 v. Photo : Bibl. Nationale, Paris.

367. Roland blowing his horn beside his wounded horse.
Historiated initial. *Ibid.*, fᵒ 29 rᵒ. Photo : Bibl. Nationale, Paris.

368. Turpin's vision : Roland's soul carried heavenwards by two angels.
Historiated initial. *Ibid.*, fᵒ 29 vᵒ. Photo : Bibl. Nationale, Paris.

369. Charlemagne appointing Ganelon ambassador to Marsile; Roland is behind Ganelon.
Historiated initial K. *Speculum historiale* of Vincent of Beauvais. Madrid, Escorial, ms. 01.4, fᵒ 1 vᵒ. Photo : Jose de Prado, El Escorial.

370. Ganelon taking leave of Marsile and Baligant.
Miniature. *Chronicle attributed to Baudouin d'Avesnes*. Chantilly, Musée Condé, ms. 869. fᵒ 188 vᵒ. About 1500. Photo : Giraudon, Paris.

371. Charlemagne appointing Ganelon ambassador to Marsile.
Historiated initial K. *Speculum historiale* of Vincent of Beauvais. Toulouse, Bibliothèque Municipale, ms. 449, fᵒ 3 rᵒ. Late 13th century. Photo : Bouillère, Toulouse.

327. Charlemagne and Roland fighting against Agolant's troops.
Miniature. *Spieghel historiael* of Jacob van Maerlant. The Hague, Koninklijke Bibliotheek, Ak. xx, fᵒ 213 vᵒ. First half of 14th century. Photo : Koninklijke Bibliotheek.

373. Roland fighting with Ferragut.
Miniature. *Ibid.*, fᵒ 214 rᵒ. Photo : Koninklijke Bibliotheek.

374. Battle of Roncevaux. Roland attacking and killing Marsile.
Miniature. *Ibid.*, fᵒ 215 rᵒ. Photo : Koninklijke Bibliotheek.

375 A. The heroes' funeral procession.
B. Ganelon's punishment.
Miniature. *Ibid.*, fᵒ 216 rᵒ. Photo : Koninklijke Bibliotheek.

376. Mounted combat between Roland and Ferragut.
Gouache. *Miroir historial* of Jean de Vignay. Paris, Bibliothèque Nationale, f. fr. 314, fᵒ 11 vᵒ. 1496. Photo : Bibl. Nationale, Paris.

377. Roland killing Ferragut.
Gouache. *Ibid.*, fᵒ 12 rᵒ. Photo : Bibl. Nationale, Paris.

378. Battle of Roncevaux.
Gouache. *Ibid.*, fᵒ 12 vᵒ. Photo : Bibl. Nationale, Paris.

379. Roland fighting with Ferragut.
Grisaille with touches of colour. *Miroir Historial* of Jean de Vignay. Paris, Bibliothèque Nationale, f. fr. 320, fᵒ 368 rᵒ. 1455. Photo : Bibl. Nationale, Paris.

380. Charlemagne mourning Roland and Oliver.
Grisaille with touches of colour. *Ibid.*, fᵒ 370 vᵒ. Photo : Bibl. Nationale, Paris.

381. Battle of Roncevaux.
Ink and wash. *Miroir Historial*. Paris, Bibliothèque Nationale, f. fr. 52, fᵒ 7 vᵒ. Photo : Bibl. Nationale, Paris.

382. Roland fighting with Ferragut.
Miniature. *Miroir Historial* of Jean de Vignay. Chantilly, Musée Condé, ms. 722, fᵒ 110 vᵒ. 1469-1473. Photo : Giraudon, Paris.

383. Burial of the knights killed at Roncevaux.
Miniature. *Miroir Historial* of Jean de Vignay. Paris, Antoine Vérard, 1495-1496. Paris, Bibliothèque Nationale, Réserve Vélin 650, fᵒ 129 rᵒ. Photo : Bibl. Nationale, Paris.

384. Roland killing Eaumont.
Miniature. *Trésor* of Brunetto Latini. Paris, Bibliothèque Nationale f. fr. 567, fᵒ 20 rᵒ. Late 13th - early 14th century. Photo : Bibl. Nationale, Paris.

385. Roland destroying the heathen idols.
Miniature. *Trésor* of Brunetto Latini. Paris, Bibliothèque Nationale f. fr. 573, f° 29 v°.Mid-15th century. Photo : Bibl. Nationale, Paris.

386. Roland destroying the heathen idols.
Miniature. *Trésor* of Brunetto Latini. Florence, Biblioteca Laurenziana, ms. Ashburnham 52, f° 31 r°. Photo : Pineider, Florence.

387. Charlemagne and Roland fighting against Agolant.
Miniature by Simon Marmion. *La Fleur des Histoires* of Jean Mansel. Brussels, Bibliothèque Royale, ms. 9232 vol. II, f° 337 v°. About 1455. Photo : Bijtebier, Brussels.

388. Roland saving the life of Charlemagne who is being threatened by Eaumont.
Miniature. *La Fleur des Histoires* of Jean Mansel. Copenhagen, Royal Library, Thott 568, f° 102 v°. Second half of 15th century. Photo : Det Kongelige Bibliothek, Copenhagen.

389. Scenes from the battle of Roncevaux. Roland blowing his horn.
Miniature. *Ibid.*, f° 121 v°. Photo : Det Kongelige Bibliothek, Copenhagen.

390. Charlemagne and his peers. Siege of a heathen city.
Miniature. *La Fleur des Histoires* of Jean Mansel. Bern, Burgerbibliothek, ms. 31-32, f° 13 r°. Late 15th century. Photo : Burgerbibliothek, Bern.

391. Charlemagne and Roland preparing to fight Eaumont.
Grisaille. *Croniques et Conquestes de Charlemaine* of David Aubert, illustrated by Jean le Tavernier. Brussels, Bibliothèque Royale, ms. 9066, f° 303 r°. About 1460. Photo : Bibl. Royale, Brussels.

392. Roland fighting the heathen king Agolant with the help of St. George.
Grisaille. *Ibid.*, f° 326 v°. Photo : Bijtebier, Brussels.

393. Roland killing the heathen king Iapher with the help of St. George.
Grisaille. *Ibid.*, f° 334 r°. Photo : Bijtebier, Brussels.

394. Roland meeting Oliver and Aude for the first time under the walls of Vienne in Dauphiné.
Grisaille. *Ibid.*, f° 367 v°. Photo : Bijtebier, Brussels.

395. Roland fighting beneath the walls of Vienne.
Grisaille. *Ibid.*, f° 386 r°. Photo : Bijtebier, Brussels.

396. The fight between Roland and Oliver under the walls of Vienne.
Grisaille. *Ibid.*, f° 427 r°. Photo : Bijtebier, Brussels.

397. Roland witnessing Fierabras' challenge to Charlemagne.
Grisaille. *Ibid.*, ms. 9067, f° 27 r°. Photo : Bibl. Royale, Brussels.

398. Roland and Oliver taken prisoner and brought before the king of the heathen.
Grisaille. *Ibid.*, f° 44 v°. Photo : Bibl. Royale, Brussels.

399. Roland at the surrender of Renaut de Montauban.
Grisaille. *Ibid.*, f° 182 r°. Photo : Bibl. Royale, Brussels.

400. St. James appearing to Charlemagne.
Grisaille. *Ibid.*, f° 189 v°. Photo : Bibl. Royale, Brussels.

401. Roland and Oliver bringing to Charlemagne the troops which are about to leave for Spain. Betrothal of Aude and Roland.
Grisaille, *Ibid.*, f° 193 r°. Photo : Bijtebier, Brussels.

402. Charlemagne, Roland and the Franks following an enchanted hind across the Gironde.
Grisaille. *Ibid.*, f° 198 r°. Photo : Bijtebier, Brussels.

403. Roland fighting in the meadows by the city of Noble.
Grisaille. *Ibid.*, f° 205 r°. Photo : Bijtebier, Brussels.

404. Charlemagne and Roland making the final preparations for the siege of Pamplona.
Grisaille. *Ibid.*, f° 214 r°. Photo : Bijtebier, Brussels.

405. Roland and Oliver at the siege of Pamplona.
Grisaille. *Ibid.*, f° 218 v°. Photo : Bijtebier, Brussels.

406. Roland leading the final attack on Pamplona.
Grisaille. *Ibid.*, f° 221 r°. Photo : Bijtebier, Brussels.

407. Roland killing Ferragut.
Grisaille. *Ibid.*, f° 227 v°. Photo : Bijtebier, Brussels.

408. Charlemagne and Roland receiving the fatal gifts which Ganelon has brought back from Saragossa.
Grisaille. *Ibid.*, f° 238 v°. Photo : Bibl. Royale, Brussels.

409. Ganelon conspiring with Marsile.
Grisaille. *Ibid.*, f° 252 v°. Photo : Bijtebier, Brussels.

410. The ambush at Roncevaux.
Grisaille. *Ibid.*, f° 271 r°. Photo : Bijtebier, Brussels.

411. Roland in the thick of the battle at Roncevaux.
Grisaille. *Ibid.*, f° 275 v°. Photo : Bijtebier, Brussels.

412. Roland blowing his horn.
Grisaille. *Ibid.*, ms. 9068, f° 1 r°. Photo : Bijtebier, Brussels.

413. Roland wounding King Marsile.
Grisaille. *Ibid.*, f° 6 v°. Photo : Bijtebier, Brussels.

414. Baudouin with the dying Roland.
Grisaille. *Ibid.,* f⁰ 12 v⁰. Photo : Bijtebier, Brussels.

415. Charlemagne learning of Roland's death and receiving Durandal from Baudouin. An angel telling Charlemagne of the miracle of the sun halted in its course.
Grisaille. *Ibid.,* f⁰ 20 r⁰. Photo : Bijtebier, Brussels.

416. Charlemagne is challenged by Baligant and prepares to fight him.
Grisaille. *Ibid.,* f⁰ 27 v⁰. Photo : Bijtebier, Brussels.

417. Marsile dying at Saragossa, as the Christians take the city.
Grisaille. *Ibid.,* f⁰ 37 v⁰. Photo : Bijtebier, Brussels.

418. Charlemagne arresting Ganelon and handing him over to the kitchen-boys.
Grisaille. *Ibid.,* f⁰ 45 r⁰. Photo : Bijtebier, Brussels.

419. Ganelon's trial and punishment.
Grisaille. *Ibid.,* f⁰ 94 r⁰. Photo : Bijtebier, Brussels.

420. Aude and Girart de Vienne coming before Charlemagne.
Grisaille. *Ibid.,* f⁰ 59 v⁰. Photo : Bibl. Royale, Brussels.

421. Charlemagne and Roland on horseback.
Pen-drawing. *L'Histoire de Charlemagne en forme d'Heures.* Paris, Bibliothèque Nationale, f. fr. 4970, f⁰ 2 r⁰. Late 15th century. Photo : Ann Münchow, Aix-la-Chapelle.

422. Roland as Charlemagne's champion.
Miniature by Loyset Liédet. *Chronicle of Baudouin d'Avesnes,* Paris, Bibliothèque de l'Arsenal, ms. 5089, f⁰ 168 v⁰. 1462. Photo : Ann Münchow, Aix-la-Chapelle.

423. The young Roland attends Charlemagne's coronation by the Pope.
Miniature by Loyset Liédet. *Chronicle of Baudouin d'Avesnes, Ibid.,* f⁰ 162 v⁰. Photo : Ann Münchow, Aix-la-Chapèlle.

424. Roland as a youth at Charlemagne's coronation by the Pope.
Ink and wash. *Cronicon Imperatorum et Pontificum.* Modena, Biblioteca Estense. Photo : Cav. Uff. Orlandidi, Modena.

425 A. Roland placed beside Charlemagne in the fifth Heaven of Paradise.
Woodcut. Dante, *La Divine Commedia.* Venice, Pietro de Piasi, 1491, 18th November. Liège, Bibliothèque de l'Université. 15th century. B. 183. Photo : Bibl. Université, Liège.

 B. Roland placed beside Charlemagne in the fifth Heaven of Paradise.
Woodcut. Dante, *La Divine Commedia.* Venice, Math. Capcasa, 1493, 29th November. Liège, Bibliothèque de l'Université, 15th century, B. 182. Photo : Bibl. Université, Liège.

426. Roland placed beside Charlemagne in the fifth Heaven of Paradise.
Miniature. Dante, *Divine Comedy,* French translation by François Bergaigne. Paris, Bibliothèque Nationale, nouv. acq. fr. 4119, f⁰ 101 v⁰. Photo : Bibl. Nationale, Paris.

427. An angel giving Charlemagne the sword and horn destined for Roland.
Pen-drawing. *Weltchronik* of Henry of Munich. Munich, Staatsbibliothek, ms. sgm. 7377, f⁰ 262 v⁰. Photo : Staatsbibliothek, Munich.

428. An angel giving Charlemagne the sword and horn destined for Roland.
Miniature. *Christherrechronik.* New York, Pierpont Morgan Library, ms. 769, f⁰ 338 v⁰. Photo : Pierpont Morgan Library, New York.

429. Charlemagne and Roland receiving a messenger.
Ink and wash drawing, workshop of Diebold Lauber. *Sieben Weise und Martin von Troppau Chronik,* Heidelberg, Universitätsbibliothek, Palat. Germ. 149, f⁰ 184 r⁰. About 1450. Photo : Ann Münchow, Aix-la-Chapelle.

430. Turpin.
Silver statuette from the Reliquary of St. Charlemagne. Aix-la-Chapelle, Cathedral treasury. About 1360. Photo : Ann Bredol-Lepper, Aix-la-Chapelle.

431. Oliver.
Silver statuette from the Reliquary of St. Charlemagne. Photo : Ann Bredol-Lepper, Aix-la-Chapelle.

432. Roland.
Reliquary of St. Charlemagne. Photo : Ann Bredol-Lepper, Aix-la-Chapelle.

433. Roland's coat of arms.
Detail, reliquary of St. Charlemagne, Aix-la-Chapelle, cathedral. Photo : Ann Bredol-Lepper, Aix-la-Chapelle.

434. Roland has a quintain erected outside the city of Vienne.
Grisaille by Jean le Tavernier. *Croniques et Conquestes de Charlemaine* of David Aubert. Brussels, Bibliothèque Royale, ms. 9066, f⁰ 414 v⁰. About 1460. Photo : Bijtebier, Brussels.

435. The Potzlow Roland.
Woodcarving. Restored after 1806. Photo : Bibl. Universitaire, Liège.

436. The Nordhausen Roland.
Woodcarving. Restored in 1717. Bildarchiv Foto, Marburg.

437. Roland promising to spare the life of all citizens of Nájera who agree to be baptized.
Miniature. *L'Entrée d'Espagne.* Venice, Biblioteca Marciana, cod. fr. XXI, f⁰ 82 r⁰. About 1350. Photo : Fiorentini, Venice.

438. The Halle Roland.
Sandstone copy of 14th century wooden statue. After 1719. Photo : Kunstgeschichtliche Bildstelle Humboldt-Universität, Berlin.

439. The Halberstadt Roland.
Stone statue. 1433. Bildarchiv Foto, Marburg.

440. The Hamburg Roland.
Stone statue. First half of 14th century (drawing by Preyer). Photo : Universitätsbibliothek, Halle.

441. The Zerbst Roland.
Stone statue. About 1445. Bildarchiv Foto, Marburg.

442. The Magdeburg Roland.
Panoramic view of the town with the statue. Woodcut. Hartmann Schedel, *Chronica Chronicorum,* Nuremberg, 1493. Photo : Bibl. Universitaire, Liège.

443. The Perleberg Roland.
Stone statue. About 1498. Bildarchiv Foto, Marburg.

444. The Stendal Roland.
Stone statue. 1525. Photo : Bibl. Universitaire, Liège.

445. The Brandenburg Roland.
Stone statue. 1474. Photo : Kunstgeschichtliche Bildstelle Humboldt-Universität, Berlin.

446. The Quedlimburg Roland.
Stone statue. About 1460. Bildarchiv Foto, Marburg.

447. Head of the Prenzlau Roland.
Stone. 1496. Municipal museum. Photo : Bibl. Universitaire, Liège.

448. The Litoměrice Roland.
Stone statue. 1539. Photo : Bibl. Universitaire, Liège.

449. The Prague Roland.
Stone statue replacing one of the late 15th century. 19th century. Bildarchiv Foto, Marburg.

450. The Roland at Ragusa (Dubrovnik).
Stone statue. About 1420. Photo : Voyages Parfaits, Liège.

451. The Dole Roland.
Stone statue. About 1400. Photo : André Bignon, Dole.

452. Turpin baptizing the heathen Otinel.
Detail of a fresco at Treviso, Museo Civico. Last quarter of 14th century. Photo : L. Bailo, Treviso.

453. Charlemagne and Roland at Otinel's baptism.
Detail of the fresco. Photo : L. Bailo, Treviso.

454. A. and B. Reconstruction of a Tournai tapestry, showing the battle of Roncevaux.
After Helbig. Photo : Musées Royaux d'Art et d'Histoire, Brussels.

455. First section of the Roncevaux tapestry.
Florence, Museo Nazionale. About 1455-1470. Photo : Soprintendenza, Florence.

456. Roland in the thick of the battle.
Detail. *Ibid.* Photo : Soprintendenza, Florence.

457. Second section of the tapestry.
Brussels. Musées Royaux d'Art et d'Histoire. About 1455-1470. Photo : Musées Royaux d'Art et d'Histoire, Brussels.

458. Roland killing King Marsile.
Fragment of a second Tournai tapestry. London, Victoria and Albert Museum. About 1455-1470. Photo : Sotheby, London.

459. Baudouin and Tierry attend the dying Roland.
Another fragment of the same tapestry. London, Victoria and Albert Museum. Photo : Sotheby, London.

460. Baudouin and Tierry attend the dying Roland.
Fragment of a third Tournai tapestry. Private collection. About 1455-1470. Photo : Sotheby, London.

461. Roland killing Ferragut.
Miniature by Jean Colombe. *Histoire et faits des Neuf Preux* of Sebastian Mamerot. Vienna, Nationalbibliothek, cod. 2577, vol. 1, f° 127 r°. Between 1480 and 1489. Photo : Österr. Nationalbibliothek, Vienna.

462-463. Roland and Oliver.
Medallions carved in wood. Saint-Bernard-de-Comminges. Decoration of choir. Early 16th century. Photo : Jean Dieuzaide, Toulouse.

464. Roland and Oliver.
Niello. Paris, Bibliothèque Nationale, Cabinet des Estampes, Ec. 27 rés. Early 16th century. Photo : Bibl. Nationale, Paris.

465. Roland.
Niello. Florence, Biblioteca Marucelliana. Early 16th century. Photo : Pineider, Florence.

466. St. Roland.
Woodcut by Leonhard Beck. *Die Heiligen aus der Sipp-, Mag- und Schwägerschaft des Kaisers Maximilians I.* About 1510. Photo : Bibl. Royale, Brussels.

467. The Pseudo-Turpin Chronicle.
Title-page. Edition by Regnauld Chauldiere, Paris, [1514]. Châteauroux, Bibl. Municipale, B. 214. Photo : Bibl. Municipale, Châteauroux.

468. Roland on foot beside Charlemagne on horseback (?).
Woodcut. *Ibid.* Photo : Bibl. Municipale, Châteauroux.

469. Charlemagne's conquest of Spain.
Woodcut. *Les Grandes Chroniques de France.* Paris, Antoine Vérard, 1493. Paris, Bibliothèque Nationale, Réserve L 35/7, vol. 1, f° 145 r°. Photo : Bibl. Nationale, Paris.

470. Roland at the siege of Noble (here called Garnople).
Woodcut (enlarged). *Les Grandes Chroniques de France.* Paris, Guillaume Eustace, 1514. Châteauroux, Bibliothèque Municipale, B. 405, f° 114 r°. Photo : Bibl. Municipale, Châteauroux.

471. Ganelon swearing to deliver Roland into the hands of the kings of Saragossa.
Woodcut (enlarged). *Ibid.,* f° 109 v°. Photo : Bibl. Municipale, Châteauroux.

472. Charlemagne, Roland, Oliver, Turpin and the other peers.
Painted woodcut. *Die alder excellentiste Cronyke van Brabant.* Antwerp, Roland van den Dorpe, 1497. Liège, Bibliothèque de l'Université, xv° s., B. 6, f° 83 v°. Photo : Bibl. Universitaire, Liège.

473. Combat between Roland and Ferragut.
Painted woodcut. *Ibid.,* f° 87 r°. Photo : Bibl. Universitaire, Liège.

474. Roland attacking Marsile at Roncevaux.
Painted woodcut. *Ibid.,* f °90 v°. Photo : Bibl. Universitaire, Liège.

475. Roland blowing his horn.
Painted woodcut. *Ibid.,* f° 203 v°. Photo : Bibl. Universitaire, Liège.

476. Oliver taking leave of the daughter of King Hugo of Constantinople.
Woodcut. *Galien Réthoré.* Paris, Antoine Vérard, 12th December 1500. Paris, Bibliothèque Nationale, Réserve Y² 322, f° 19 v°. Photo : Bibl. Nationale, Paris.

477. Battle of Roncevaux.
Woodcut. *Ibid.,* f° 48 v°. Photo : Bibl. Nationale, Paris.

478. Galien, with Roland, watching over the dying Oliver.
Woodcut. *Ibid.,* f° 51 v°. Photo : Bibl. Nationale, Paris.

479. Roland and Oliver at Charlemagne's court.
Woodcut. *Fierabras.* Lyons, Guillaume le Roy, about 1483. Liège, Bibliothèque de l'Université, xv° s. B. 119. Photo : Bibl. Universitaire, Liège.

480. Disputation between Roland and Ferragut.
Woodcut. *Fierabras.* Lyons, Loys Garbin, 1483. London, British Museum, Incunable C. 6, B. 12. Photo : British Museum.

481. Ganelon's message. Ganelon plotting with the kings of Saragossa.
Woodcut. *Ibid.* Photo : British Museum.

482. Battle of Roncevaux.
Woodcut. *Ibid.* Photo : British Museum.

483. Charlemagne finds Oliver's body.
Woodcut. *Ibid.* Photo : British Museum.

484. Ferragut carrying away two Christian knights under his arms.
Woodcut. *Fierabras.* Lyons, Guillaume Le Roy, 1487. London, British Museum, Incunables IB 41525. Photo : British Museum.

485. Disputation between Roland and Ferragut.
Woodcut. *Ibid.* Photo : British Museum.

486. Ganelon's message. Ganelon plotting with the Kings of Saragossa.
Woodcut. *Fierabras.* Lyons, Guillaume le Roy, 1487. London, British Museum, Incunables IB 41525. Photo : British Museum.

487. Charlemagne finds the body of Roland.
Woodcut. *Ibid.* Photo : British Museum.

488. Roland fighting Ferragut.
Woodcut. *La conqueste du grant roy Charlemaine des Espaignes et les vaillances des douze pers de France, et aussi celles du vaillant Fierabras.* Lyons, Pierre Maréchal and Barnabé Chaussard, 4th April 1497. Paris, Bibliothèque Nationale Réserve Y² 993, f° I vij. Photo : Bibl. Nationale, Paris.

489. Roland killing Marsile.
Woodcut. *Ibid.,* f° Kii. Photo : Bibl. Nationale, Paris.

490. Charlemagne finds the body of Roland.
Woodcut. *Ibid.,* f° Kiii. Photo : Bibl. Nationale, Paris.

491. Richard of Normandy bringing Charlemagne news of Roland's death.
Woodcut. *Ibid.,* f° Giiii v°. Photo : Bibl. Nationale, Paris.

492. Roland.
Woodcut. Hartmann Schedel, *Chronica chronicorum.* Nuremberg. Anton Koberger, 12th July 1493. Liège, Bibliothèque de l'Université, xv° s. A 7. Photo : Bibl. Universitaire, Liège.

493. Charlemagne welcoming Roland and Oliver to his court.
Woodcut. *Fierabras.* 1533. London, British Museum, Incunables C. 125.e.16, f° Dij. Photo : British Museum.

494. Mounted combat between Oliver and Fierabras.
Woodcut. *Ibid.,* f° Biiij. Photo : British Museum.

495. Oliver fighting on foot against Fierabras.
Woodcut. *Ibid.,* f° B iiij. Photo : British Museum.

496. An episode in the battle of Roncevaux.
Woodcut. *Rotta di Roncisvalle,* Florence, without date or publisher (early 16th century). Venice, Biblioteca Marciana, Marc. Misc. 1016-14, f° A iiij. Photo : Bibl. Marciana, Venice.

497. Battle of Roncevaux.
Woodcut. *Orlando Innamorato* of Boiardo. Venezia, Georgio Rusconi, 25-X-1506. Venice, Biblioteca Marciana, Marc. Rari V. 477 (n. 47.009). Photo : Bibl. Marciana, Venice.

498. Ganelon.
Woodcut. *Libro di Battaglie* of Pandolfo de Bonacossi, Firenze, Bernardo Zuchetta, 14.X.1525. Venice, Biblioteca Marciana, Marc. 125. D. 21 (n. 46.423). Photo : Bibl. Marciana, Venice.

499. Roland.
Woodcut. *Orlando Innamorato* by Boiardo. Mediolani, Leonardus Vegius, 23.II.1513. Venice, Biblioteca Marciana, Marc. Rari 532 (n. 46.471). Photo : Bibl. Marciana, Venice.

500. Charlemagne appointing the twelve peers. Gascon ambush after Pamplona.
Miniature. *Recueil sommaire des croniques françoyses* of Guillaume Cretin. Paris, Bibliothèque Nationale, f. fr. 1820, f° 65 r°. Between 1515 and 1525. Photo : Bibl. Nationale, Paris.

501. Charlemagne's vision of St. James. Charlemagne and Roland outside Pamplona.
Miniature. *Ibid.,* f° 70 v°. Photo : Bibl. Nationale, Paris.

502. Charlemagne receiving envoys from King Agolant. Miracle of the flowering lances, and battle of Charlemagne and Roland against Agolant.
Miniature. *Ibid.,* f° 85 v° - 86 r°. Photo : Bibl. Nationale, Paris.

503. Roland fighting with Ferragut.
Miniature. *Ibid.,* f° 99 r°. Photo : Bibl. Nationale, Paris.

504. Roland's fight with Ferragut, second day. Disputation.
Miniature. *Ibid.,* f° 103 v°. Photo : Bibl. Nationale, Paris.

505. Roland's fight with Ferragut. Third day (Roland kills Ferragut).
Miniature. *Ibid.,* f° 107 r°. Photo : Bibl. Nationale, Paris.

506. Ganelon is paid for his treason. Heathen ambush and first victorious charge of Roland and Oliver.
Miniature. *Ibid.,* f° 118 r°. Photo : Bibl. Nationale, Paris.

507. Roland forcing a Saracen to point out Marsile to him. Roland charging with Oliver. Roland blowing his horn.
Miniature. *Ibid.,* f° 124 r°. Photo : Bibl. Nationale, Paris.

508. Roland trying to break Durandal. Death of Roland.
Miniature. *Ibid.,* f° 127 v°. Photo : Bibl. Nationale, Paris.

509. Charlemagne mourning Roland. Ganelon's punishment.
Miniature. *Ibid.,* f° 133 v°. Photo : Bibl. Nationale, Paris.

510. Roland's funeral at Blaye.
Miniature. *Ibid.,* f° 141 v°. Photo : Bibl. Nationale, Paris.

NOTE. To locate the giant statues of Roland (Figures 435, 436, 438-451) see the map in vol. I), p. 355.

385

Weltchronik, Weihenstephan 350 (8) n. 7

Wernher 118

Willehalm of Wolfram von Eschenbach 236, 238

HISTORICAL FIGURES

Abbon, Frankish nobleman, founder of monastery of Novalese near Mont Cenis 79

Adelardi, family of Ferrara 65

Adrian I, pope 43

Adrian IV, pope 85

Aguesseau, chancellor d' 344 (1) n. 3

Aimeri VII, viscount of Touars 146

Alberto de Sambonifaccio, count 69

Alexander II, pope 30

Alexander III, pope 101, 146

Alfonso VI of Castille 50 n. 21

Alfonso VII of Castille 50 n. 21

Alfonso the Warrior, king of Aragon 39 n. 6

Alix, mother of Henry I, count of Champagne 165

Alphonse de Poitiers, count of Toulouse 276

Anastasius IV, pope 85

Andrew, abbot of Saint-Faron, Meaux 168 n. 27

Anne, daughter of Rudolf II of Bavaria, third wife of emperor Charles IV 353

Anne de Boulogne, viscountess of Turenne 399

Anne of Brittany, queen of France 385

Antoine de Croy, bailiff of Hainaut 314

Arnaut du Mont, monk 57

Artusius (deed of 1125, Modena) 106

Autcharius, duke 161

d'Avesnes family 310

Aymery de Rochechouart, lord of Mortemart 346 (1) n. 48

Baudouin V, count of Hainaut 271, 344 (1) n. 2

Baudouin VI, count of Hainaut 347 (3b) n. 3

Baudouin d'Avesnes 310, 347 (3b) n. 1

Beatrice de Bourgogne, wife of Frederick Barbarossa 362

Béatrice de Gavre, wife of Guy IX, count of Montmorency-Laval 316

Berlaimont-Ligne family 314

Bertha, Pepin's wife 278

Berthier family, Troyes 306

Boiamonte family of Modena 106

Boleslas, duke of Poland 123

Blankenheim, counts of 243, 267 (6) n. 33

Bolomier, Henri 388

Bongars, Jacques 349 (6) n. 5

Borso d'Este 259

Boscho family of Modena 106

Bouchard d'Avesnes, father of Baudouin d'Avesnes 310

Brun van Sconenbeke, Magdeburg 364 (2) n. 8

Calixtus II, pope 36, 43, 44, 48, 49, 50 n. 21, 51-53, 132, 402, 405

Carrara, family of Paduan *podestà*, Francesco il Vecchio and Francesco il Novello 369

Catherine of Luxembourg, daughter of the emperor Charles IV, wife of Otto of Brandenburg 353, 354

Charlemagne *or* Charles 45, 46, 72, 111, 142, 143, 153, 159, 169, 193, 271, 277, 352-354, 406, 410; *Charles le Grant* 275

Charles IV the Fair, king of France 345 (2) n. 36, 352, 362, 363 (1) n. 2, n. 3

Charles V, king of France 215, 278, 281, 288, 289, 294, 299, 366, 370, 406

Charles VI, king of France 215, 274, 278, 289, 297, 303

Charles VII, king of France 278, 280, 290, 294, 326, 327, 386, 394

Charles VIII, king of France, 280, 290, 294, 326, 327, 386, 394

Charles IV, emperor 278, 352-354, 356, 404, 406

Charles V, emperor 281

Charles of Anjou 327

Charles the Bald, king of France 37, 148

Charles the Bold, duke of Burgundy 224, 265 (4) n. 15, 280, 328, 372, 374, 406

Charles Martel 27

Charles-Orland and Charles, sons of Charles VIII 280, 344 (2) n. 23, 381

Charles de Valois 276

Charlotte, princess of France 261

Chimay, princes of 314

Chuonrat Plebanus, cleric of Ratisbon 115

Claude, wife of Francis I of France 261

Clovis 139, 203, 205

Colbert 268 (7) n. 18

Conrad de Hunebourg, bishop of Strasbourg 122

Conrad de Krosigh, bishop of Halberstadt 356

Constantine 86, 134

Créquy family of Hainaut 314

Croy family 314

Dampierre family 310

Des Voisins family of Burgundy 297

Diocletian 200

Donato Acciaioli, Florentine ambassador 280

Dubrowski, Peter 297

Duprat, Antoine, cardinal and chancellor to Francis I 261

Eble de Roucy, French son-in-law of Ramiro I 26, 50 n. 21

Edward III of England 180

Eleanor of Aquitaine 112, 115, 165, 174, 344 (1) n. 2, 406

Elizabeth of Bohemia 352

Etienne de Berry, nephew of Calixtus II 43

Eugenius III, pope 82

Eugenius IV, pope 362, 364 (2) n. 24

Eulogius, Cordovan bishop 30

Ferracutus Oriundus de Busto (document of 1188) 96 n. 5

Ferragut Filius Mainardi (document of 1159) 96 n. 5

Ferraguth Miles (deed of 1171) 94, 96 n. 5

Fillastre, Guillaume, abbot of Saint-Bertin, bishop of Verdun, Toul and Tournai 297, 299, 329

Florent V, count of Holland 320

Foulcoie de Beauvais, archdeacon of Meaux 164, 166 n. 18, n. 19

Francesco Gonzaga 244, 259, 267 (7) n. 3

Francis I, king of France 261, 280, 281, 381, 394, 395, 399, 406

Frederick I (Barbarossa), emperor 112, 113, 142, 153, 169, 174, 177 n. 24, 362

Frederick II 174, 177 n. 14, 192, 405

Frederick I, archbishop of Cologne 37, 111

Frederick, count Palatine 399

Fulk V, count of Anjou 89

Fulrad, abbot of Saint-Denis 143

Gavre, lords of 316, 318, 319, 348 (3d) n. 14

Gaufridus, abbot of St. Albans 57

Gautier de Chatillon 165

Gelasius II, pope 36, 43

Gelmirez, Diego, archbishop of Compostela 49

Geoffrey of Anjou 160

Geoffrey of Monmouth 348 (3c) n. 15

Geoffrey Plantagenet 68, 358

Geoffroy d'Argenton 146

Geoffroy du Breuil, prior of Vigeois 57, 115

Gerald de Fay 85, 89

Gertrude, daughter of the emperor Lothair and wife of Henry the Proud 112, 115, 137 n. 10

Girard d'Angoulême, legate, bishop and builder of Angoulême cathedral 30, 36, 37, 38, 41 n. 30, n. 31, 111, 405, 408

Girart, son of William II, count of Macon 164

Gisolfo, bishop of Vercelli 82

Gloucester, duke of 372

Goderan, founder of the abbey of Saint-Gilles in Liège 150

Gonzaga, family of Mantua 209, 243, 259

Gouffier, Guillaume, lord of Bonnivert, admiral 261

Gui de Dampierre 318

Guillaume de Béthune 309

Guillaume d'Estrabonne 362

Guiscard, Robert 260, 263 (1) n. 4, 268 (8) n. 5

Guy d'Argenton 146

Guy of Burgundy, pope under the name of Calixtus II 43

Guy (or Guillaume) de Gavre, said to be a contemporary and soldier of Charlemagne 317-319

Guy IX, count of Montmorency-Laval, husband of Béatrice de Gavre 316, 348 (3d) n. 6

Haakon V, king of Norway 342

Hapsburg family 384

Henry II of England 112, 210, 406

Henry V of England 372

Henry VI of England 212

Henry VII of England 294

Henry VIII of England 372

Henry VI, emperor 110, 142, 144 n. 11

Henry I the Liberal, count of Champagne 164, 166 n. 20

Henry the Lion, son of Henry the Proud 112-116, 118, 136, 174, 358, 406

Henry the Proud, duke of Saxony 112-115, 137 n. 10

Hildegard, Charlemagne's wife 162

Honorius II, pope 36

Hugh Capet 395

Hugo, monk of Fleury-sur-Loire 284

Ingo, bishop of Vercelli 80

Isabella of Bavaria 264 (2) n. 5

Itier Archambaud, canon of Angoulême 36, 41 n. 30

Jacques d'Armagnac 326

Jadot Gilbert 310

Jean de la Barre, chief tax officer for Languedoc 345 (2) n. 48

Jean de Gavre 318, 319, 348 (3d) n. 10, n. 14

Jean de Mauléon, bishop 382

Jean de Vienne, admiral who died at the siege of Nicopolis 362

Jean de Wavrin, natural son of Robert VII, lord of Wavrin 318, 384 (3d) n. 9

Jeanne de Bourbon, wife of Charles V 289

Jeanne de Bourgogne, wife of Philip the Tall 324

Jeanne d'Evreux, daughter of Louis X and wife of Charles IV (the Fair) 345 (2) n. 36

Jean sans Peur, see John the Fearless

Joanna, sister of Richard the Lion-Heart and wife of William II of Sicily 210

John, duke of Berry, brother of Charles V of France 278, 288, 294, 344 (2) n. 12, 345 (2) n. 48, n. 51, 370

John the Fearless, duke of Burgundy 220, 298

John II the Good, king of France 244, 278, 281, 284, 286, 288, 298-300, 320, 358, 366, 407

John V of Créqui 331

John Lackland, king of England 174, 309

John of Luxemburg 352

John de la Pole, duke of Suffolk 346 (2) n. 52

Lalaing, count of 314

Lambert le Bègue, priest of Liège 149, 151

Lambert, abbot of Saint-Faron at Meaux 167 n. 27

Lamoignon, C.F. de 303

Lanfranc of Pavia 106

Lannoy family 310

Leon III, pope 169, 176 n. 1, 281, 339, 341, 351 (8) n. 10, 353, 402

Leo Magnus, Danish king 122

Leopold I, king of the Belgians 348 (3d) n. 5

Leoprandus, supposed dean of Aix-la-Chapelle 51

Libri, book collector 343 (1) n. 3

Lionel d'Este 341

Liutprand, king of the Lombards 27

Lorandus (= Rolandus ?) (document of 1086, Split) 362

Lothair, emperor 112

Lothair III 69, 122

Louis the Pious 225

Louis VII of France 201

Louis IX of France (St. Louis) 276, 281, 310, 319, 406

Louis XI of France 224, 226, 278, 280, 326, 349 (4) n. 16, 382

Louis XII of France 280, 385, 394

Louis I of Anjou, king of Naples 370

Louis de Gruuthuse, art patron 324

Louis de Laval, lord of Châtillon-en-Vendelais 380, 391 (1) n. 5

Louis of Luxemburg, count of Saint-Pol 374

Louis of Orleans-Valois, second son of Charles V 372

Loyse de la Tour, wife of John V of Créqui 331

Ludwig IV of Heidelberg 242

Luigi I Gonzaga 259, 268 (7) n. 16, 406

Luitgard, one of Charlemagne's wives 344 (2) n. 23

Malet de Graville family 302

Margaret of Anjou 212, 216, 221

Margaret of Constantinople, wife of Bouchard d'Avesnes 310

Marie of Burgundy 384

Marie of Champagne, wife of Henry the Liberal 164, 165, 166 n. 24, 344 (1) n. 2

Matilda Plantagenet, wife of Henry the Lion 112-115, 135, 136, 174, 406, 410

Matilda of Tuscany, countess 106

Matthew, clerk to Guillaume de Béthune 309

Matthew of Vendome, abbot of Saint-Denis 276, 281

Maxentius, beaten by Constantine at the Milvian Bridge 134

Maximianus Hercules 201

Maximilian of Austria 203, 384, 404, 406

Mechtilda of Wittelsbach, sister of Ludwig IV of Heidelberg 242

Michael, lord of Harnes in Artois 271

Minuti, Jacopo, senator of Florence (16th century) 261

Montmorency family 330, 348 (3d) n. 6, 350 (7) n. 7

Napoleon Bonaparte 56

Nicolas de Senlis 343 (1) n. 2

Noël de Fribois, secretary to Charles VII 380

Odo, count of Chartres 200

Odo of Francoville, abbot of Lièpvre 143

Odoacer 72

Oliverius (document of 1088, Split) 362

Ottheinrich, count Palatine 116

Otto II, emperor 81, 82

Otto IV, emperor 136, 174, 177 n. 24, 406

Otto of Brandenburg, son-in-law of the emperor Charles IV 353

Otto, bishop of Freisingen 111

Ottonello, assessor of the Podestà of Treviso 370

Otonelus (document of 1246, Ferrara) 369

Otonele de Orlandino (document of 1247, Ferrara) 369

Ottonellus (document of 1174, Padua; 1180, Verona) 369, 376 (1) n. 18

Hercules 70 n. 27, 361
Homer 394
Livy 66, 386
Marcus Aurelius 134
Mars 166 n. 19, 260
Medea 385
Minerva 165
Paris 385
Priam 224
Sophocles 399
Theseus 165, 366
Virgil 224, 394
Xerxes 119

AUTHORITIES CONSULTED

Abdul-Hak, Selim 206 (2) n. 1-2
Abel, Armand 90 n. 15
Adam, Paul 348 (3d) n. 14, 349 n. 11,
 400 n. 4
Adhémar, Jean 168 n. 28
Adler, Alfred 264 (3) n. 2
Aebischer, Paul 24 n. 6; 39 n. 14; 40
 n. 26; 46; 71 n. 32; 76 n. 8; 138 n. 29;
 167 n. 21; 176 n. 17; 206 (2) n. 11;
 265 (5) n. 8; 267 n. 18, n. 20; 342;
 351 n. 25-26, n. 28; 364 n. 19; 367-
 369; 376 n. 12, n. 14, n. 16, n. 18
Ahnne, P. 144 n. 4
Alexandre, J. 177 n. 24
Allario Caresana, Giorgio 83 n. 1
Alónso, Dámaso 24 n. 5; 28 n. 1; 93
Ambrosiani, V. 90 n. 10
Amman, J.-J. 266 n. 2
Andolf, Sven 90 n. 19
Arbellot, Abbé 87, 88
Arens, Eduard 171; 176 n. 10, n. 18;
 177 n. 21
Arents, A. 349 (4) n. 3
Arslan, Eduardo 70 n. 1, n. 15
Asdahl Holmberg, Märta 350 (8) n. 5
Aubert, Marcel 24 n. 2; 39 n. 1; 41 n.
 43; 206 (1) n. 1
Aubert-Susini, Julia 226; 265 (5) n. 10-
 11
Auracher, Theodor 42 n. 47
Auriol, A. 24 n. 9
Aus'm Weerth, Ernst 176 n. 18
Auvray, Lucien 268 n. 3, 269 n. 14, n.
 16, n. 19
Avogadro 376 (1) n. 13
Baer, Leo 267 n. 31
Balau, Sylvain 177 n. 25
Ballocco, A. 83 n. 16
Banasevič, N. 364 n. 20
Barbacci, A. 62
Barré, L. Carolus 400 n. 4

Barrois, M.J. 345 n. 18; 346 n. 63
Barroux, Robert 60 n. 2
Bartsch, Adam 391 n. 12
Bartsch, Karl 112; 137 n. 5, n. 17; 144
 n. 9; 227, 229, 240; 266 n. 2, n. 7,
 n. 10
Batard, Yvonne 269 n. 8
Bateson, F.H. 90 n. 19
Baudouin, Frans 346 n. 75
Bayot, Alphonse 299, 310, 347 (3b) n. 2
Beaulieu, Michèle 38 n. 6; 91 n. 23; **163**
Bédier, Joseph 20, 24 n. 4; 37; 39 n. 13;
 40 n. 17; 50 n. 9; 51, 52; 60 n. 3;
 62; 70 n. 8; 97; 102 n. 2; 153-155;
 157; 160 n. 2-3; 161-164; 166 n. 1,
 n. 9, n. 13; 216; 264 (3) n. 1; 265 (5)
 n. 8; 345 n. 33; 351 n. 22; 364 n. 20;
 366; 368; 376 (1) n. 3
Beenken 28 n. 2
Beer, Ellen J. 237
Beer, R. 391 (1) n. 4
Béjot, Monsignor 207 n. 1
Bekker, I. 264 (3) n. 2
Bellocchi, V. 393 n. 29
Benoît, Fernand 265 (5) n. 4, n. 10
Bergmans, Paul 348 n. 5
Bernouilli, Christoph 24 n. 3
Bertaux, Emile 90 n. 1, 100, 101, 102
 n. 2
Bertoni, Giulio 62-64; 70 n. 7, n. 14,
 n. 19; 91 n. 34; 103; 107 n. 1, n. 4,
 n. 8, n. 10
Bertrand, Gustave 297
Bethmann, L.C. 83 n. 17; 177 n. 24
Beyer, Victor 140; 144 n. 4, n. 8
Bibolet, Françoise 165 n. 24
Bischoff, Bernhard 117, 137 n. 18
Blum, André 386; 391 (2) n. 4; 392
 (5) n. 3
Boase, T.S.R. 136; 138 n. 45, n. 51
Bodmer, Martin 376 n. 16
Boeckler, Albert 118; 137 n. 13, n. 10;
 138 n. 26, n. 36, n. 40; 267 n. 21
Boekenoogen, G.J. 392 n. 11
Böhmer 363 n. 2
Boinet, Amédée 345 n. 27; 348 (3c)
 n. 12
Boissonnade, Prosper 37
Boni, Marco 214; 263 (1) n. 12, n. 14;
 351 n. 13
Bonnardot 364 n. 20
Bonnefoy, Yves 376 (1) n. 2, n. 6
Bordona, Jesús Dominguez 60 n. 15
Bordonau, Miguel 60 n. 12
Bos, Alphonse 152 n. 2
Bossuat, Robert 344 (1) n. 1, n. 9, 344
 (2) n. 2, 349 n. 13, 350 (7) n. 1
Bousquet, Louis 24 n. 3
Boussard, Jacques 41 n. 38

Boutemy, André 166 n. 19
Boy, M. 348 (3c) n. 12
Brandin, Louis 207 (2) n. 13; 212; 263
 (1) n. 6; 264 (3) n. 4, n. 5
Brassinne, Joseph 149, 152 n. 16
Brault, Gérard J. 344 (1) n. 10, n. 11
Braunfels, Wolfgang 341; 391 (3) n. 8
Brayer, Edith 346 n. 53, n. 73; 349 (5)
 n. 3
Breuer, Tilmann 29; 39 n. 1; 41 n. 35
Brincard, Baroness 88; 91 n. 25, n. 27-28
Briquet 240, 330
Brizio, A.M. 83 n. 3
Bruck, Robert 144 n. 4; 331
Brugnoli, Pier Paolo 70 n. 15
Brunet 392 n. 15
Brusin, G. 83 n. 20
Buberl, P. 138 n. 25
Bulteau 200
Bützmann 267 n. 26
Byvanck, A.W. 323; 349 n. 12
Cahier, Charles 71 n. 30
Camara, Cascudo, Louis da 110 n. 3
Cames, Gérard 144 n. 21
Cannobio 61
Carmody, Francis J. 327, 328; 344 (1)
 n. 6; 349 (5) n. 2, n. 3
Carro Garcia, Jesús 54, 57; 60 n. 11,
 n. 14, n. 16, n. 21
Castets, Ferdinand 50 n. 10; 264 (4) n.
 1, n. 2
Catalano, Michele 62-64, 67; 70 n. 10,
 n. 11; 102 n. 4; 268 n. 17-18
Chabaille 349 (5) n. 3
Chabaneau, Camille 225; 265 (5) n. 1,
 n. 5
Chachuat, Madame 90 n. 21
Champigneulle, Bernard 70 n. 27
Champion, Pierre 345 n. 19
Charlier, Gustave 346 n. 61
Charrière, E. 376 (1) n. 1
Chastel, André 193; 206 (1) n. 1; 260;
 269 n. 8
Chernova, G.A. 299, 300; 346 n. 73,
 n. 74
Chesney, Kathleen 400 n. 1
Chevalier, Ulysse 207 n. 7
Ciampoli 258
Cipolla, Carlo 71 n. 38; 76 n. 2; 83
 n. 14-17
Cittadella, N.L. 65; 70 n. 21; 71 n. 29
Claudin, A. 392 n. 15, n. 18
Clemens, Paul 50 n. 20; 60 n. 13; 176
 n. 18
Clive, H.P. 344 (1) n. 1
Cloetta 70 n. 12
Cluzel, Irénée 24 n. 7; 50 n. 9; 90 n. 19;
 264 (3) n. 3
Coderera y Solano, Valentin 26

Coletto, Luigi 376 (1) n. 8, n. 9

Collon-Gevaert, Suzanne 176 n. 1; 177 n. 33; 391 (2) n. 3

Conant, Kenneth John 90 n. 21; 152 n. 15

Craplet, Bernard 96 n. 7

Crick-Kuntziger, Marthe 372, 373, 377 n. 10

Crous, Ernst 116, 137 n. 18

Crouvezier, Gustave 207 (3) n. 1

Crozet, René 39 n. 1; 96 n. 1; 134

Curtius, Ernst Robert 269 (8) n. 12

Dacier, Emile 347 (3c) n. 10

D'Allemagne, Henri-René 384, 385; 392 (4) n. 4-7

D'Alverny, Marie-Thérèse 50 n. 16

Daras, Charles 29, 36, 38; 39 n. 1, n. 6; 41 n. 29-32, n. 35, n. 37

D'Arbois de Jubainville 166 n. 23

David, Henri 377 n. 5

David, Pierre 60 n. 4

De Azevedo, Antonio 109, 110 n. 6

De Boor, Helmut 112, 137 n. 6, 266 (6) n. 4, 350 (8) n. 4, n. 6

Dechamps, Jan 343

Deckert, Professor 350 (7) n. 6

De Fontenay, Harold 385

Defourneaux, Marcelin 50 n. 21, 60 n. 4

De Francovich, Geza 27, 28 n. 2, 104, 107 n. 2, n. 5; 154, 157; 160 n. 8, n. 9, n. 17, n. 18, n. 20

De Gaiffier, Baudouin 145, 152 n. 4

Delaborde, H.F. 344 (2) n. 1

Delaissé, L.M.J. 220, 299, 312, 316, 324, 329, 339, 346 n. 69; 347 n. 76-77, (3b) n. 6; 348 (3c) n. 13-14, (3d) n. 5, n. 8; 349 n. 14, (6) n. 2-3; 350 n. 13, (8) n. 1

Delaporte, Yves 200-202; 206 (1) n. 1, n. 3, n. 11, (2) n. 1

Delbouille, Maurice 264 (2) n. 6; 364 n. 20

Delehaye, Hippolyte 206 (2) n. 5-6

De Leo, Ortensio 102 n. 2

Delisle, Léopold 264 (2) n. 5; 276; 288; 310, 344 (2) n. 8-9; 345 n. 13-14, n. 28, n. 37-38; 346 n. 48, n. 51; 347 (3a) n. 1-2; 349 (6) n. 5

Del Redan, G. 91 n. 32

Demaison, Louis 207 n. 2

De Mandach, André 28 n. 5; 52; 60 n. 6, n. 10; 114; 266 n. 5; 267 n. 21, (7) n. 3; 268 (7) n. 13, n. 16; 344 (1) n. 1-2, n. 8; 351 n. 29-30

Demay, G. 39 n. 8, n. 10

Denti, Nino 160 n. 1

De Poerck, Guy 349 (6) n. 1, n. 4

De Raadt, J.T. 348 (3d) n. 10; 349 n. 6

De Reiffenberg, F. 344 (1) n. 9

De Riquer, Martin 50 n. 9; 264 (3) n. 3

Deschamps, Paul 24 n. 3; 28 n. 2; 29; 39 n. 1; 41 n. 43; 63; 64; 70 n. 18; 134; 146; 152 n. 1; 350 (7) n. 9; 366; 376 (1) n. 2, n. 6-7

Desjardins, Gustave 24 n. 4

Desonay, Fernand 318, 372, 373, 377 n. 14

De Vries, M. 349 (4) n. 5

D'Herbecourt, Pierre 91 n. 26-27

D'Heur, Jean-Marie 110 n. 3

Dier-Manse, P.J.J. 351 n. 51

Donati, Lamberto 268 (8) n. 7

Donisotti, Carlo 267 n. 3; 268 n. 11-12

Dorez, Léon 269 n. 17; 347 n. 11

Dougherty, David M. 215

Doutrepont, Georges 264 n. 7, (4) n. 1-2; 298, 299, 331; 346 n. 68, n. 70; 347 (3b) n. 5, (3c) n. 9; 348 n. 9; 349 n. 15; 350 (7) n. 3, n. 5-6; 392 n. 13, n. 15

Drescher, T. 240, 267 n. 28

Dreyer, J.C.H. 359; 364 n. 3

Droz, Eugénie 345 n. 20

Duchein, Michel 91 n. 23

Duchesne 381; 391 (2) n. 1, n. 8

Dufour, C. 152 n. 1

Du Plessis, Toussaint 166 n. 7, n. 23

Duprat, Clémence-Paul 152 n. 1

Durand 78

Durliat, Marcel 41 n. 43

Durrieu, Paul 326; 346 n. 47

Duvernoy, E. 144 n. 15

Duvivier, Charles 347 (3b) n. 1

Endres, A. 166 n. 15

Ennen 267 (6) n. 33

Eisler, Robert 391 (3) n. 10

Essling, prince d' 160 n. 17

Eusebi, Mario 166 n. 2, n. 8

Ewert, Alfred 42 n. 47

Fainelli, V. 71 n. 37

Faral, Edmond 30, 39 n. 12

Farinelli, Arturo 261; 269 n. 15, n. 20-21

Fau, Jean-Claude 19, 20, 24 n. 3, n. 10-12, n. 18

Fawtier, Robert 351 n. 23

Faymonville, Karl 176 n. 1, n. 18

Febvre, Lucien 345 n. 24

Fehrlin, Hans 266 n. 9

Ferrari, Giorgio E. 116 n. 10; 263 (1) n. 2; 267 (7) n. 2; 393 n. 24-28

Fiocco, G. 391 (2) n. 7

Focillon, Henri 206 (2) n. 4; 385; 392 (5) n. 1; 410

Folz, Robert 47; 50 n. 5, n. 9, n. 12; 52, 112; 137 n. 1, n. 3, n. 6; 139; 144 n. 1-2; 176 n. 3, n. 5; 193; 206 (1) n. 4; 227; 266 n. 2, n. 6, n. 11, n. 15-16; 346; 350 (8) n. 4-6; 352, 356,

357; 363 n. 2-4, n. 8, n. 11; 364 n. 1, n. 5-6, n. 15; 391 (3) n. 6

Foote, Peter G. 351 n. 27

Fortia d'Urban, Marquis, 312; 347 (3c) n. 3, n. 6; 348 (3c) n. 15

Foulet, Lucien 40 n. 17

Fourez, Lucien 349 n. 11

Fourrier, Anthime 167 n. 24-25

Francastel, Pierre 24 n. 3

François, Michel 345 n. 25-26; 346 n. 46

Frappier, Jean 42 n. 47; 263 n. 2; 400 n. 4

Freher, Marquand 400 n. 6

Gabotto, F. 83 n. 16

Gachet, Emile 348 (3d) n. 5

Gad, Tue 349 (6) n. 4

Gaillard, Georges 24 n. 3; 26; 28 n. 2

Ganshof, François-Louis 344 (1) n. 5

Gantner, Joseph 39 n. 1

Gasdia, V.E. 90 n. 1, n. 7

Gaspar, Camille 288, 299, 345 n. 39-40, 346 n. 64-67

Gasparrini-Leporace, Tullia 160 n. 10; 267 n. 2; 269 n. 10; 393 n. 24-28

Gathen, Antonius David 356-369, 361; 364 n. 1-2, n. 4, n. 9, n. 13-14, n. 18

Gauthier, Serge 90 n. 23

Gautier, Léon 39 n. 9-11; 70 n. 7; 331

Gay, 39 n. 8, 76 n. 5, 83 n. 19

Gaya Nuño, Juan Antonio 24 n. 14; 28 n. 2; 96 n. 9; 138 n. 44

Gazzola, Piero 76 n. 1

Génicot, Léopold 24 n. 13

Gilbert, A. 41 n. 28

Gilson, J.P. 221, 263 (1) n. 10; 346 n. 51

Giovenale, Gian-Battista 43-45, 47, 49; 50 n. 3-4; 405

Girolla, P. 268 (7) n. 3

Giry, Arthur 344 (1) n. 5

Gischia, Léon 70 n. 27

Glotz, Gustave 392 (5) n. 1

Göbel, Heinrich 374; 377 n. 5, n. 15, n. 17-18

Gody, Simplicien 362, 364 n. 22

Goerlitz, T. 358; 364 n. 12, n. 16-17

Goffler, Karl 267 n. 30

Goldschmidt, Adolphe 57; 60 n. 23, n. 25; 138 n. 24

Golther, W. 50 n. 13

Grabar, André 44, 50 n. 2; 207 n. 6; 405

Graff, Jean 112, 115, 116, 123, 126, 129; 137 n. 6, n. 9, n. 21

Grimm, Jacob 112; 137 n. 4; 227

Grimm, Wilhelm 116

Grimme, Ernst Günther 174, 175, 176 n. 1; 177 n. 28, n. 30-32; 194; 206 (1) n. 1, n. 4, n. 6, n. 7; 363 n. 1, n. 9